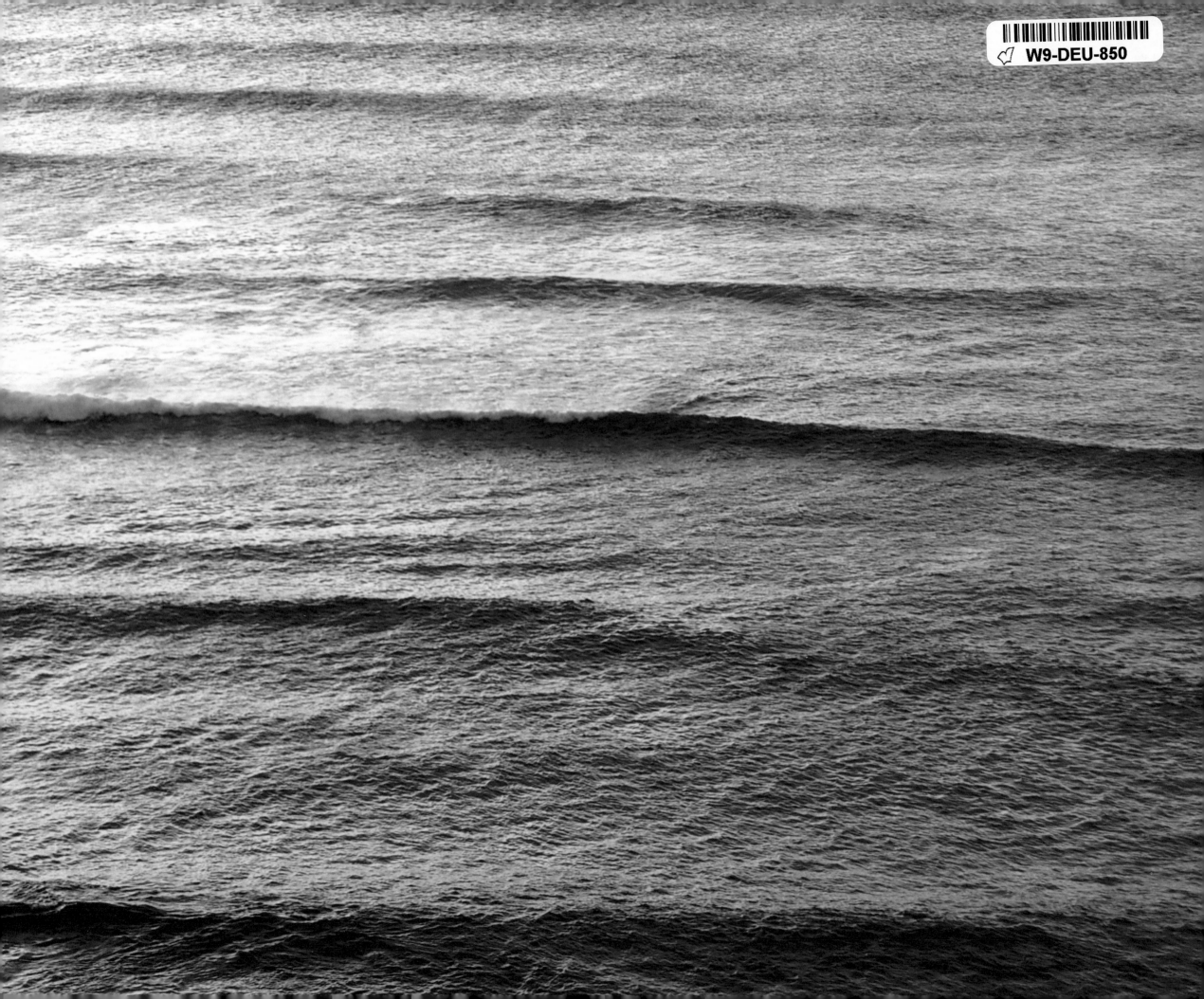

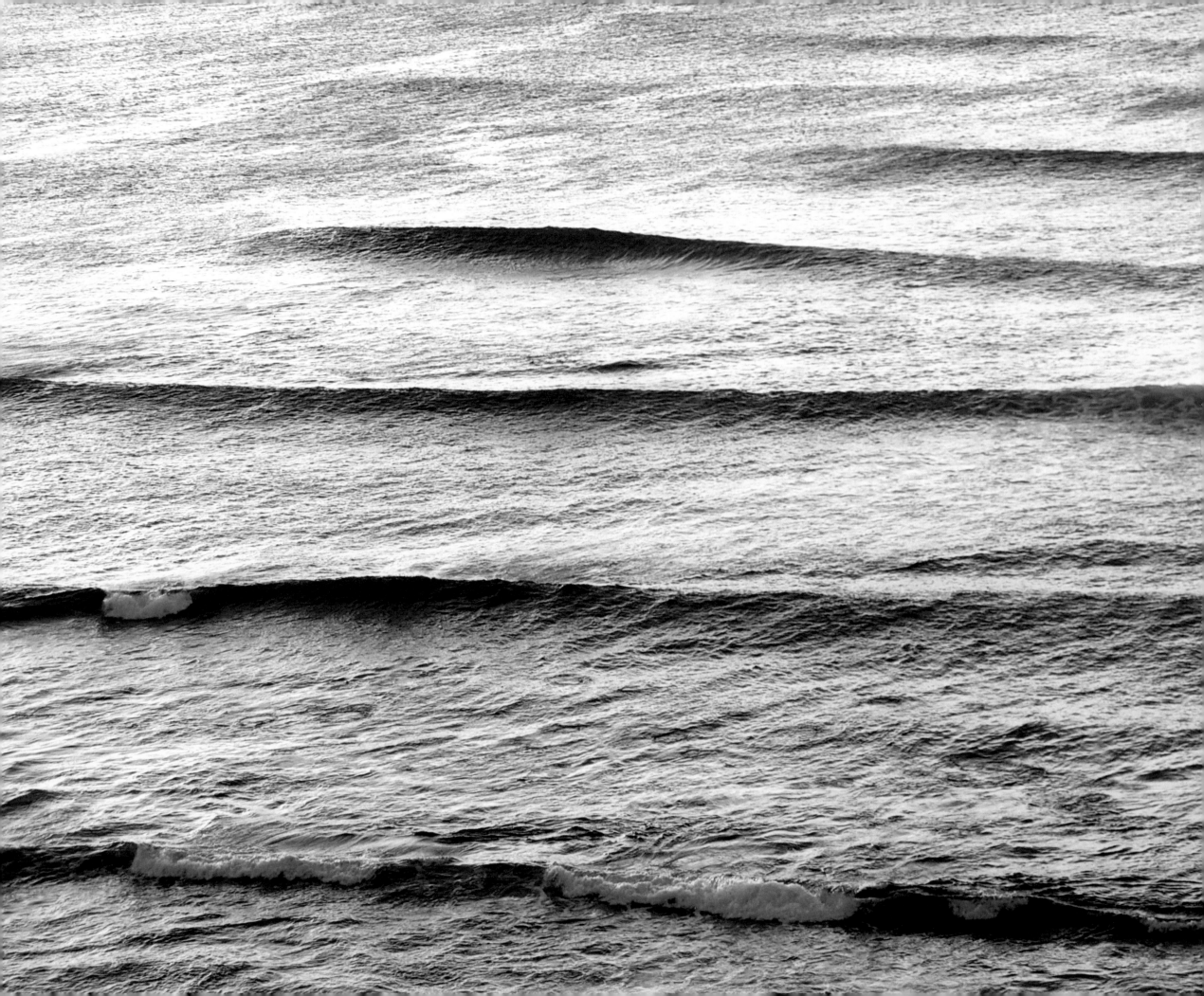

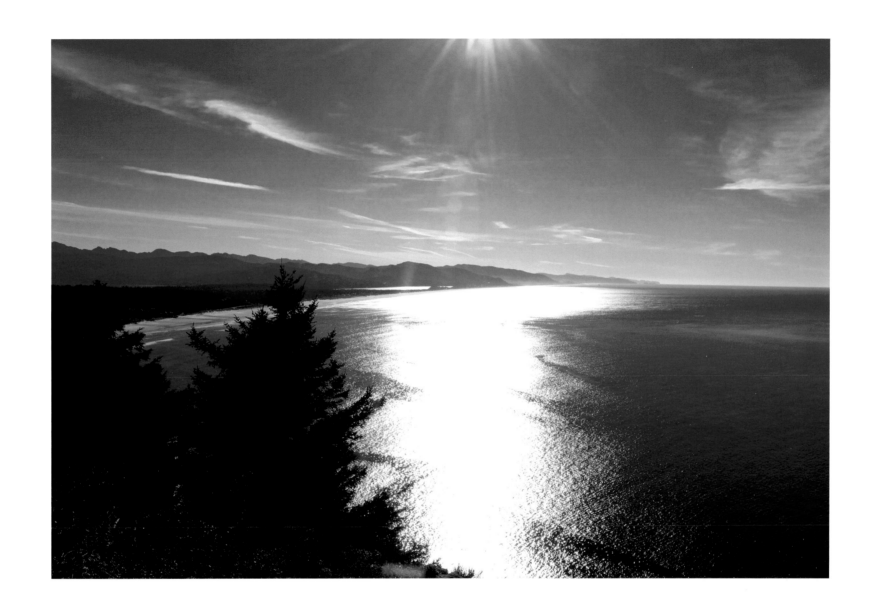

Ocean

photography by **Dain Blair** & **Aaron Taylor**

 Immaginare Press

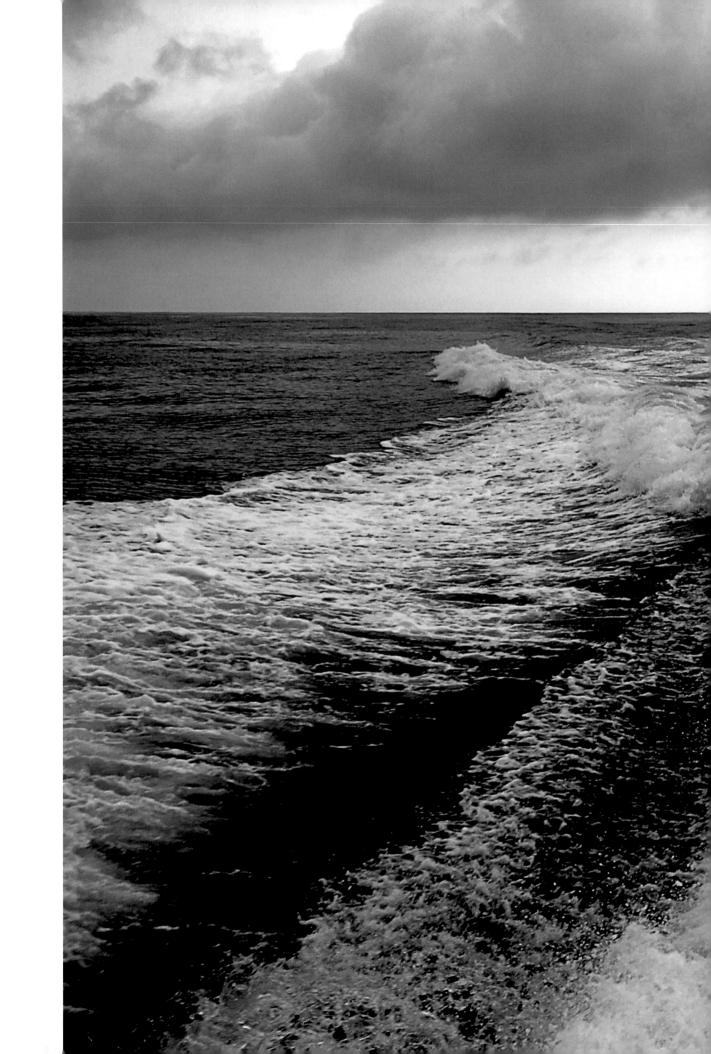

Library of Congress Cataloging in Publication Data available.

ISBN: 978-0-9720618-5-8

Printed in China.

www.immaginarepress.com

Immaginare Press
1418 2nd Street
Santa Monica, CA 90401
310.260.2626

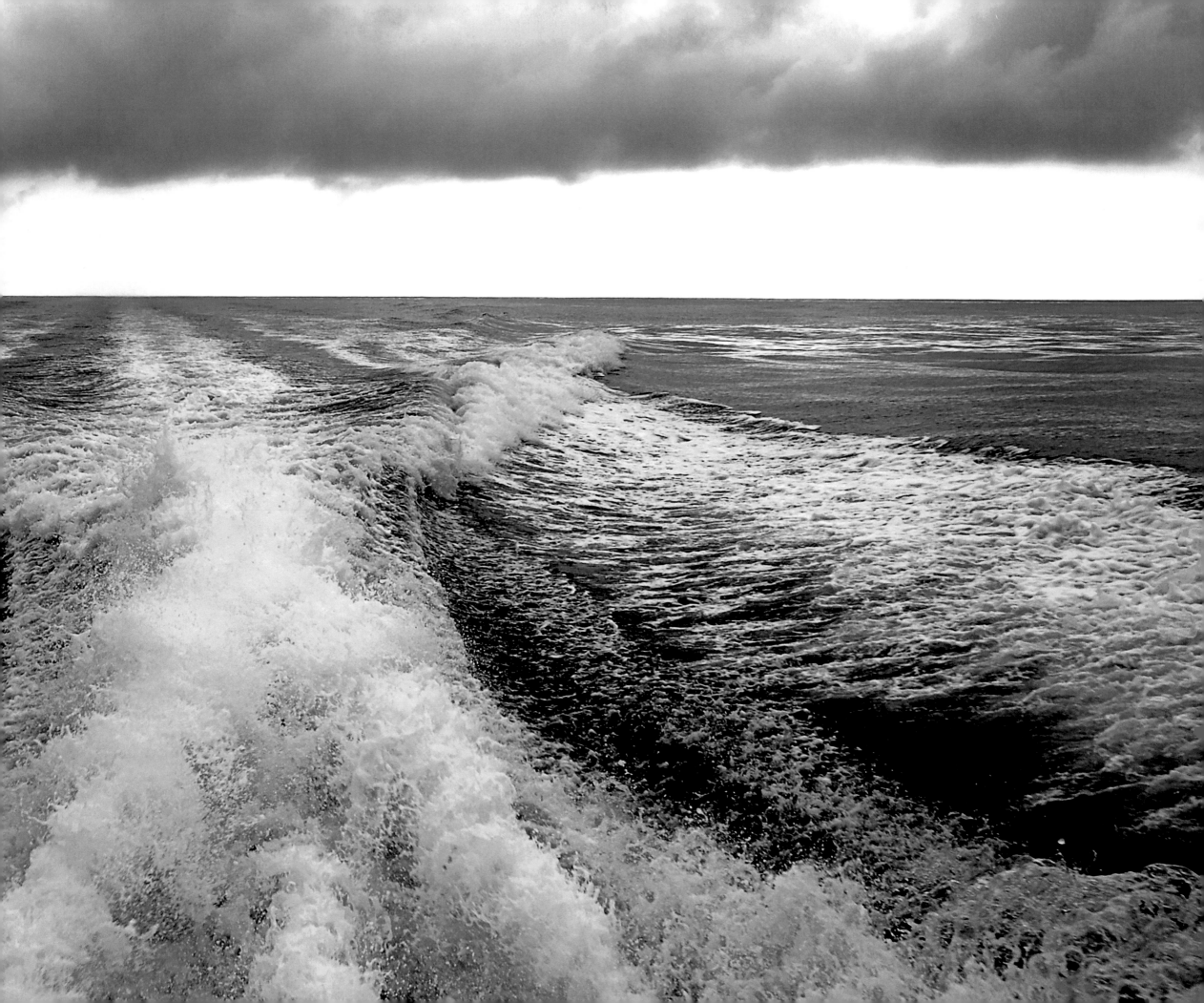

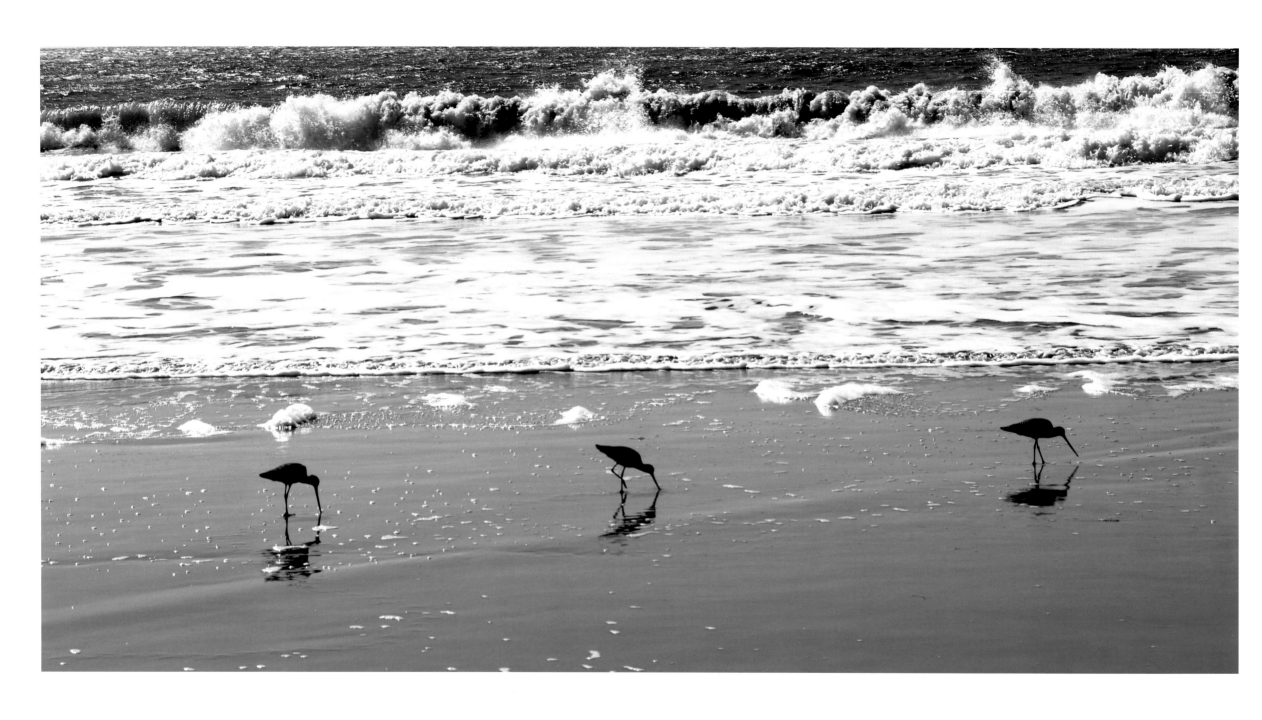

Santa Barbara, California

ocean

This book is a glimpse of my experiences on and around the ocean.

I have had a love affair with the ocean from my earliest memories. I was raised in Panama. My father worked on the Locks of the Panama Canal, and we lived in the "Canal" Zone," a little utopia of America. We lived on the Atlantic side. I spent time between both the Pacific and Atlantic sides of Panama. The beaches were fantastic. I spent my childhood boating and swimming. When I turned 18, I moved to Florida to attend college. During the college years I became a lifeguard, sailed, body surfed and spent as much time on and around the water as possible.

I combine my passion for photography along with my passion for the ocean to create this simple book, where I have captured moments in time. Reflective, exciting, beautiful, exhilarating and breathtaking. Moments I share in places you may have already visited to places you may hope to visit one day soon.

Dain Blair

The Ocean has been my place of peace since I was able to remember events.

My father, being a surfer growing up, has always kept us close to the edge of land. Something about being able to look into the vastness and see nothing but pure beauty wipes your worries away. Gives you a perspective on your place in this earth's ecosystem, however small, still very important.

The smallest sea life is the life force of the water, it's energy is carried on all the way to the surface.

I hope I am able to share at least a glimpse of the energy and zest that I gather from the Ocean with you, don't be shy to get lost in the images, but above all, go out there and enjoy the beauty of natures playground yourself!

Aaron Taylor

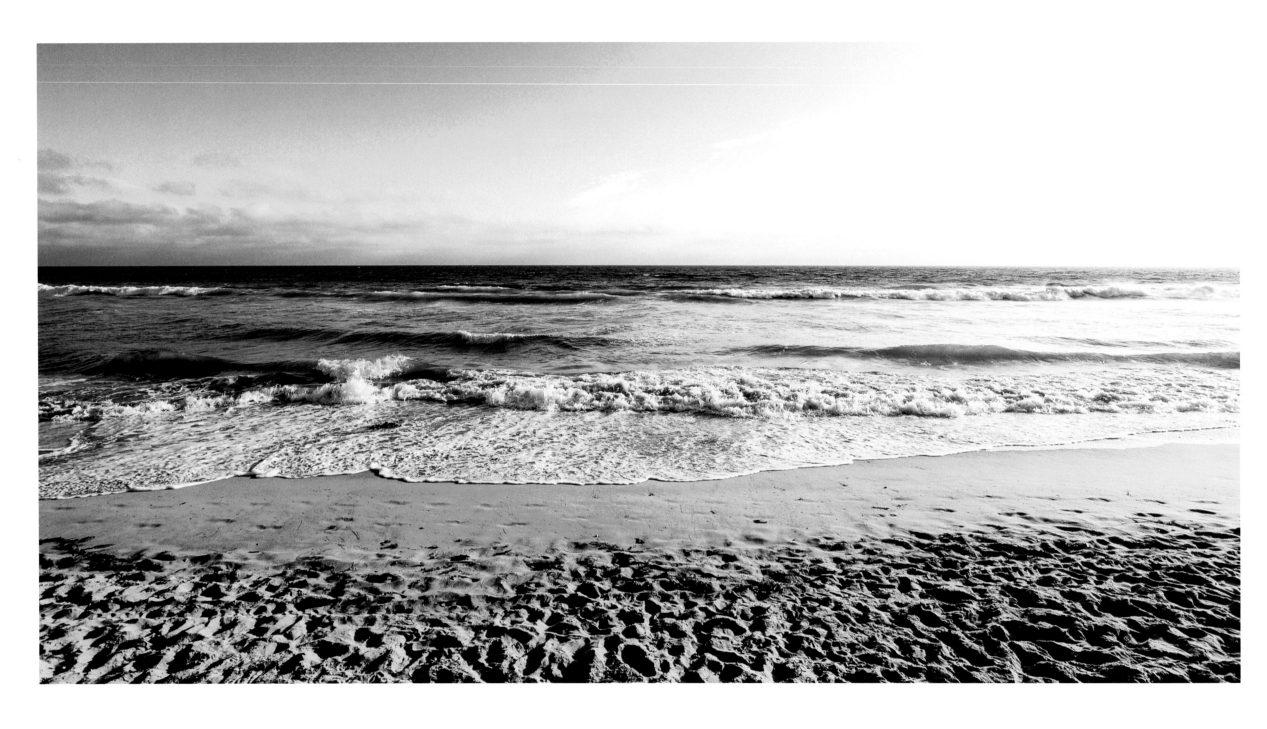

Malibu, California

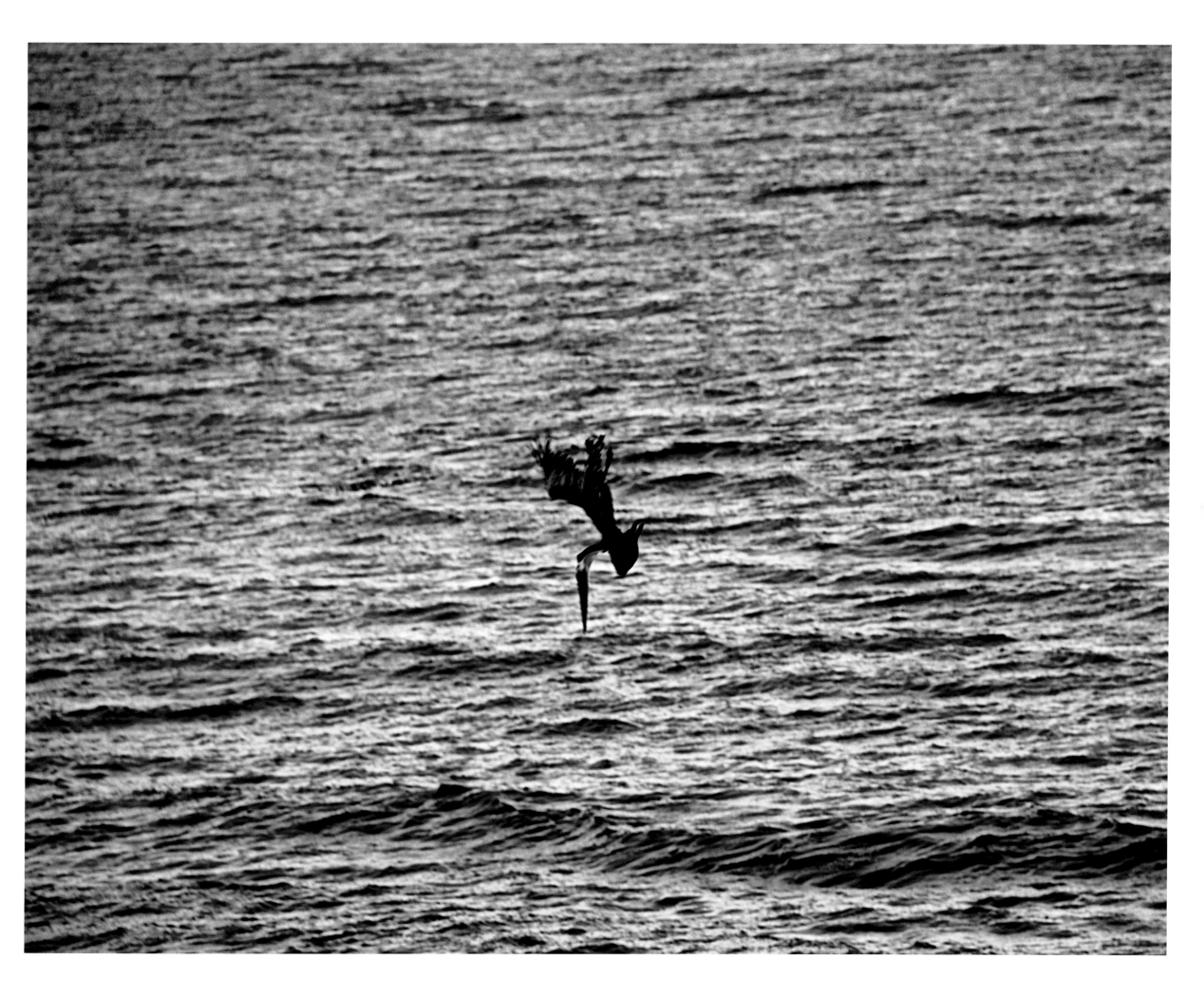

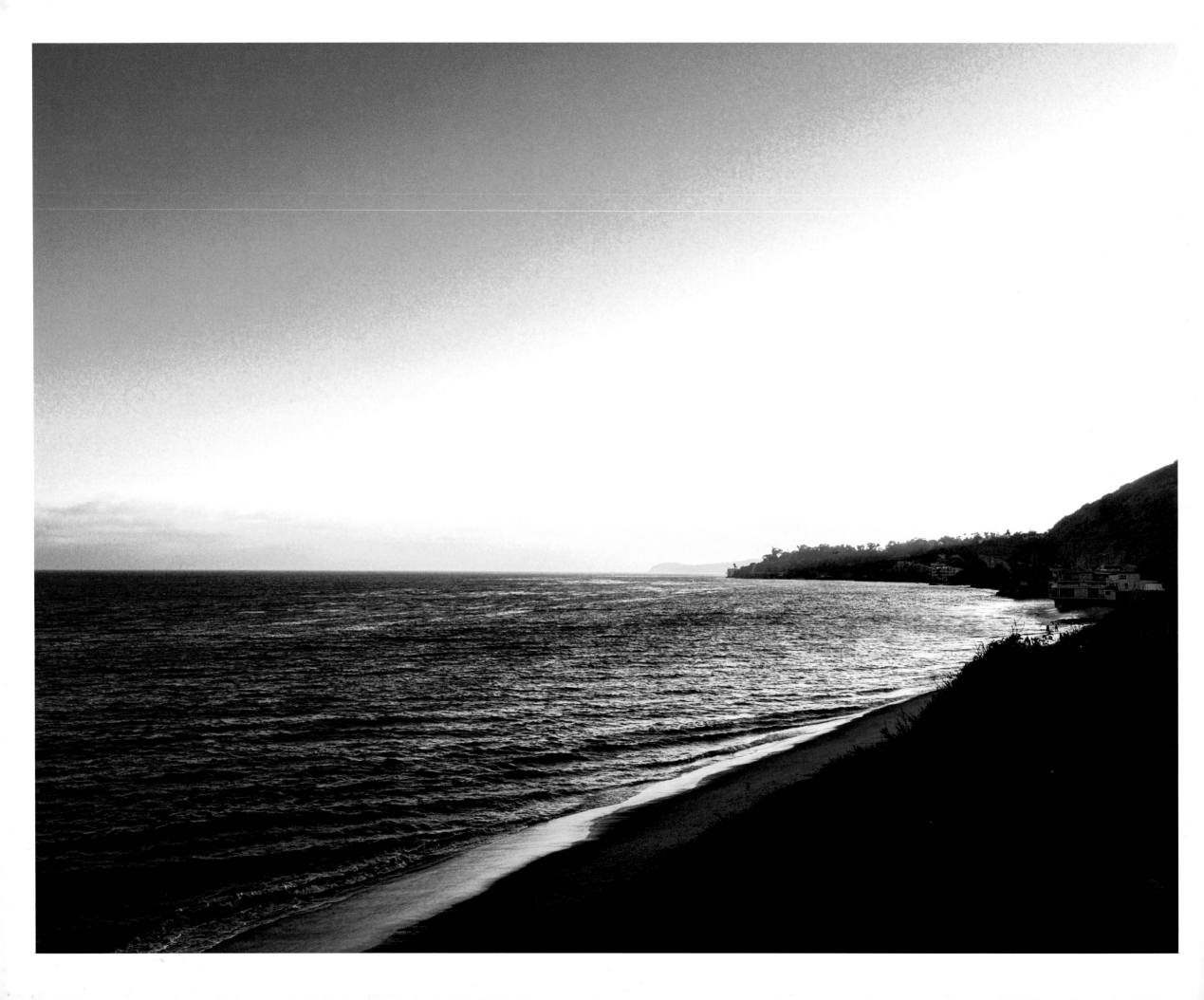

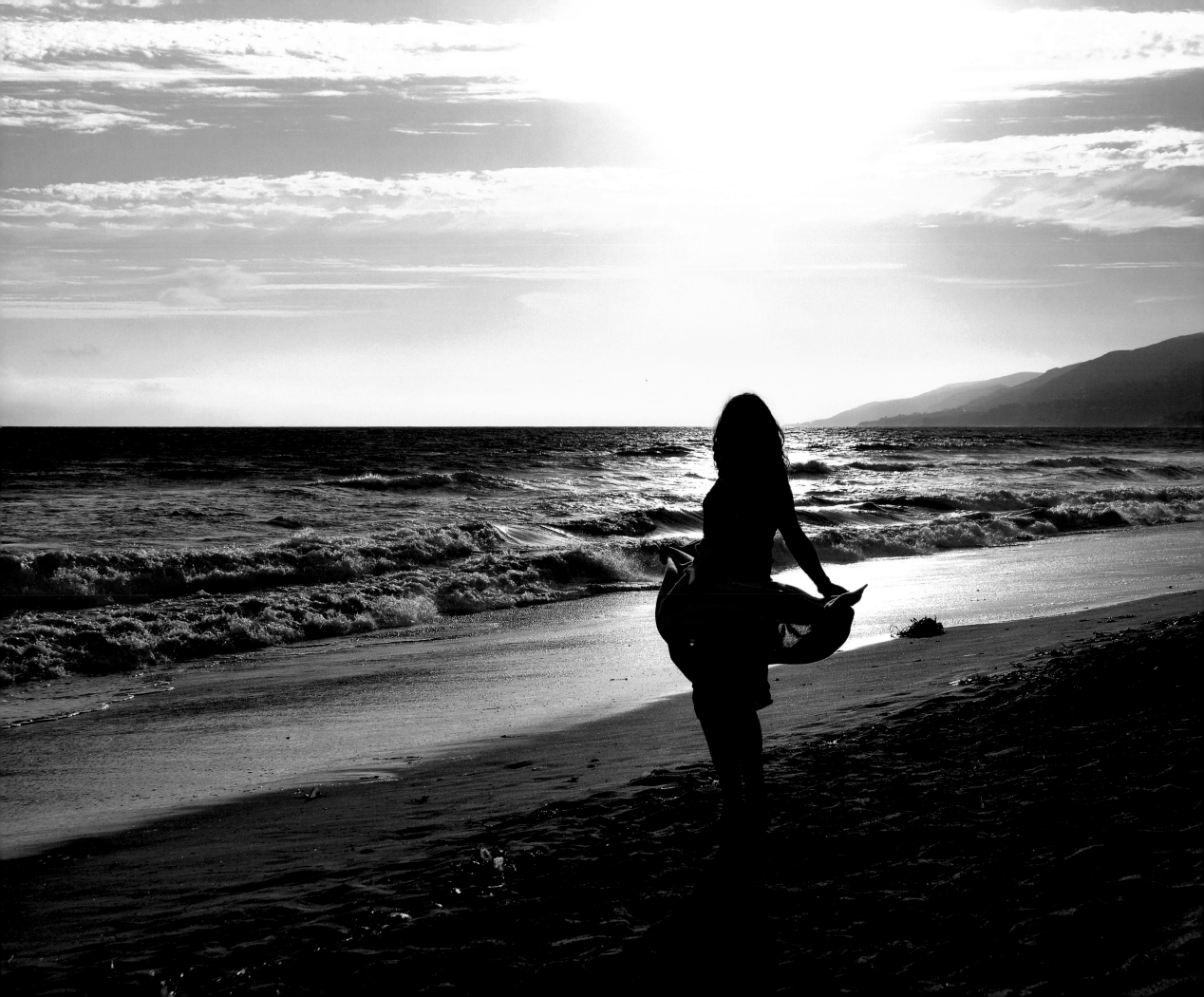

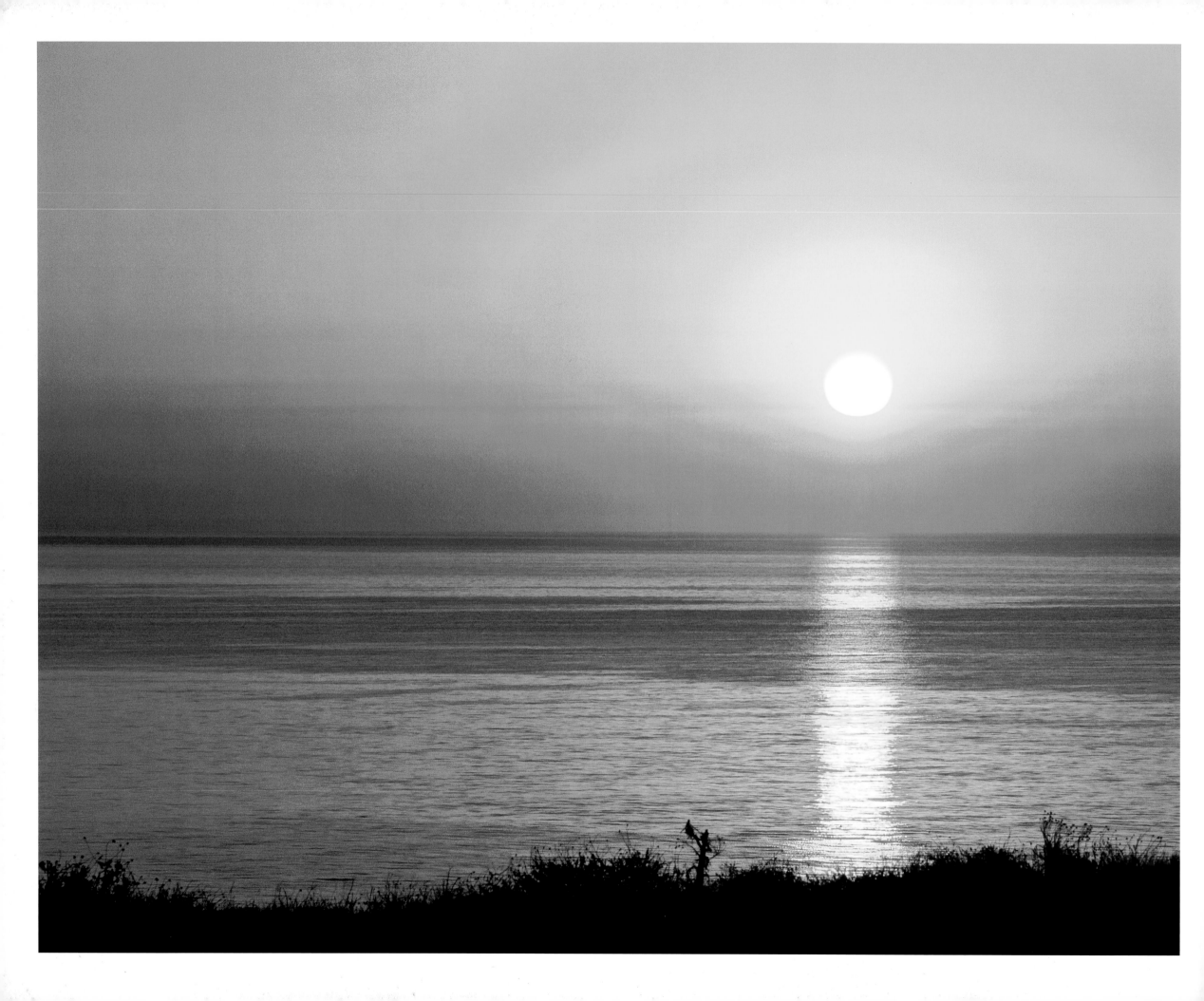

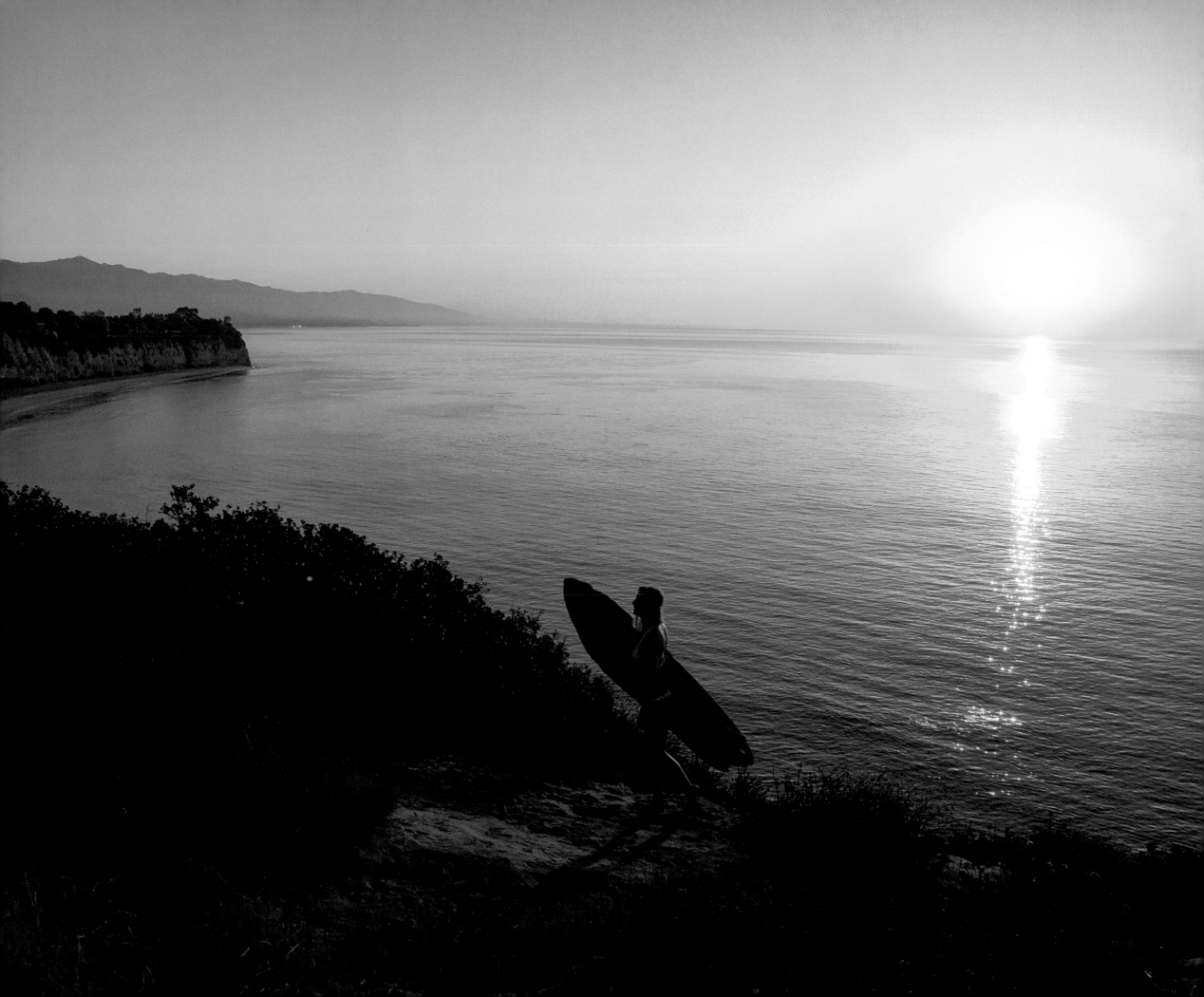

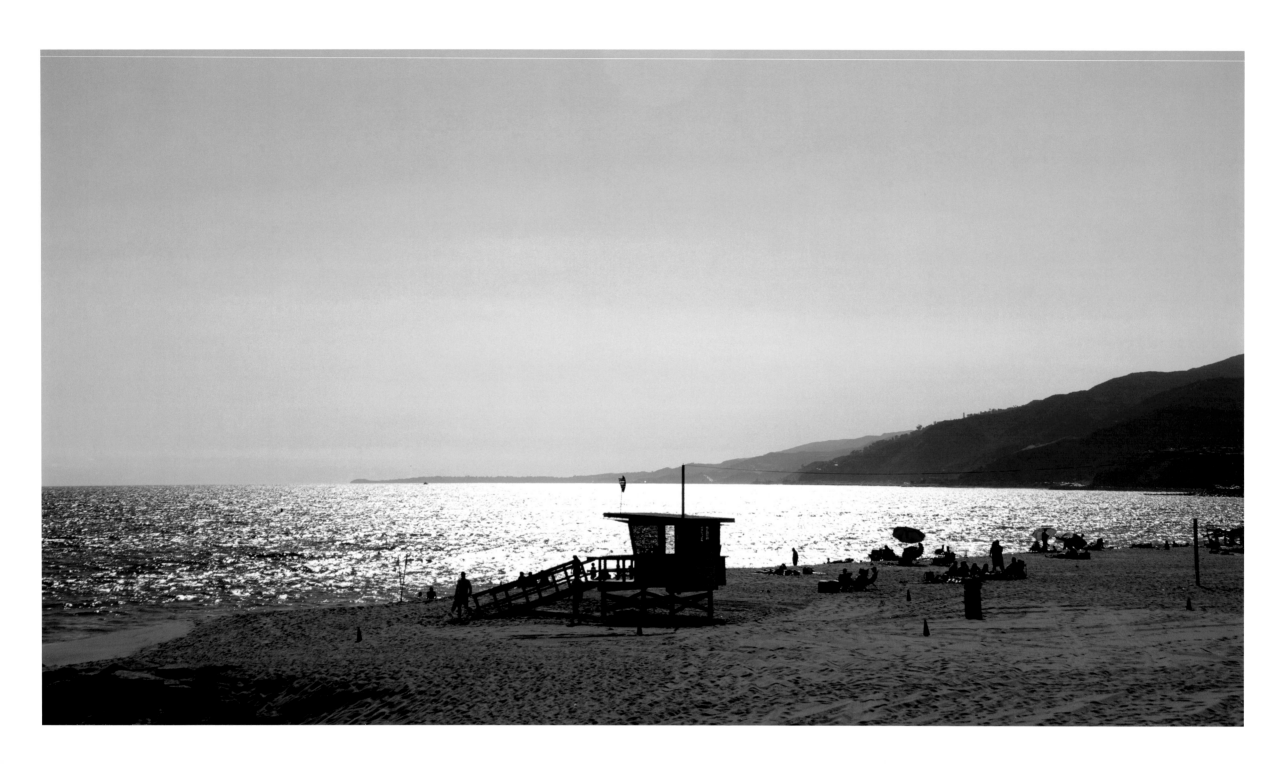

Santa Monica, California

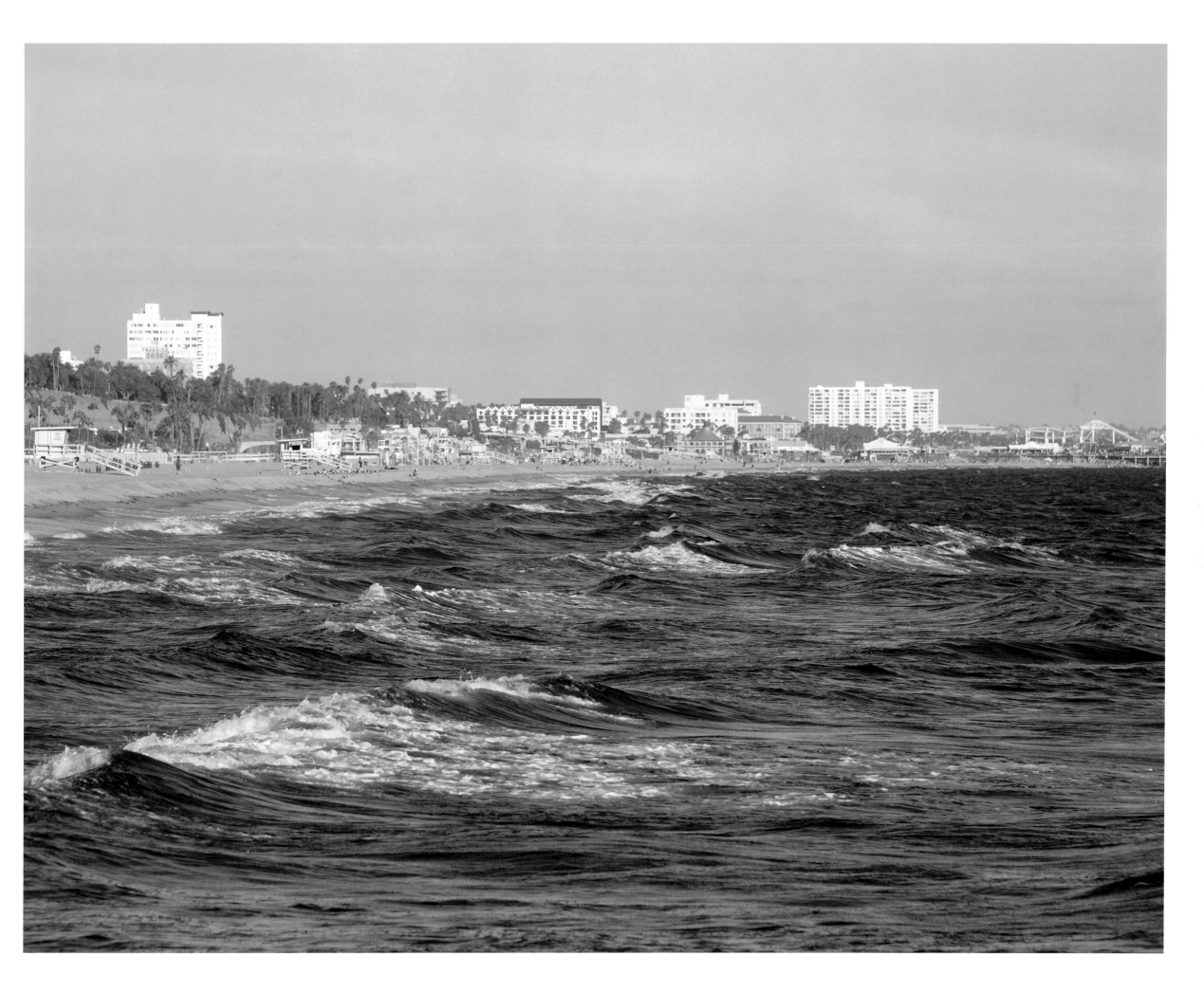

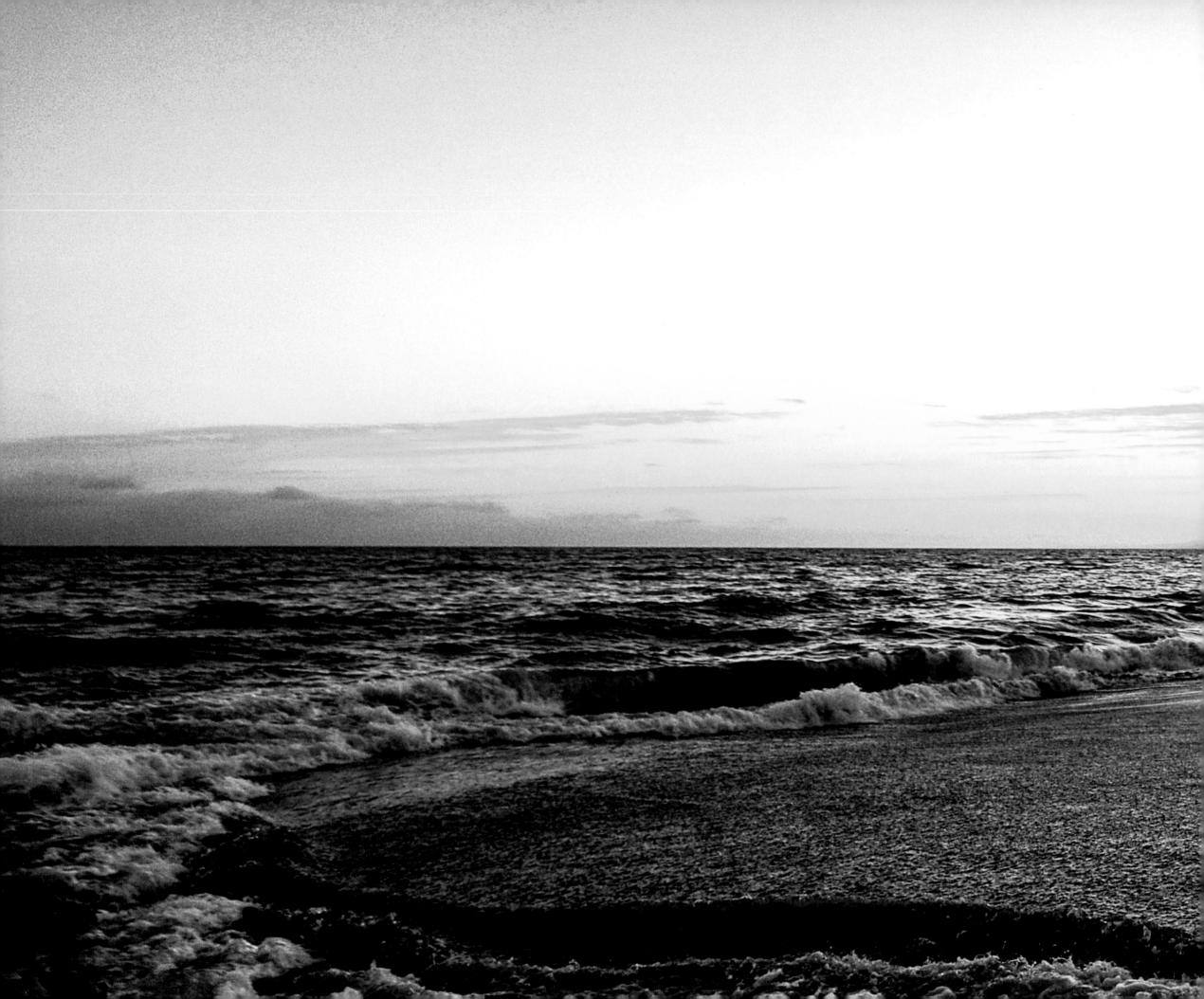

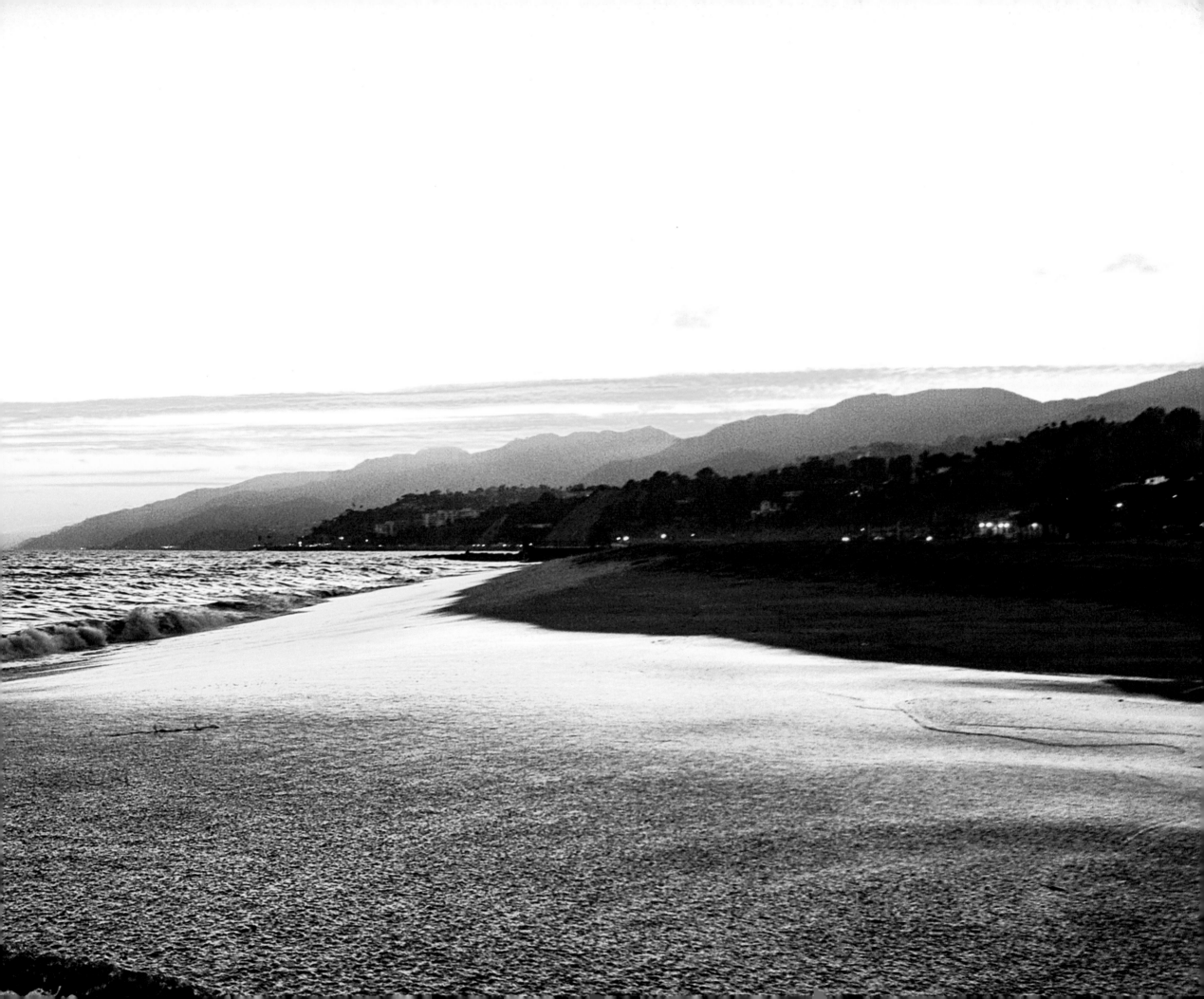

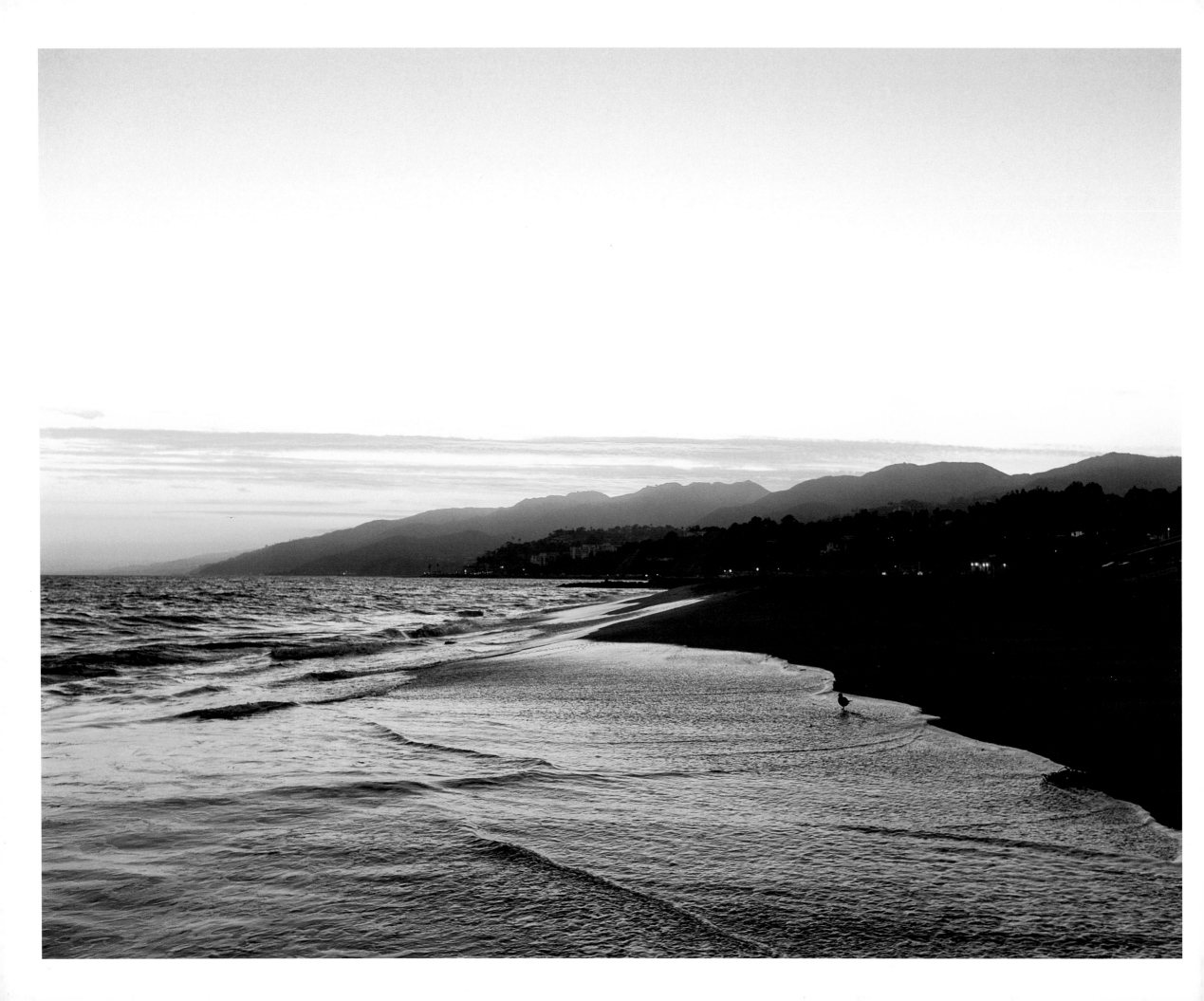

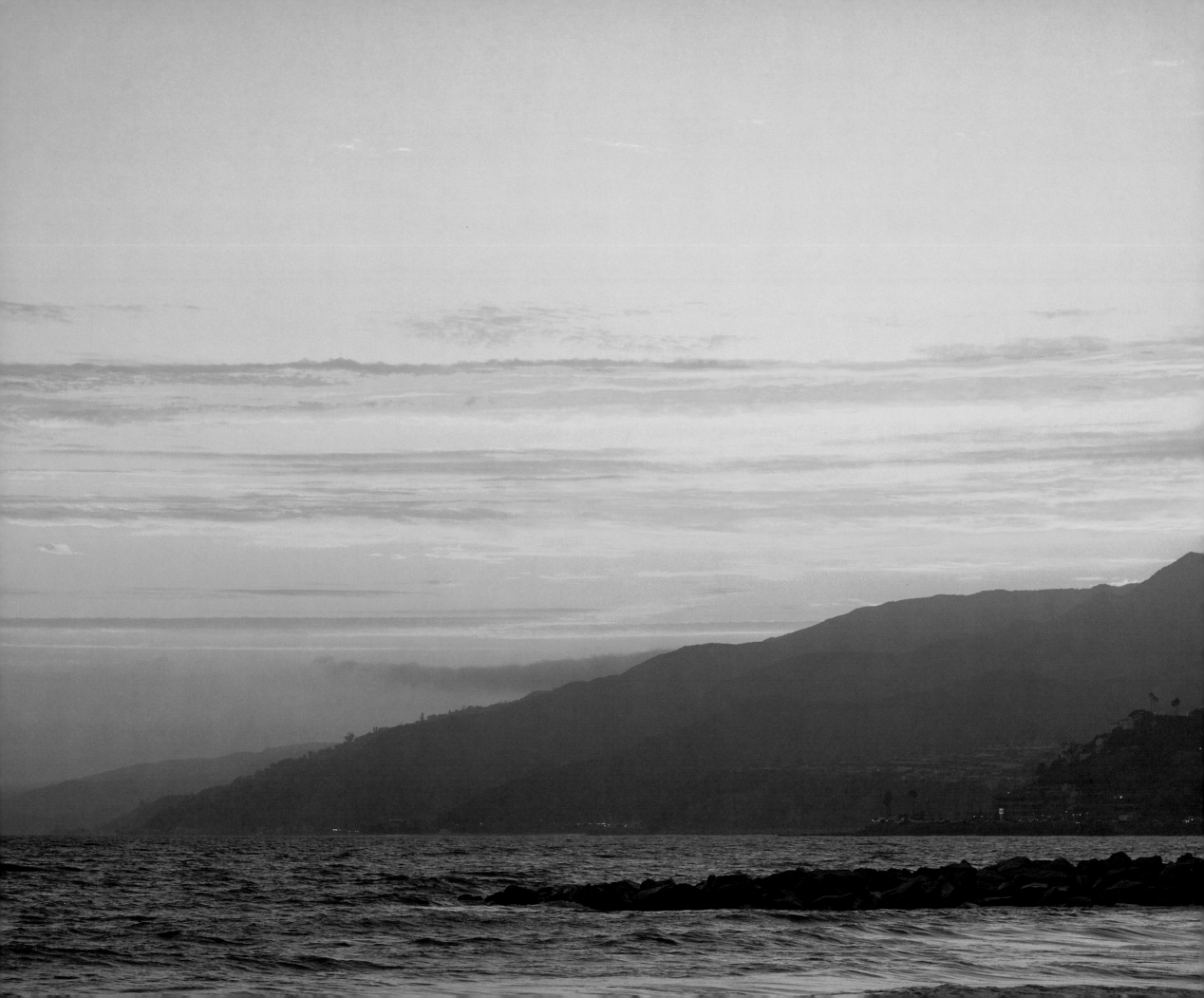

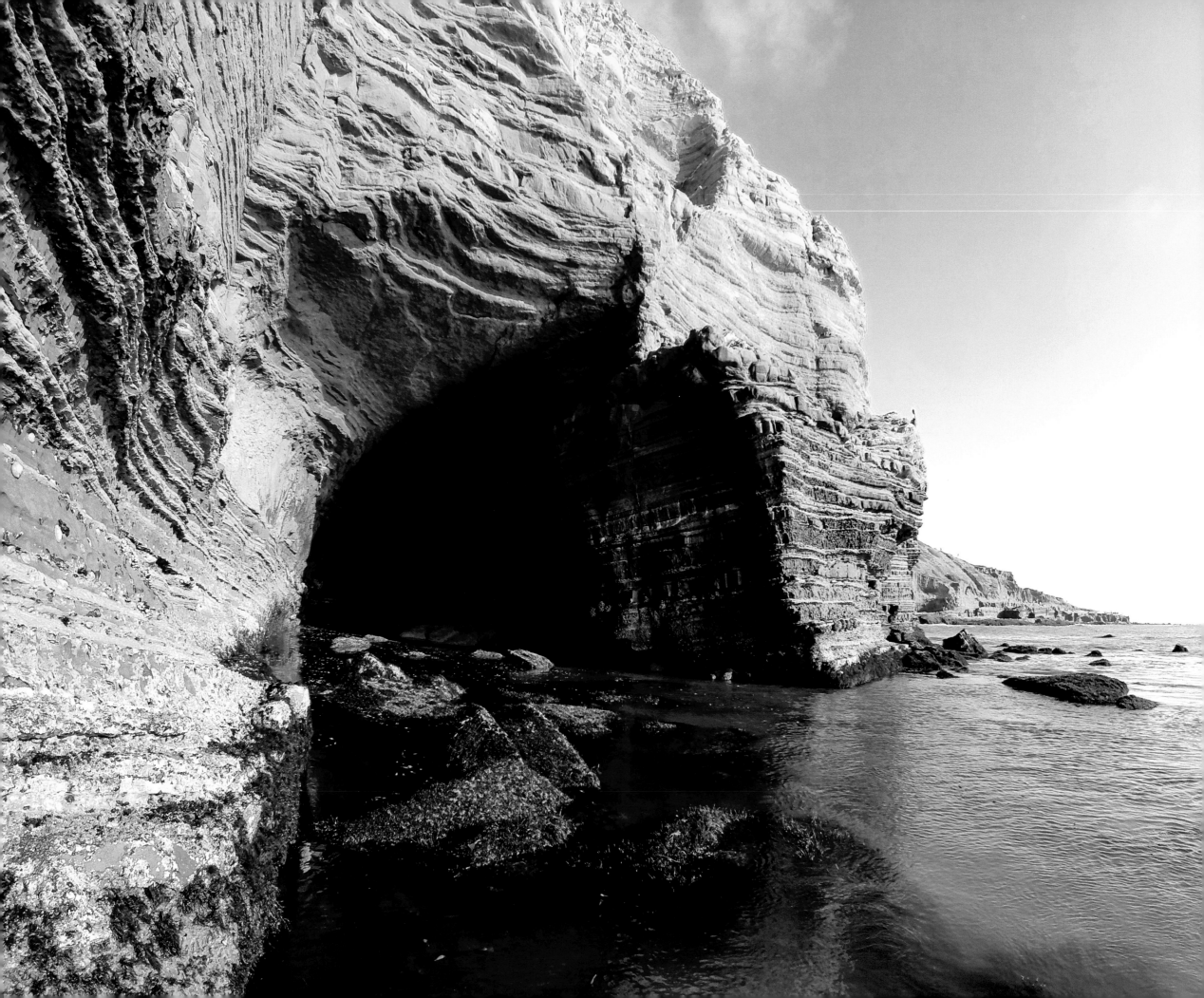

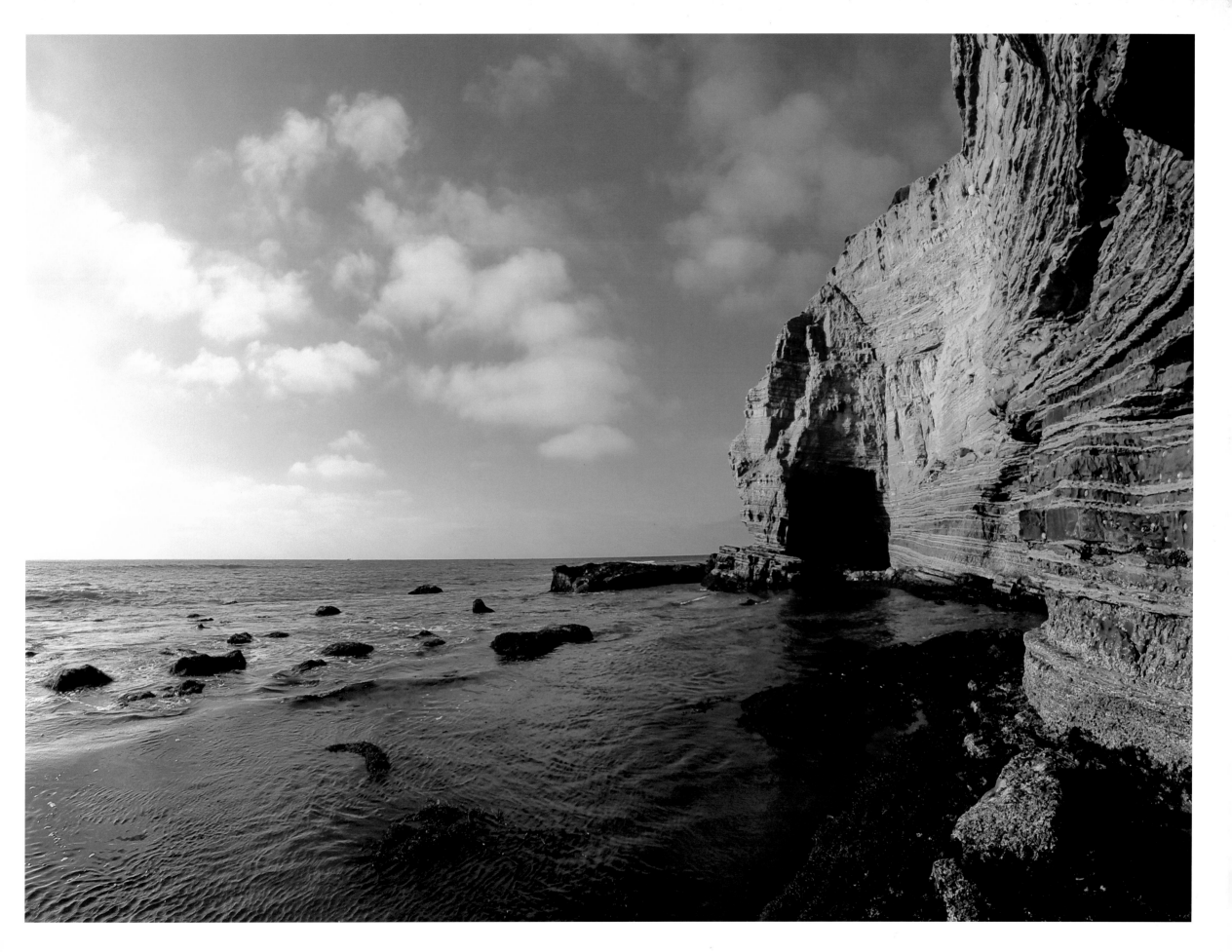

Pt. Loma, San Diego, California

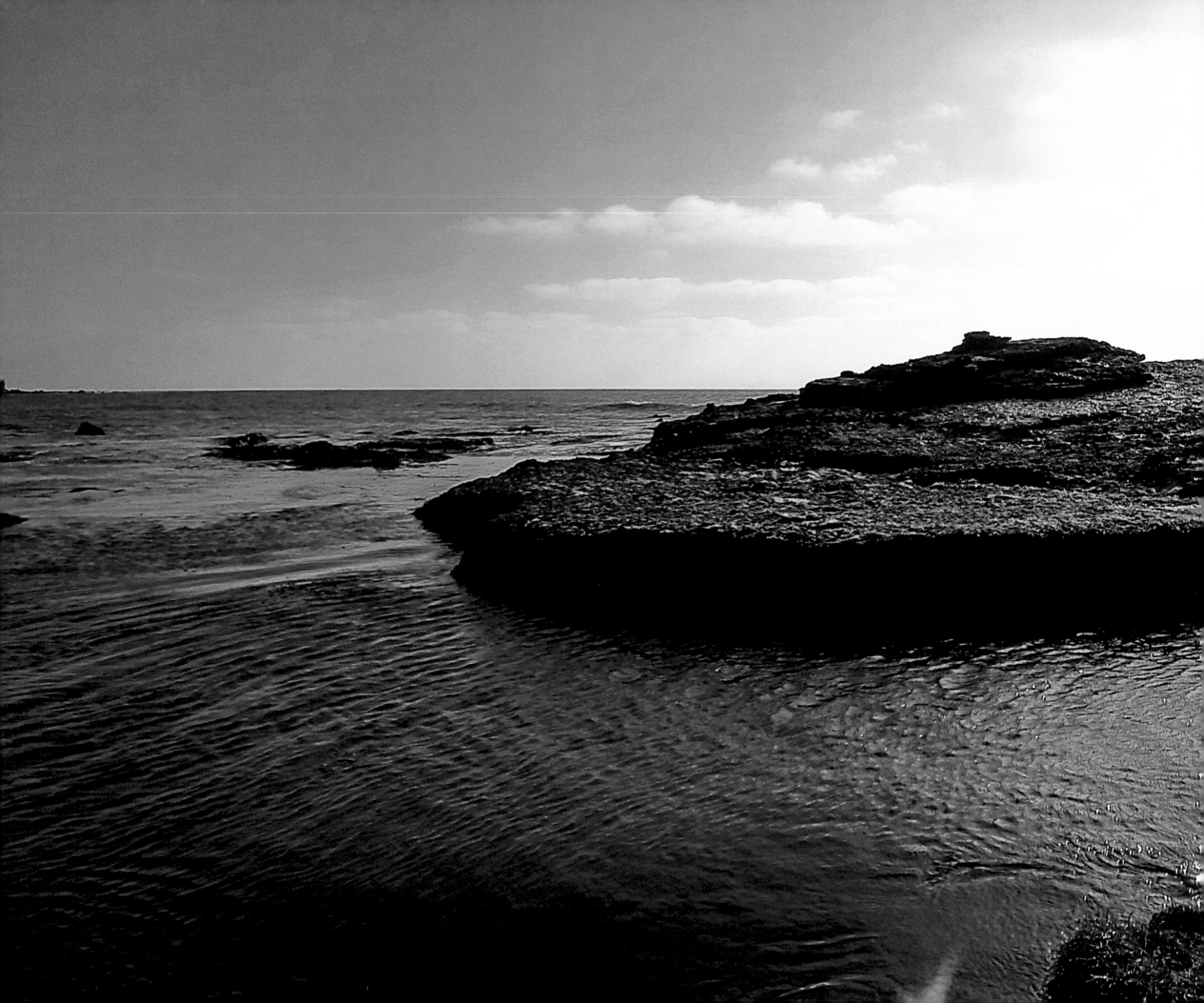

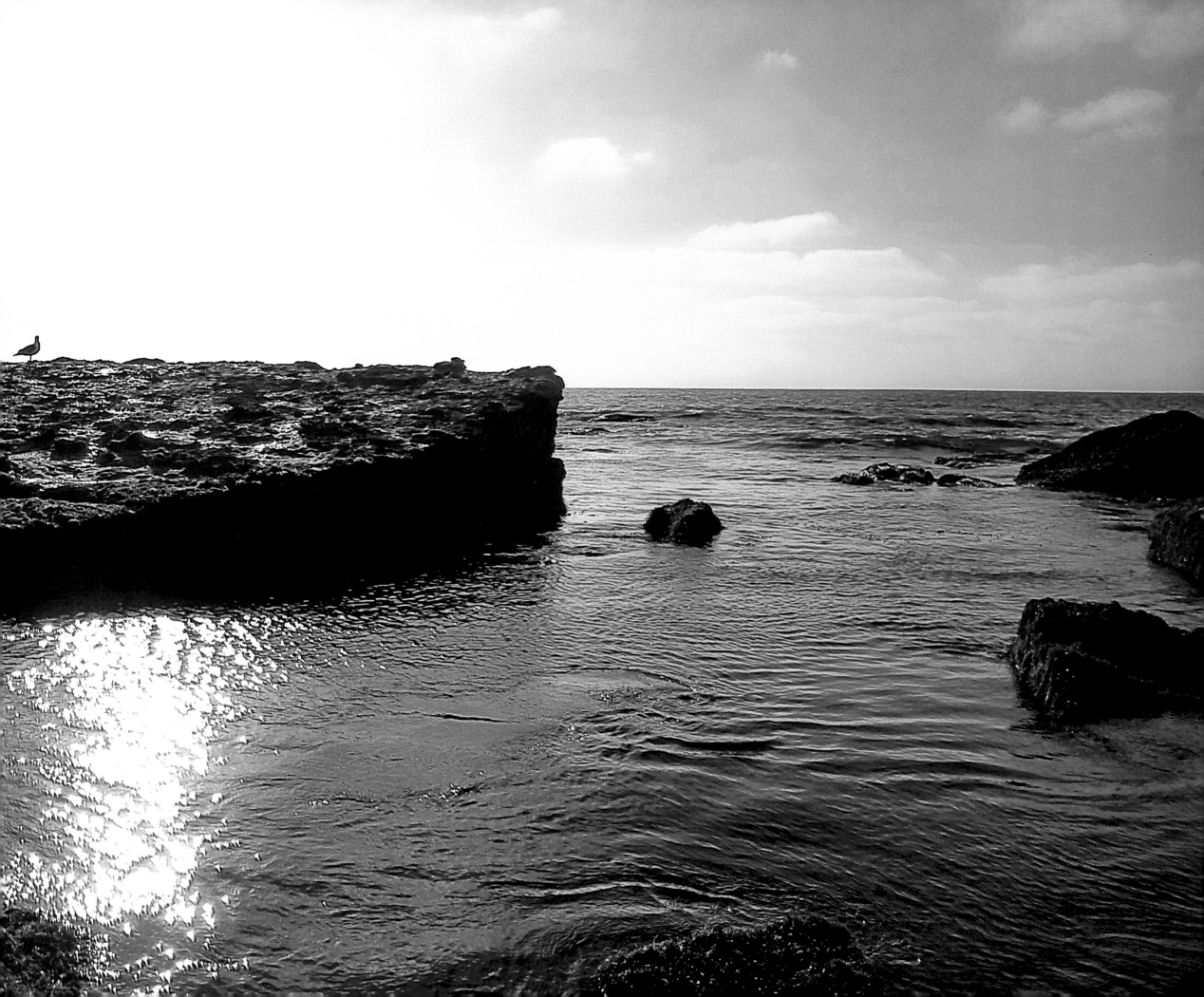

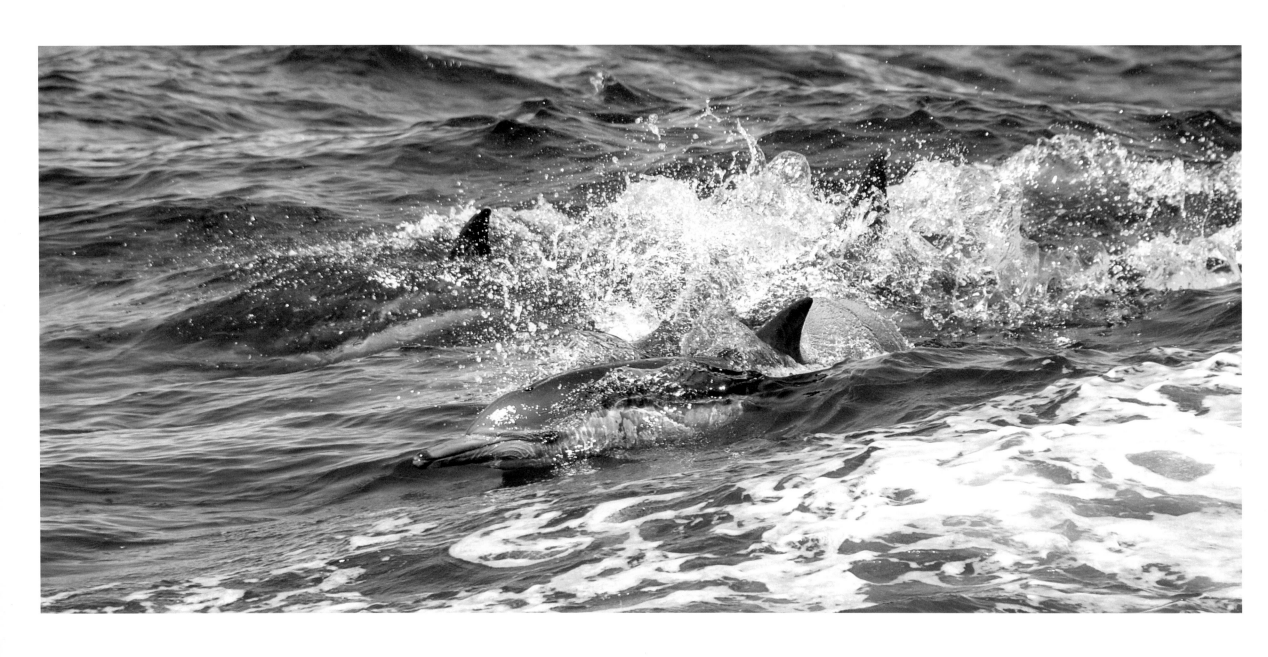

Ocean Beach, California

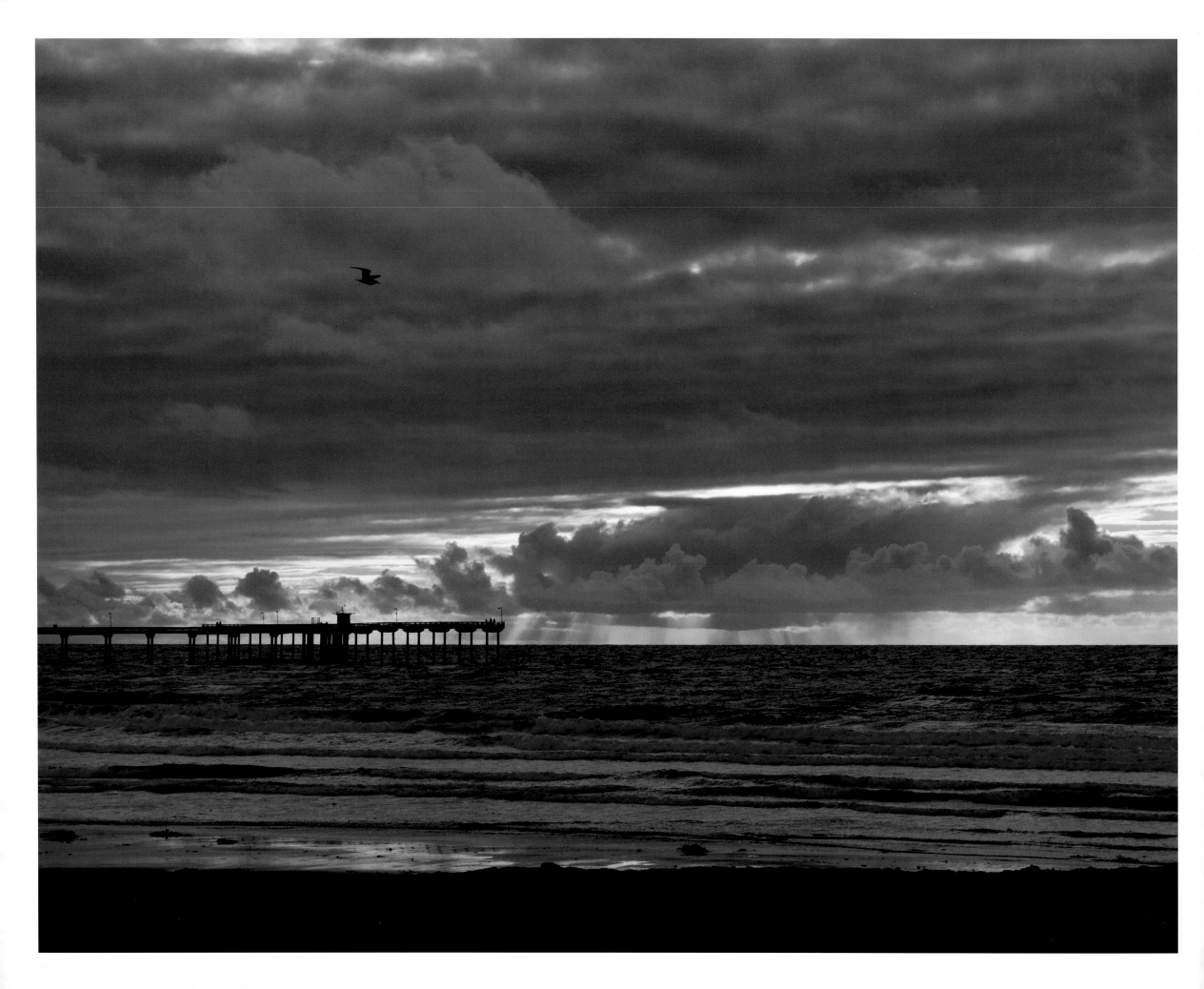

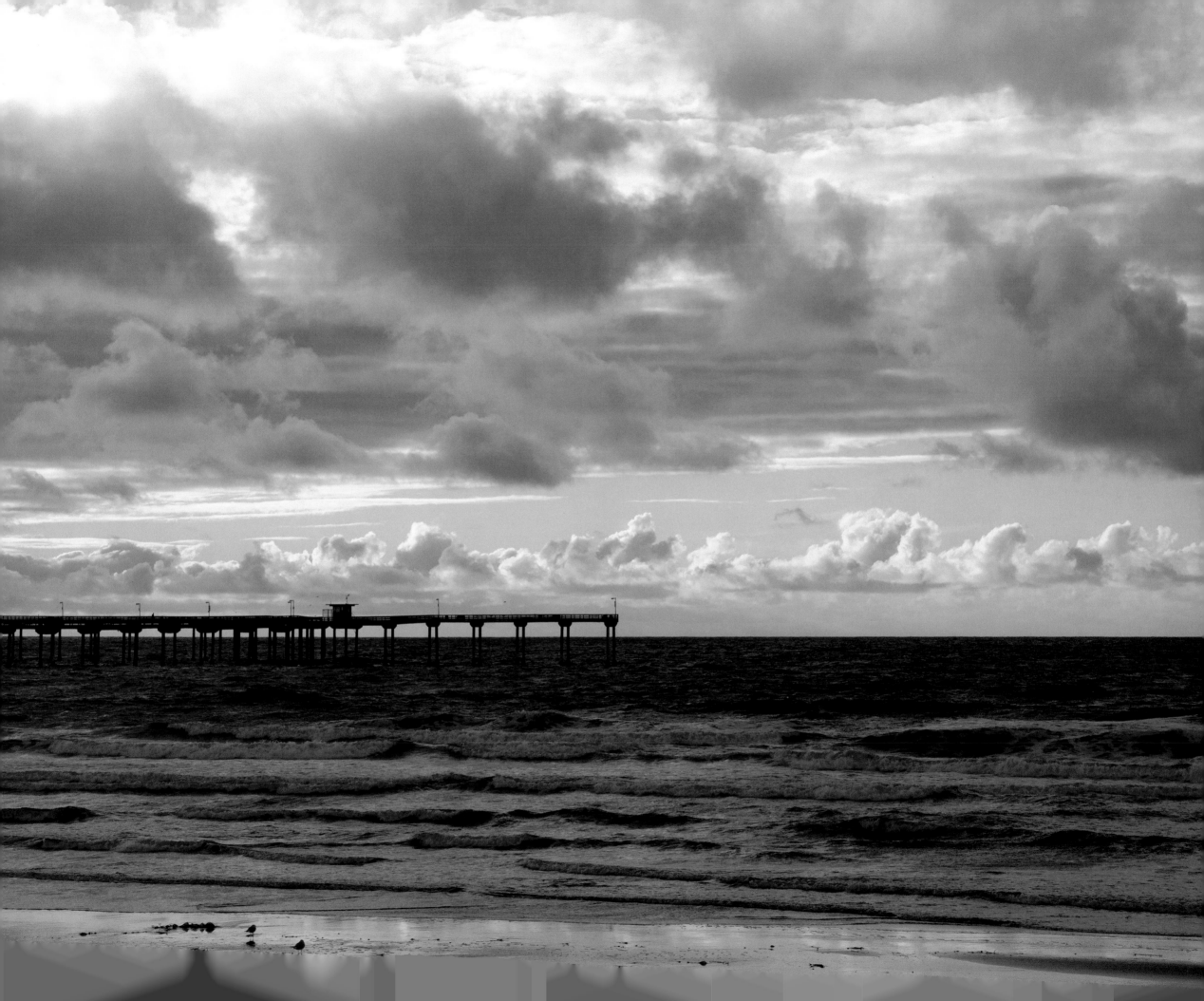

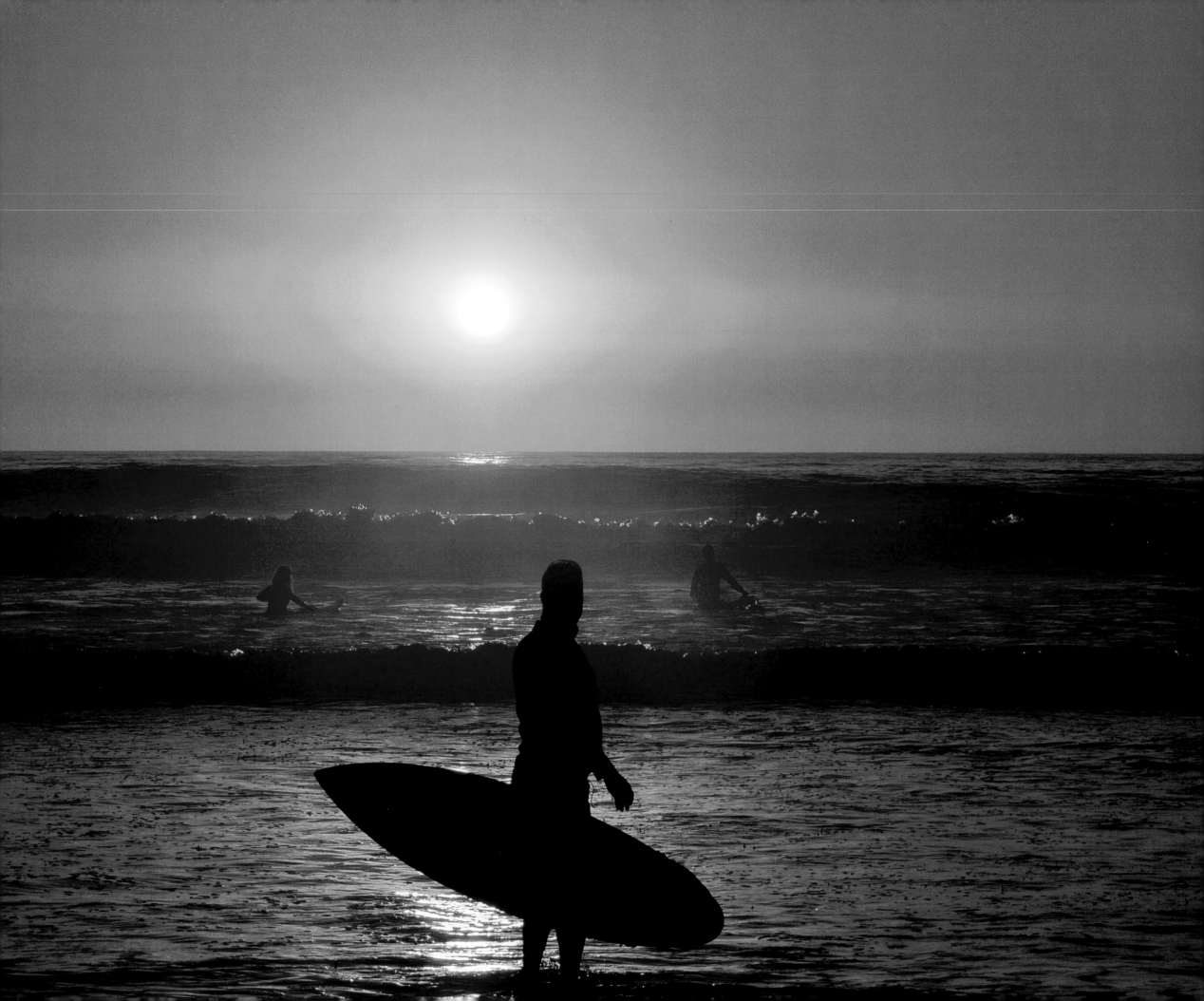

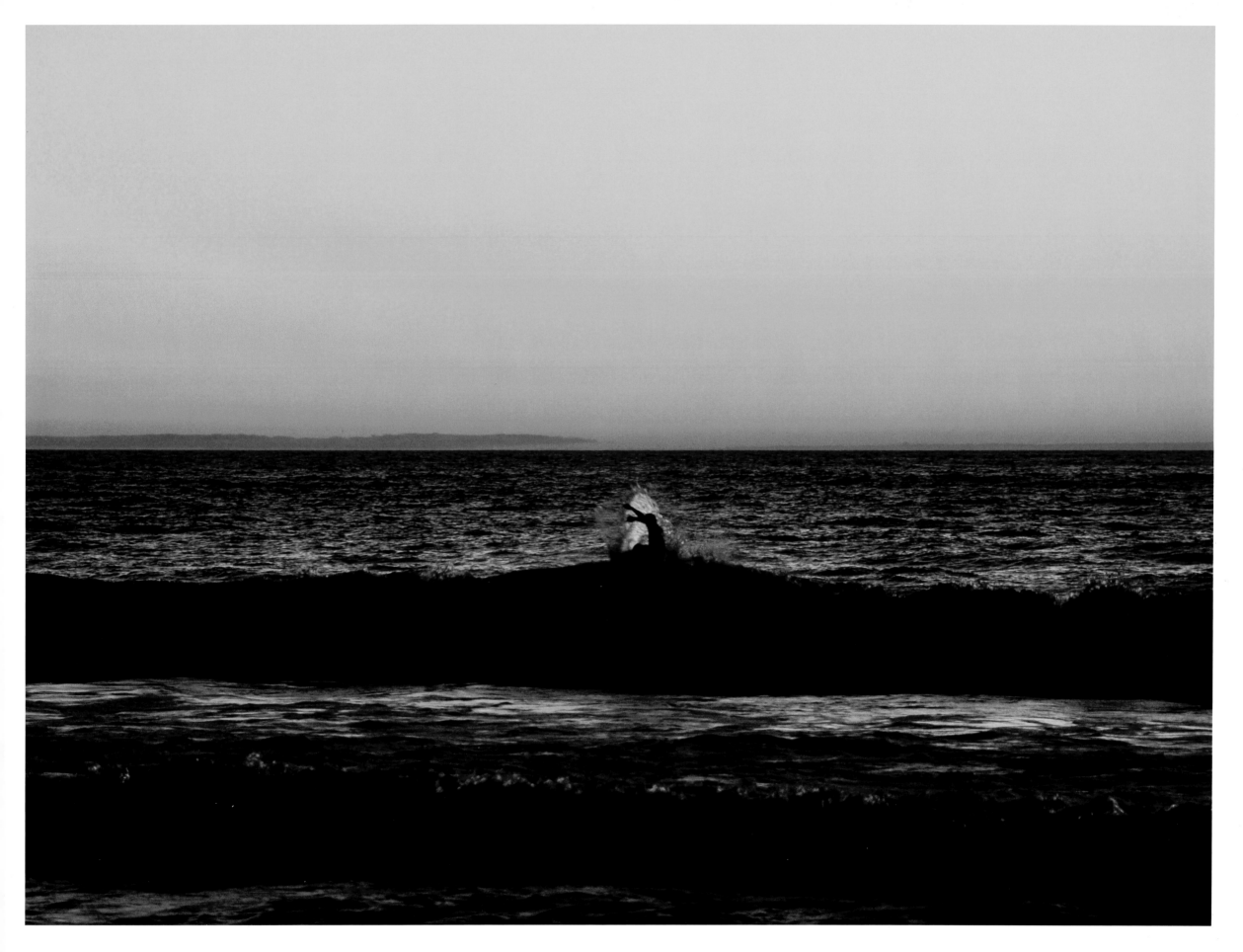

Del Mar, California

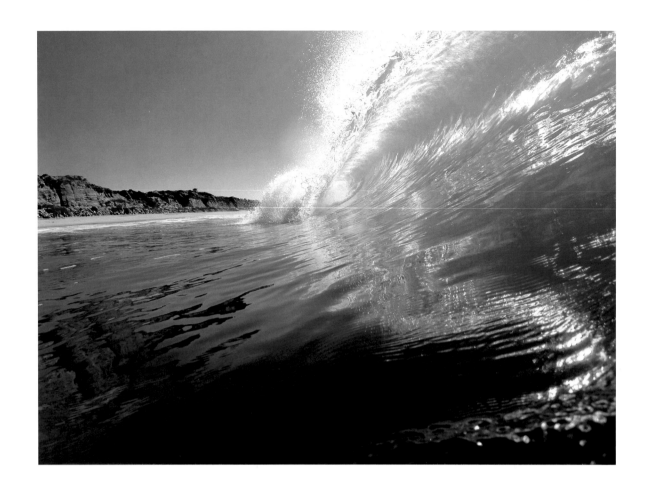
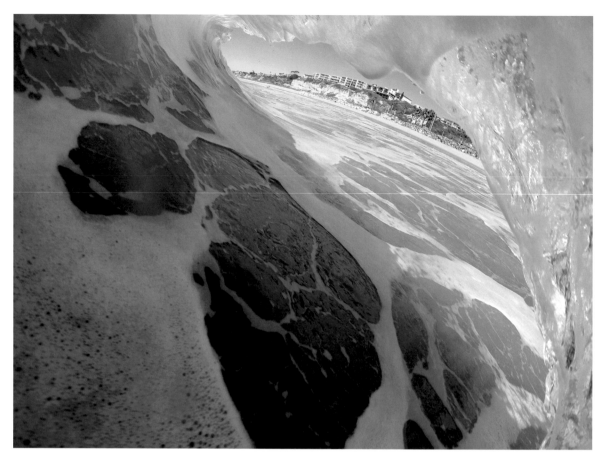
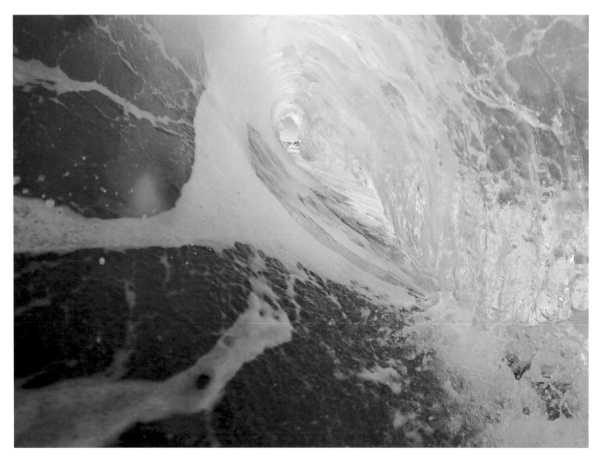
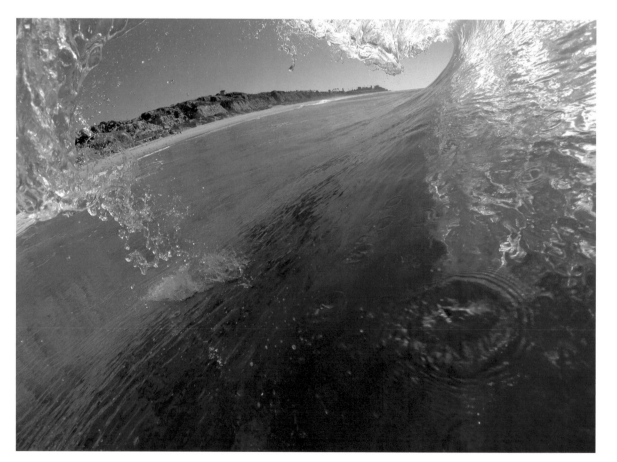

San Clemente, California

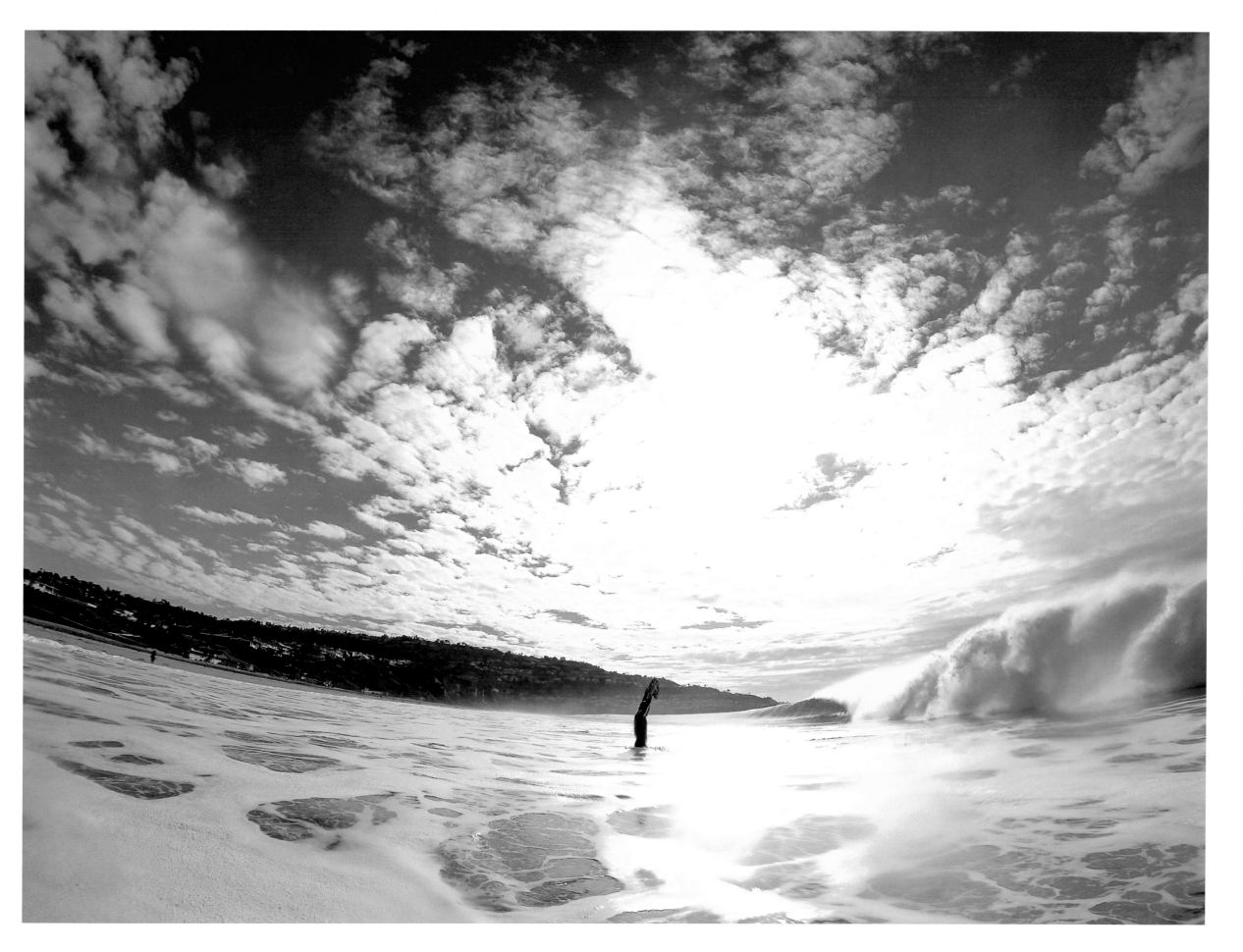

Redondo Beach, California

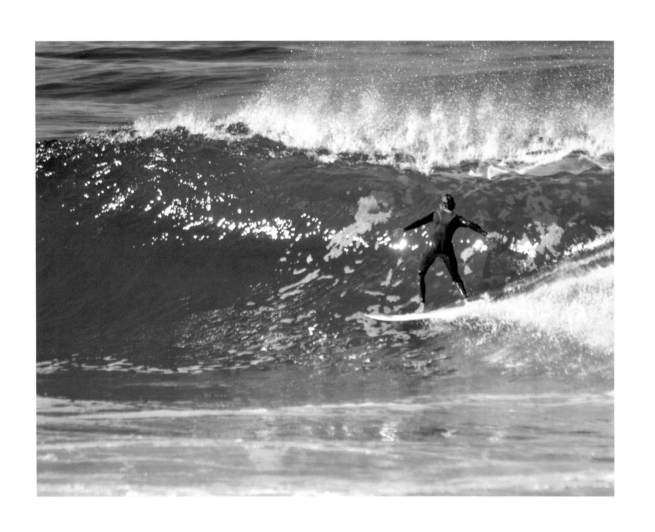
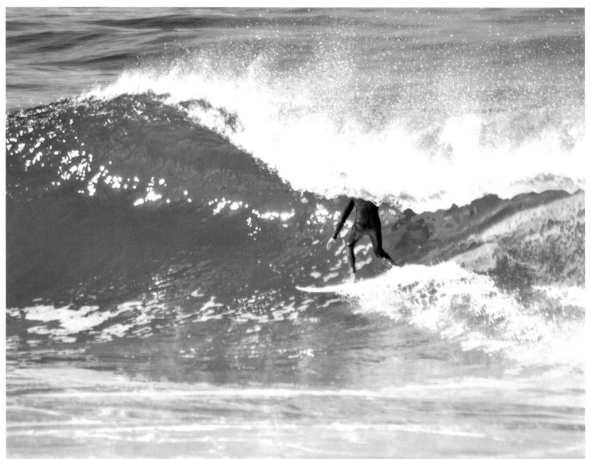

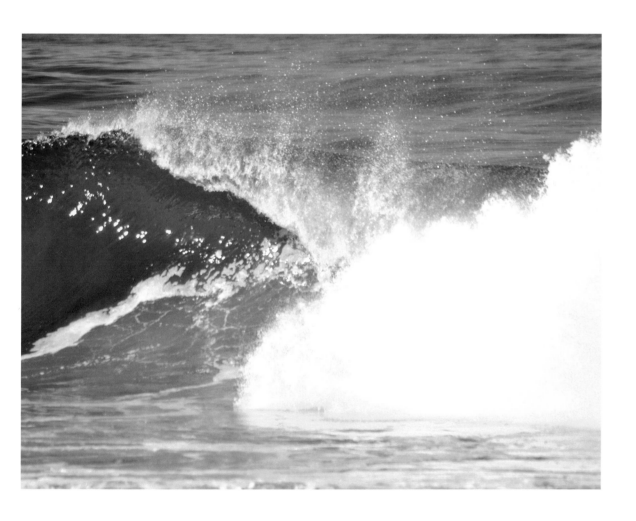
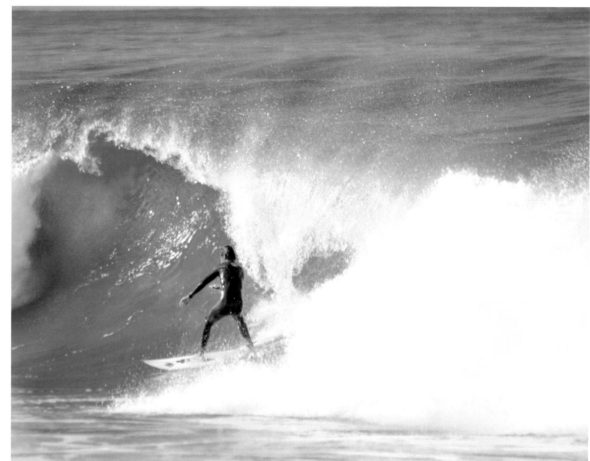

Redondo Beach, California

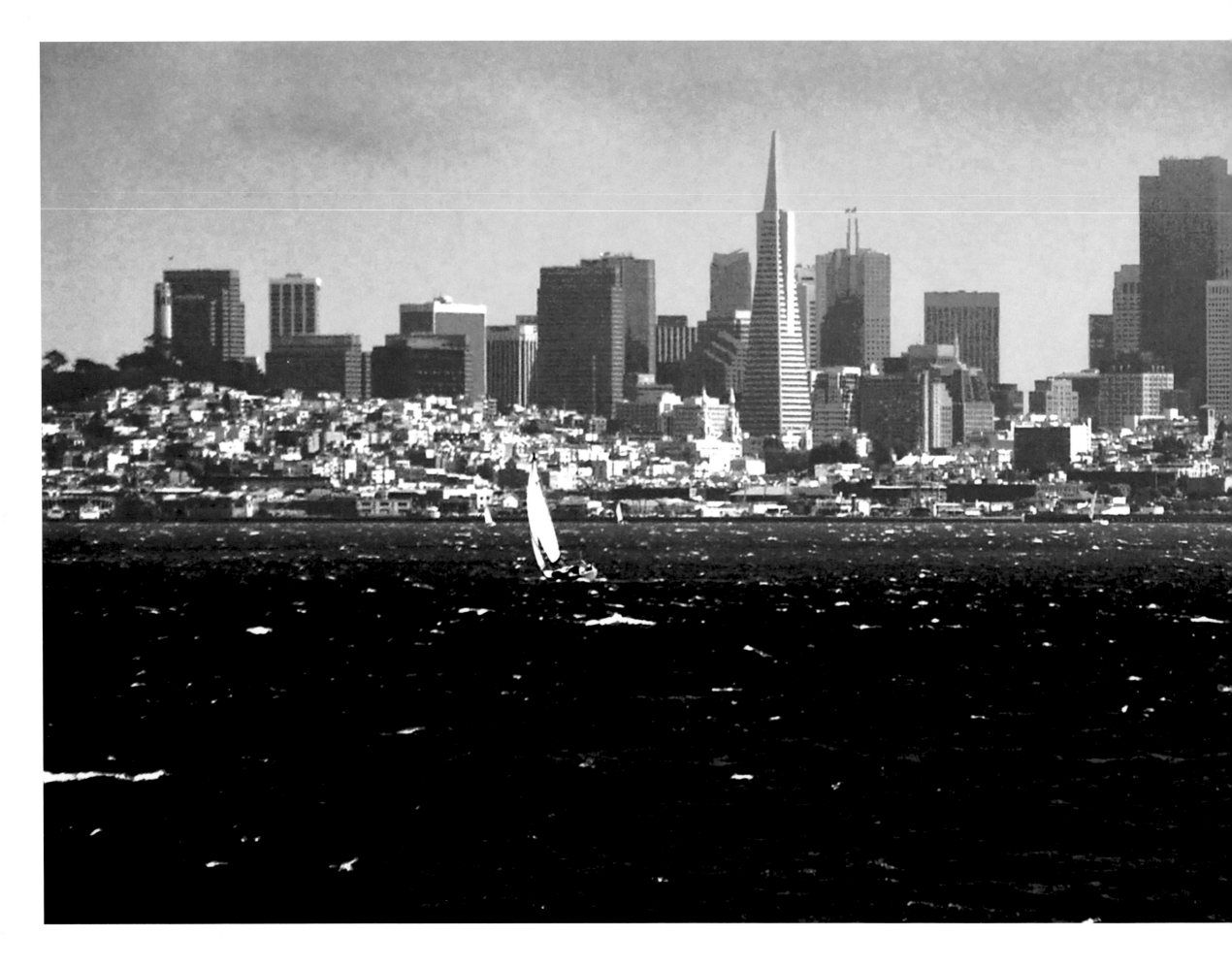

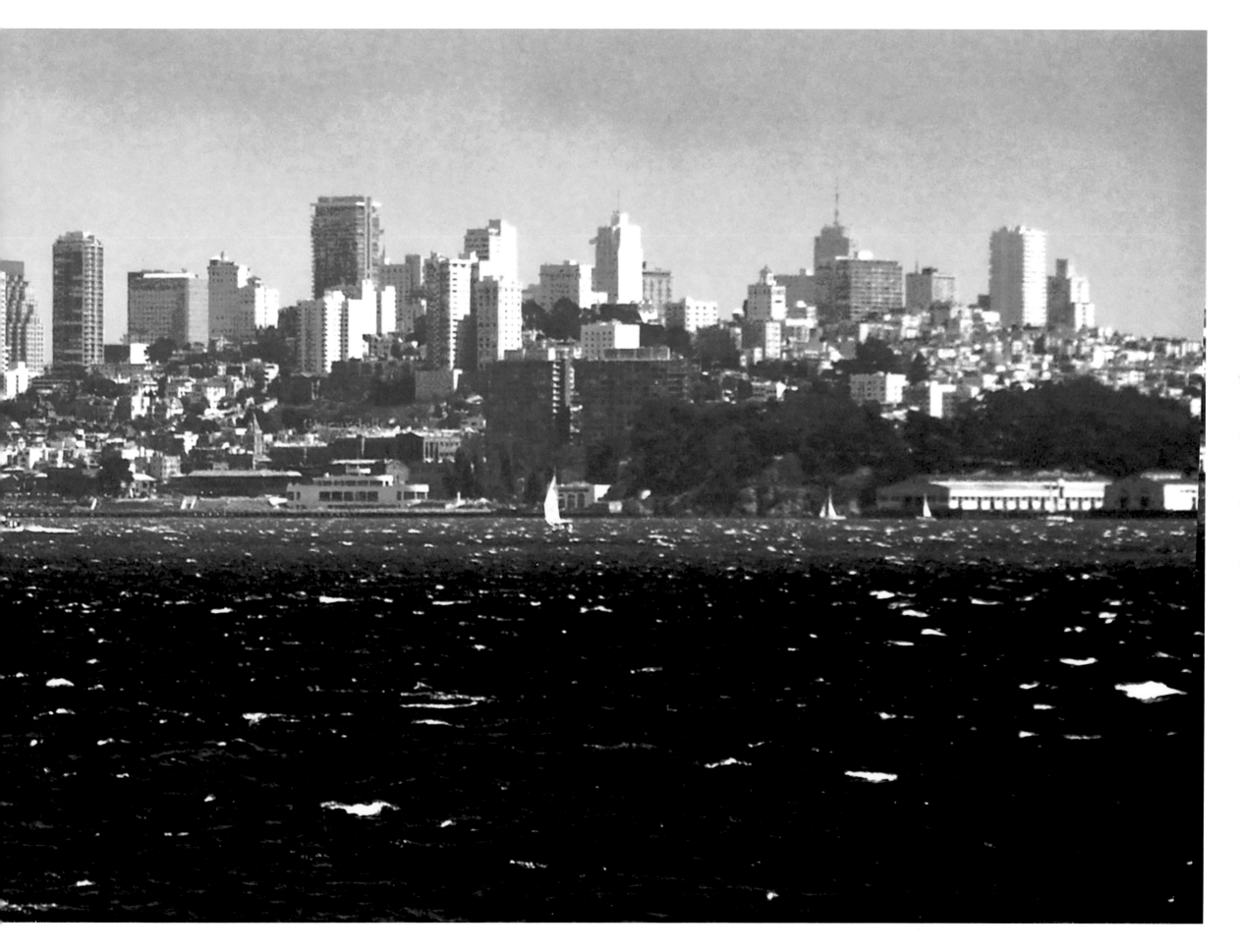

San Francisco, California

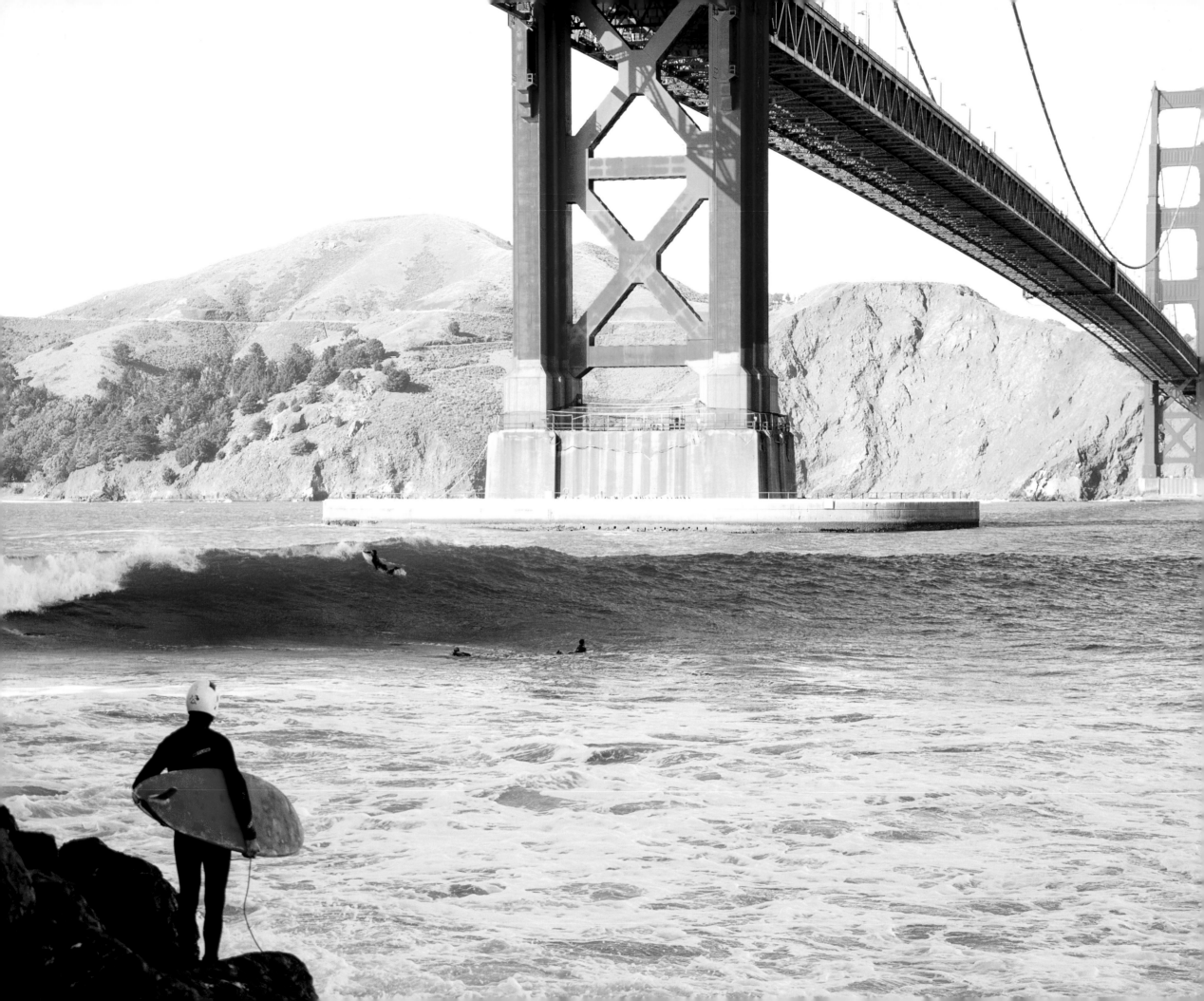

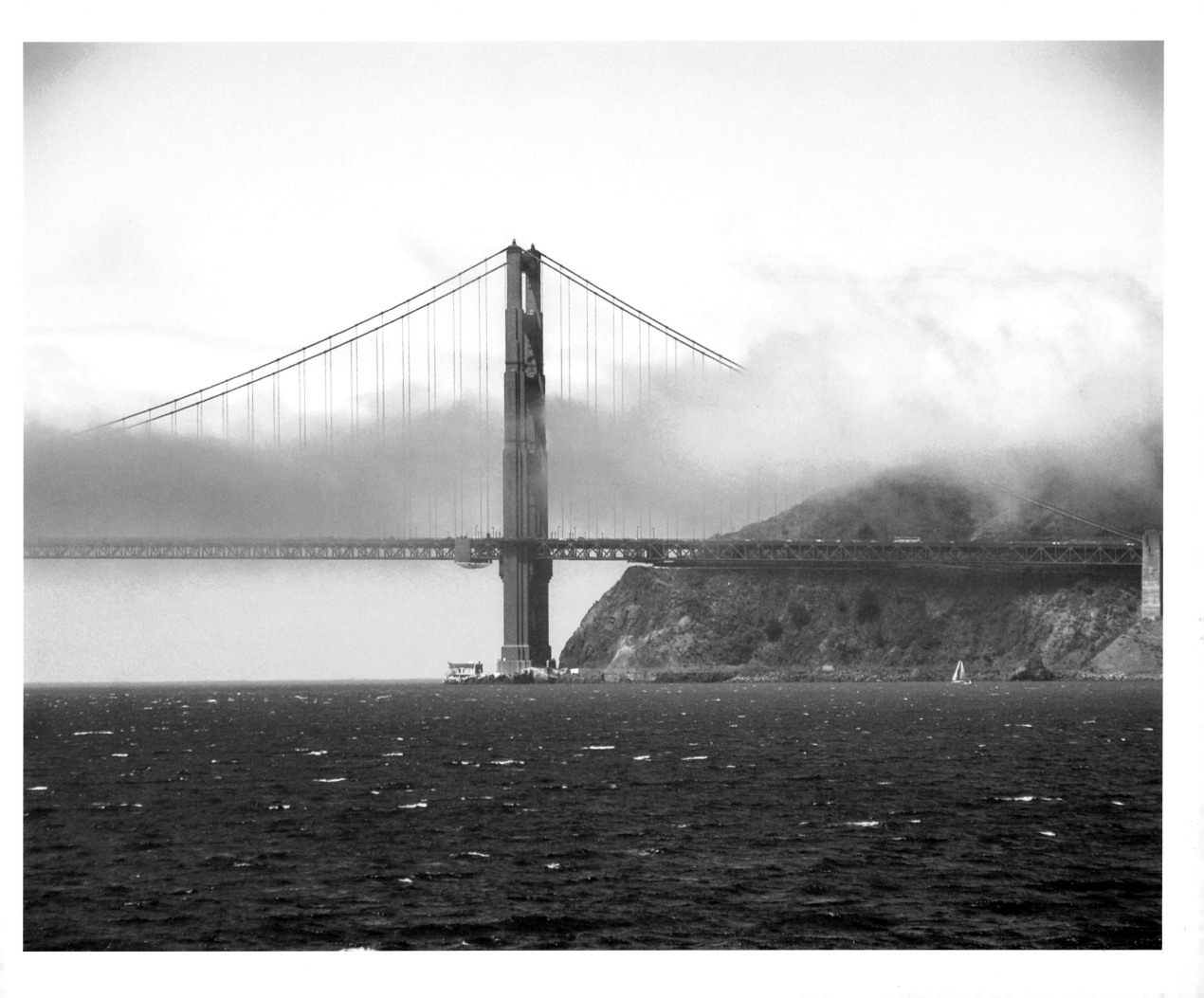

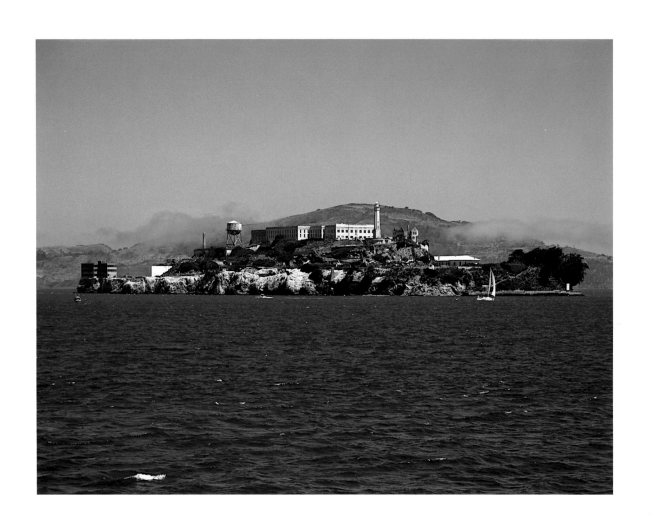
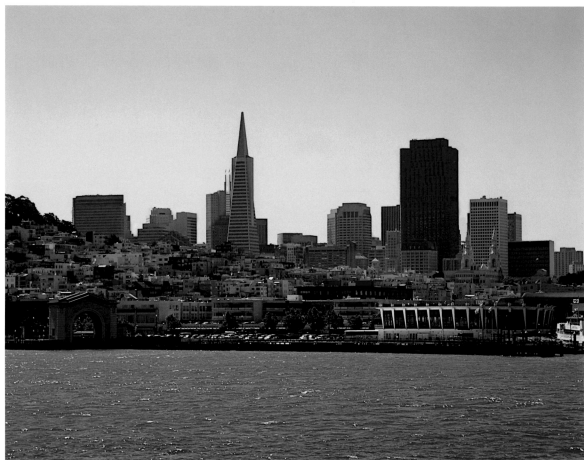

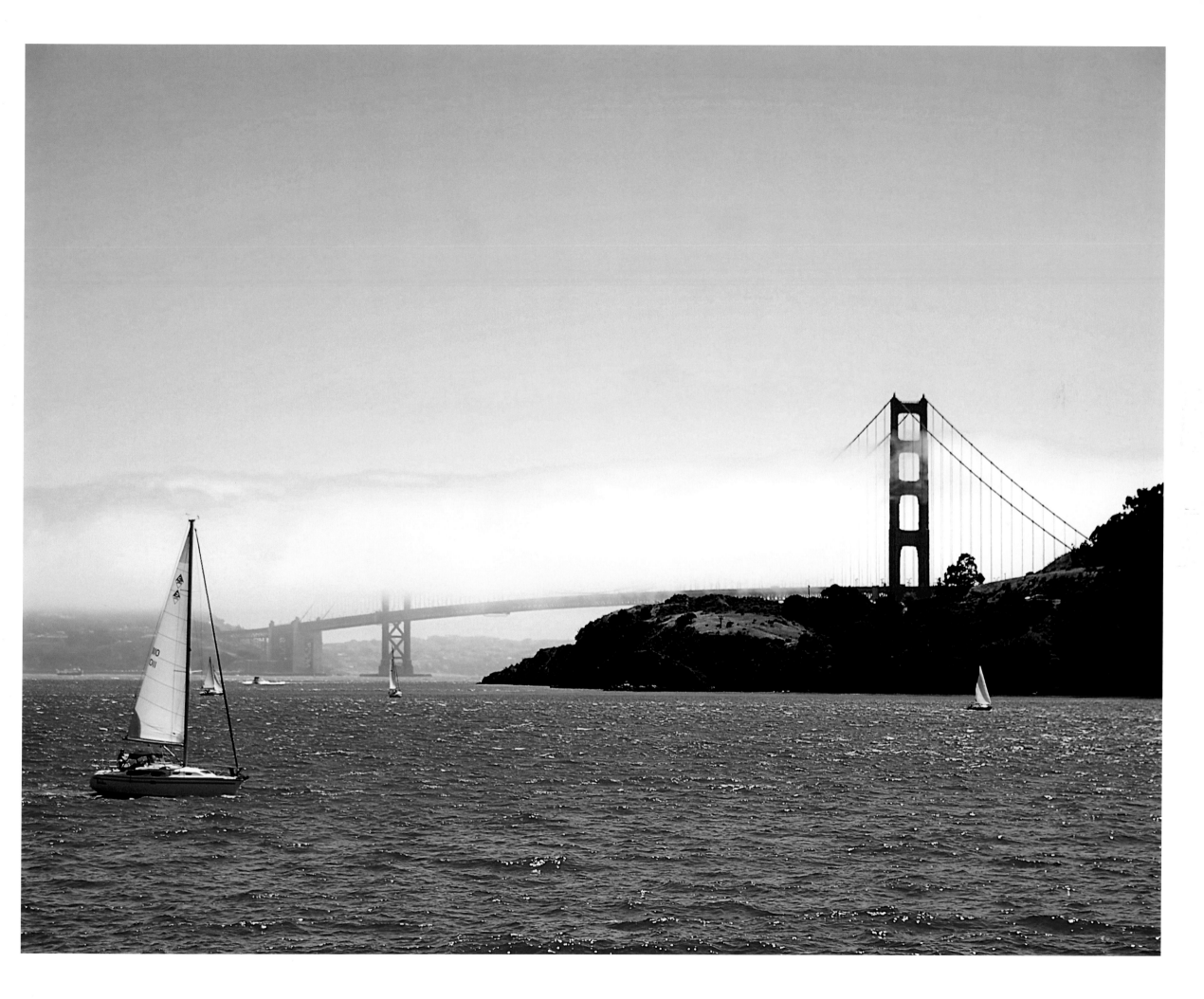

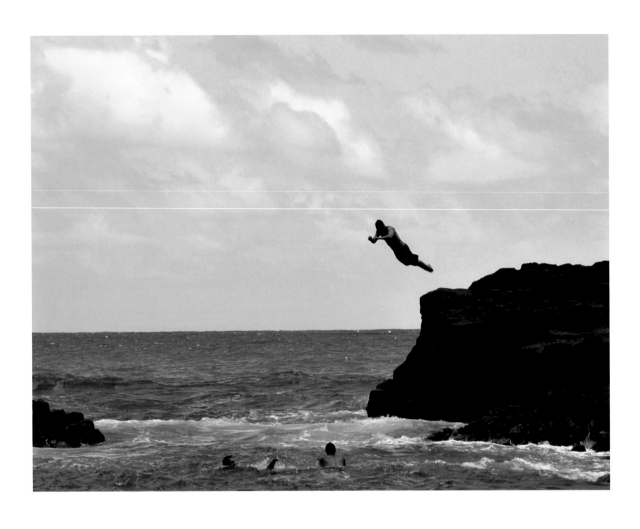

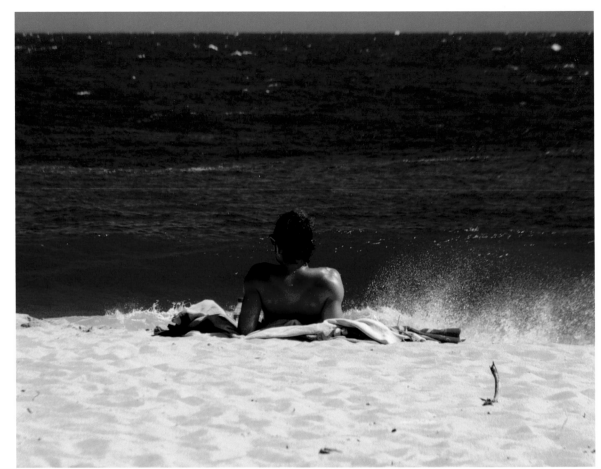

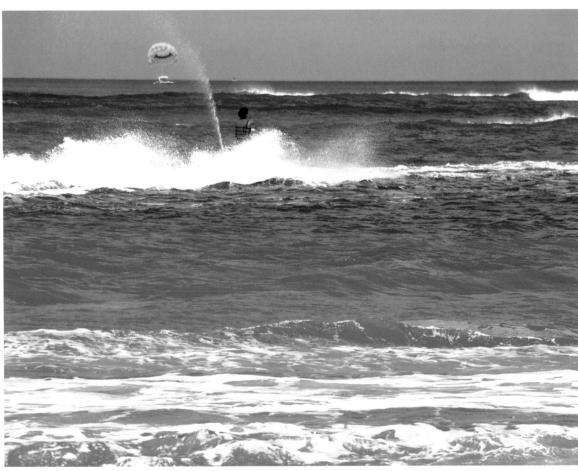

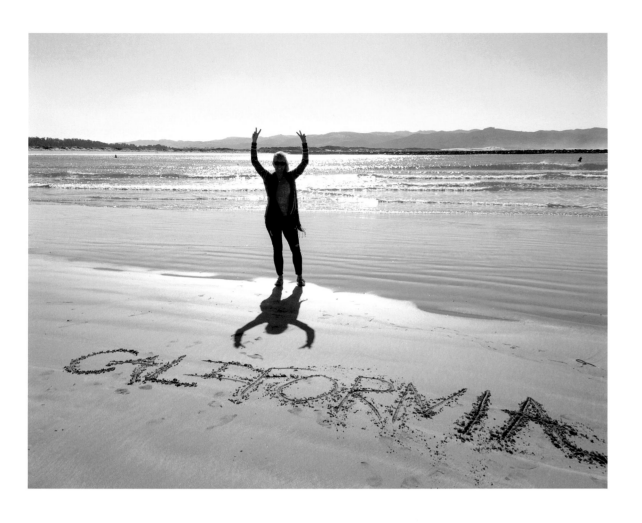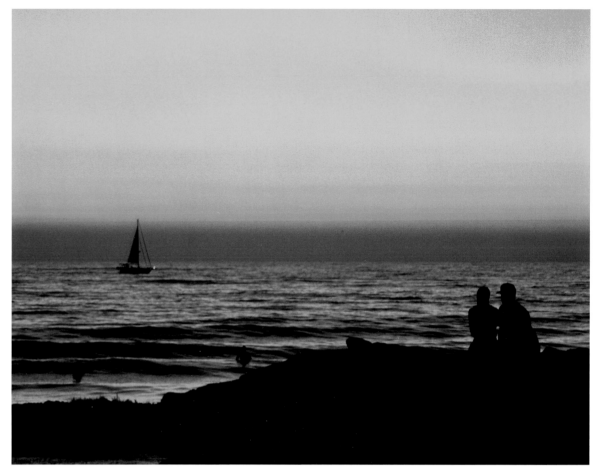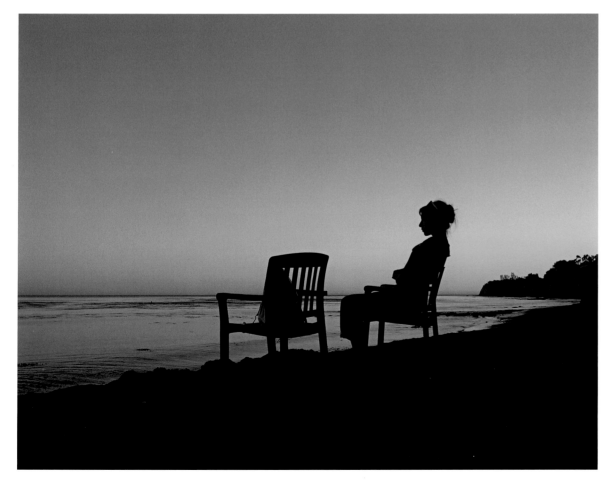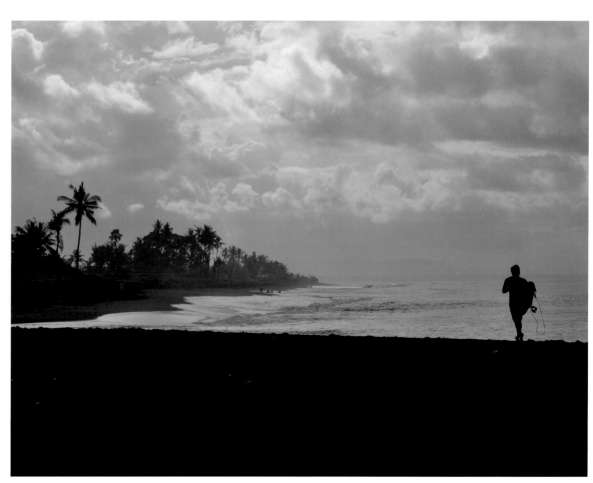

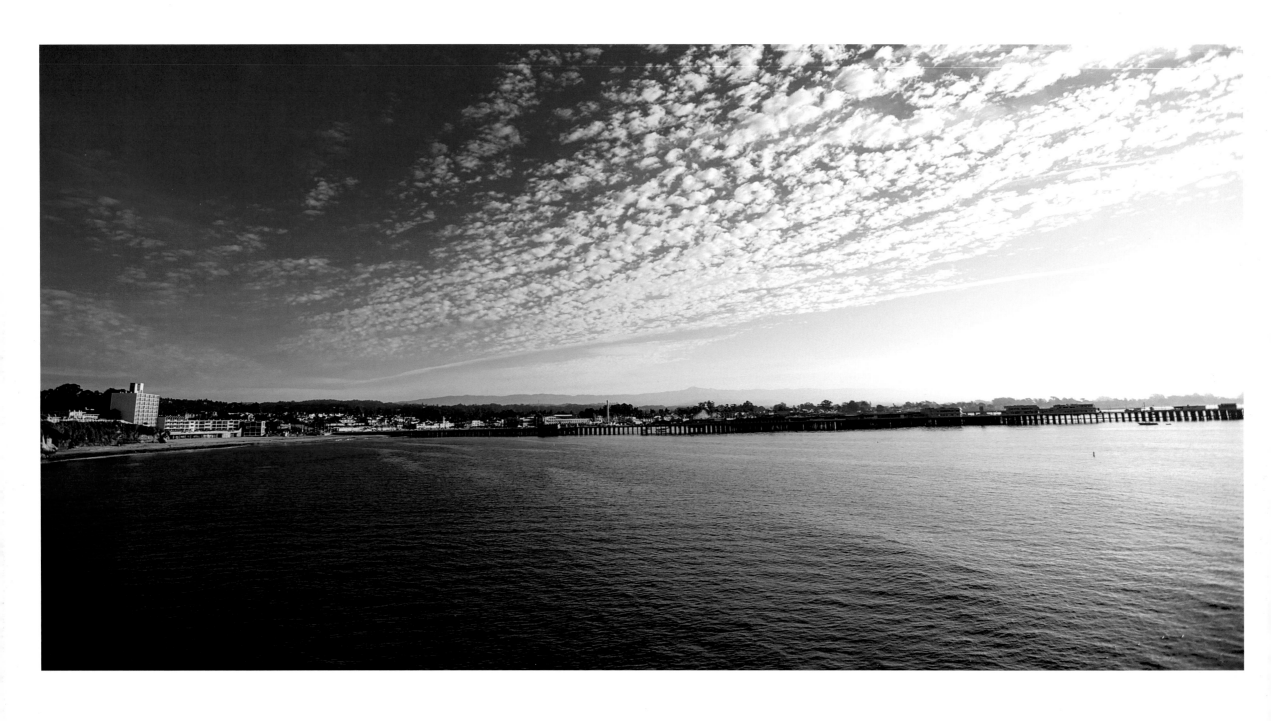

Santa Cruz, California

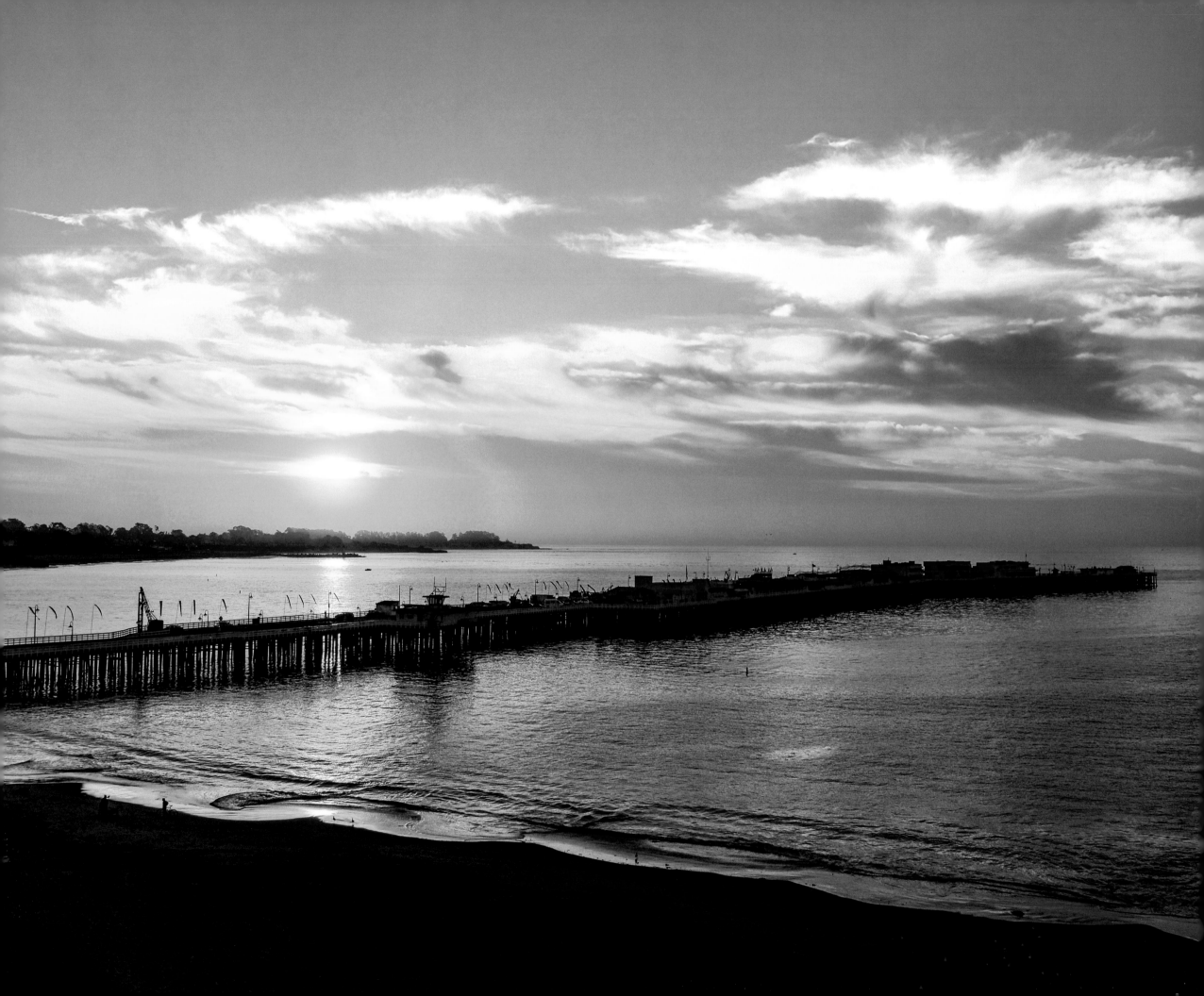

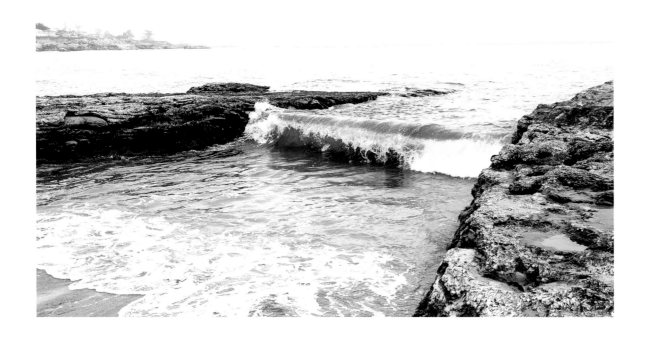

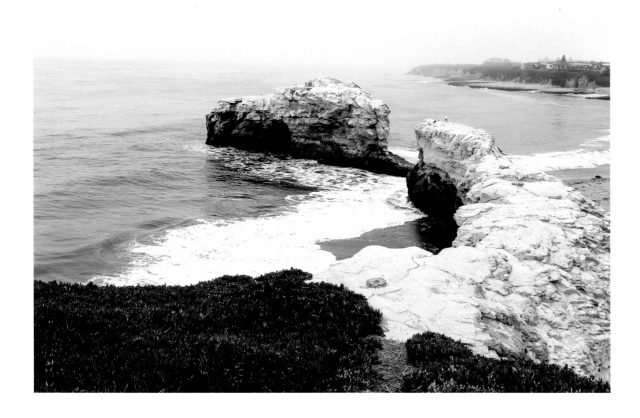

Monterey, California

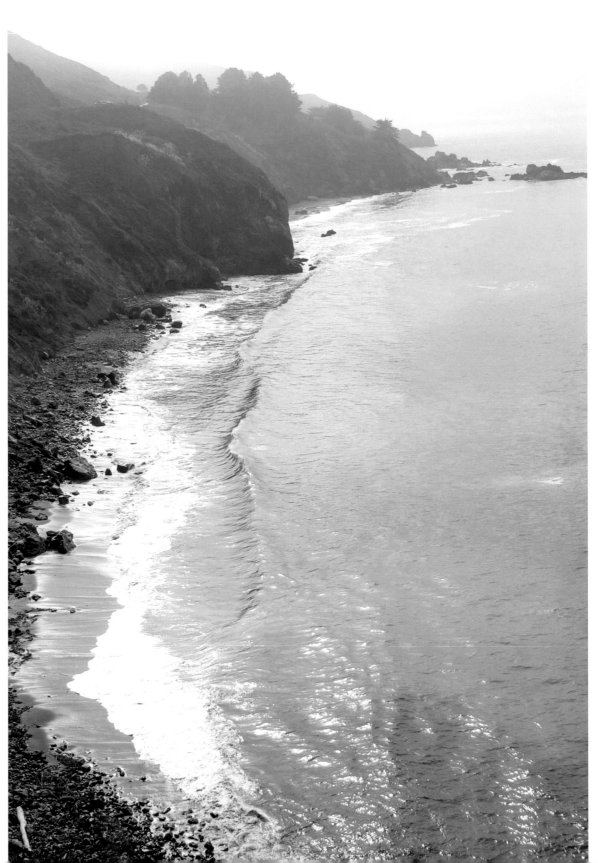

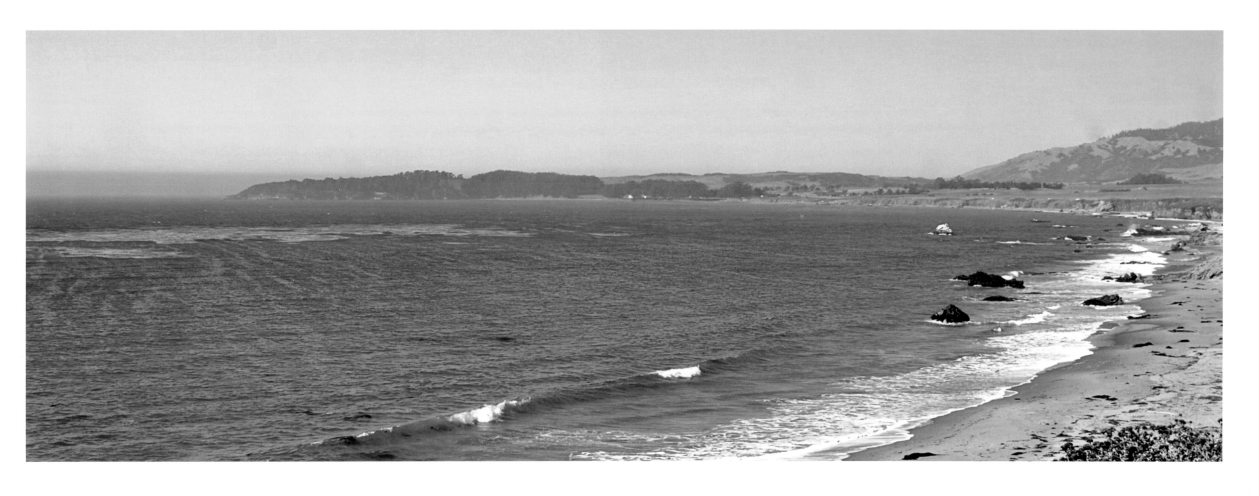

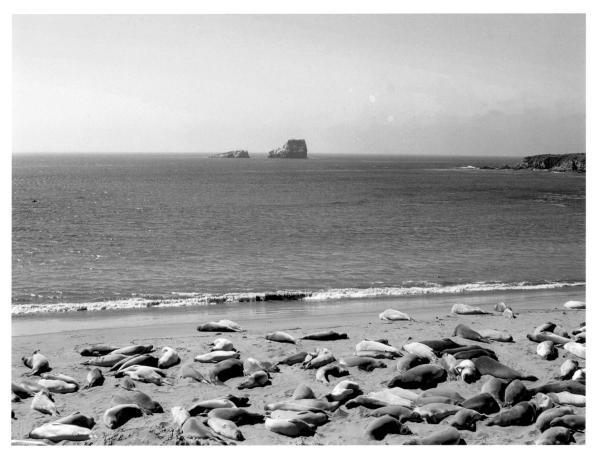

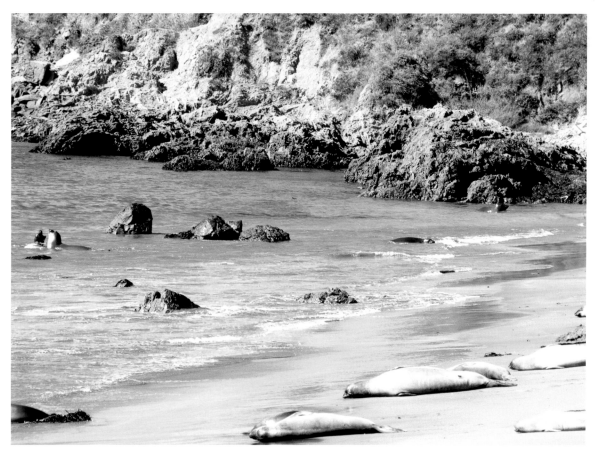

The Elephant Seals, San Simeon, California

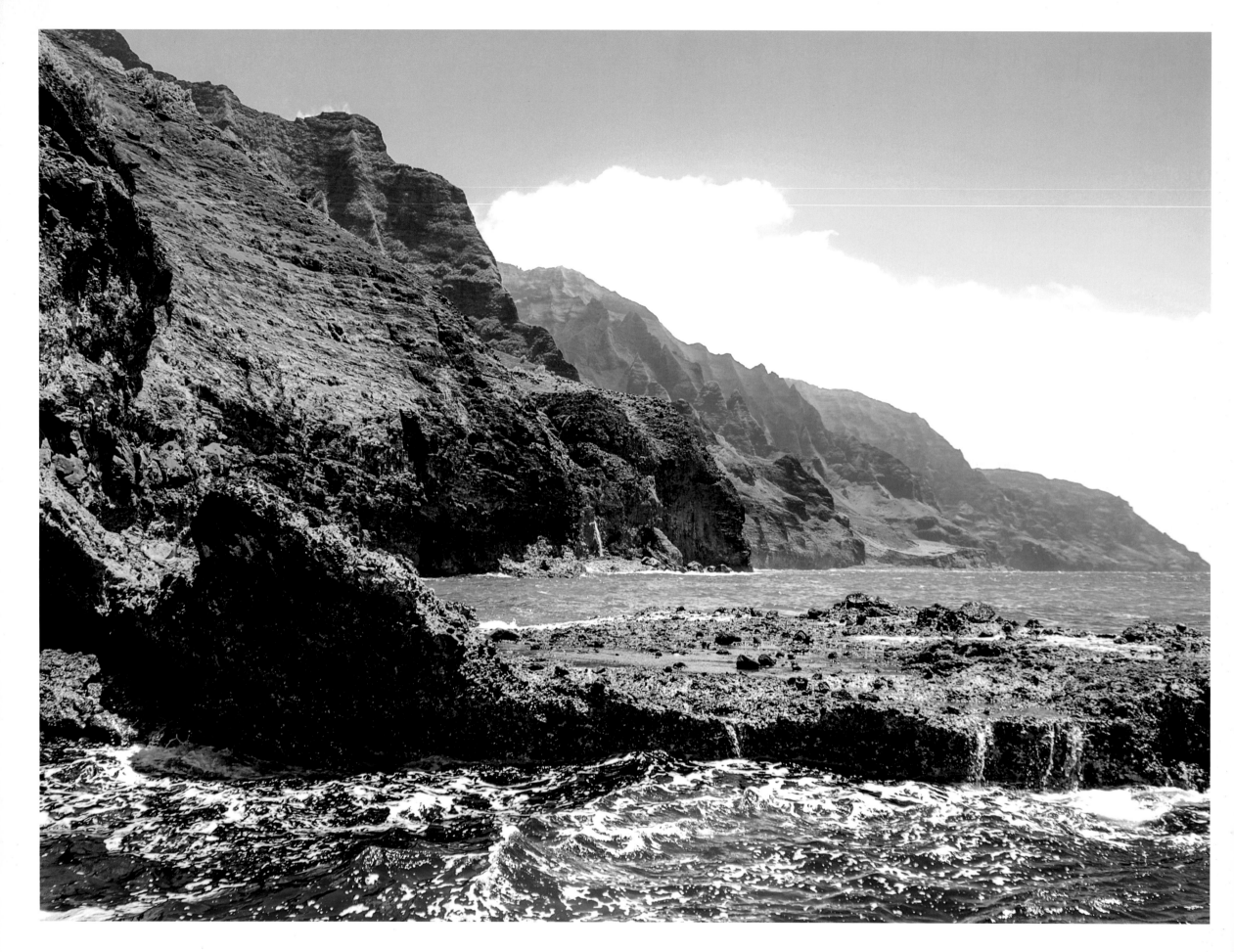

The Napali Coast, Kauai

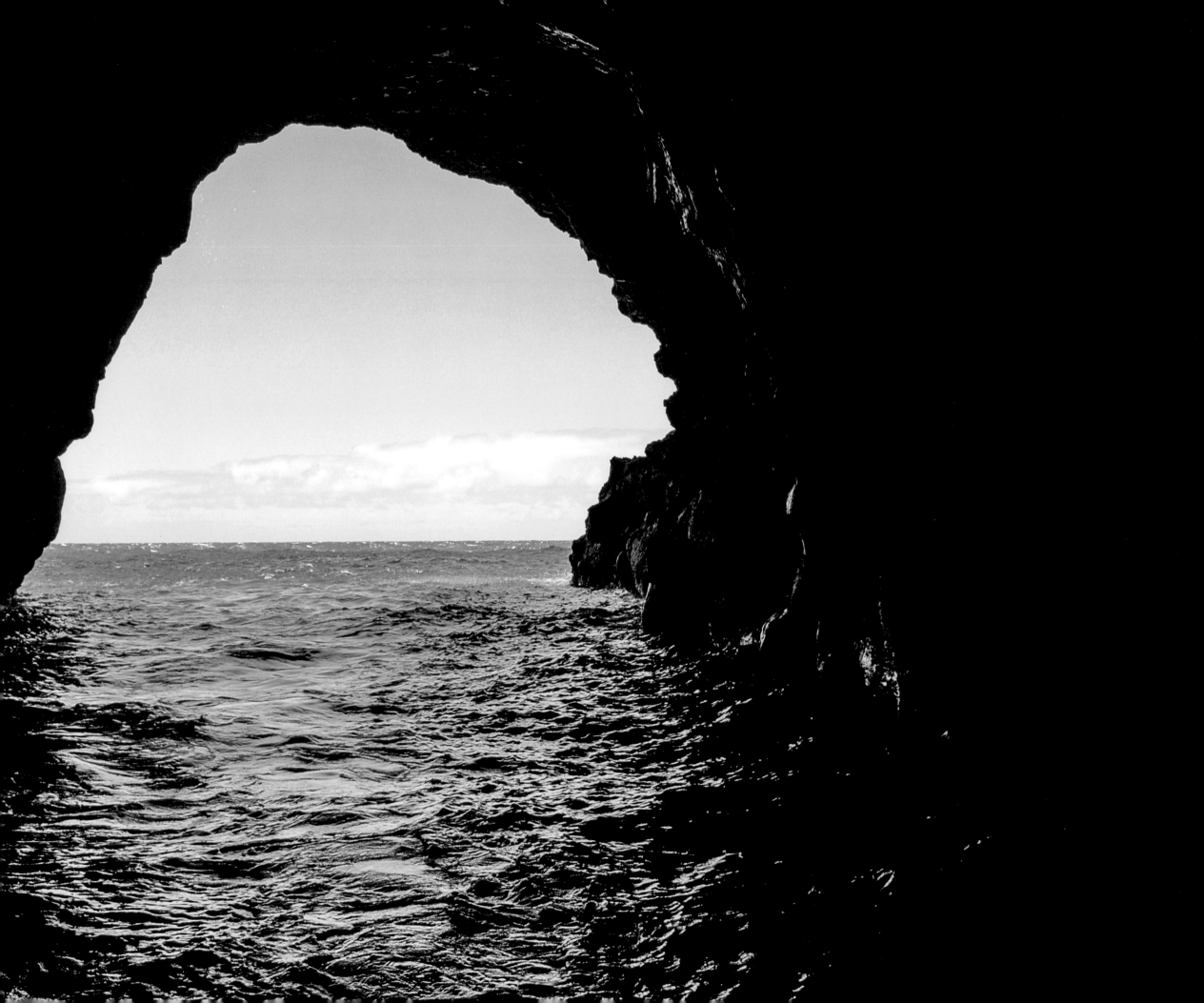

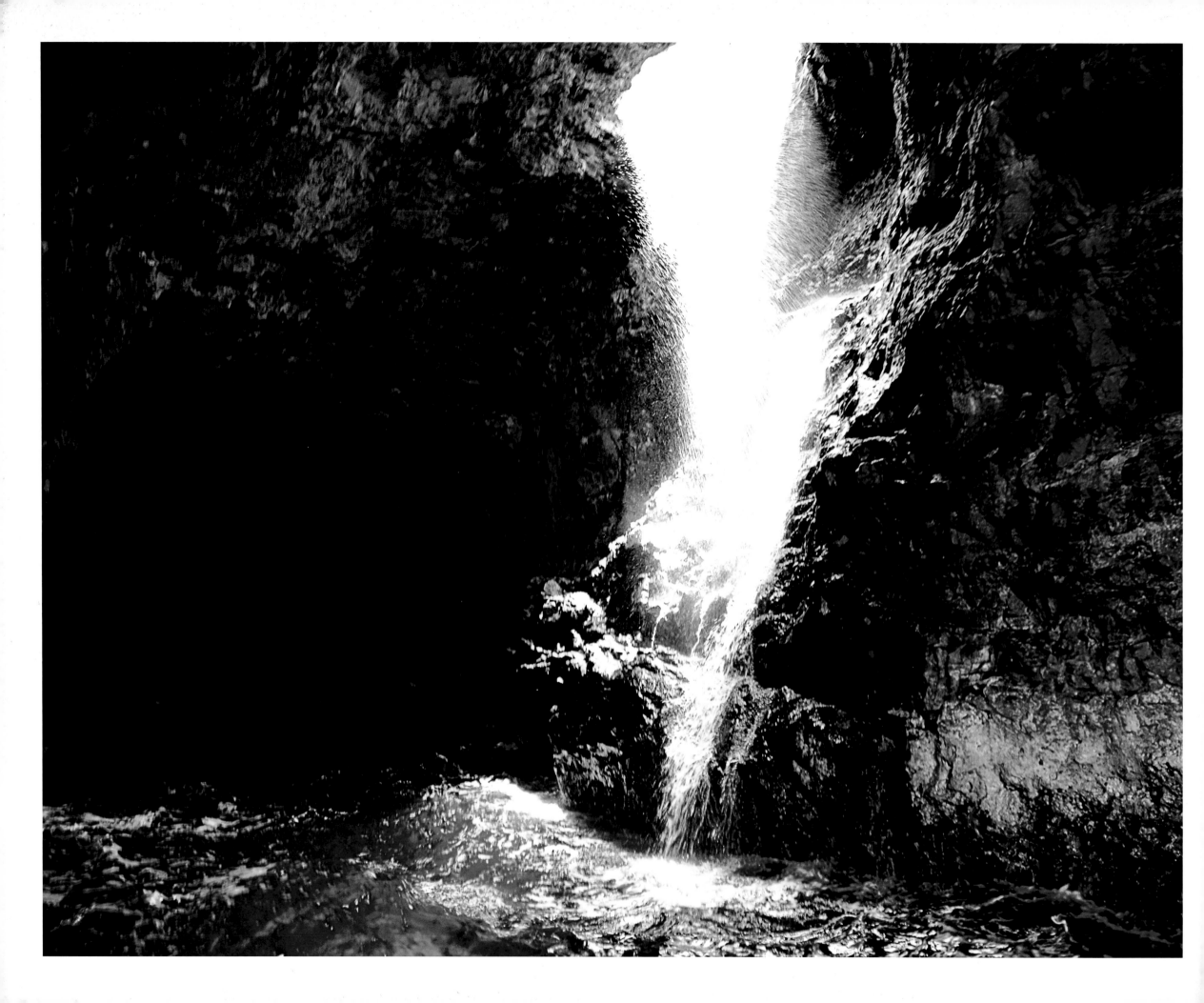

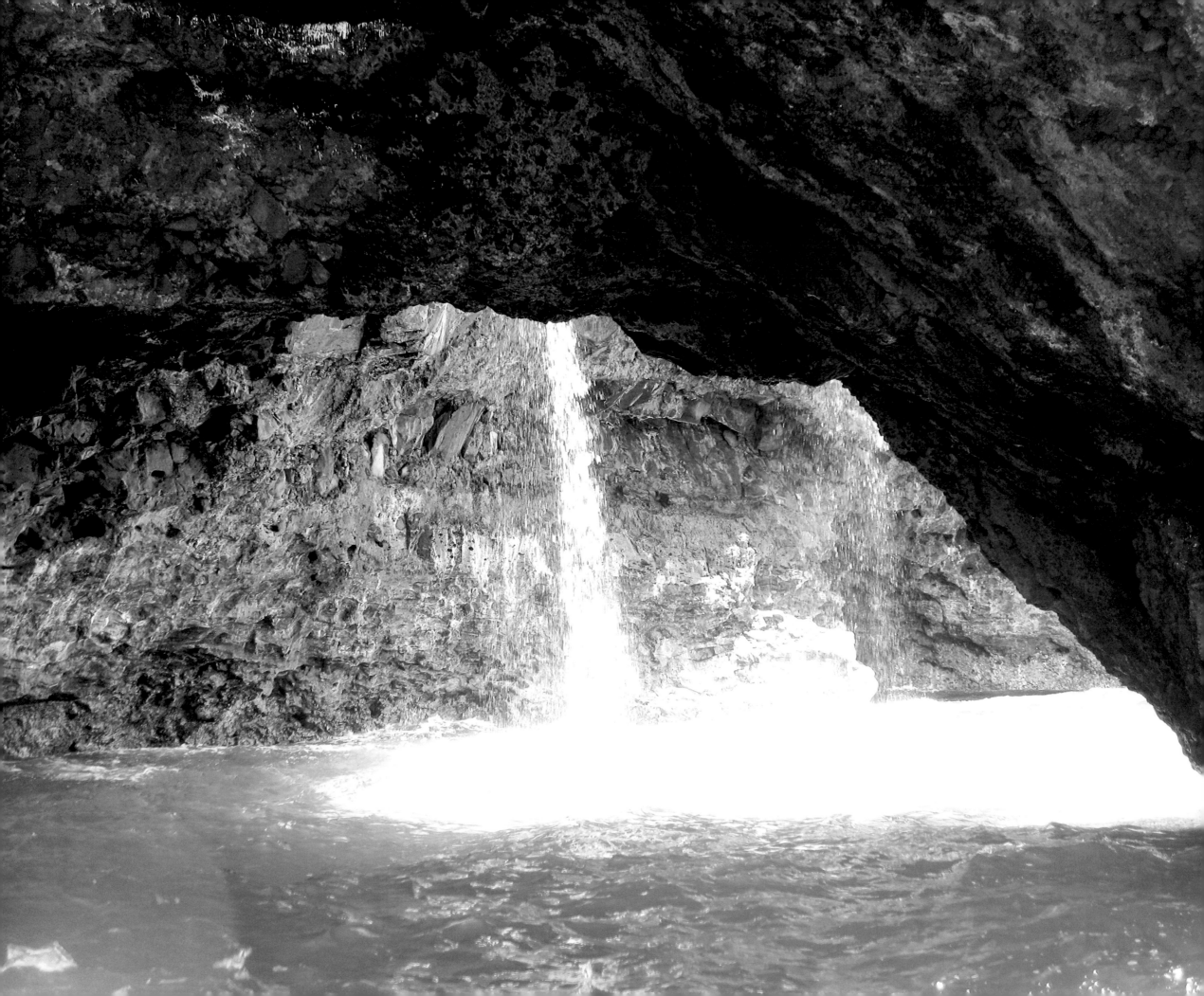

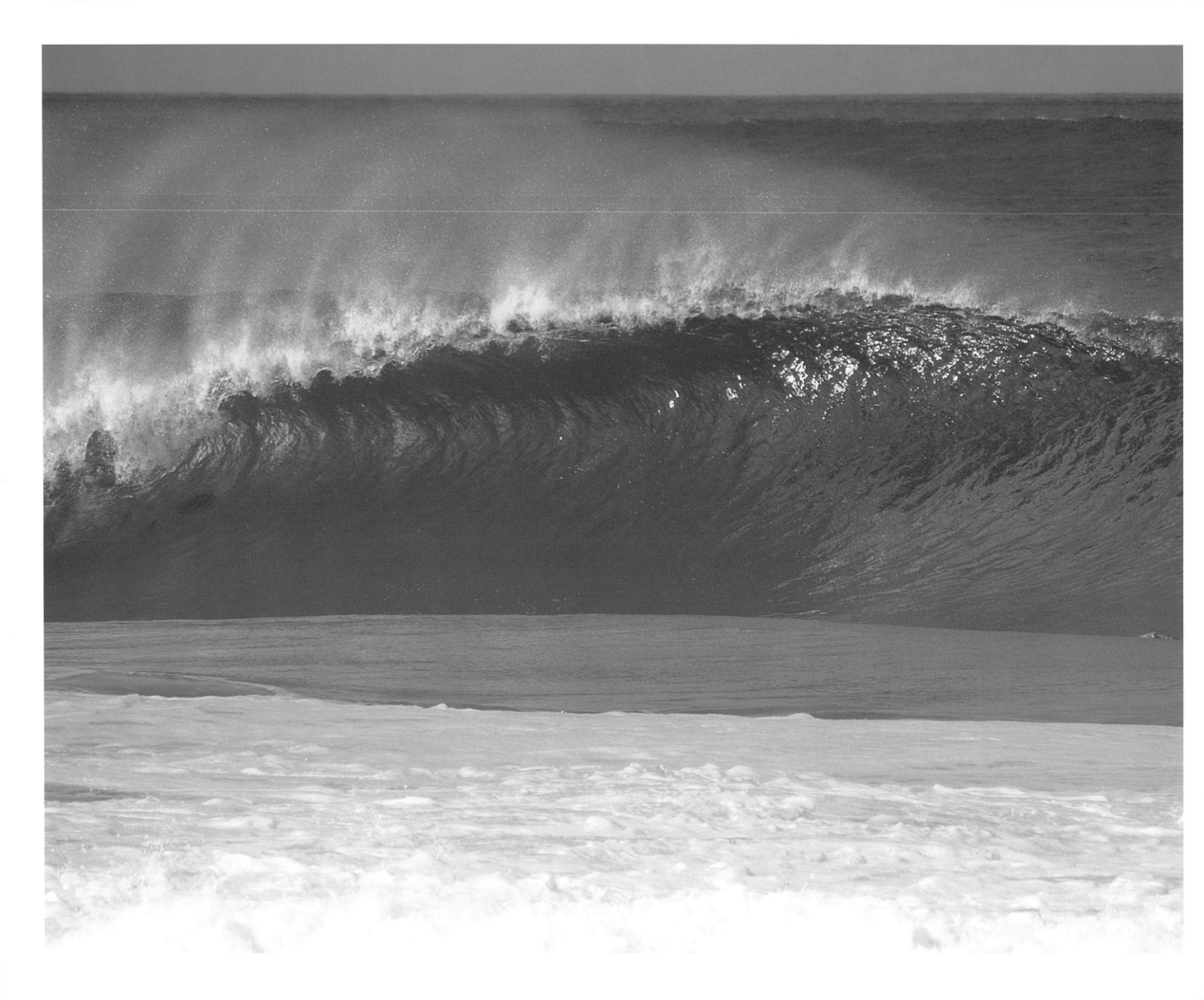

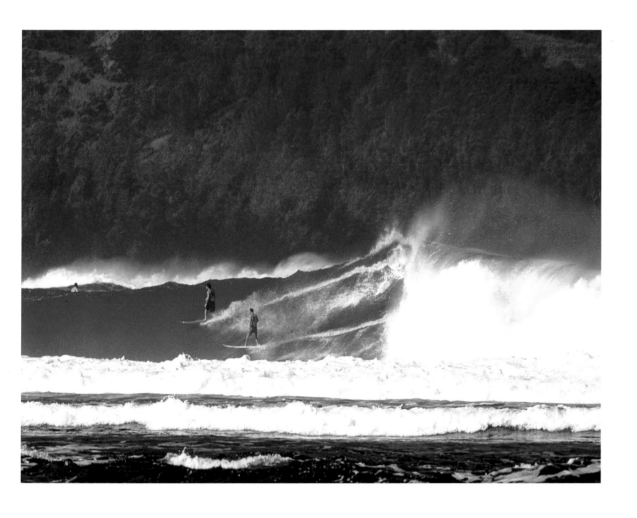 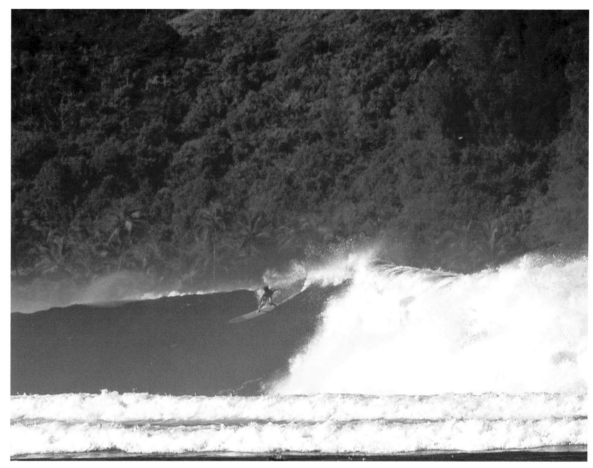

Winter surf, The Napali Coast, Kauai

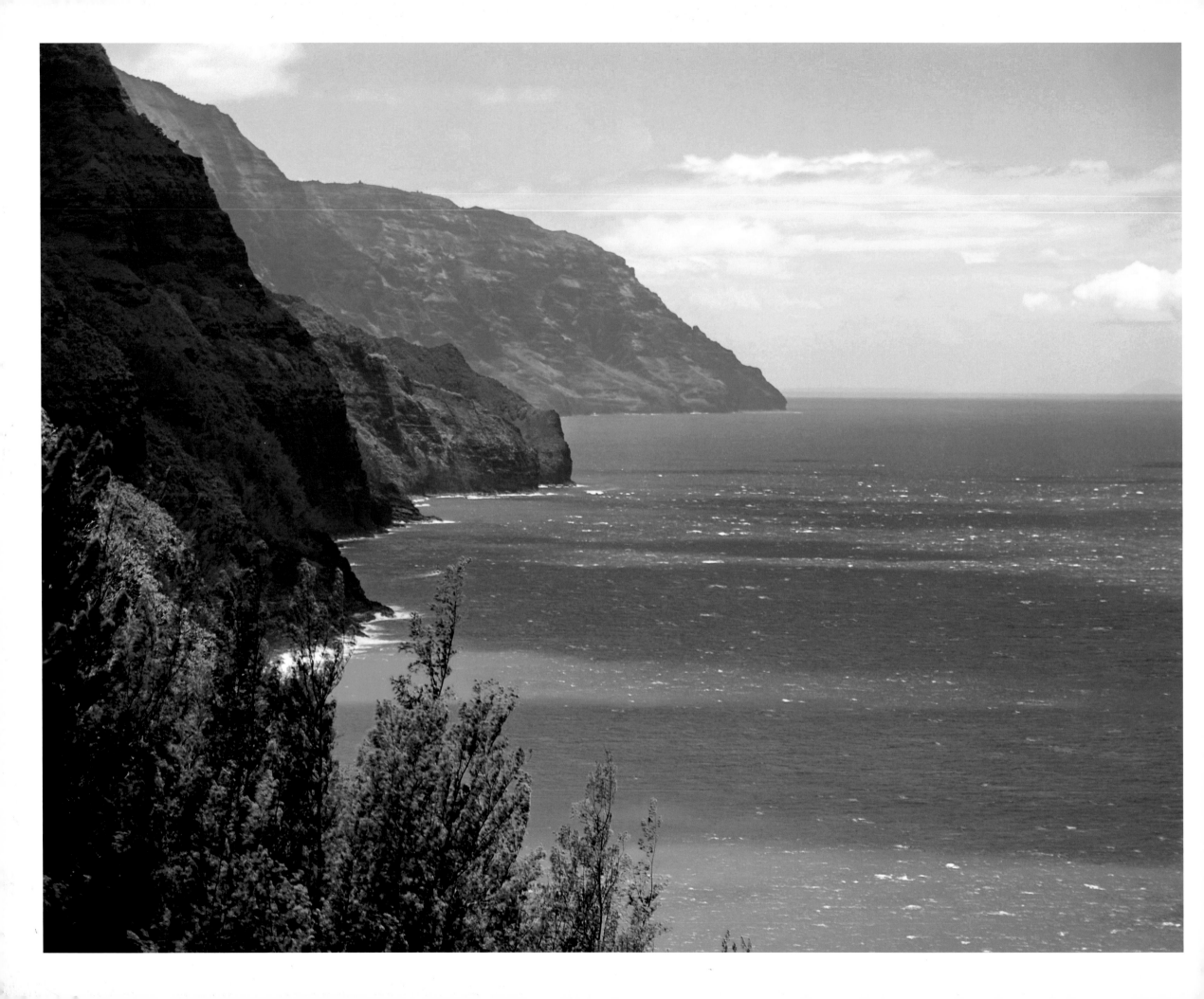

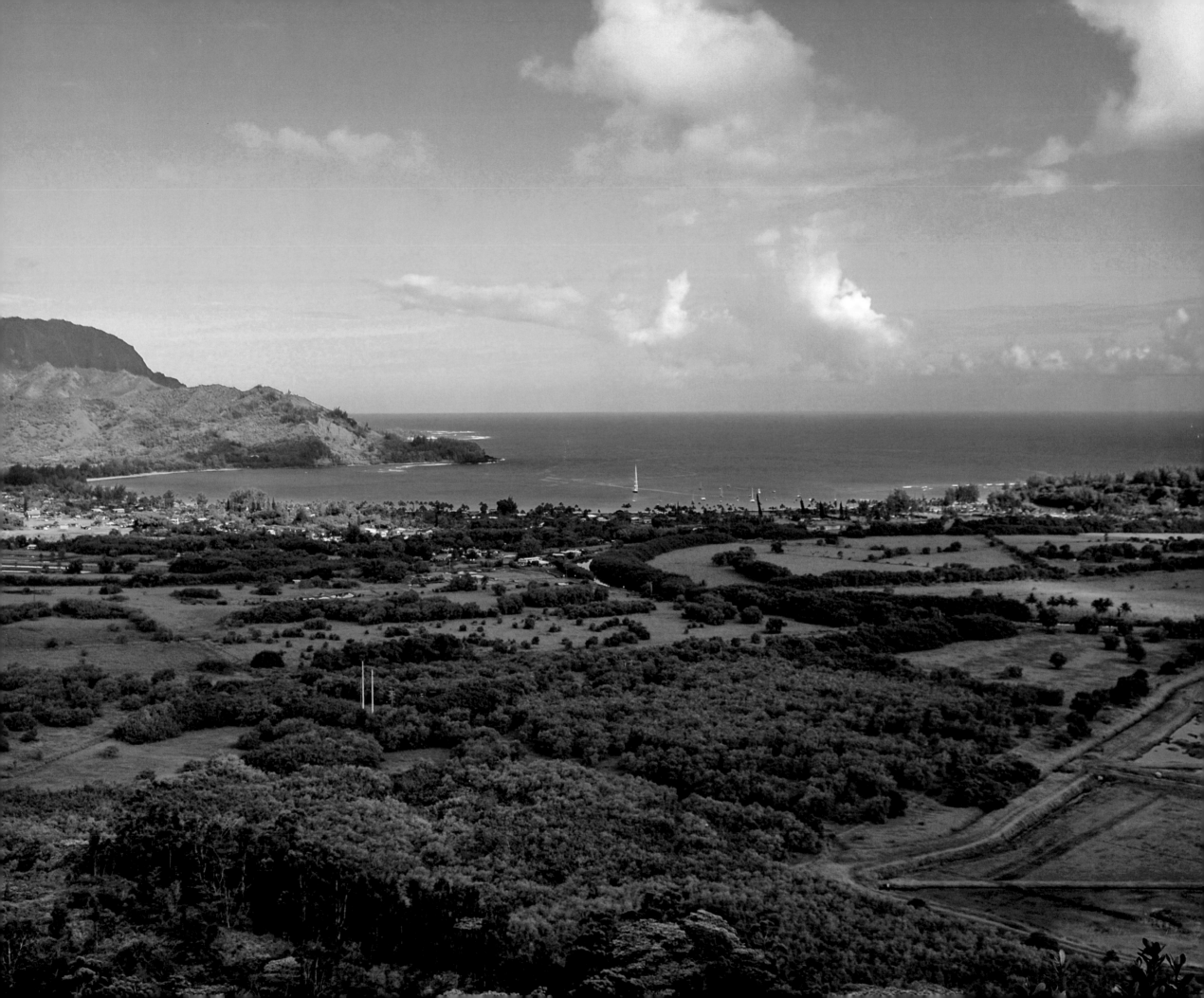

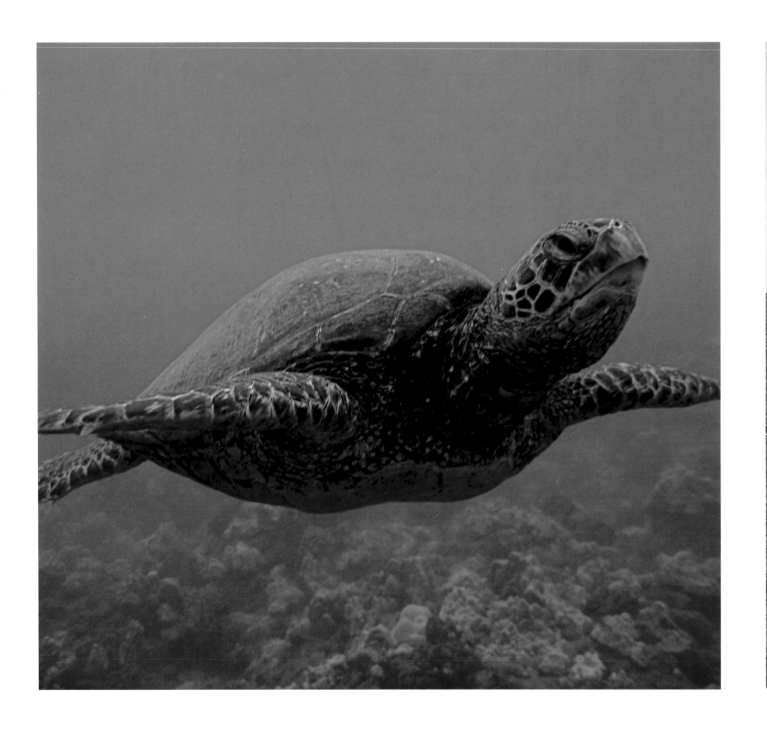
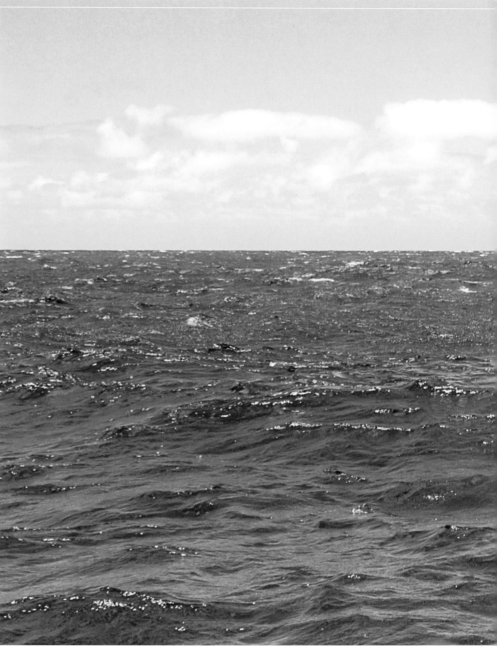

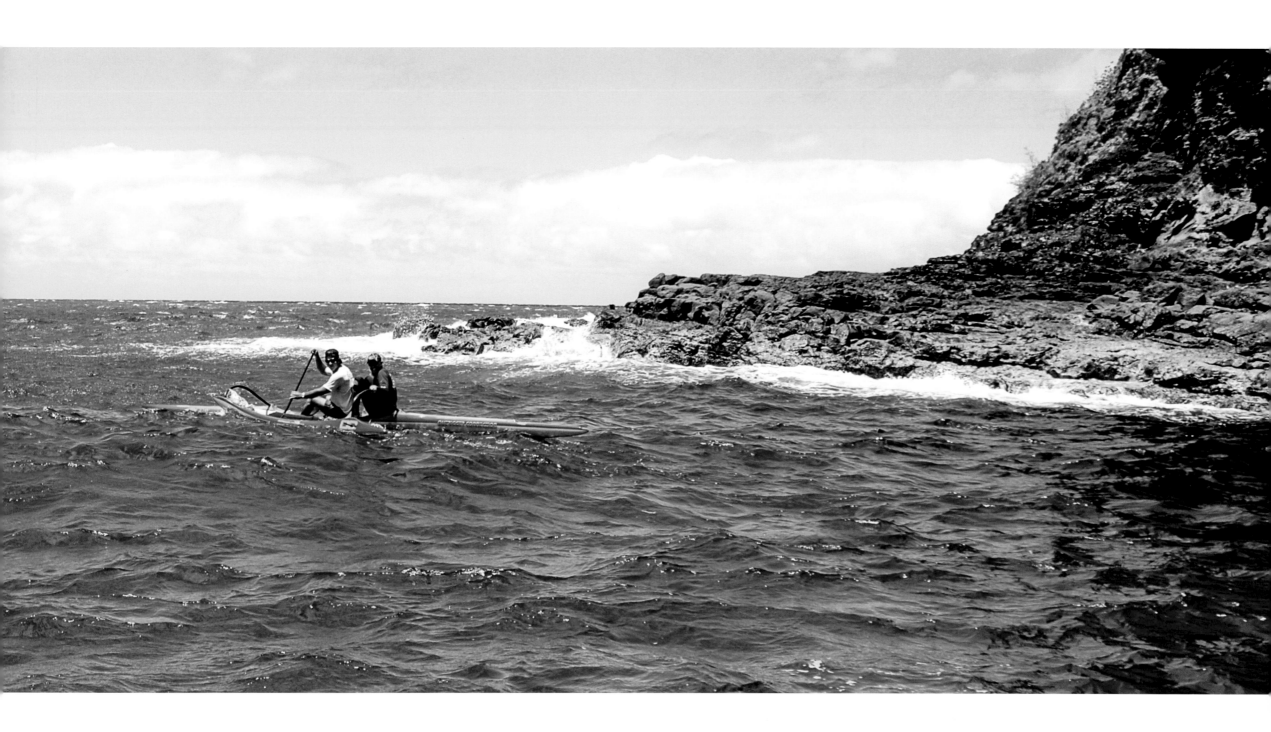

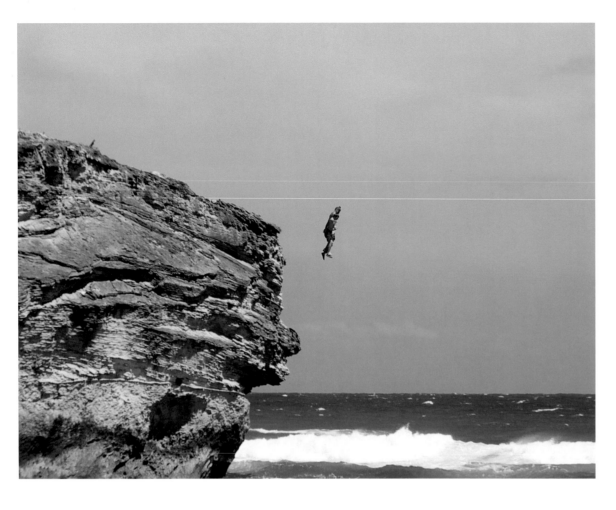
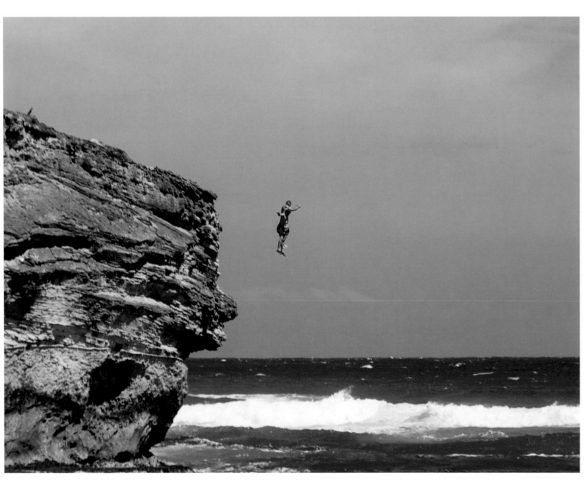
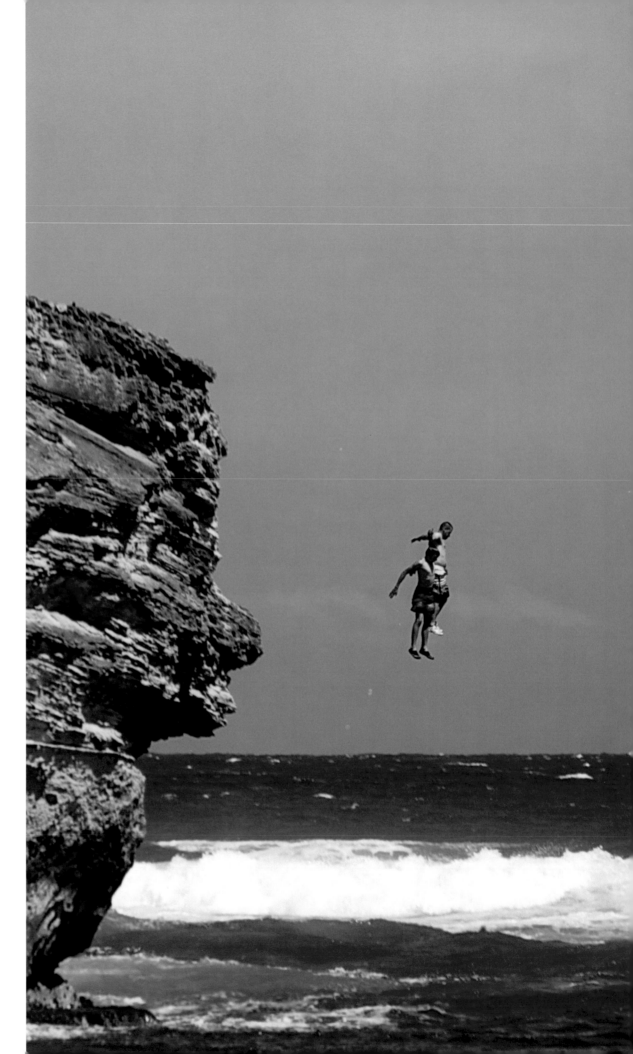

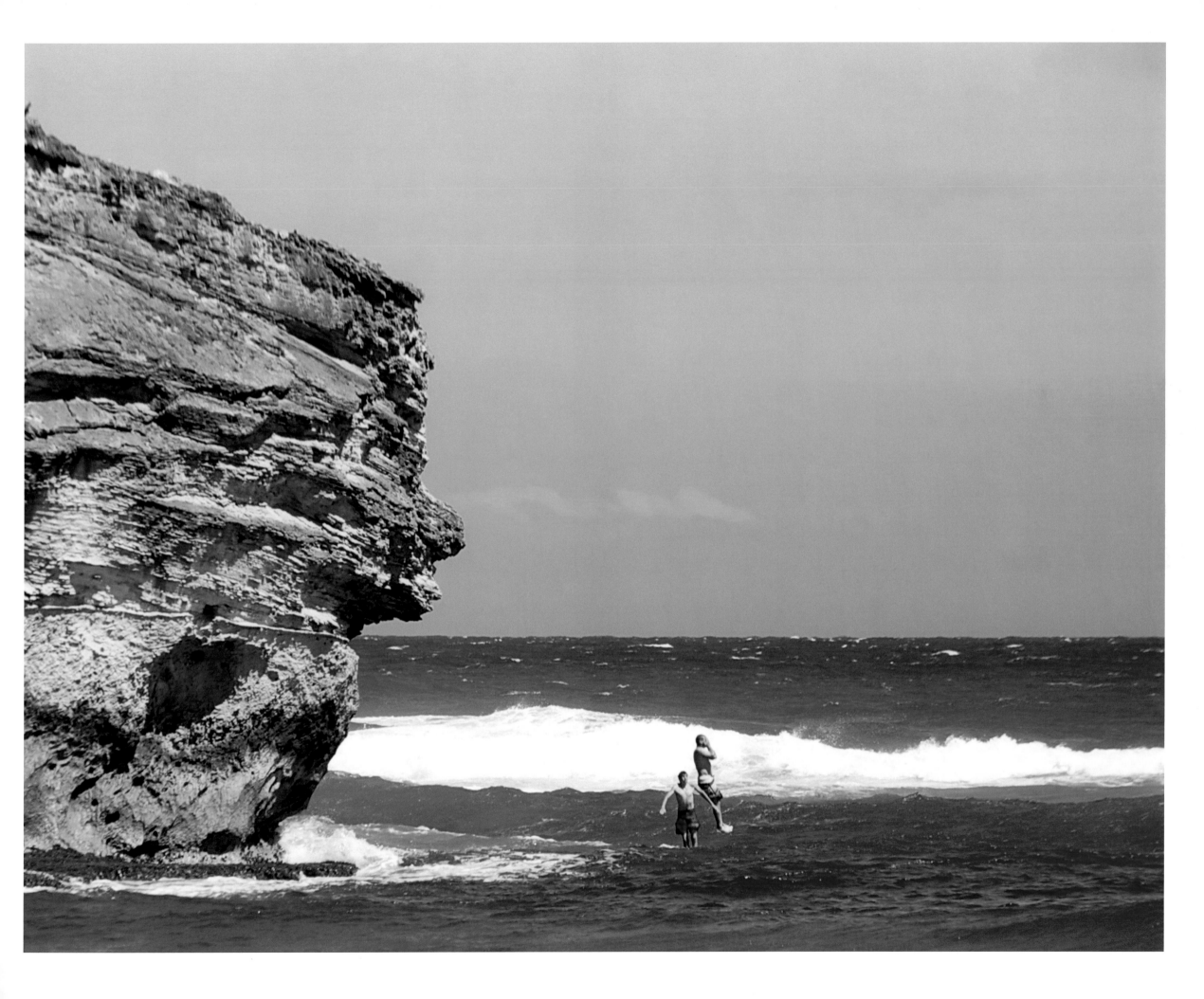

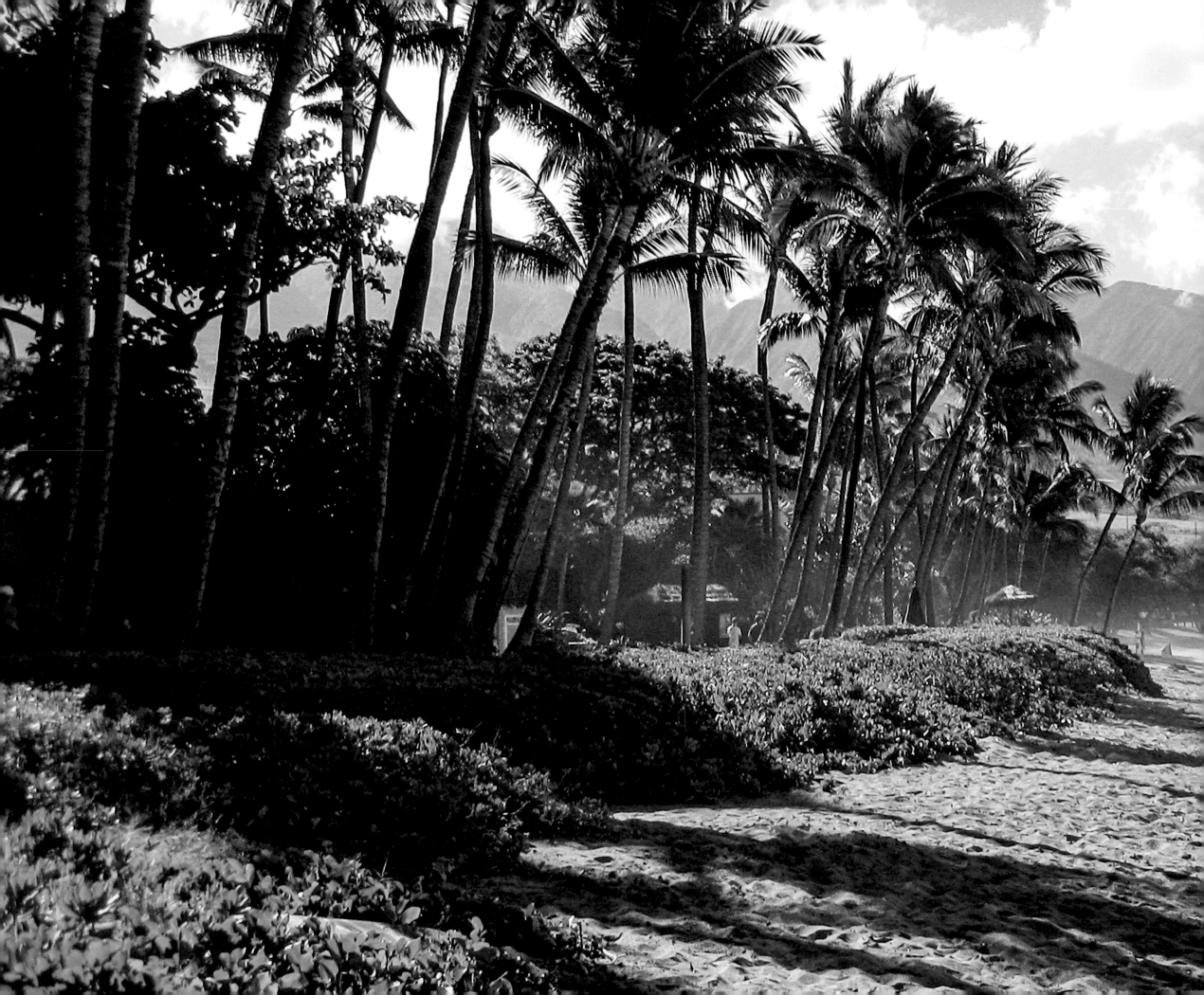

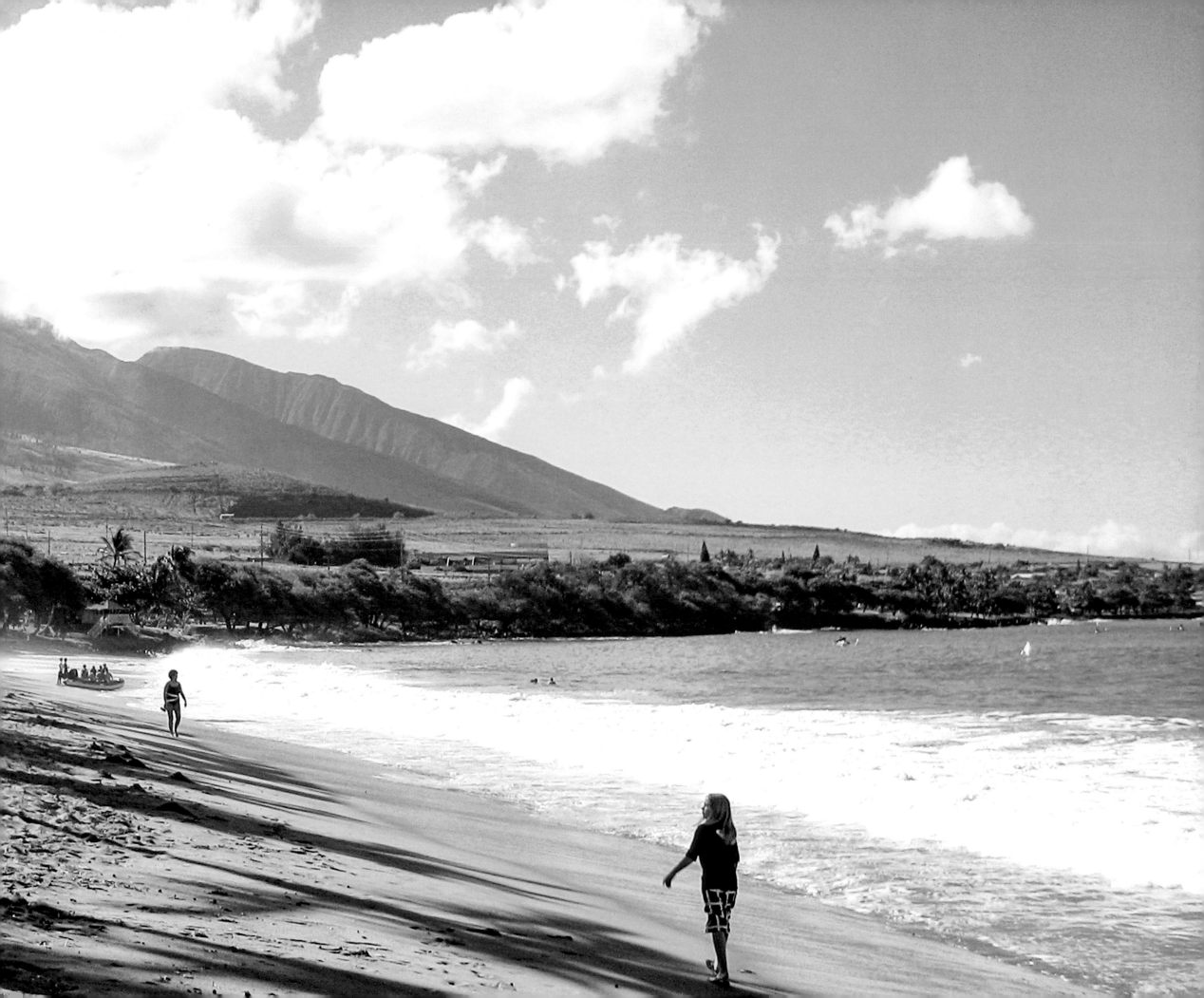

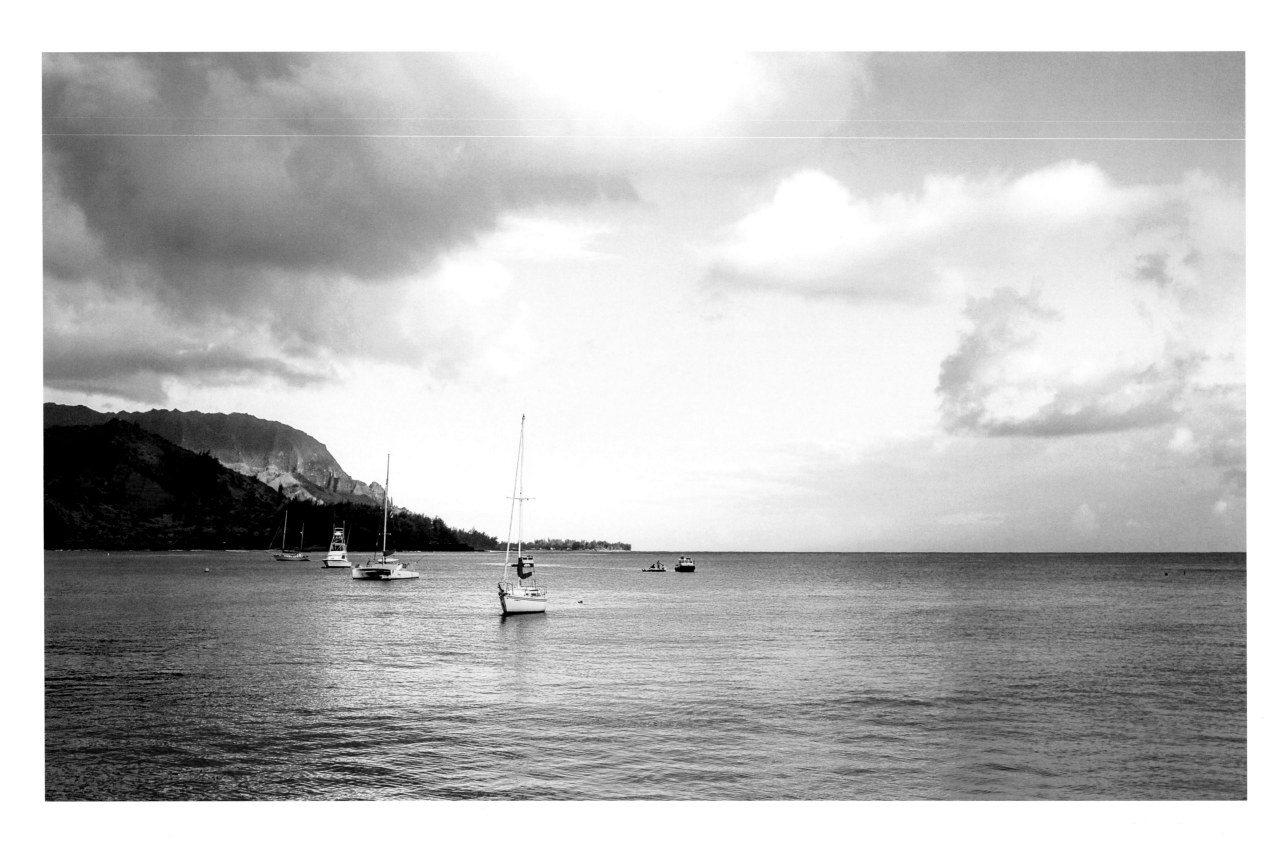

Hanalei Bay, Kauai

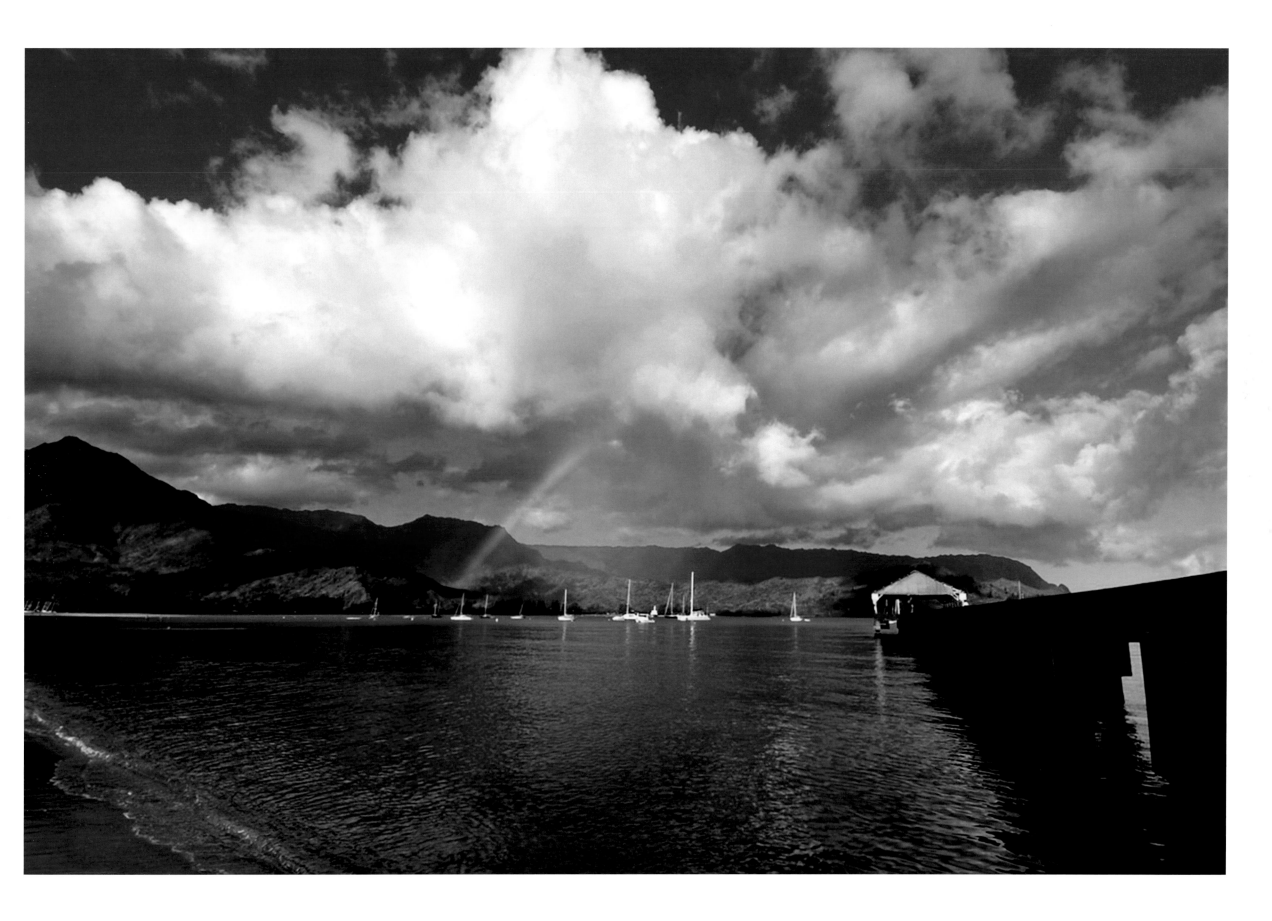

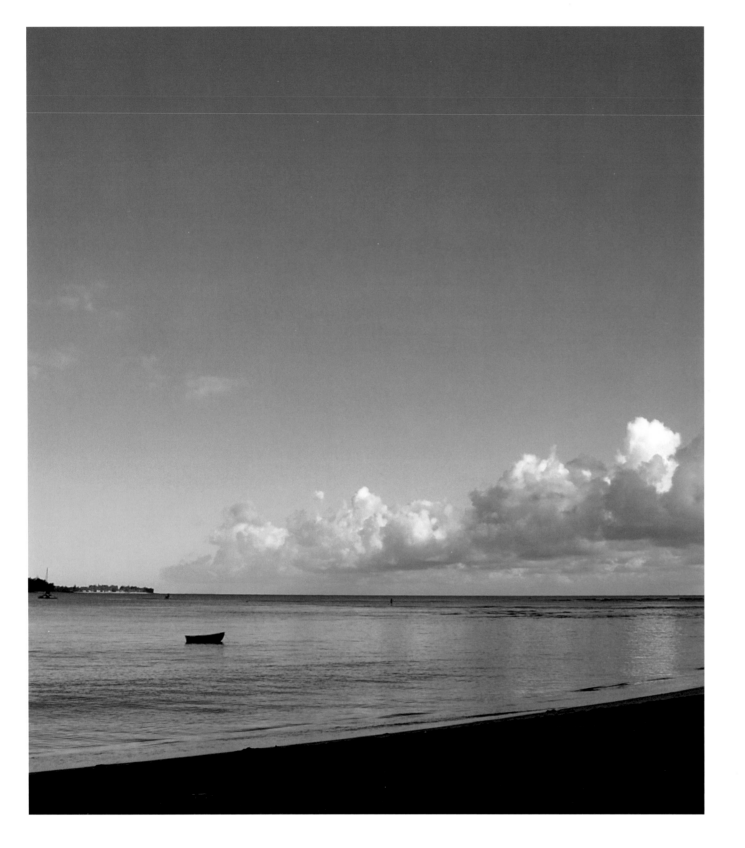
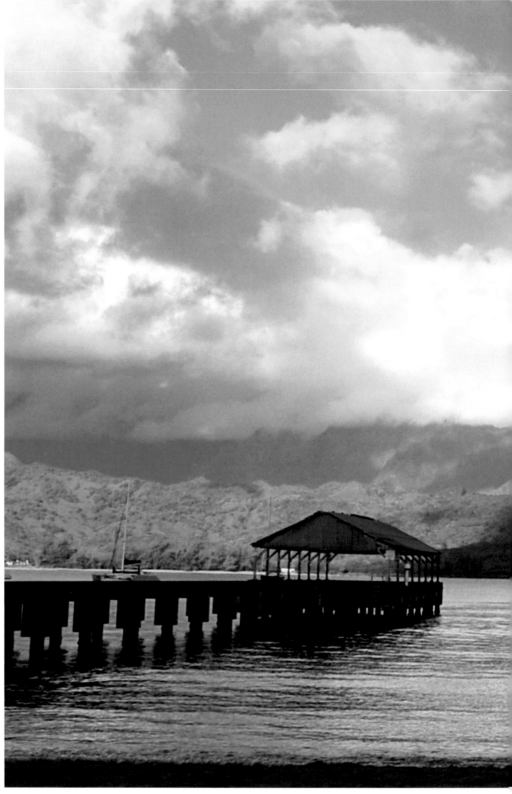

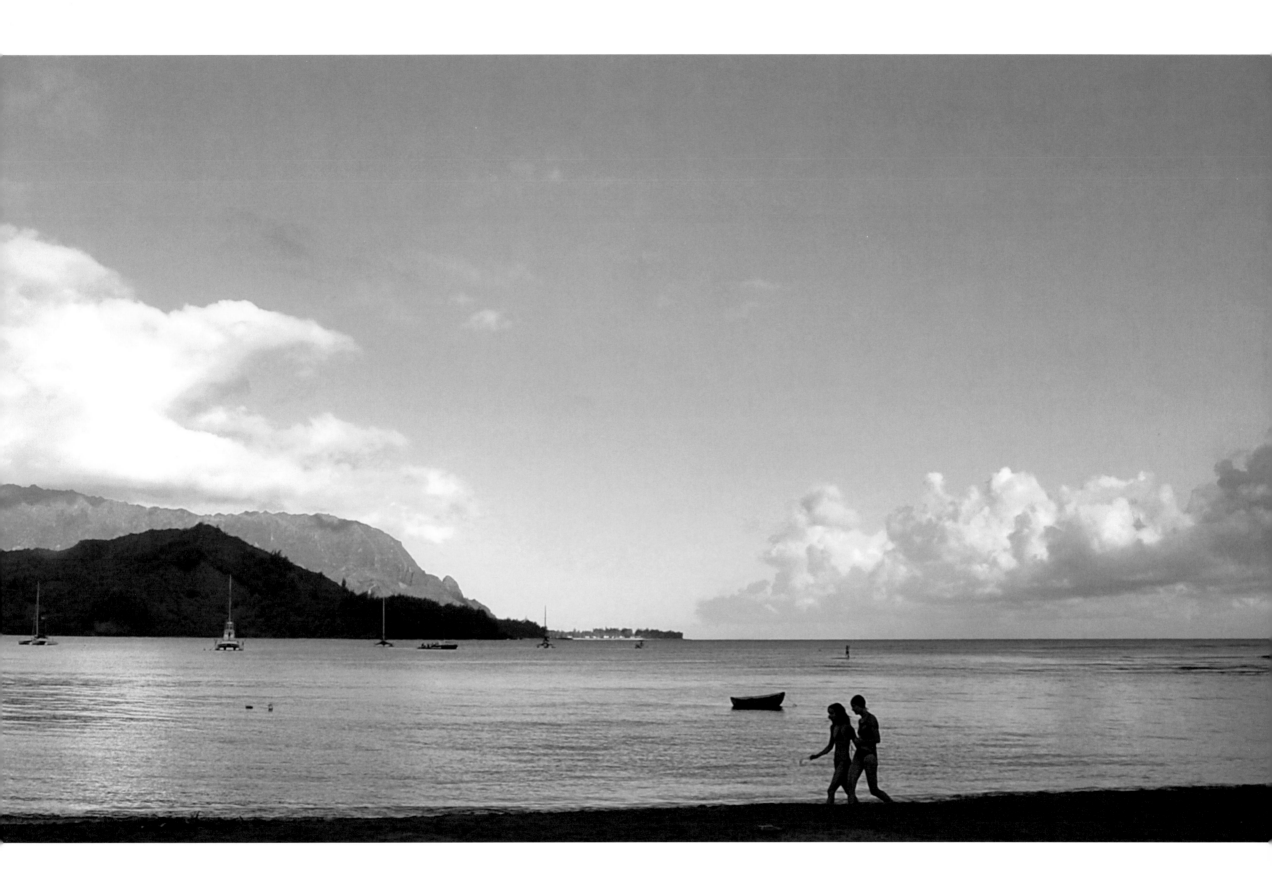

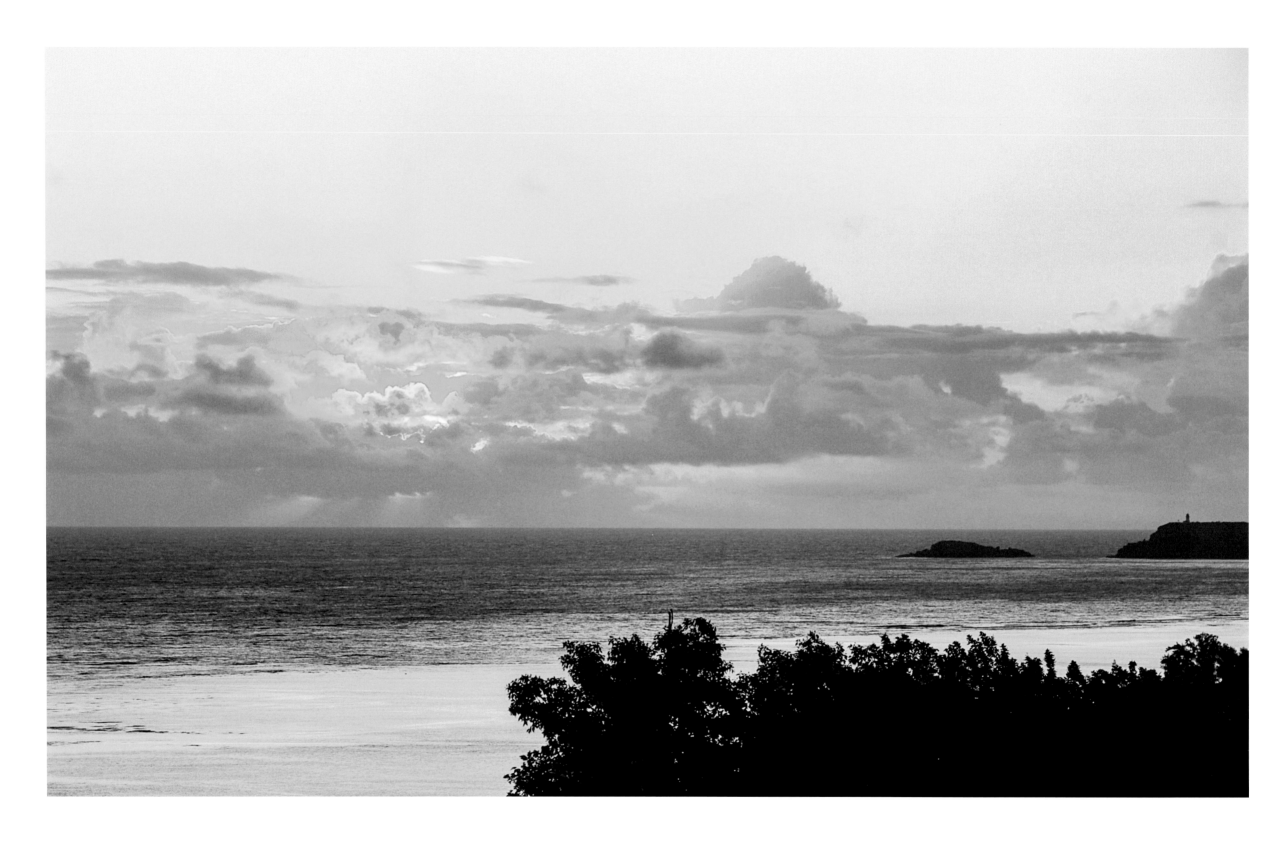

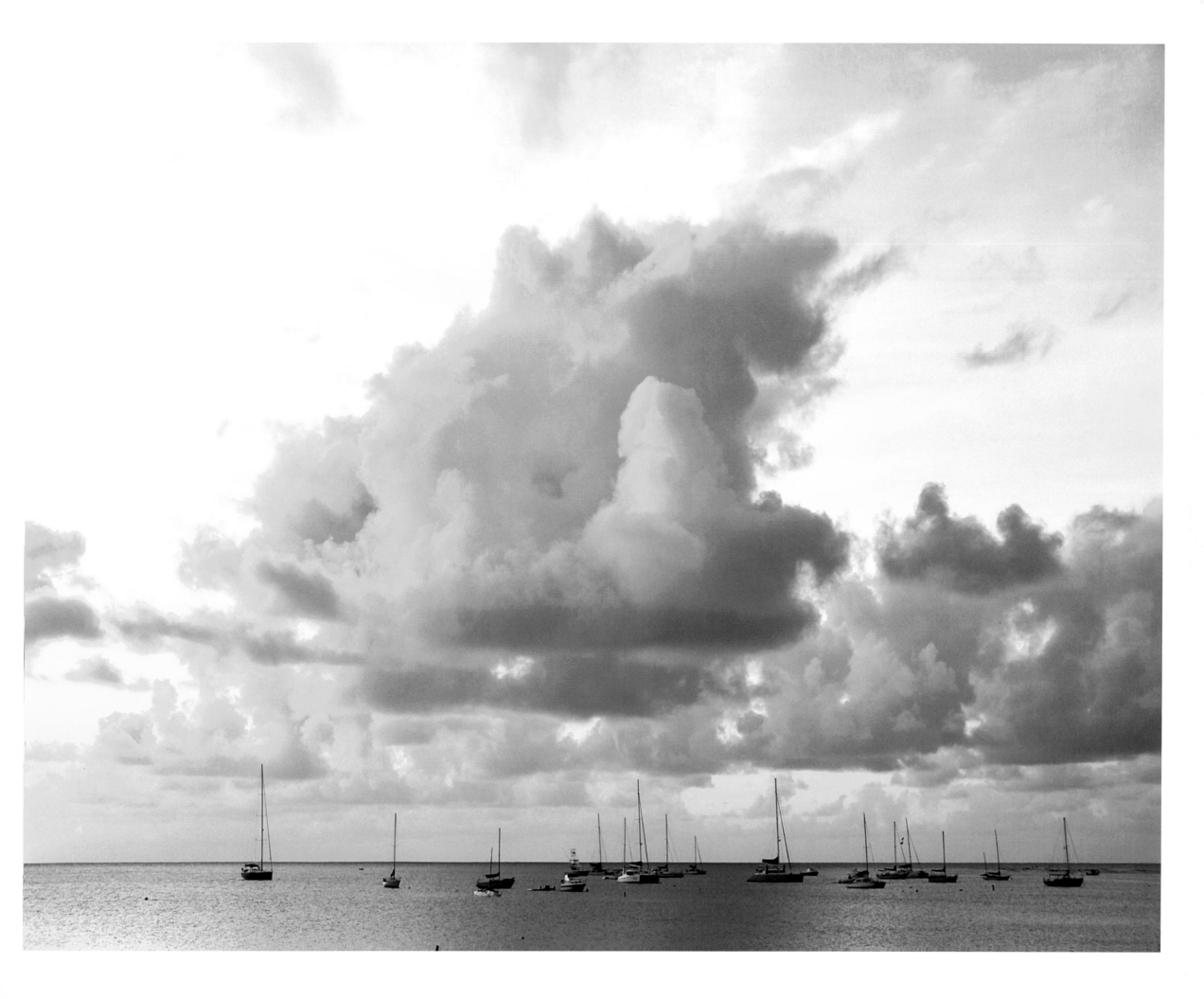

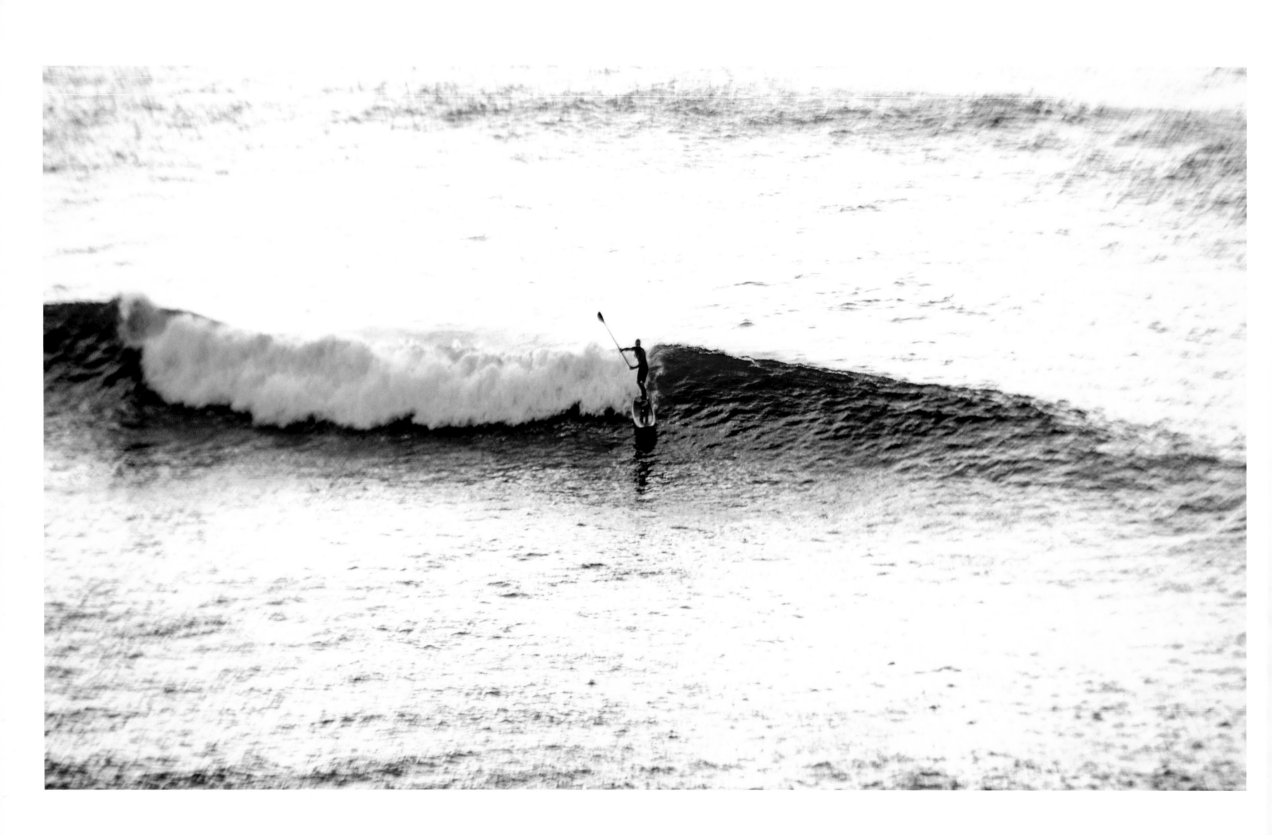

Hanalei Bay, Kauai

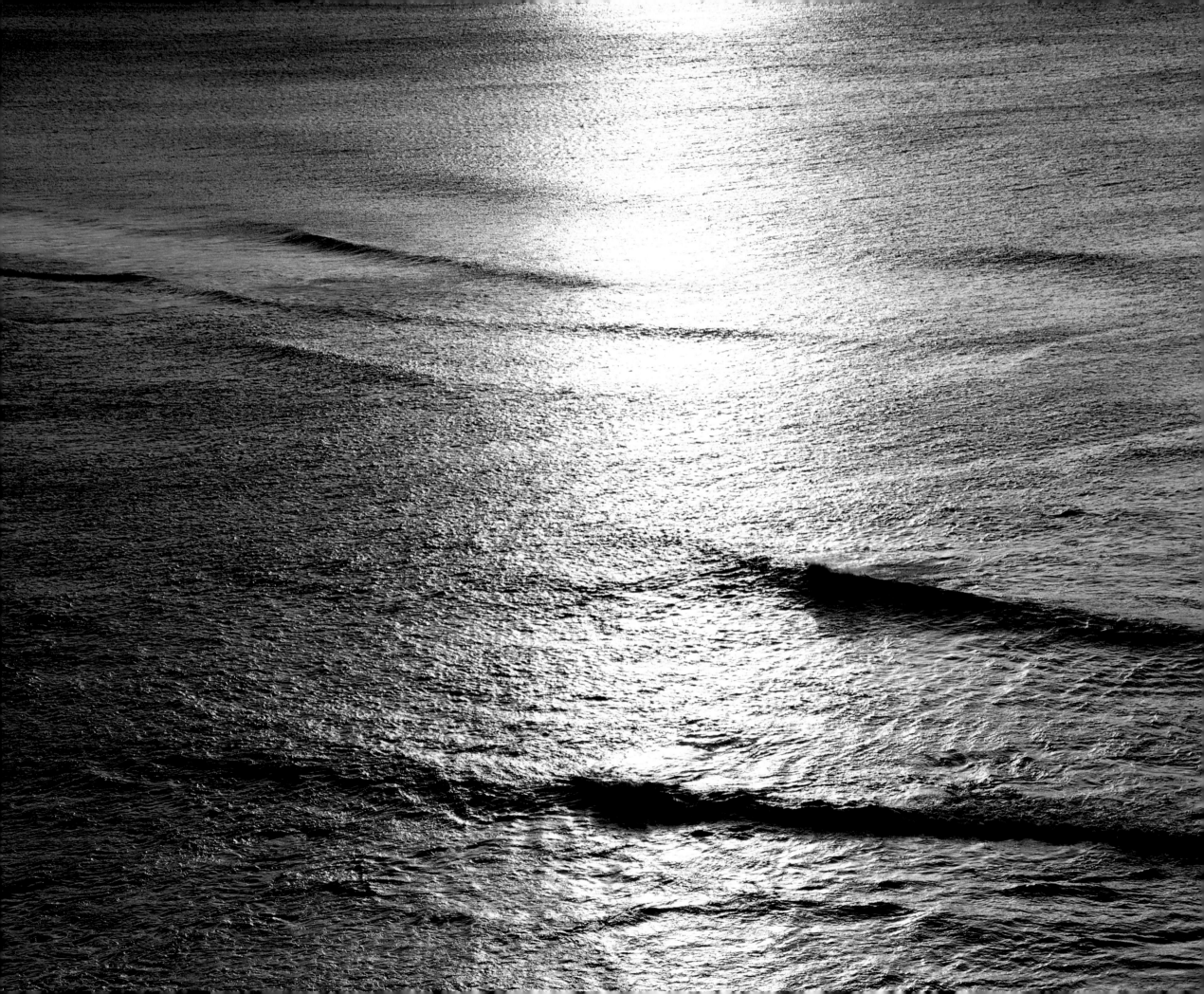

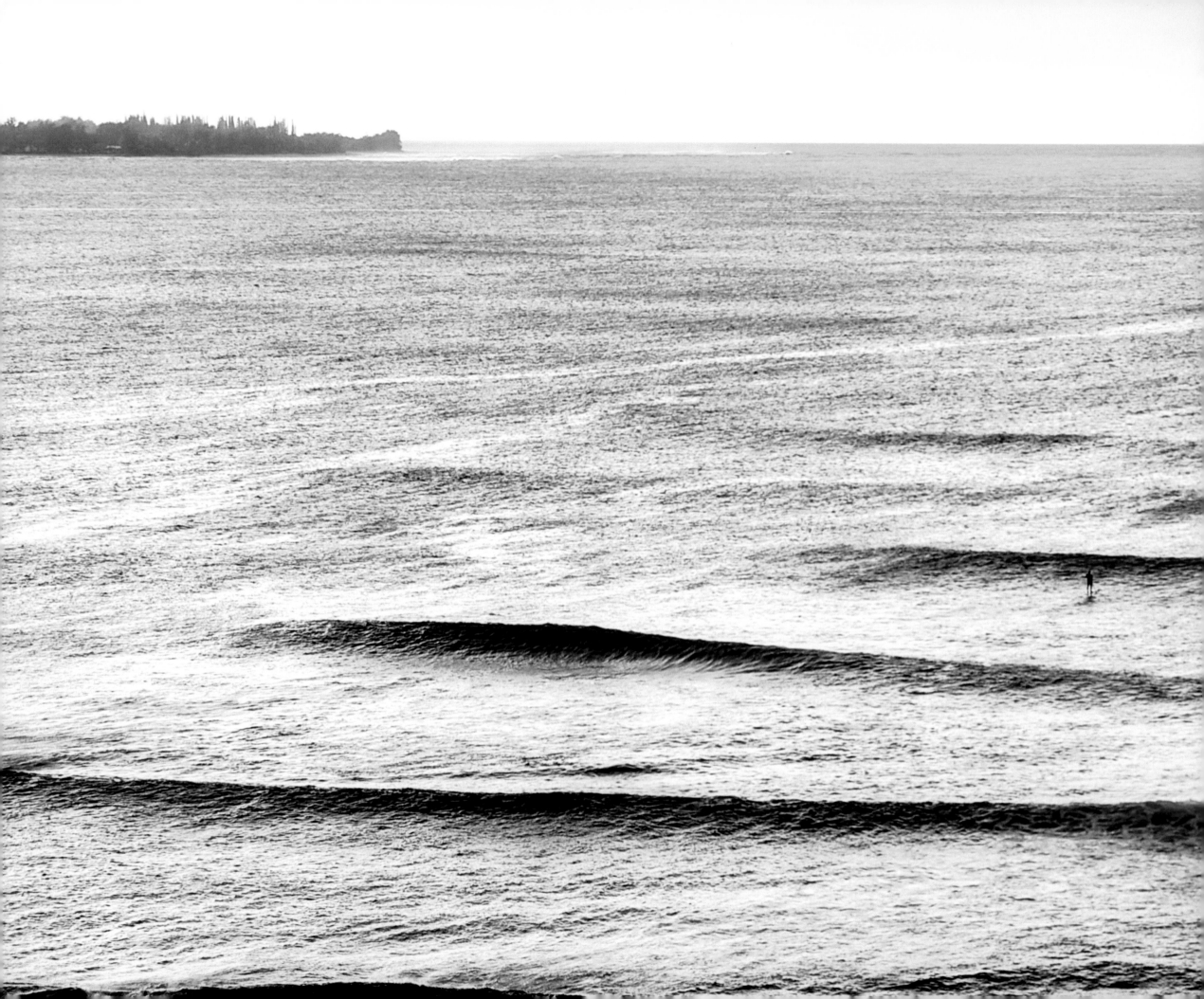

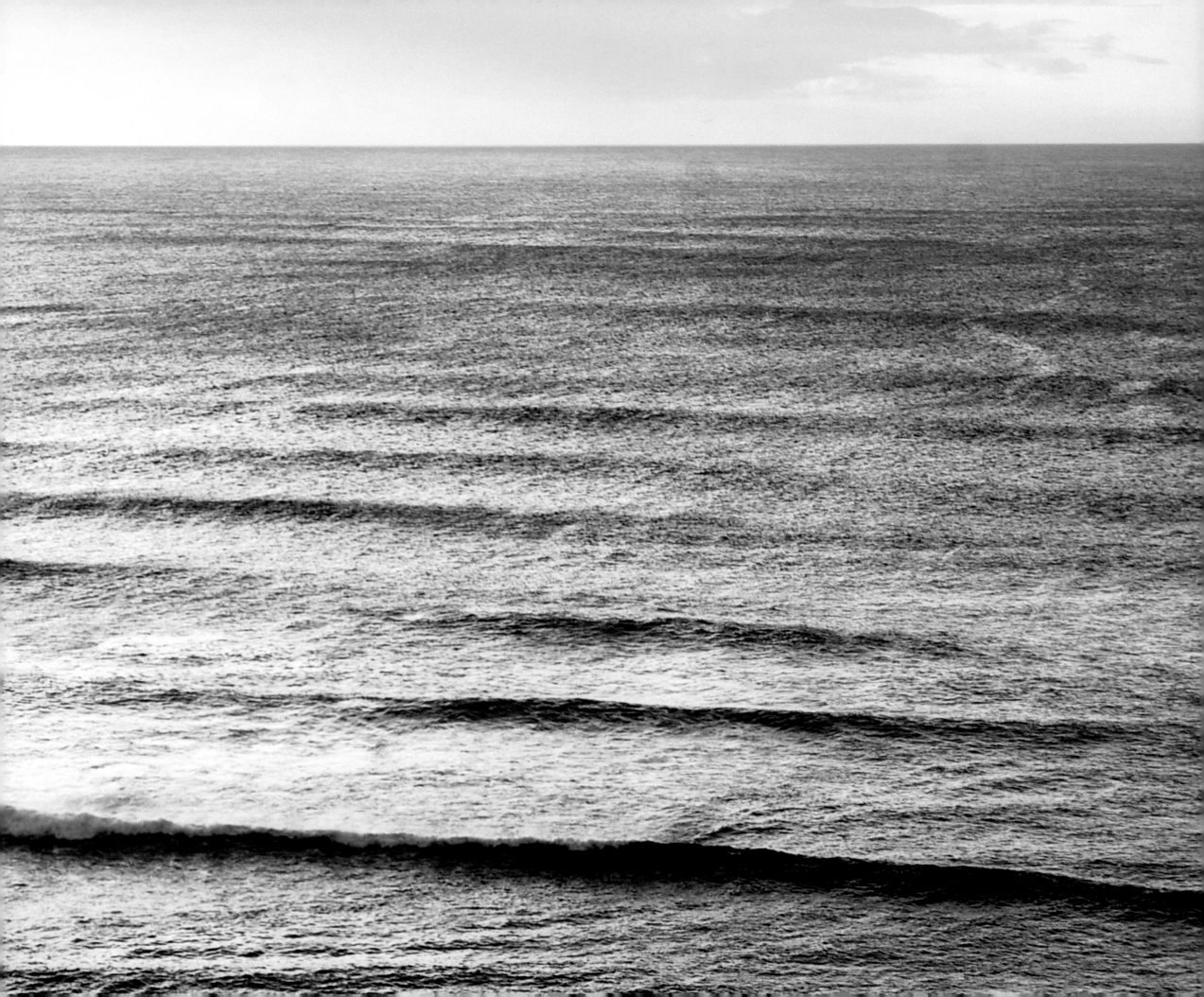

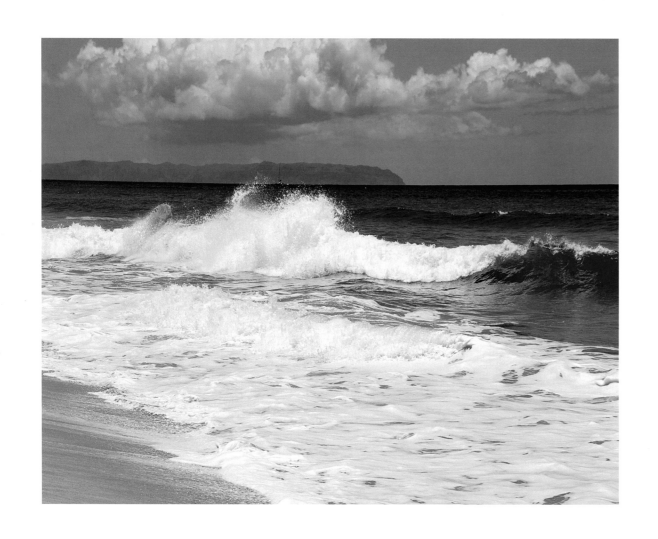
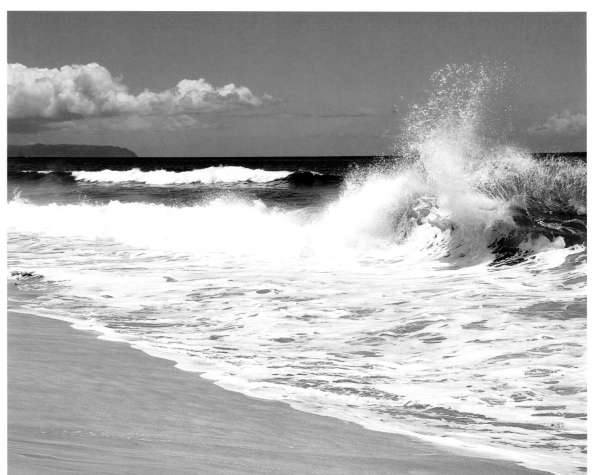

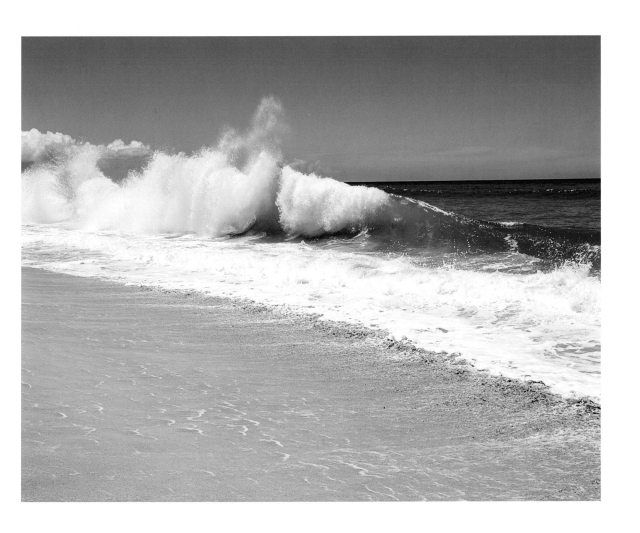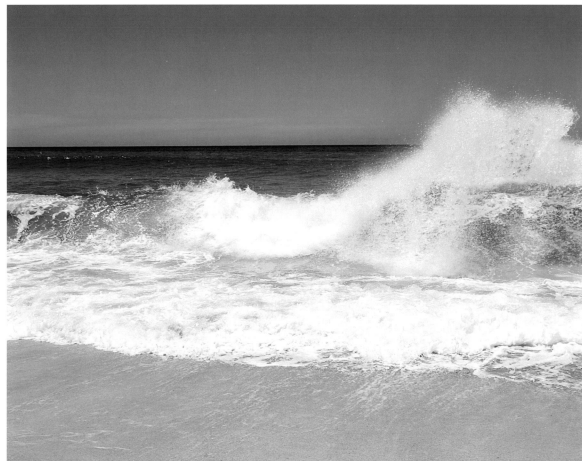

Polihale Heiau Beach, Kauai

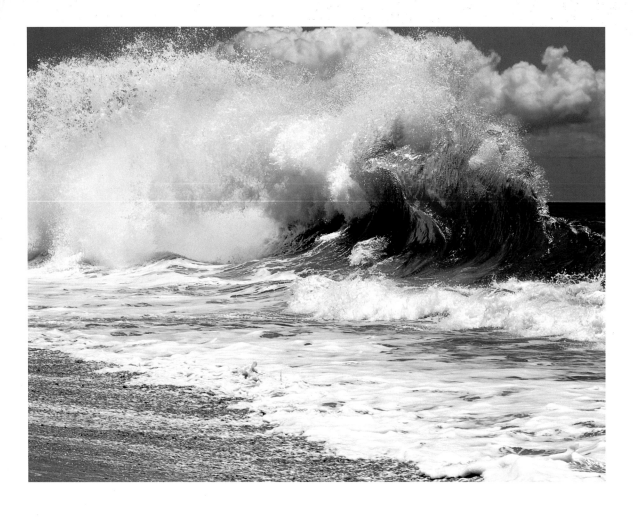

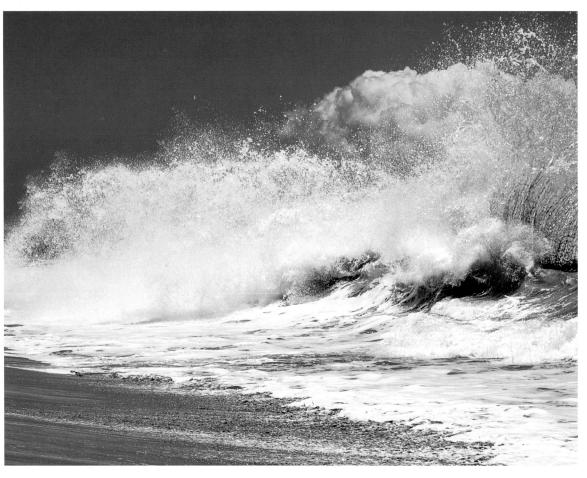

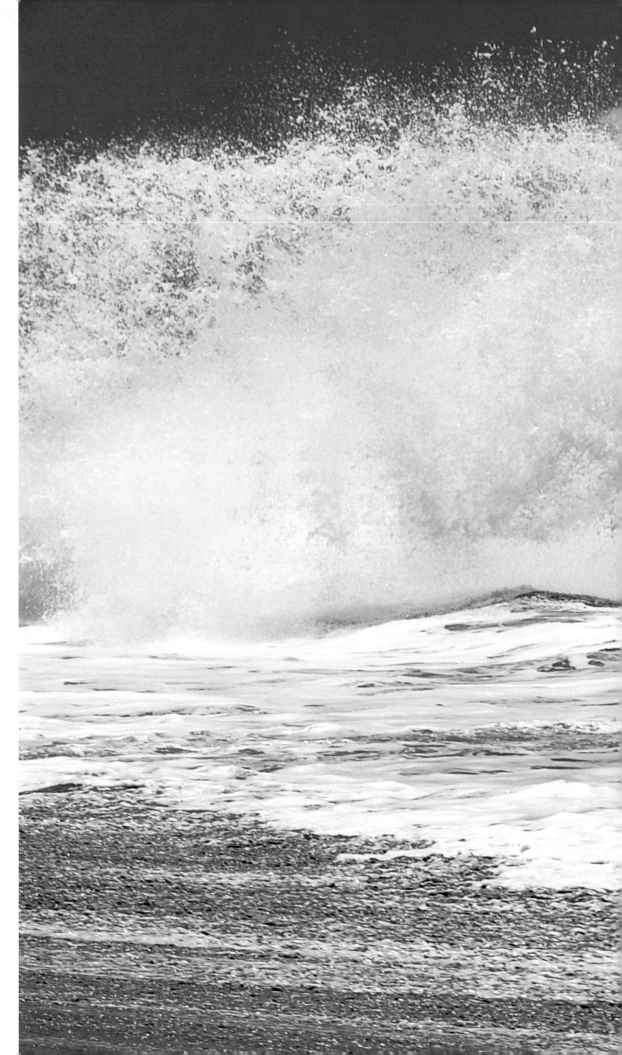

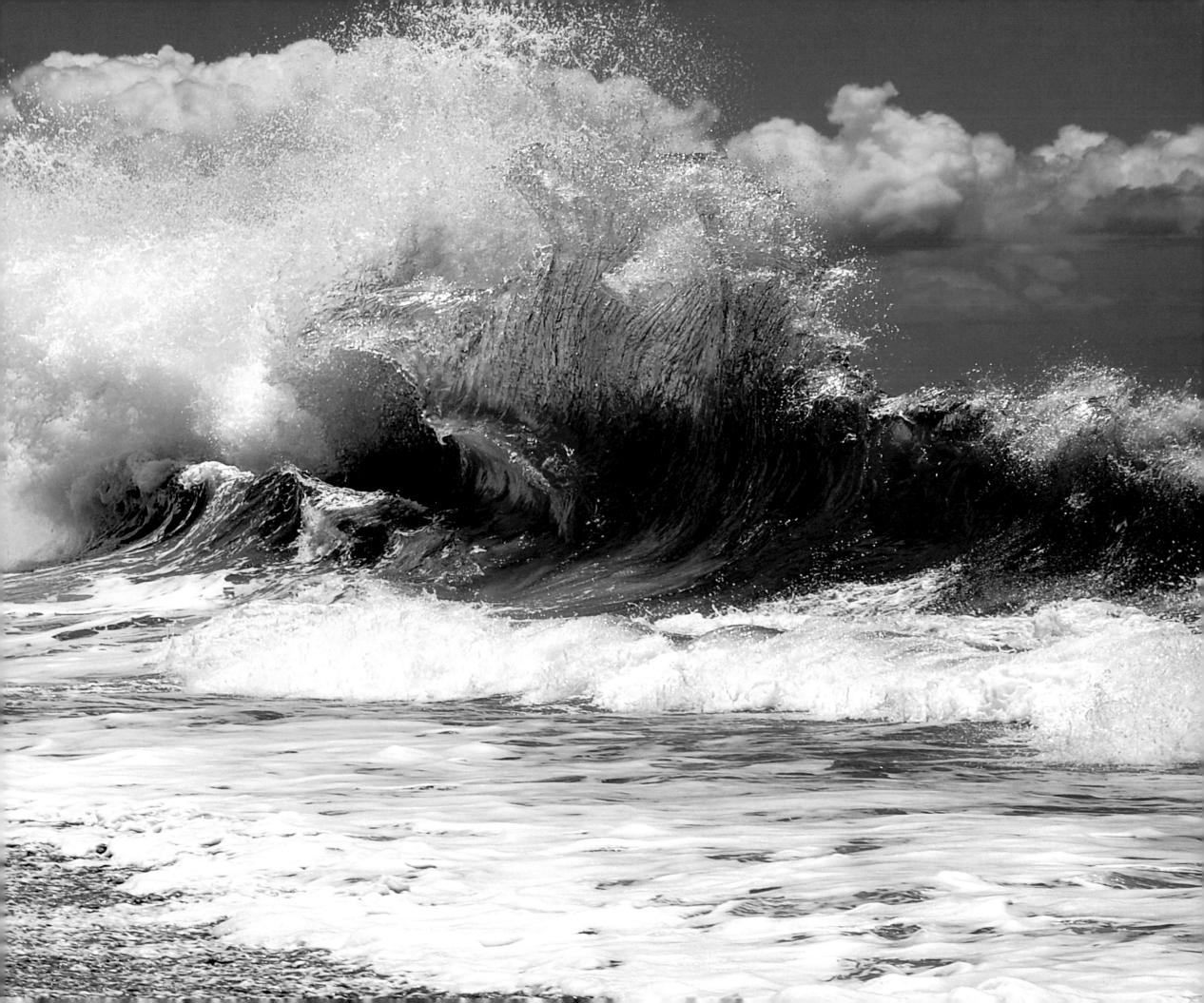

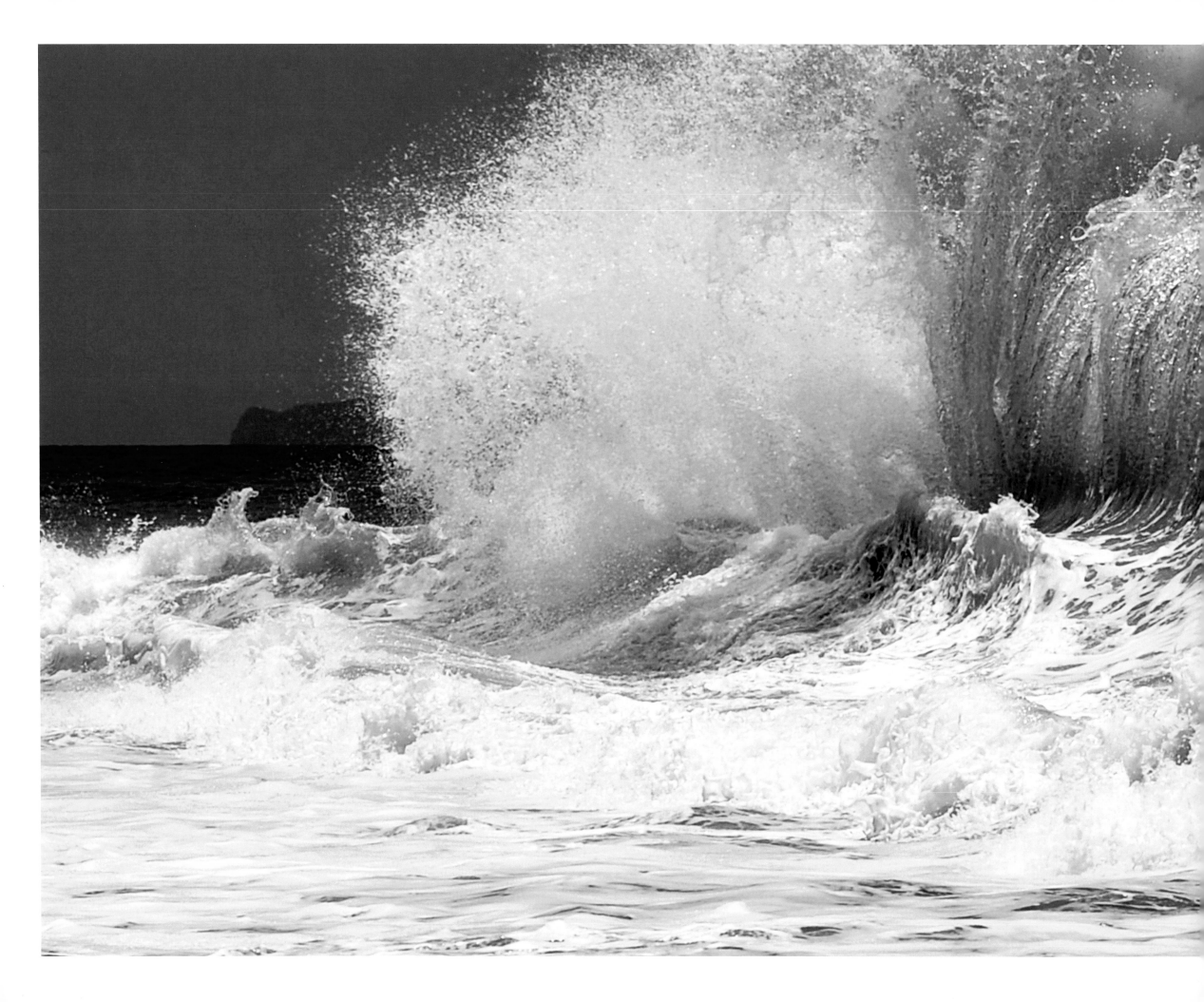

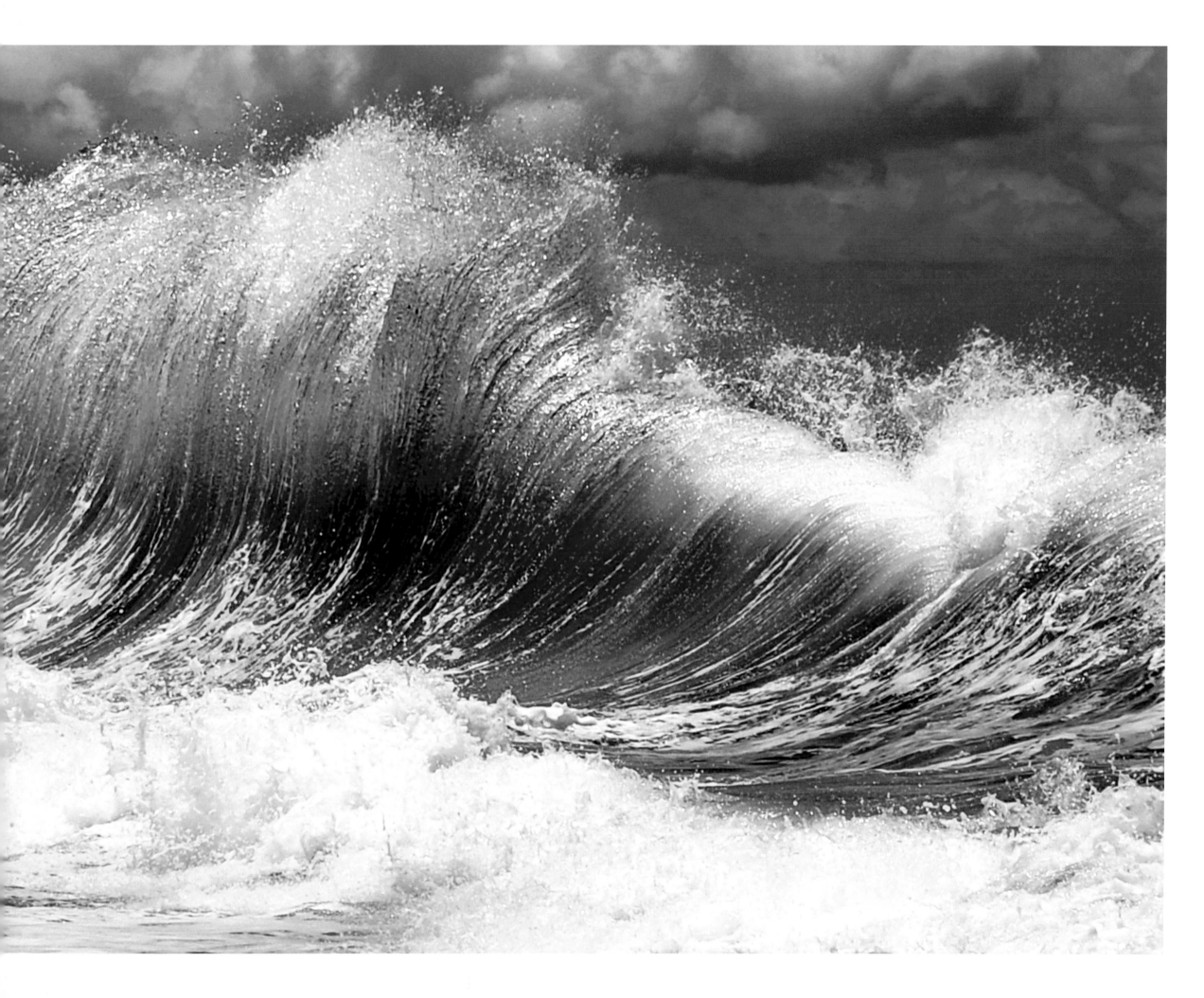

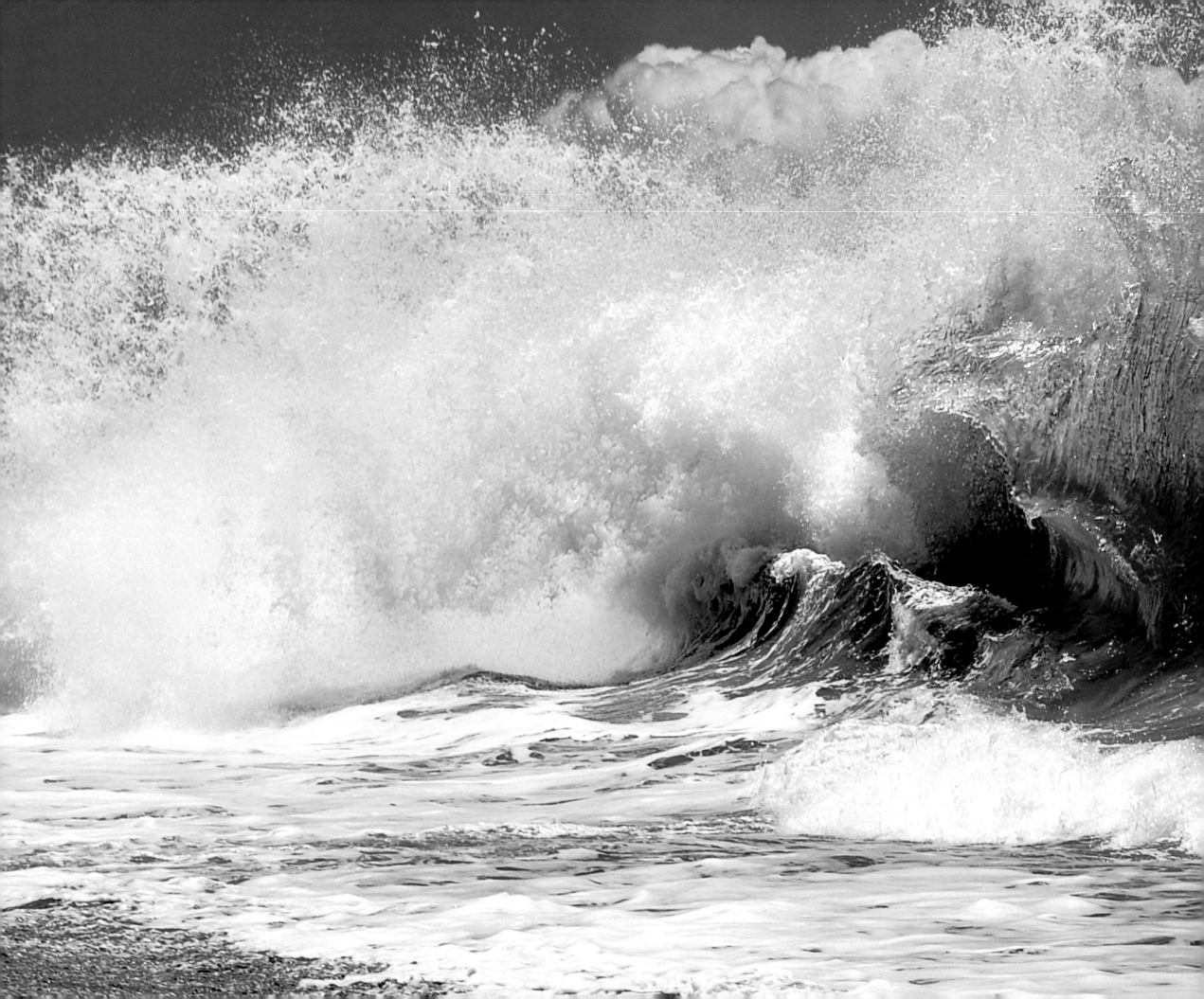

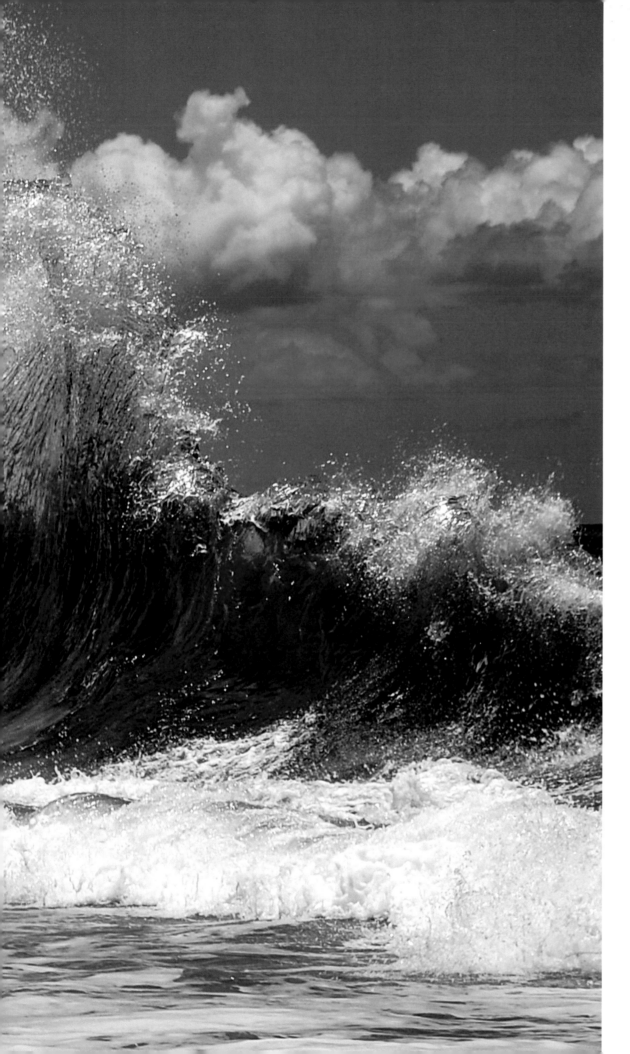
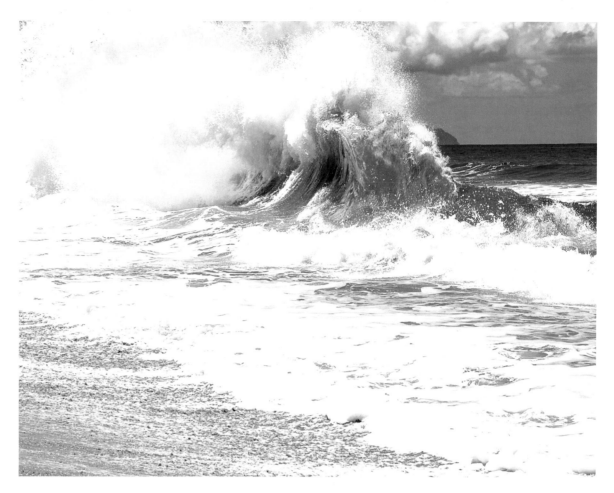
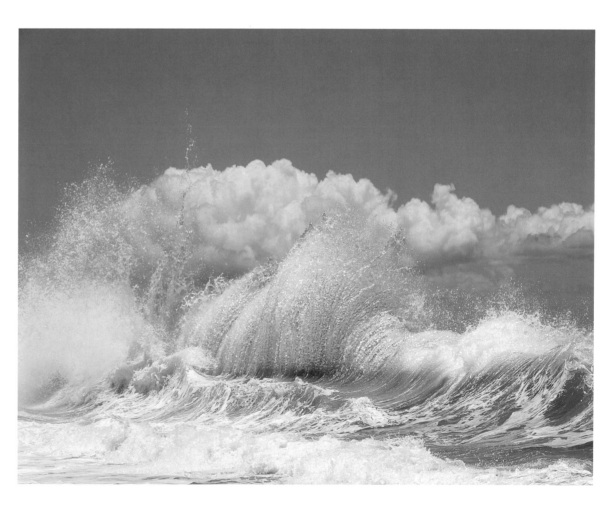

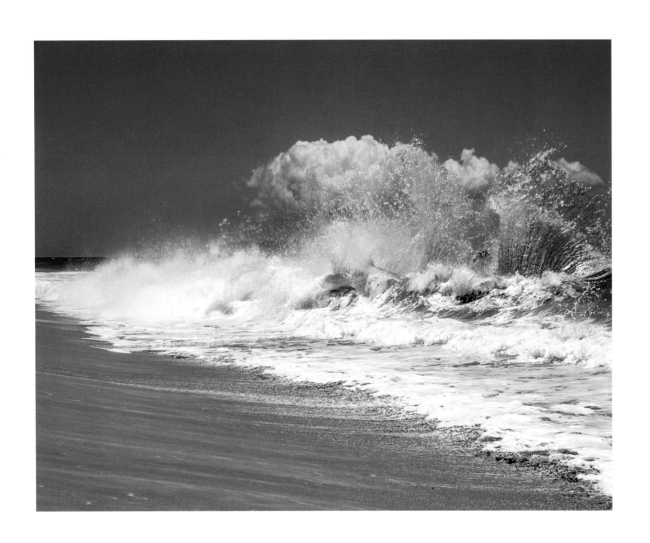
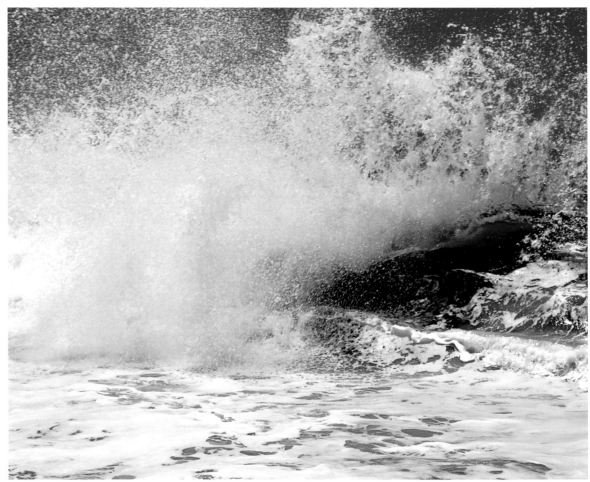

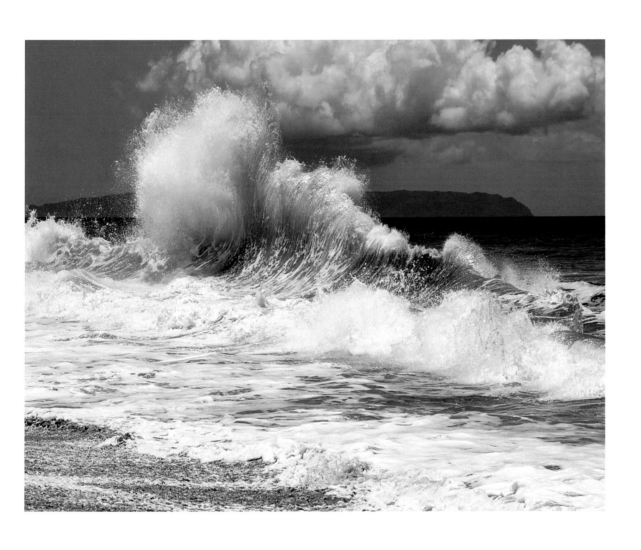
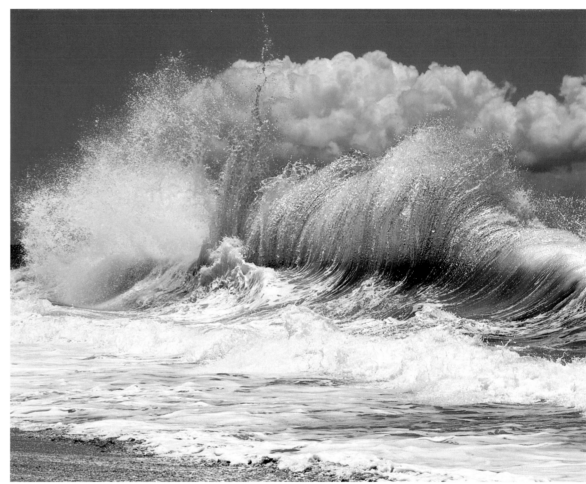

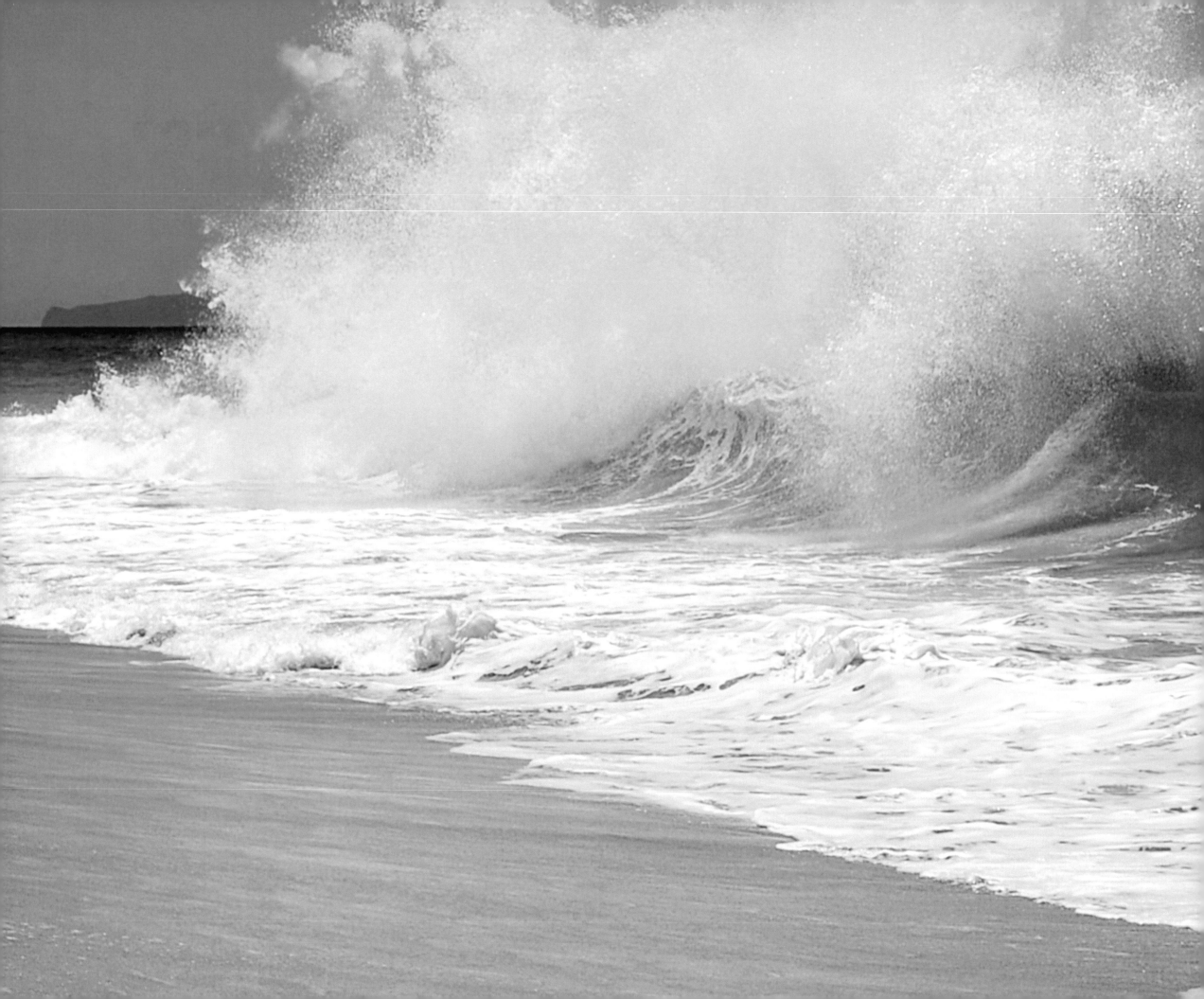

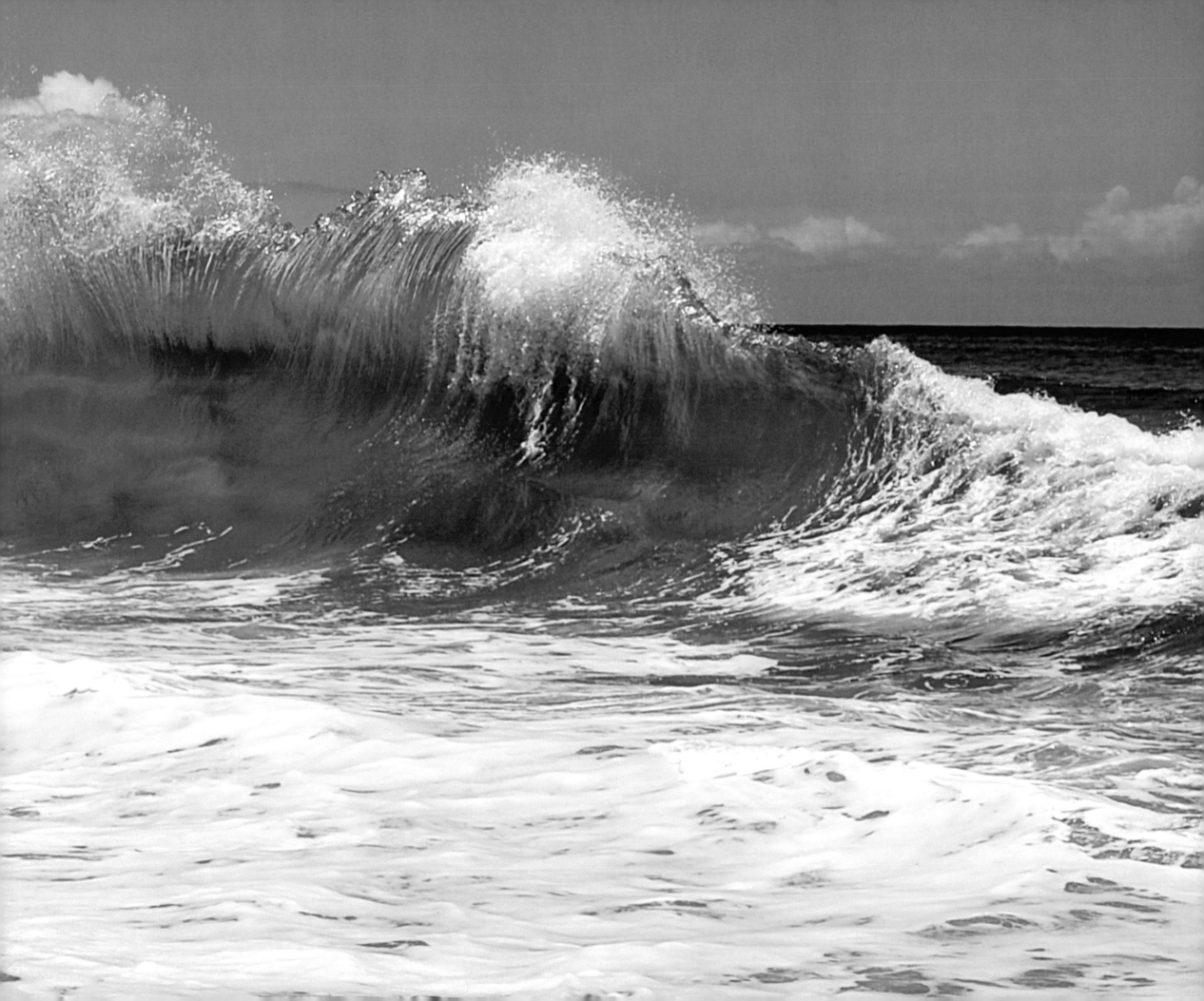

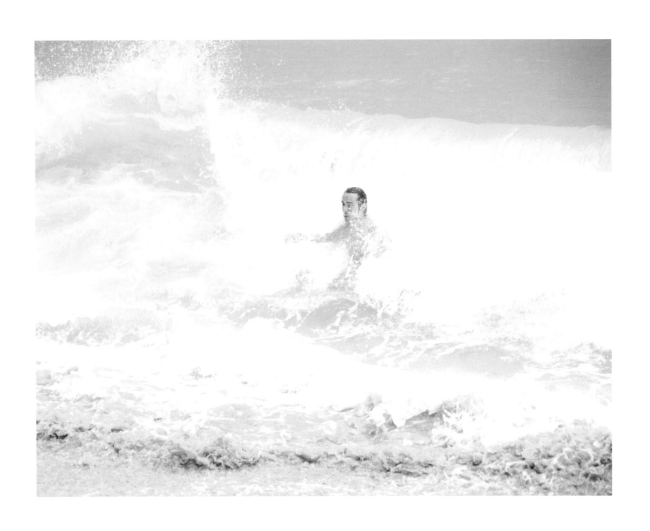

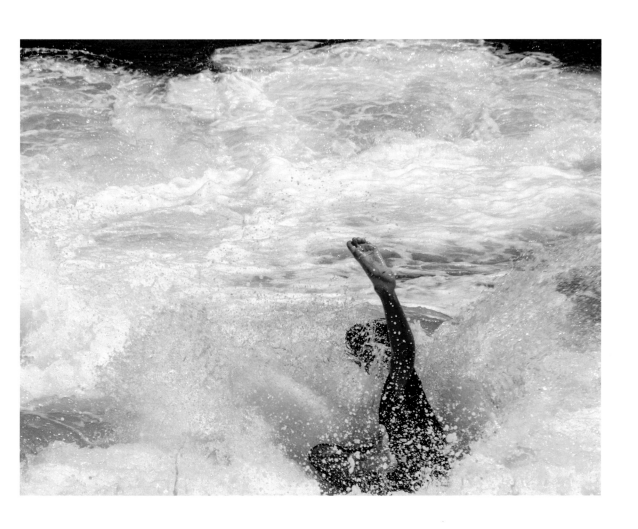
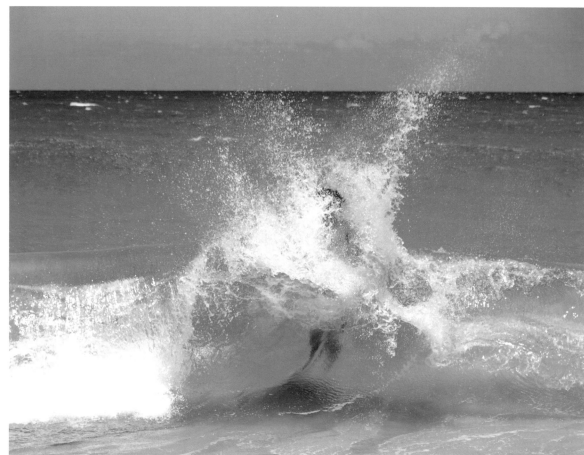

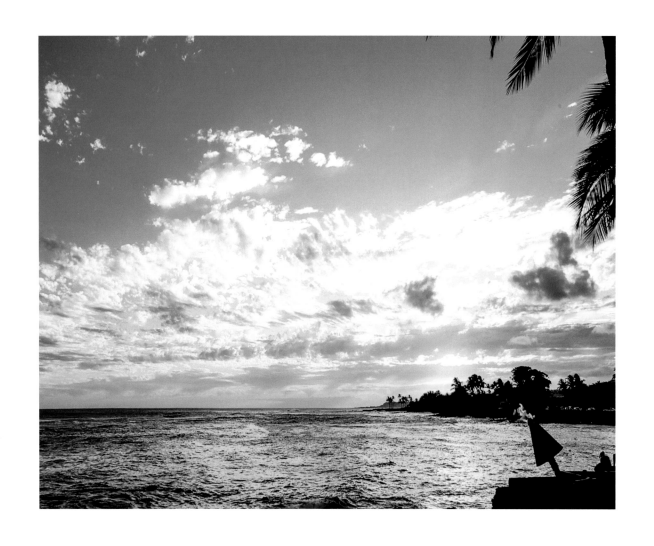

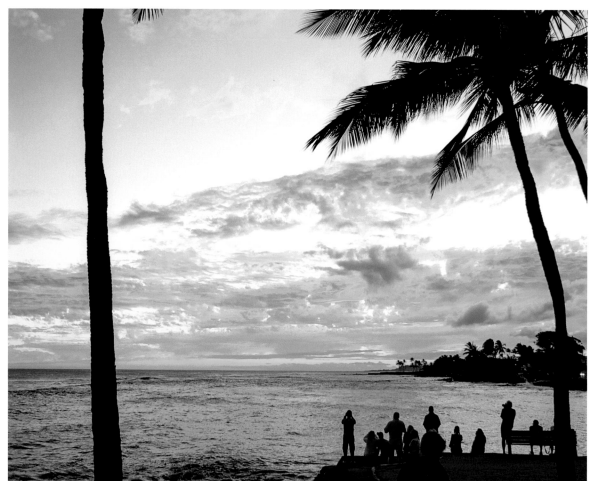

Poipu, Kauai

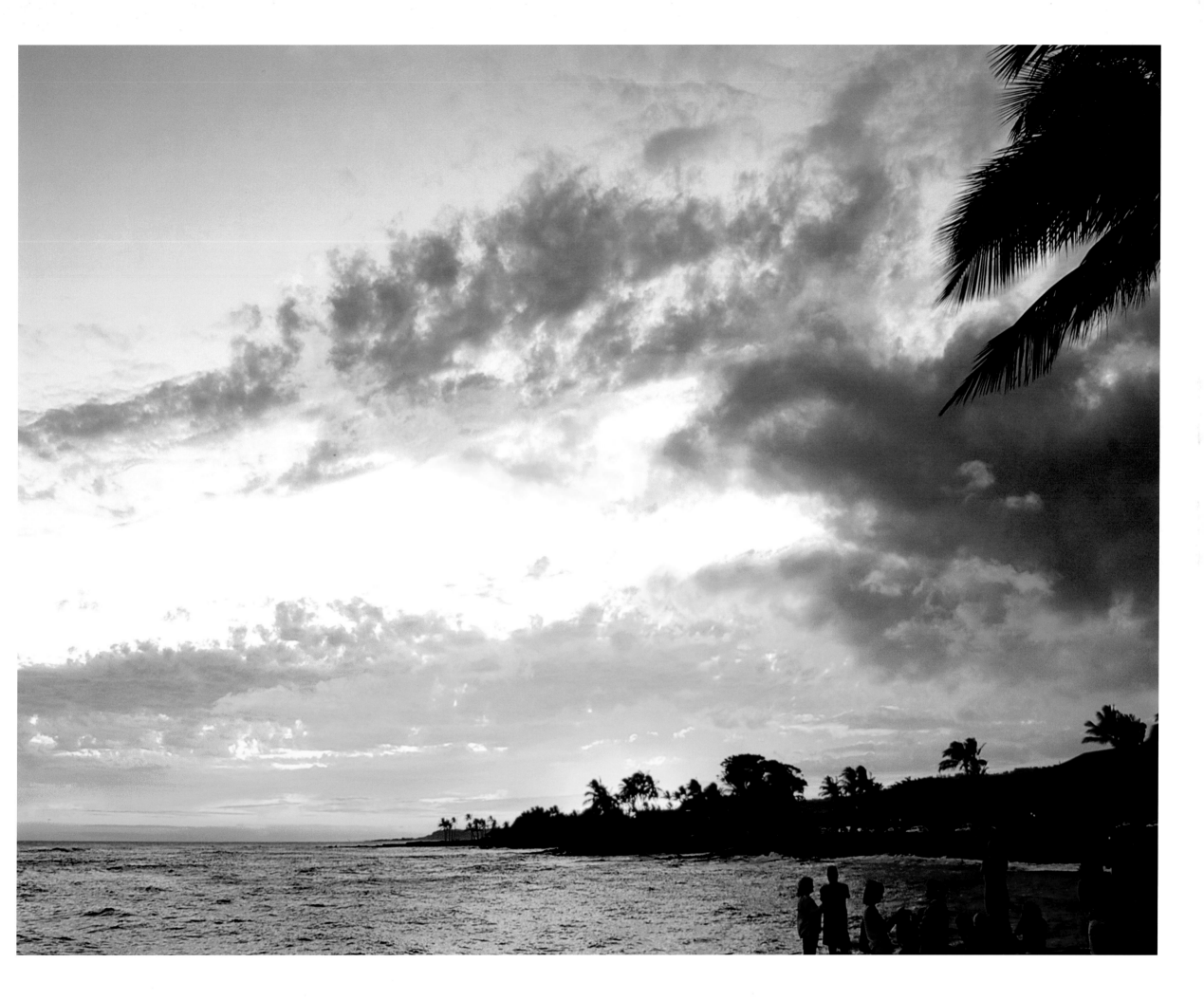

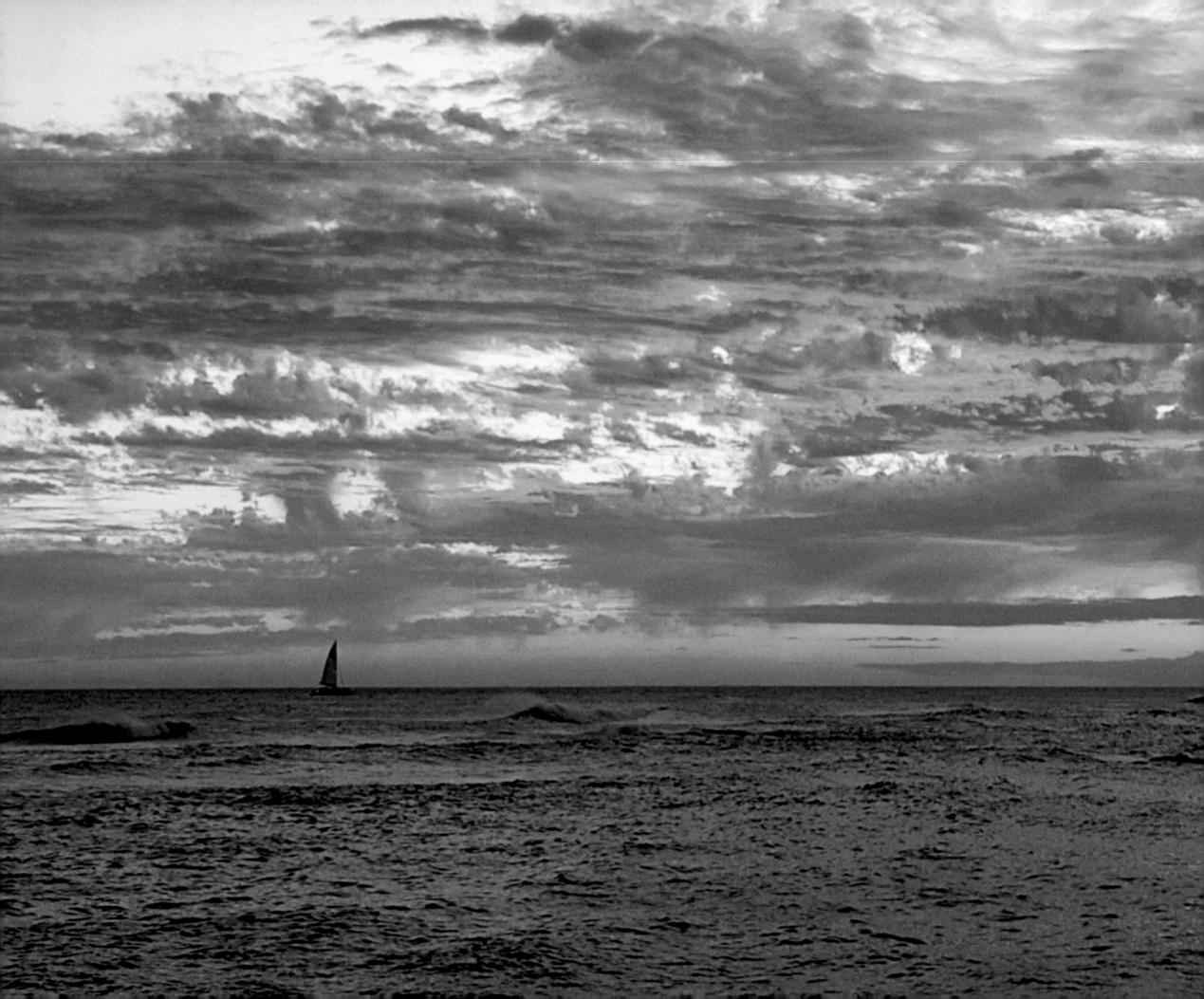

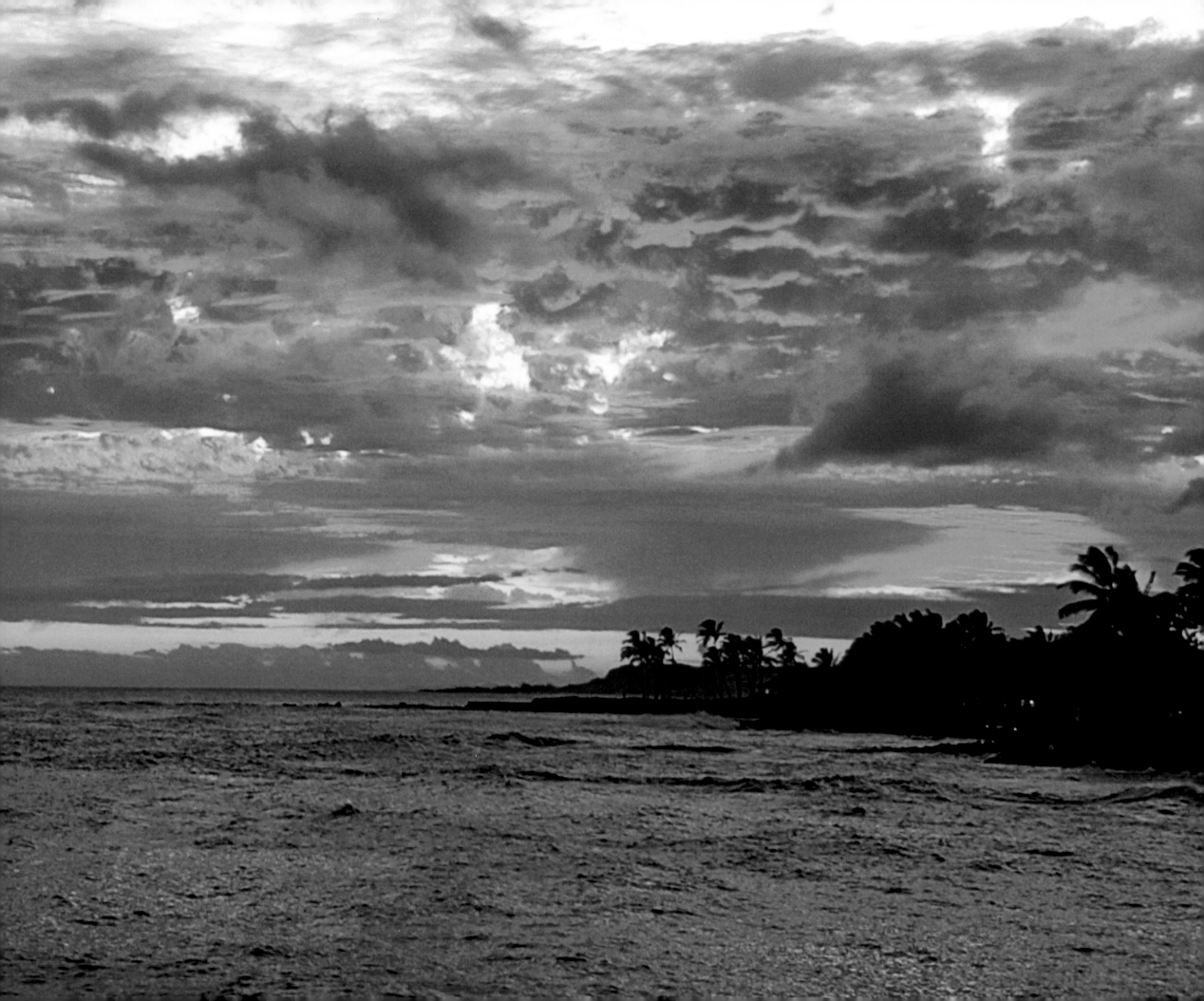

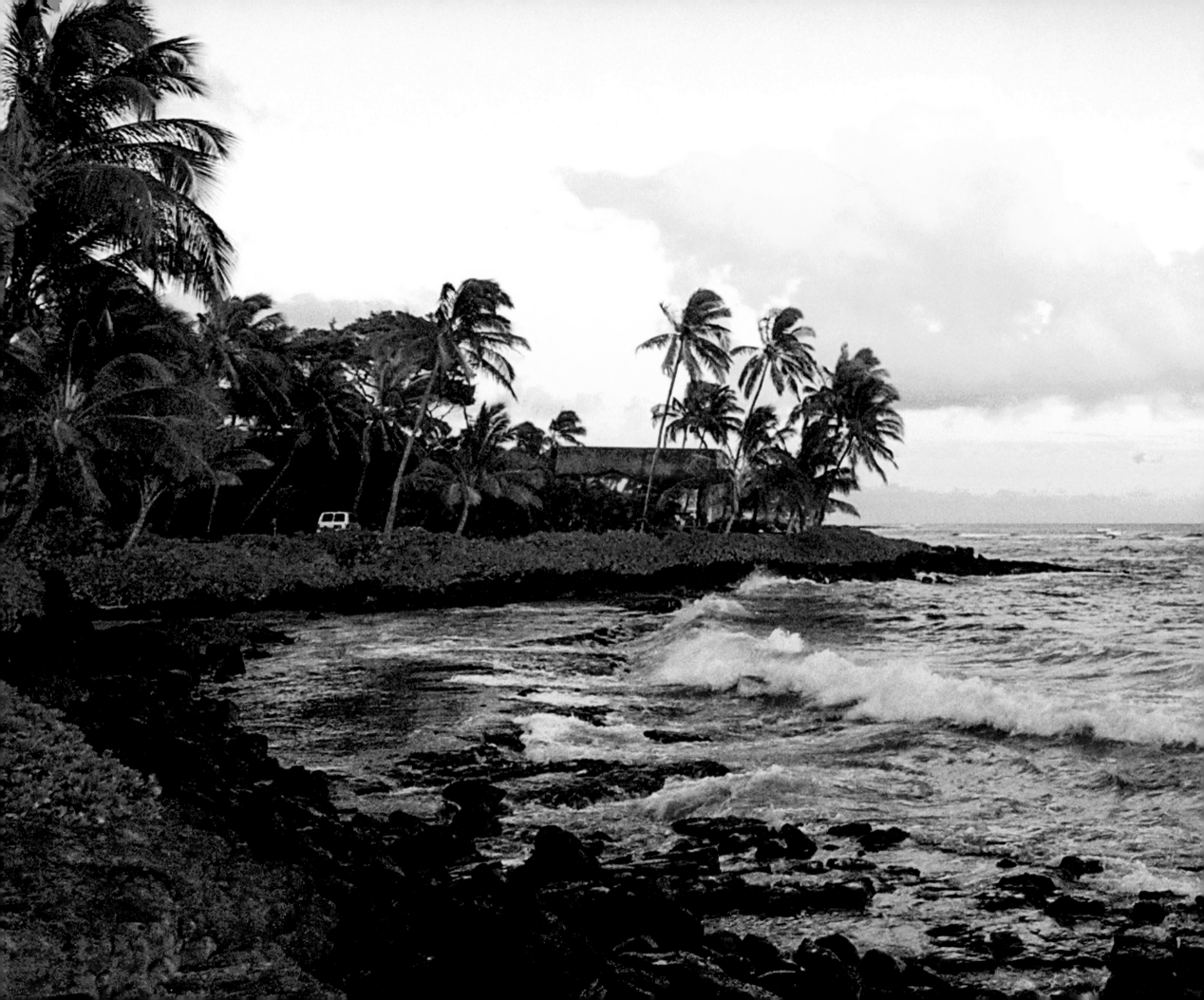

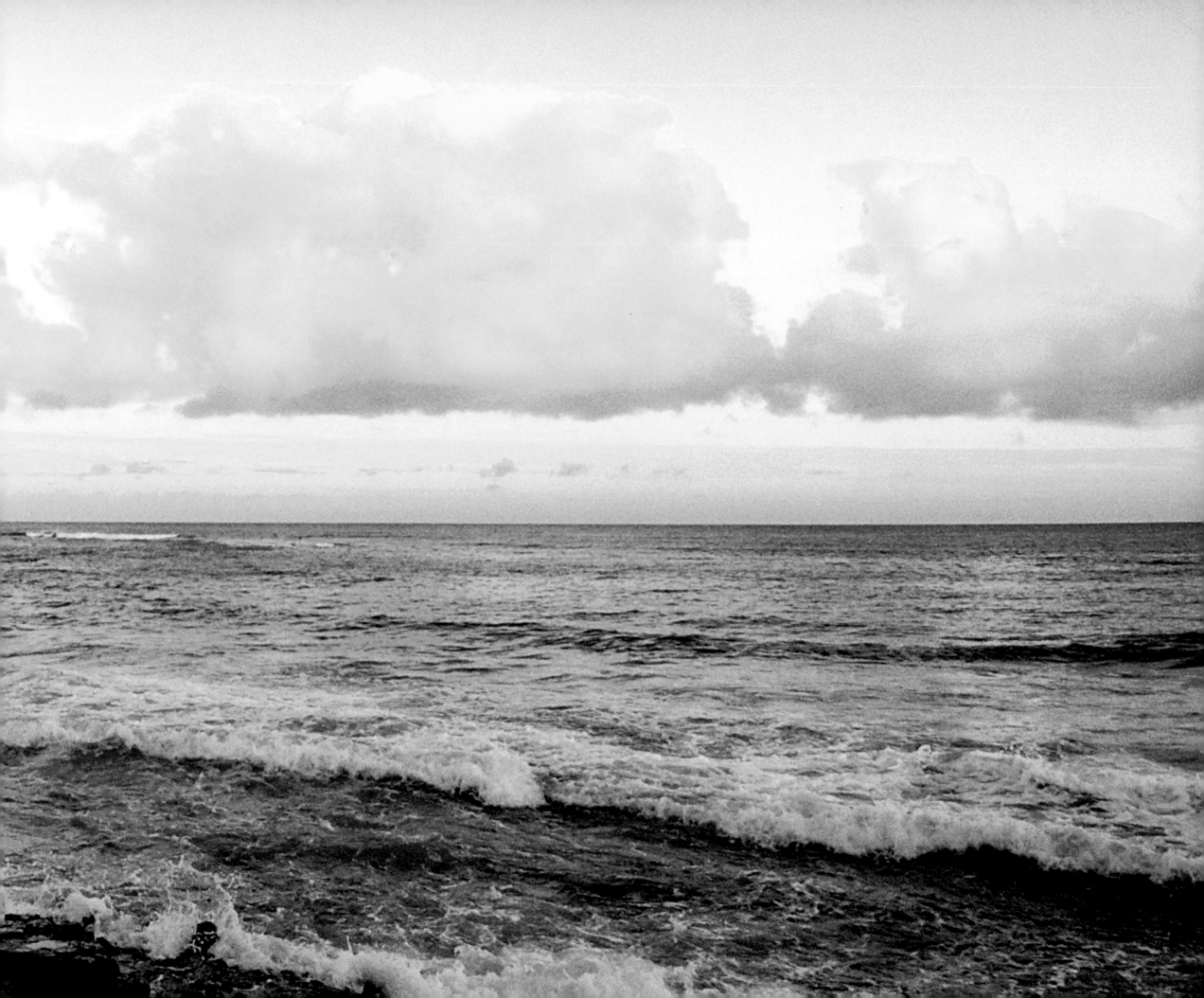

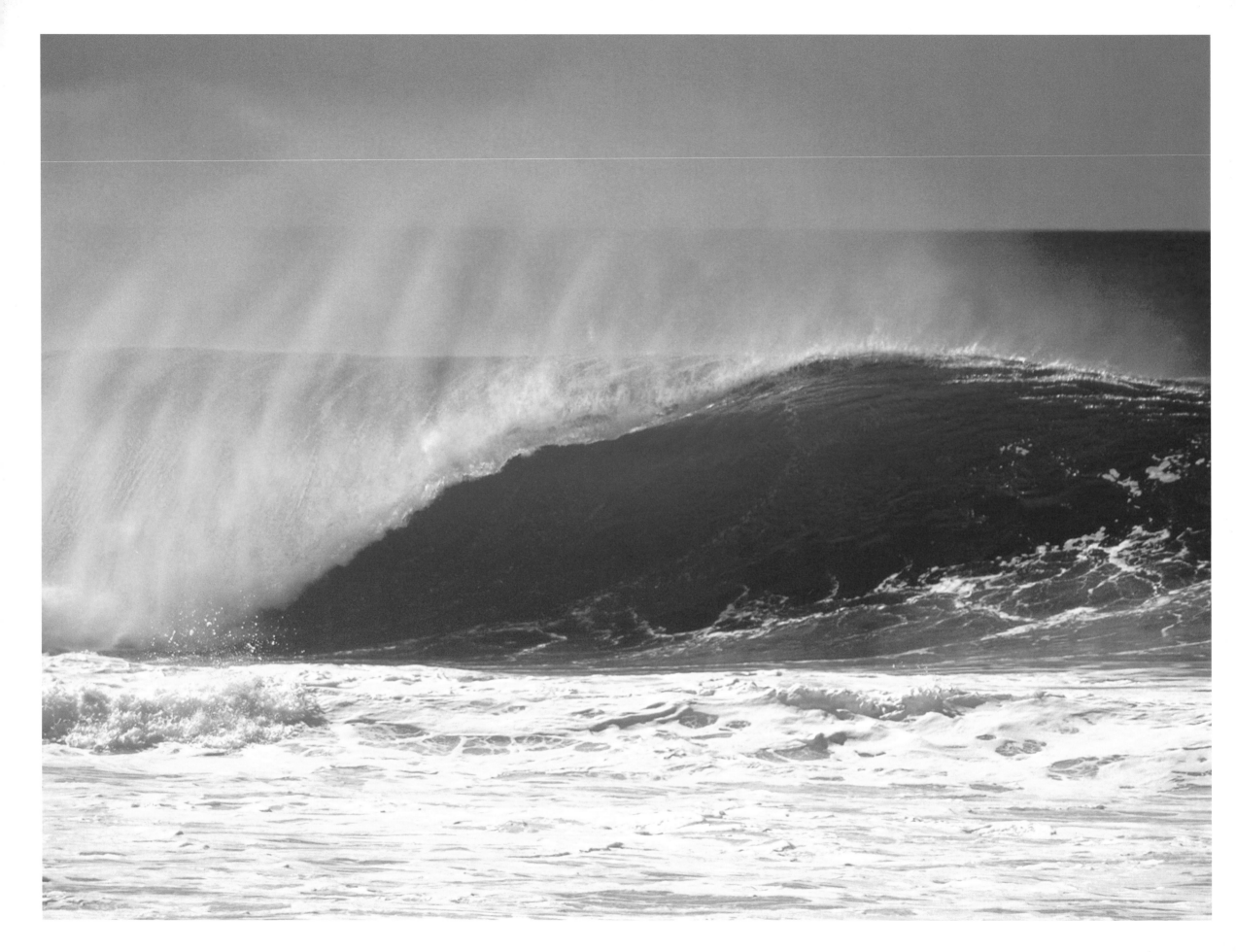

Pipeline, Oahu

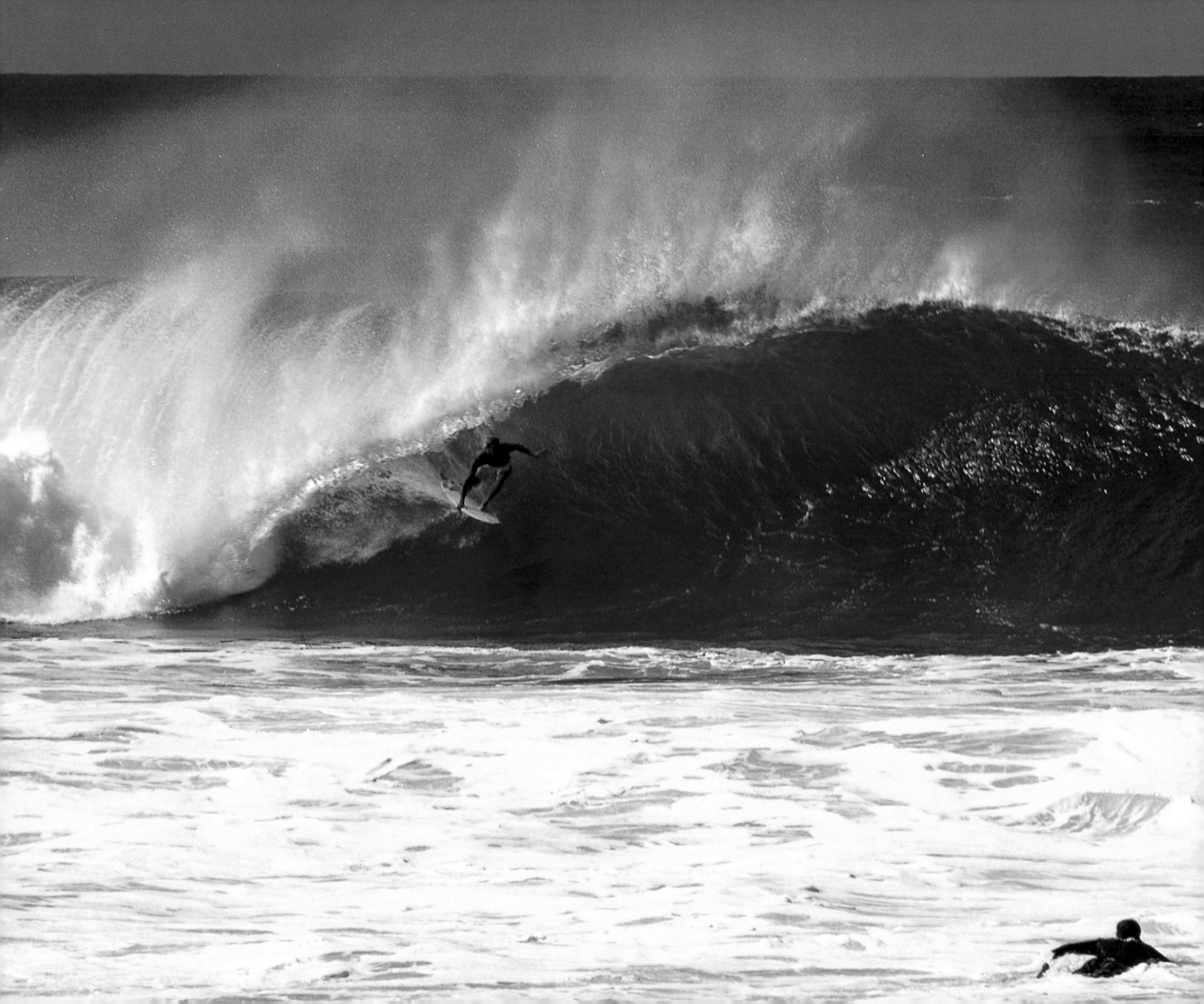

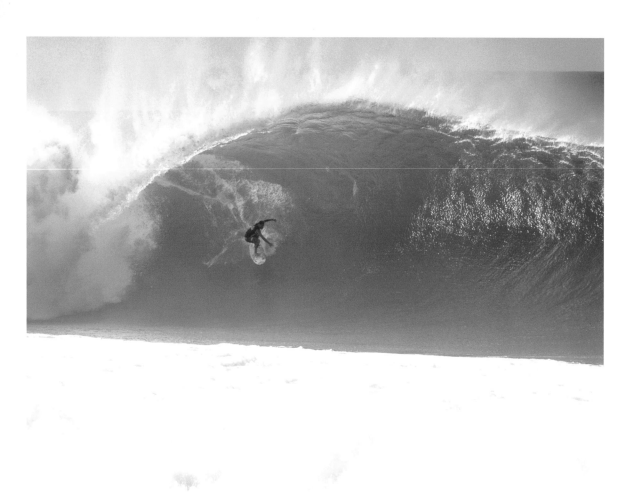
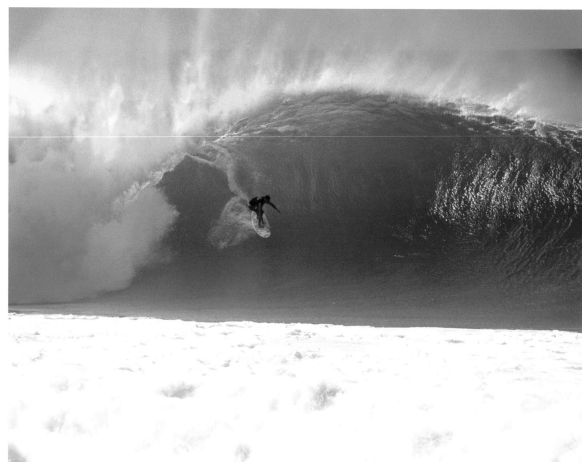
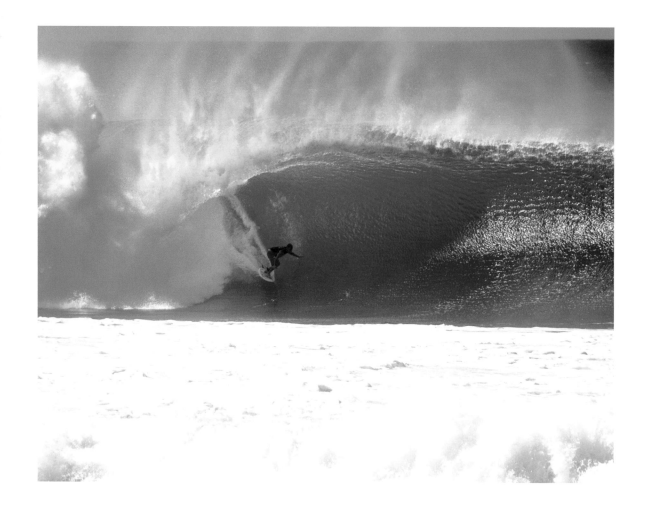
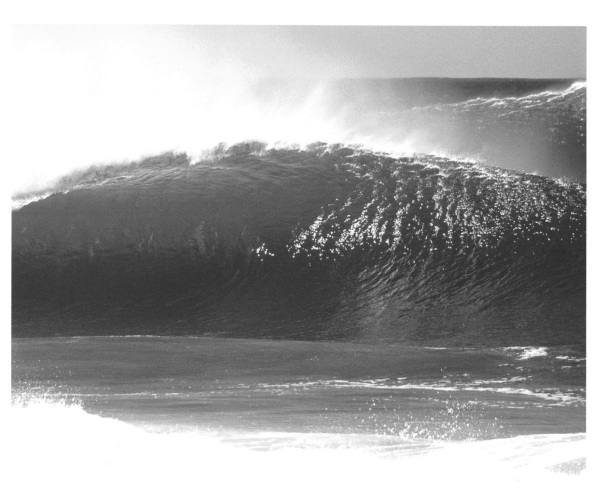

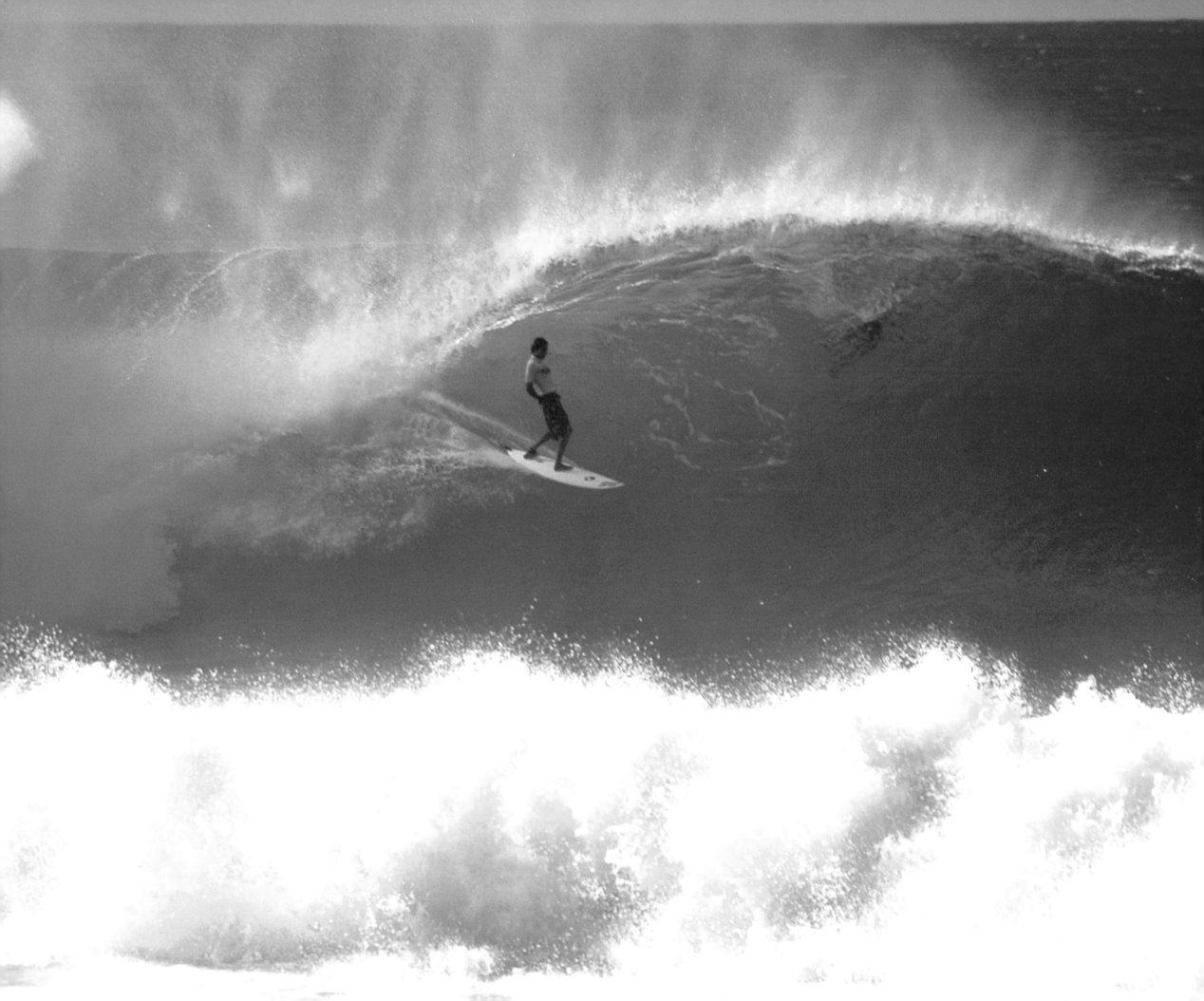

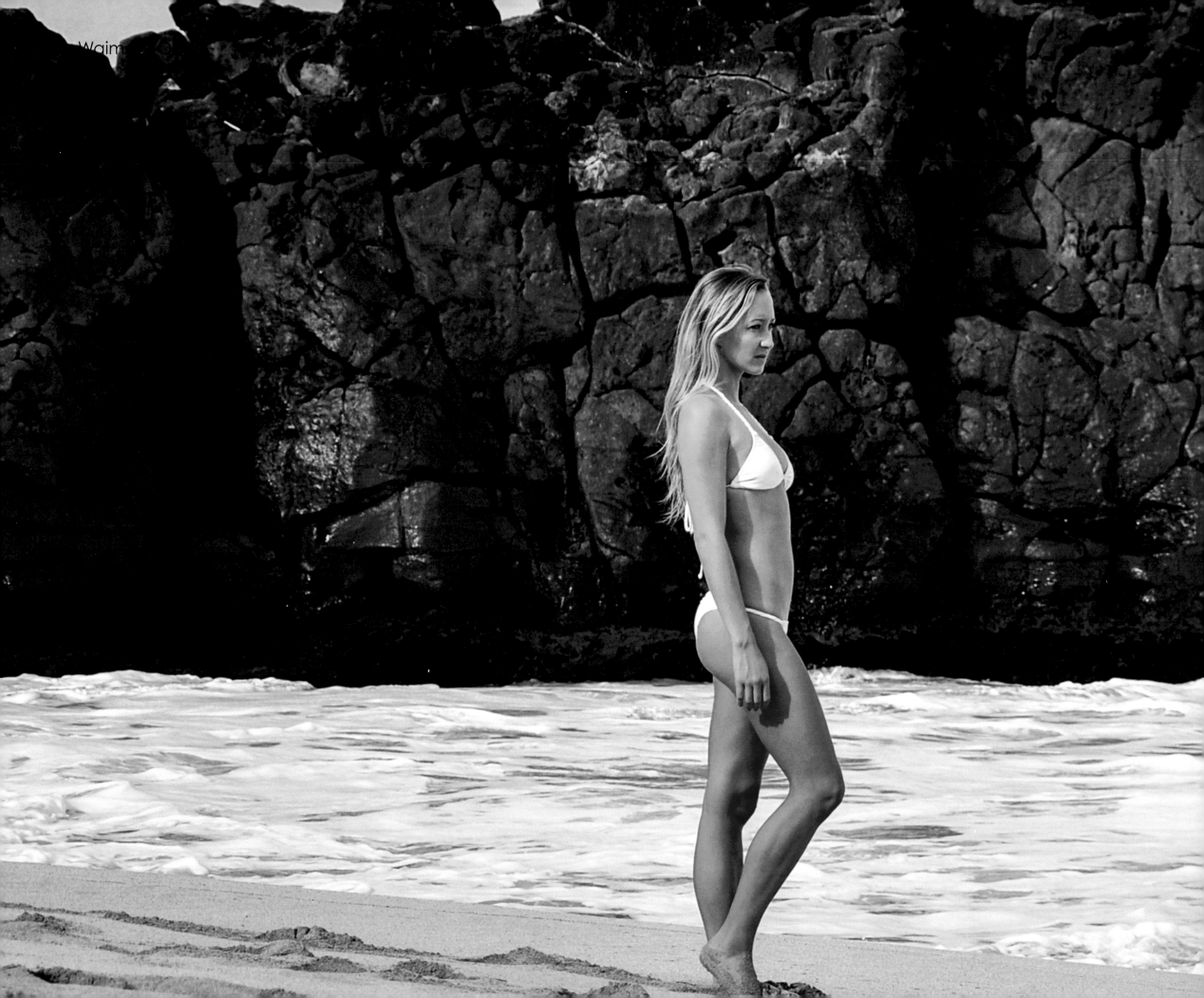

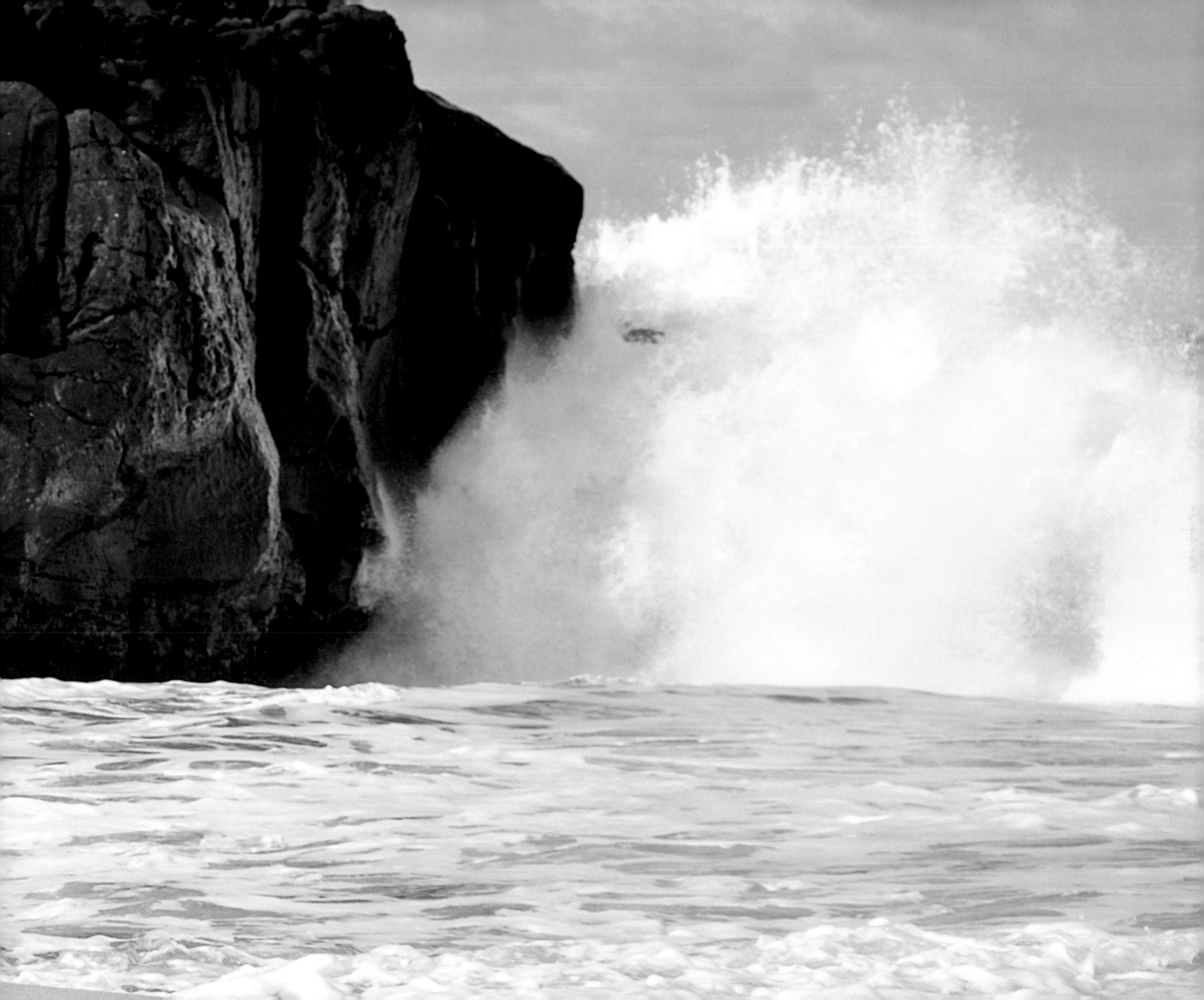

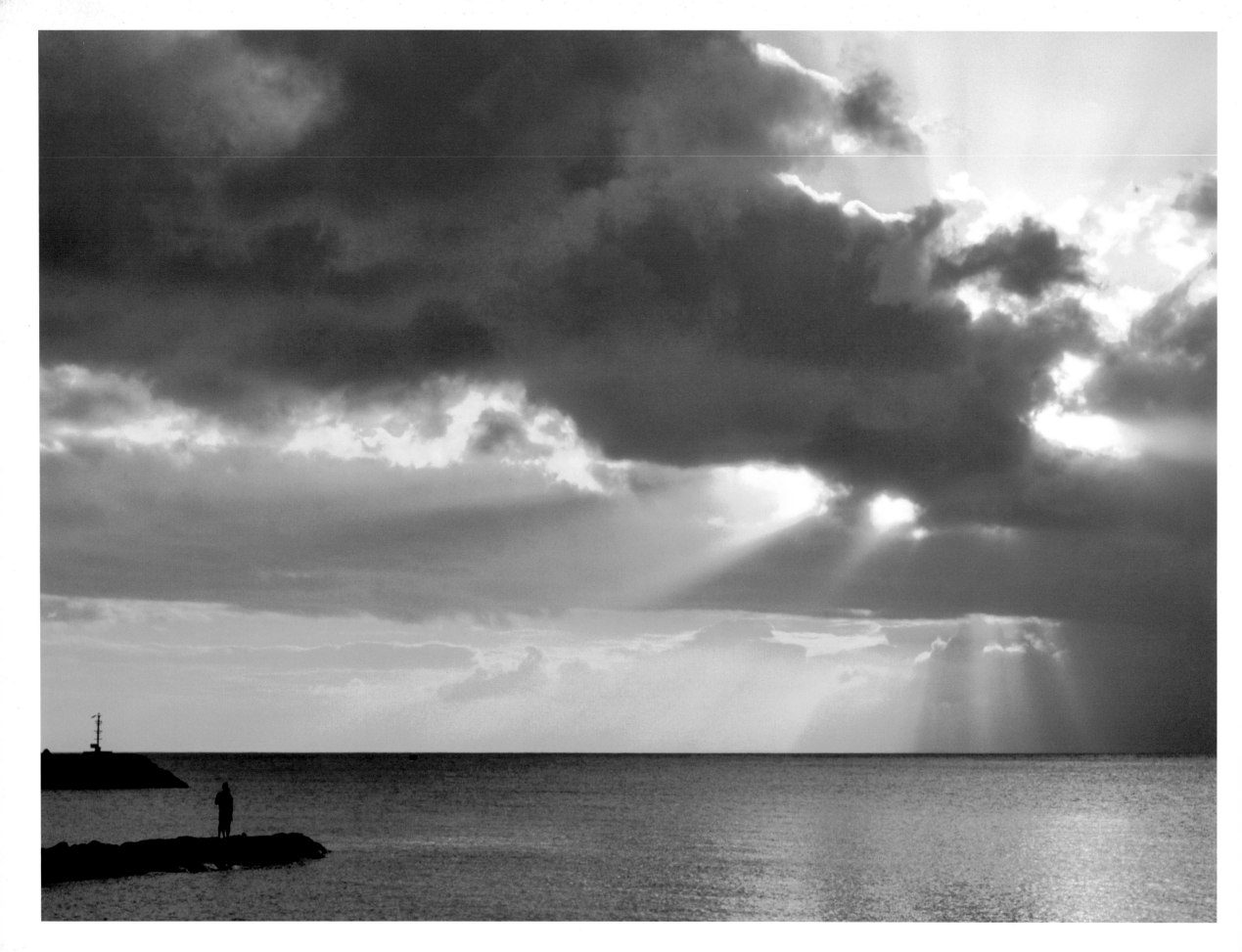

Haliewa, Oahu

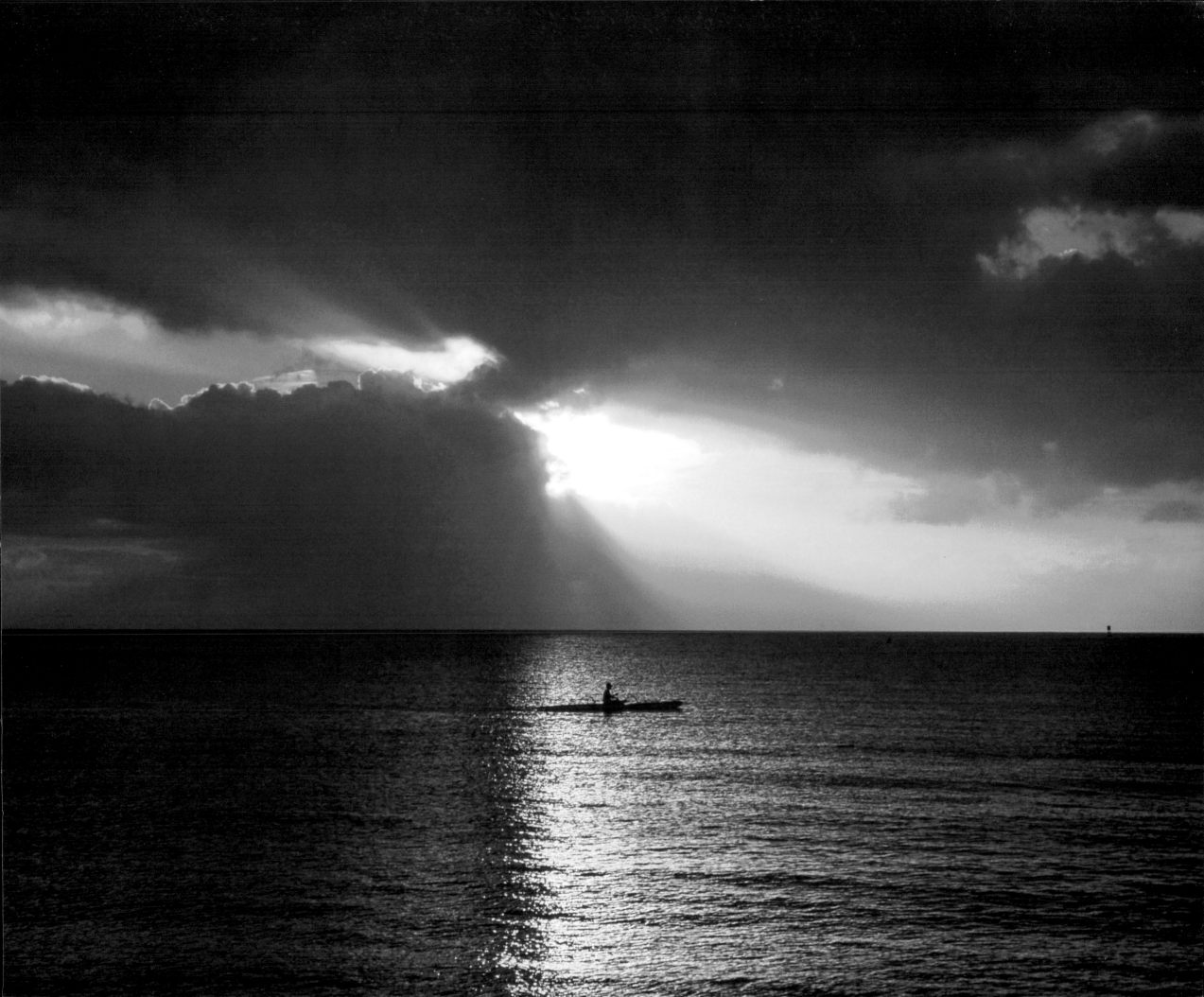

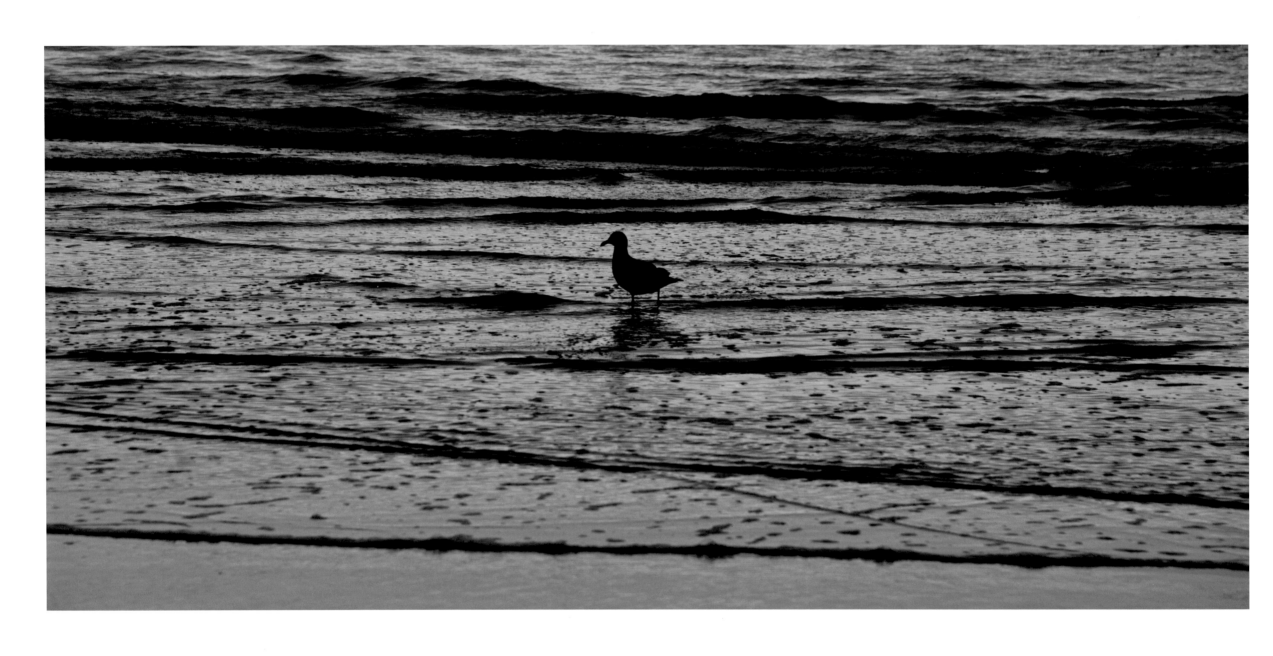

Cannon Beach, Oregon

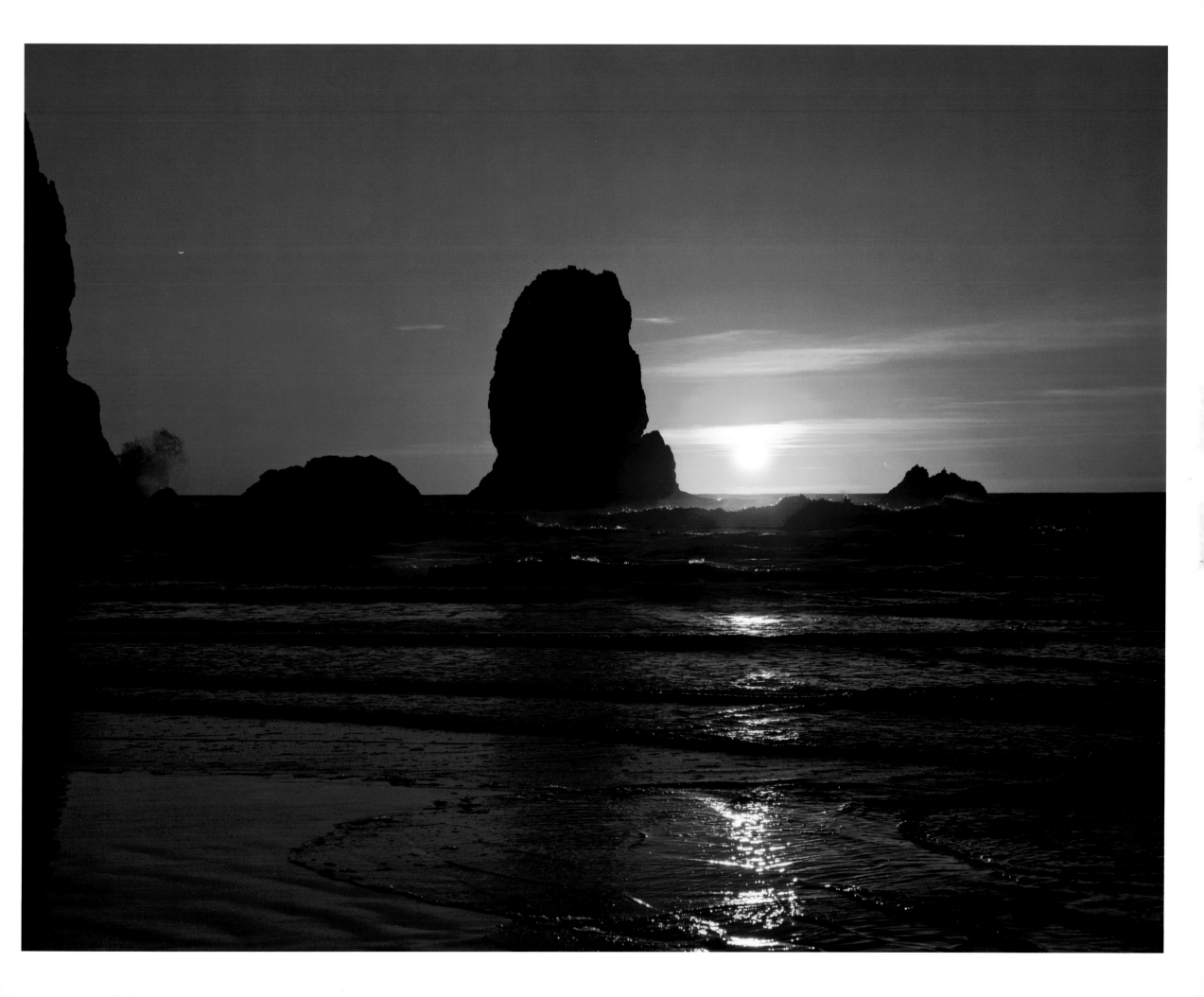

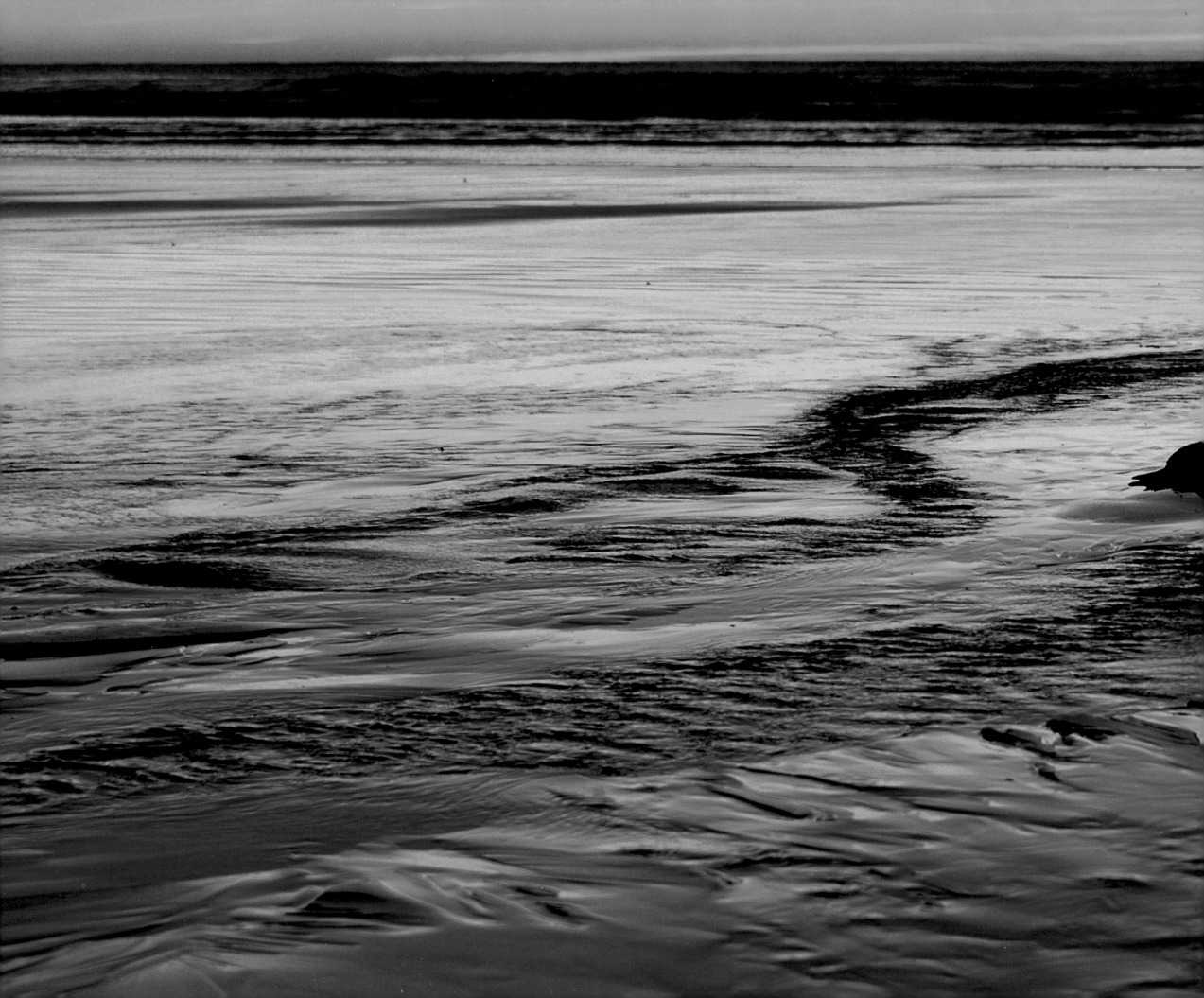

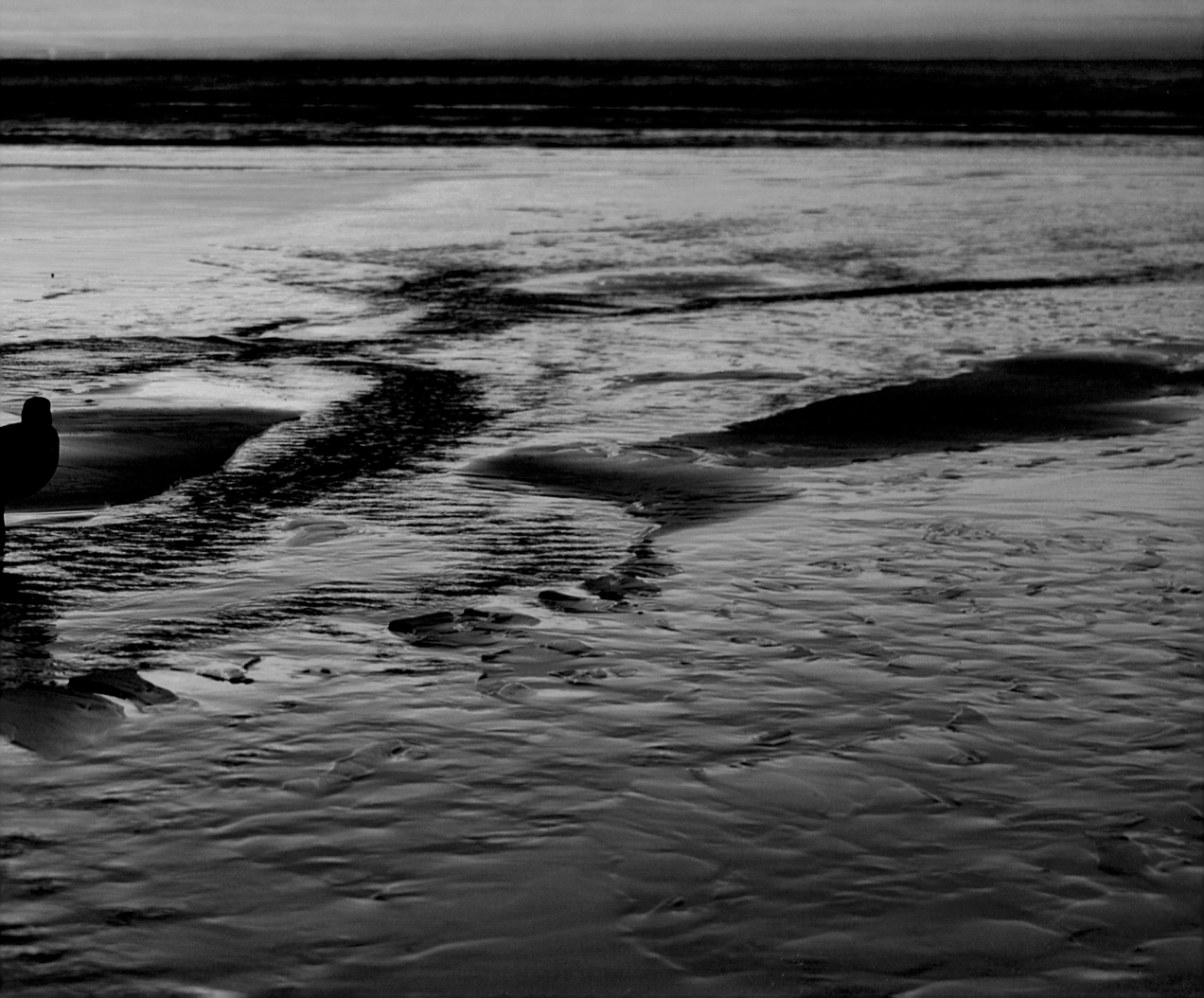

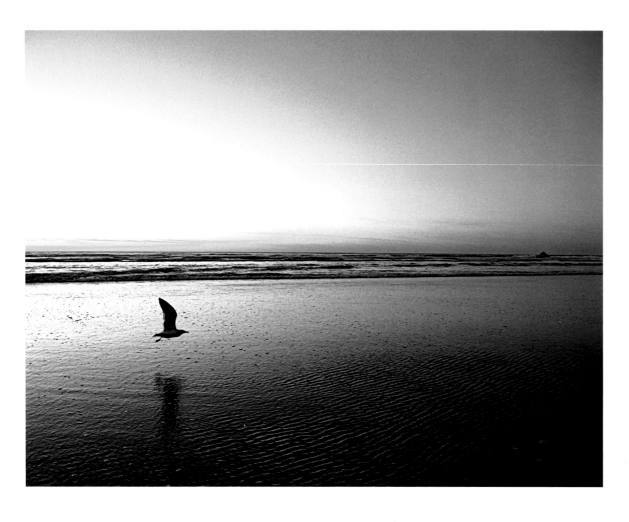

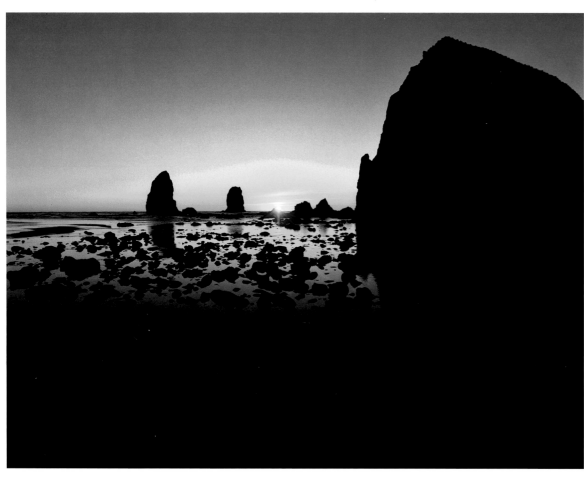

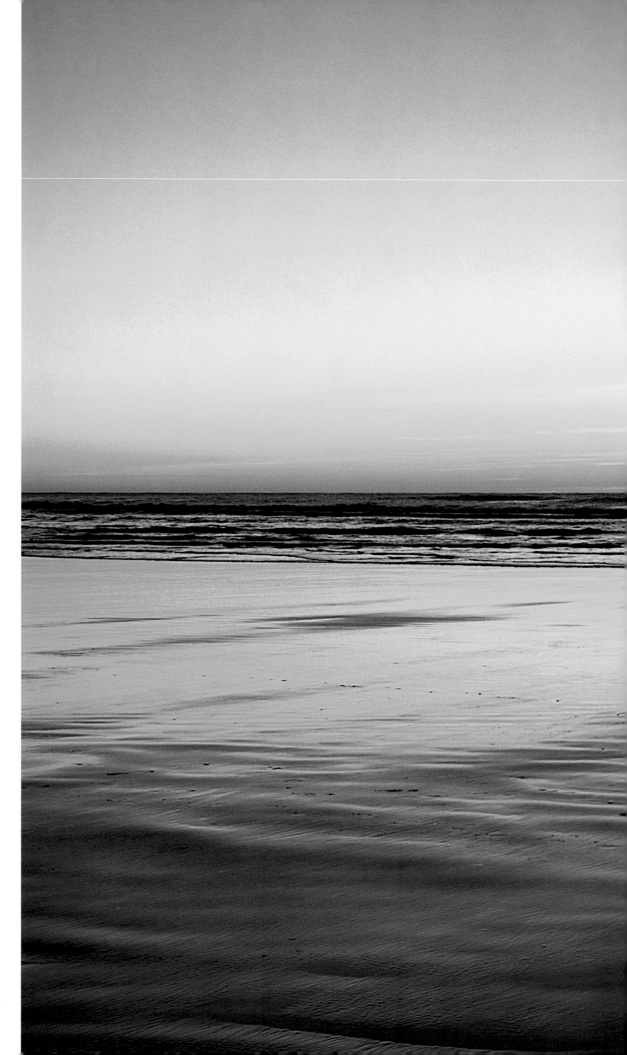

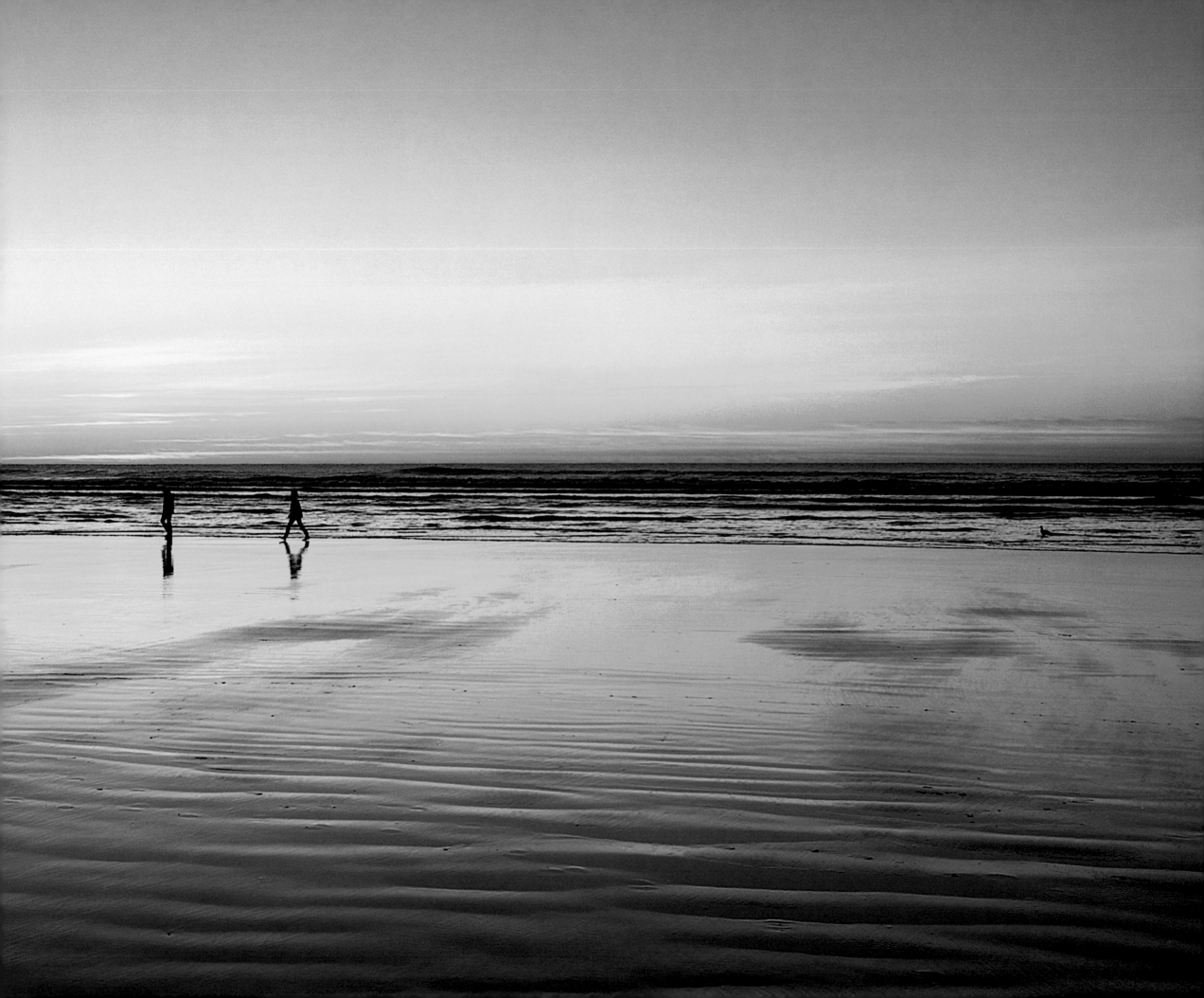

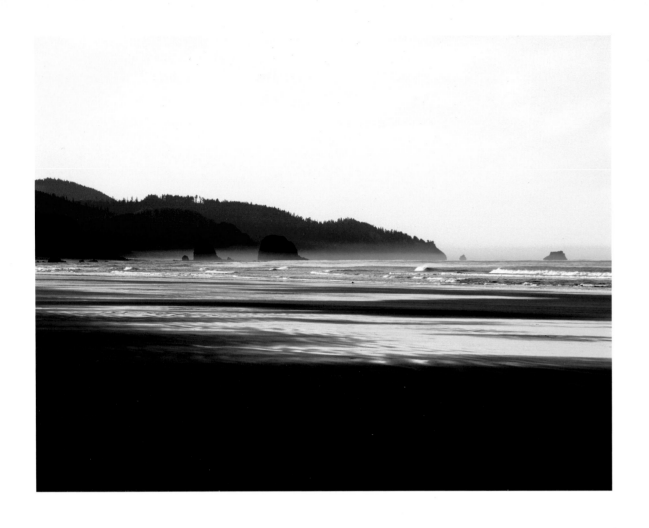
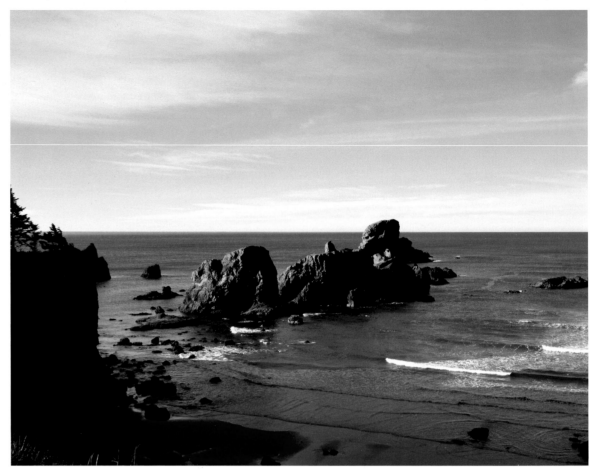
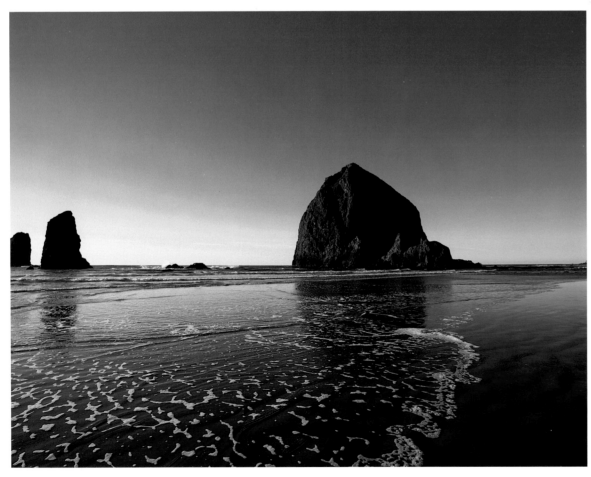
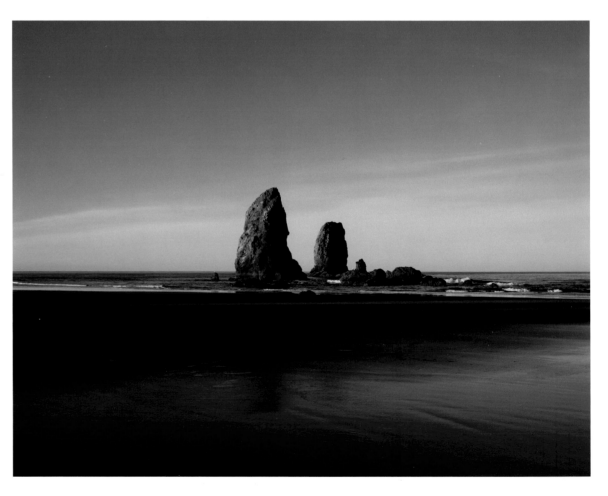

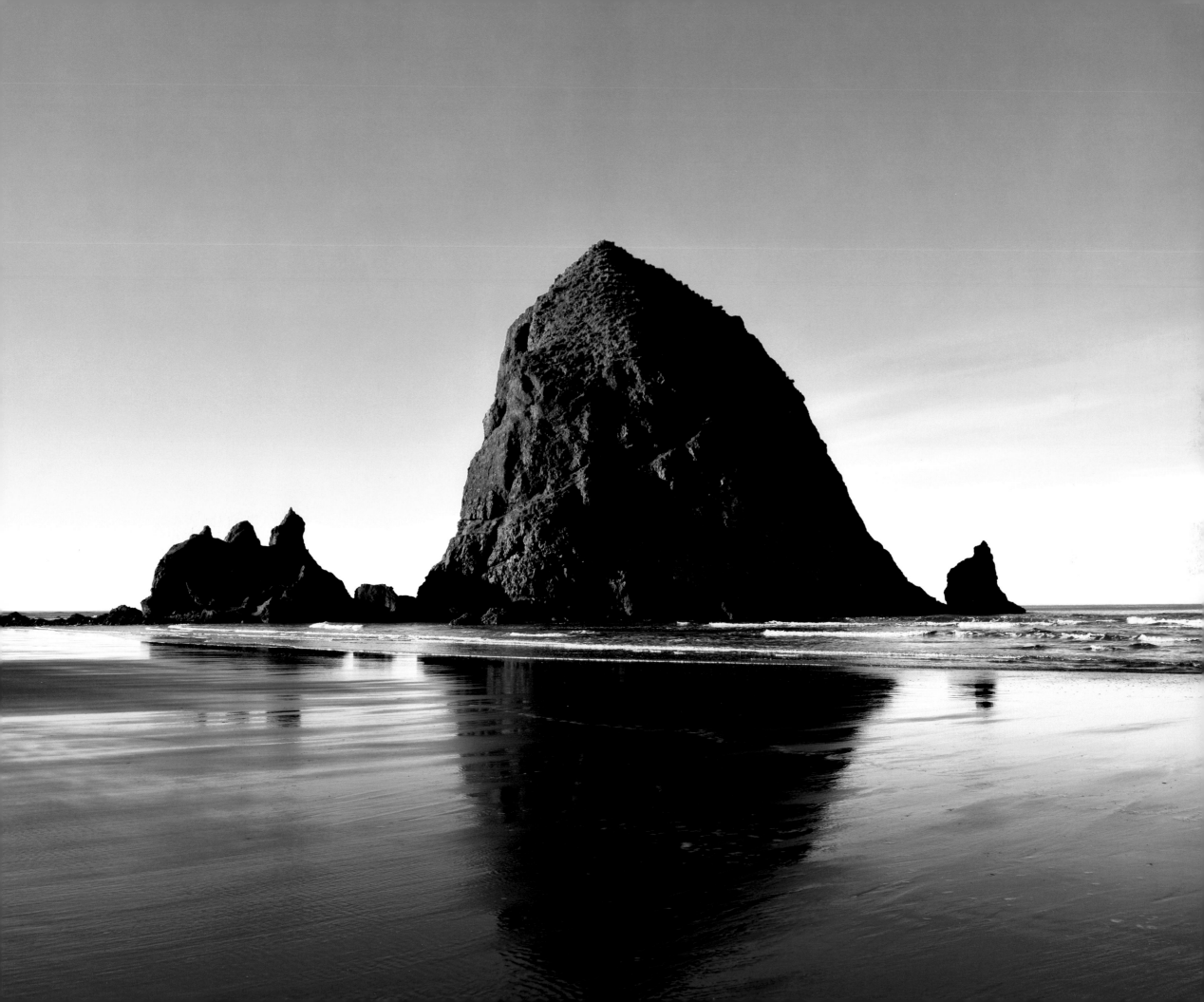

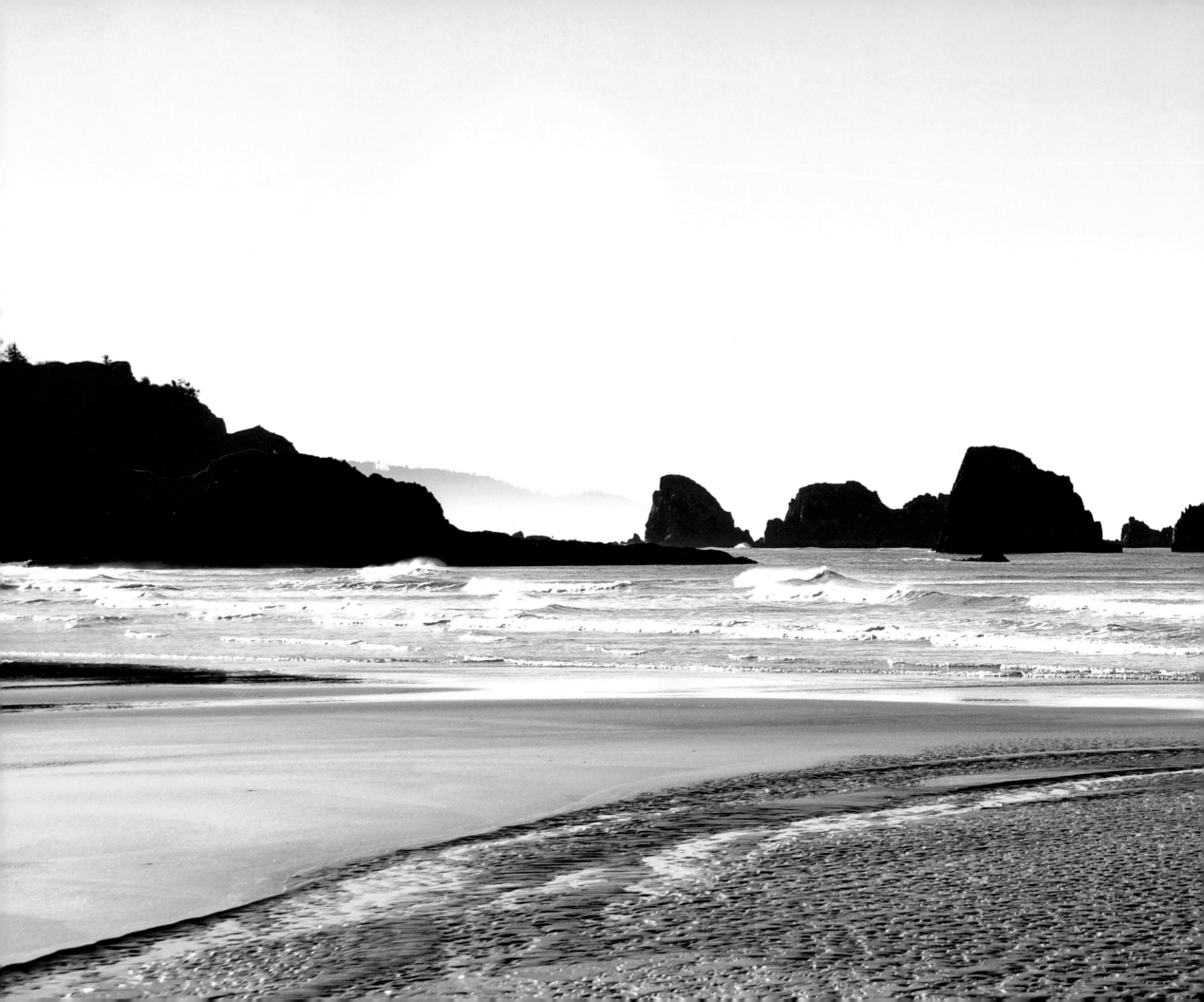

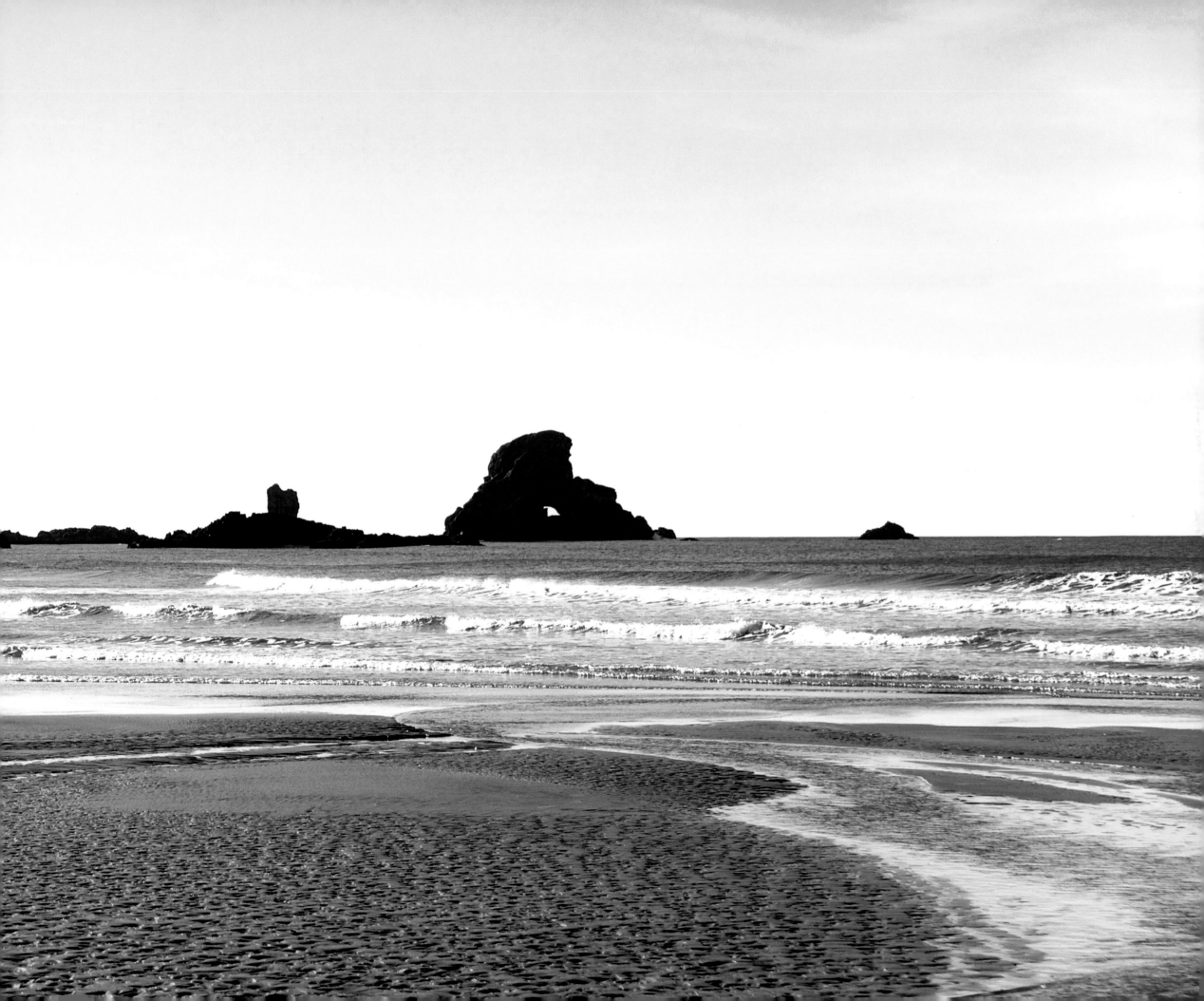

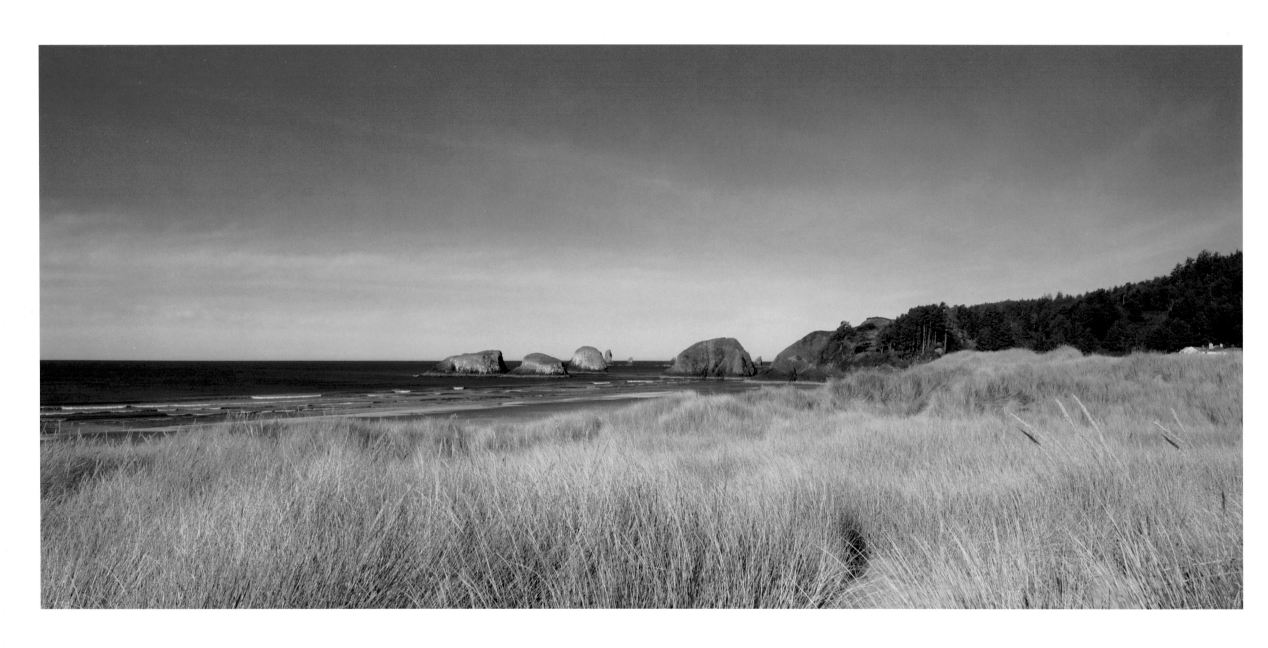

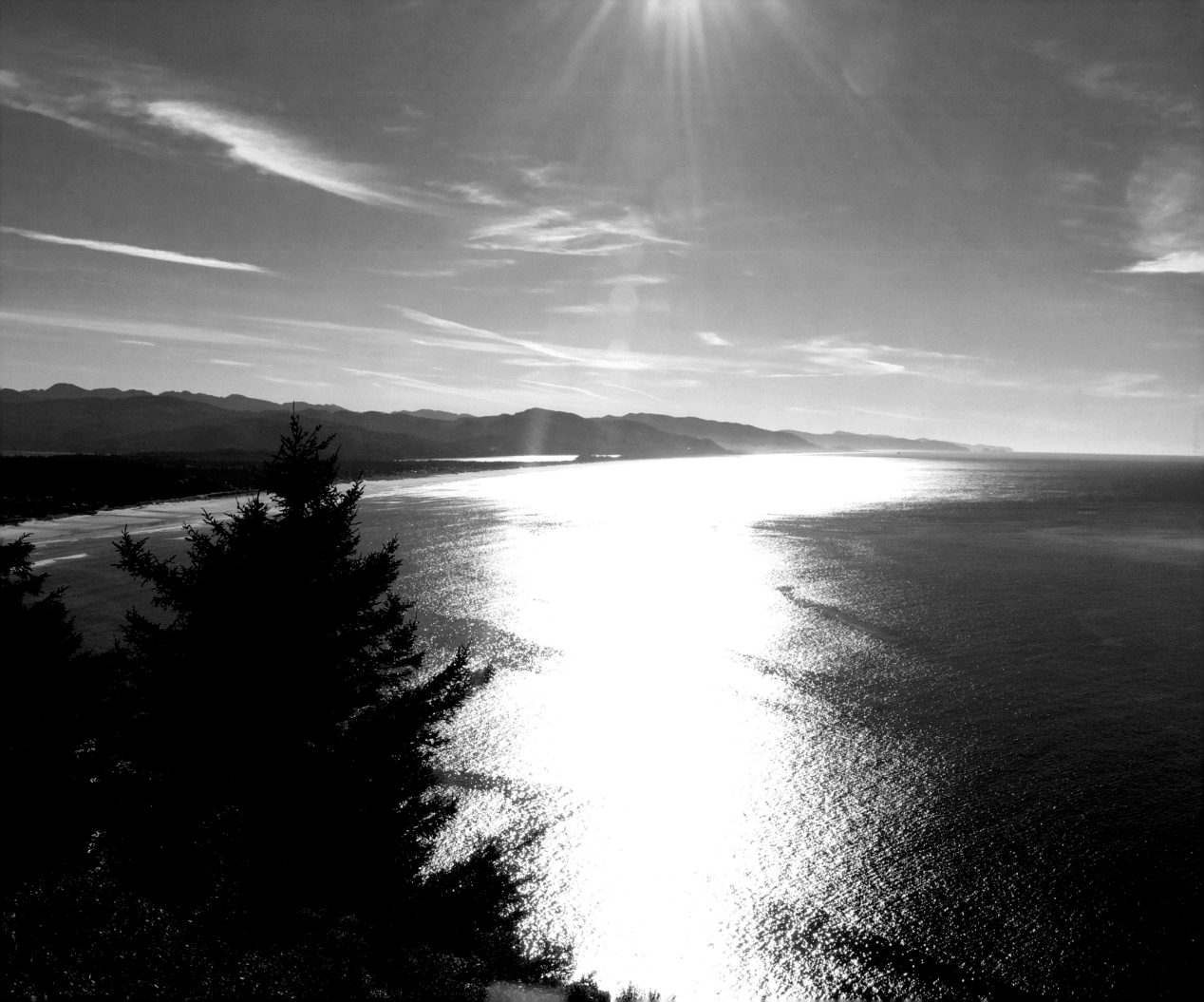

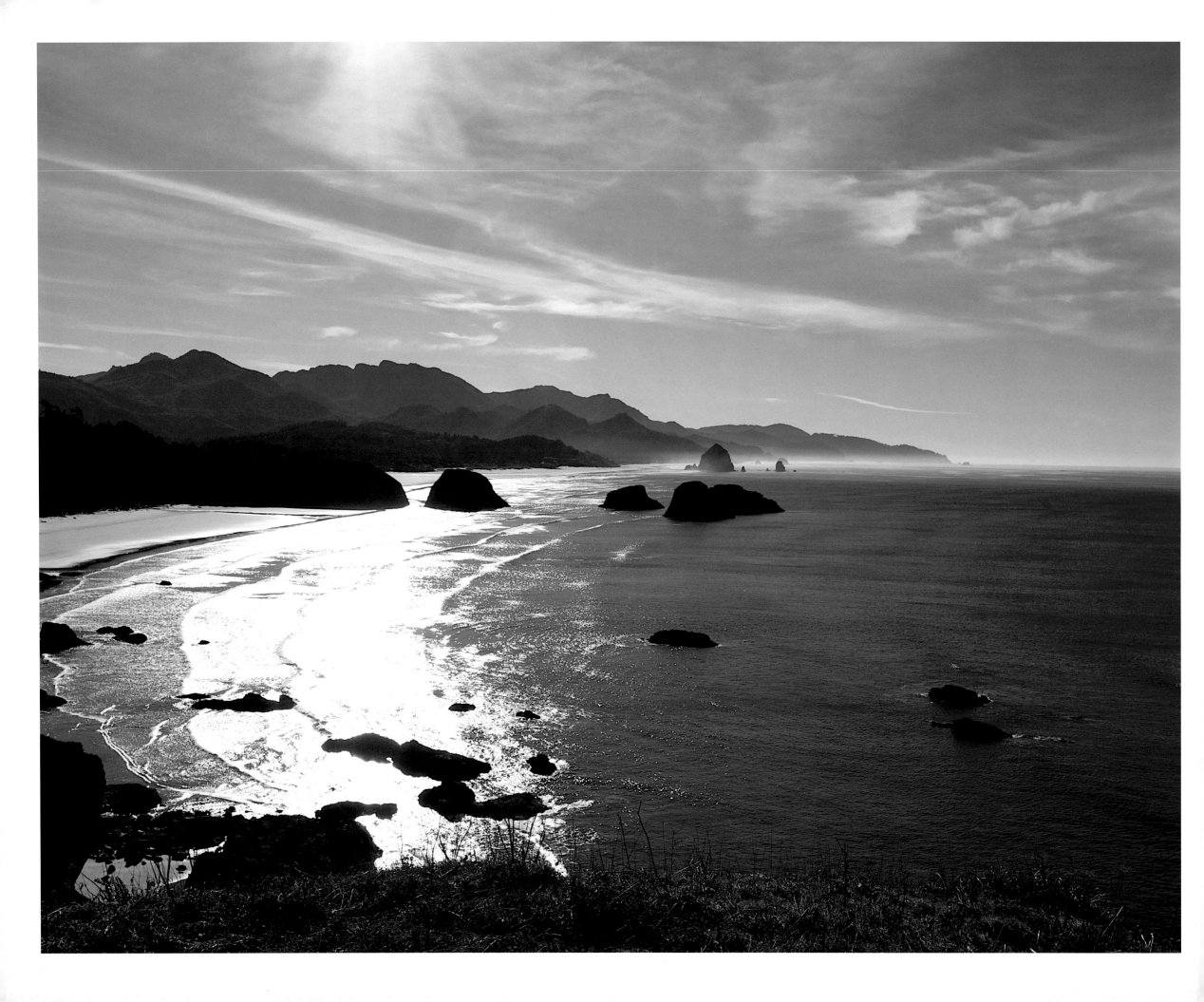

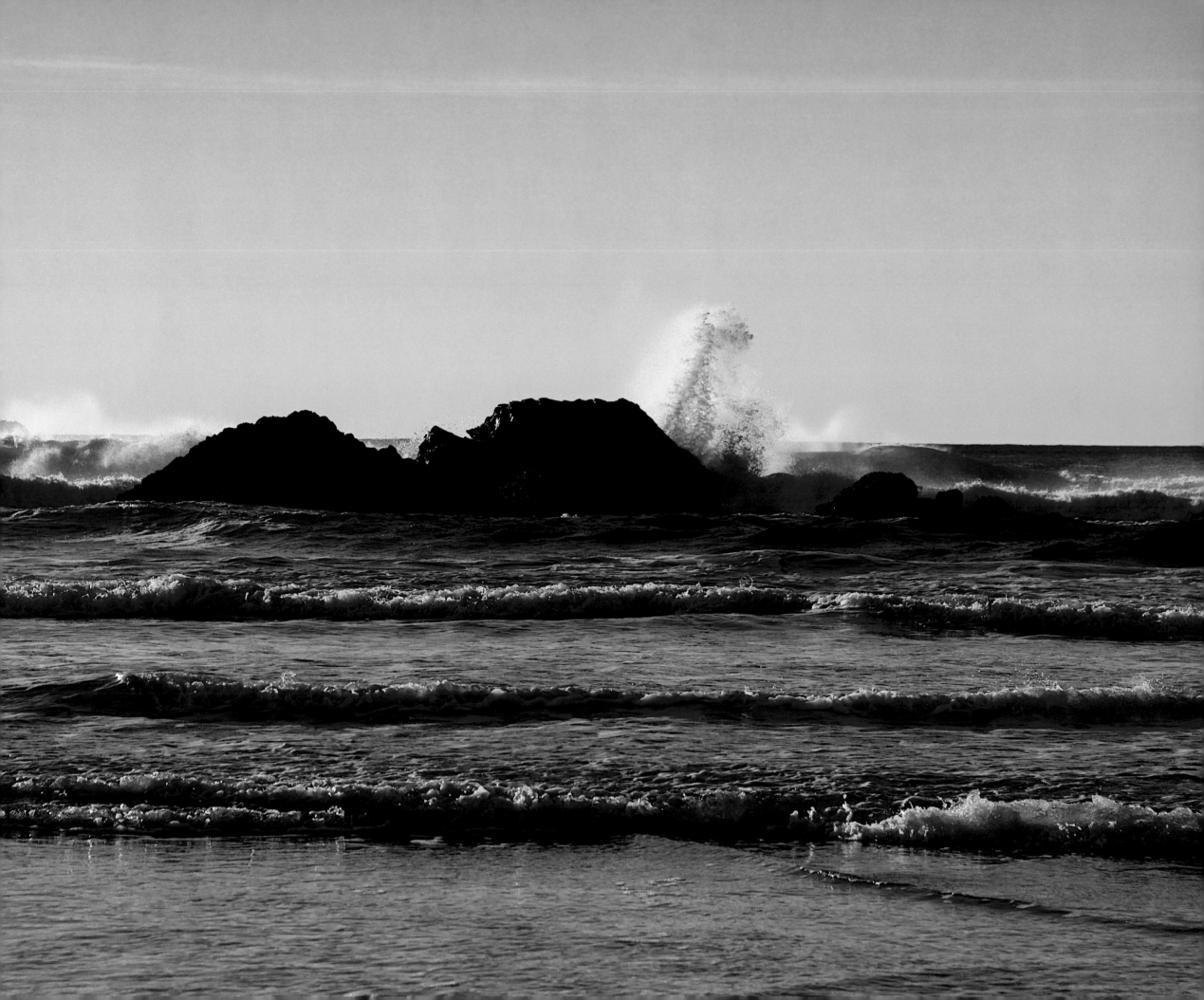

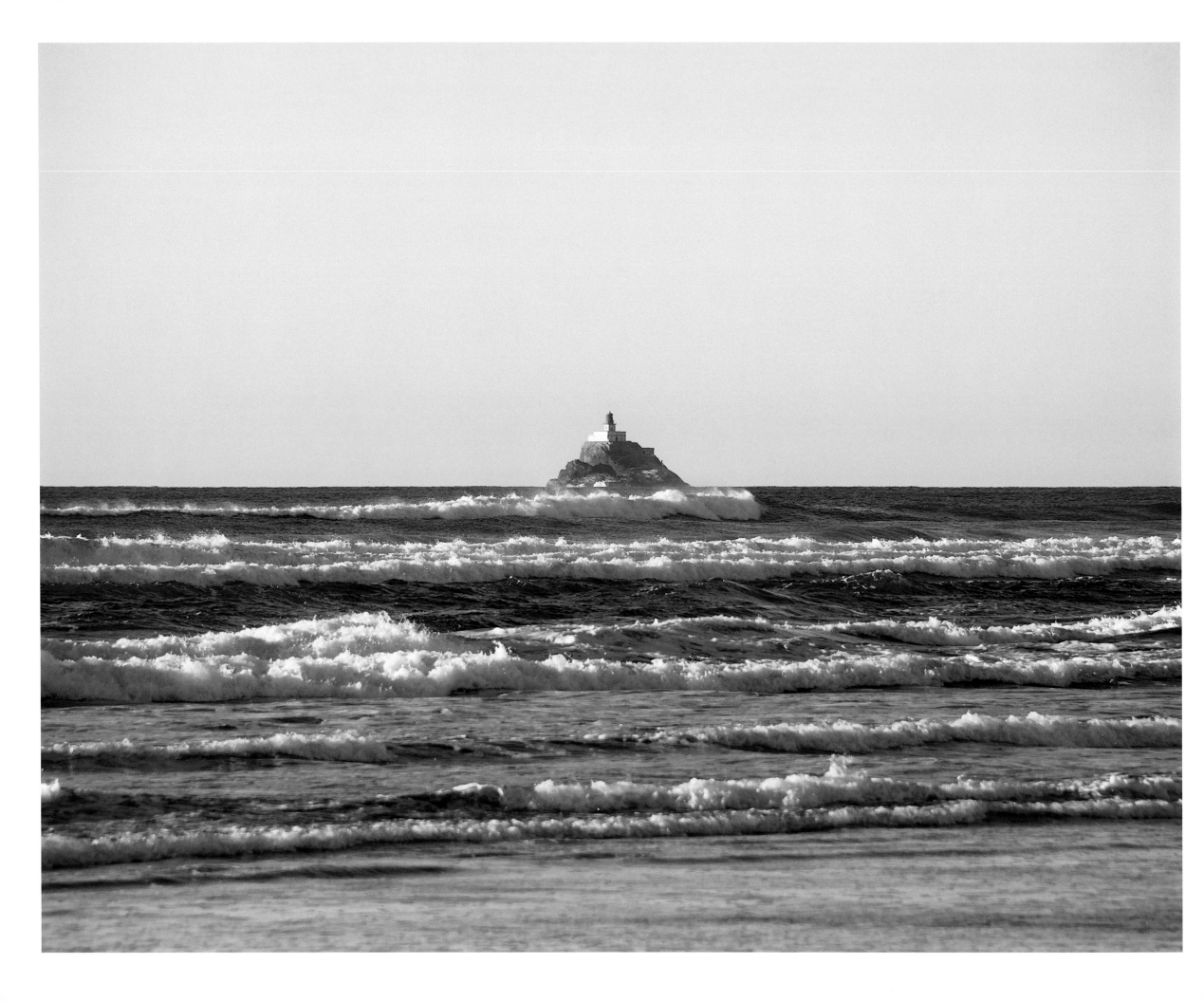

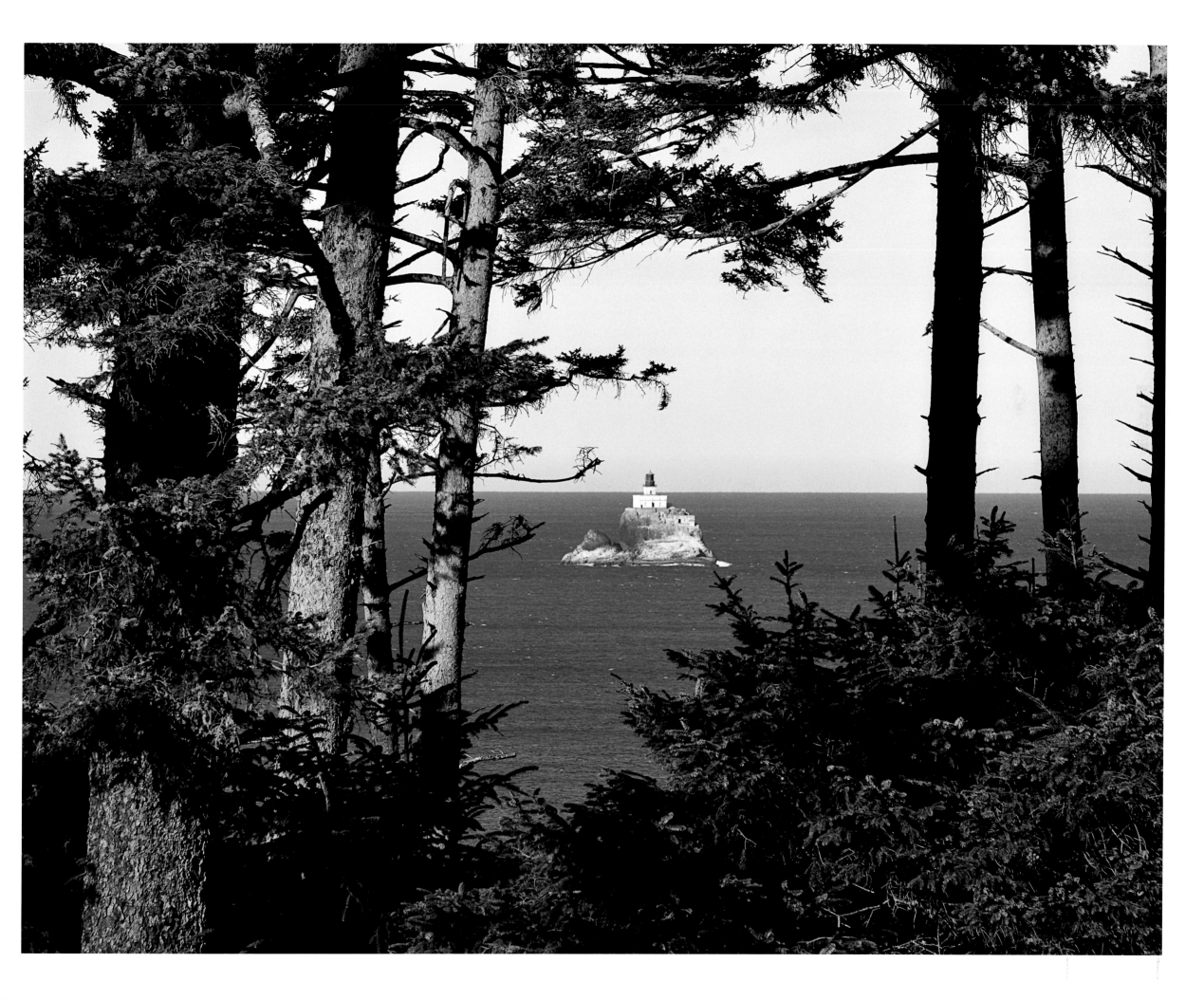

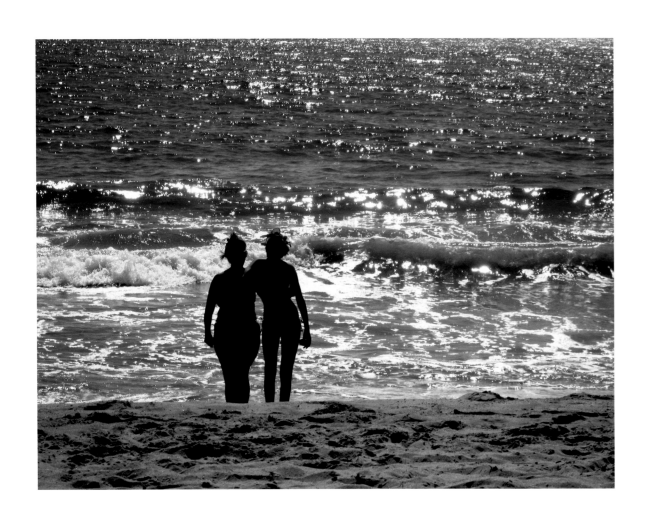
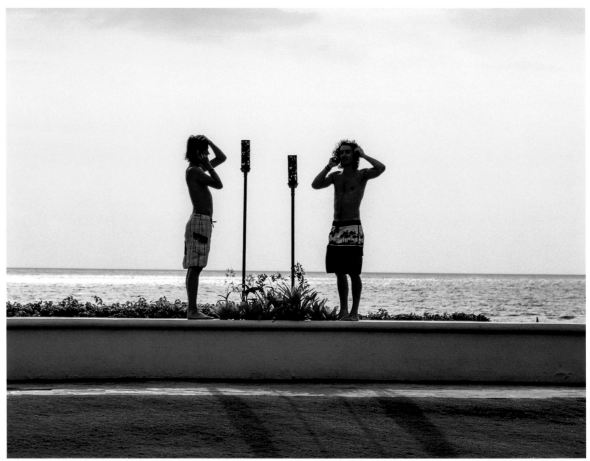

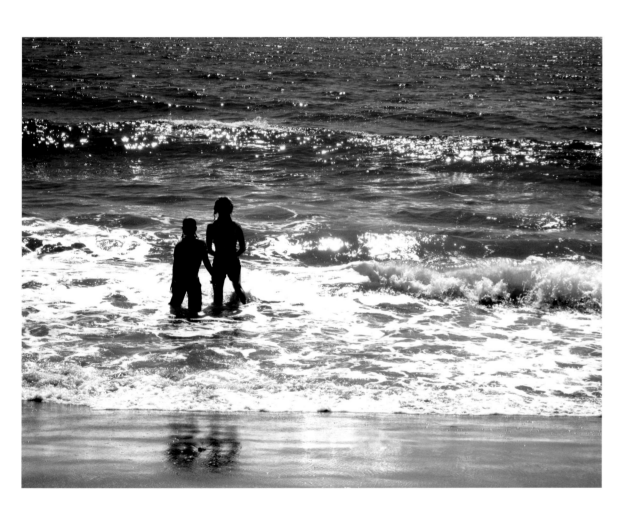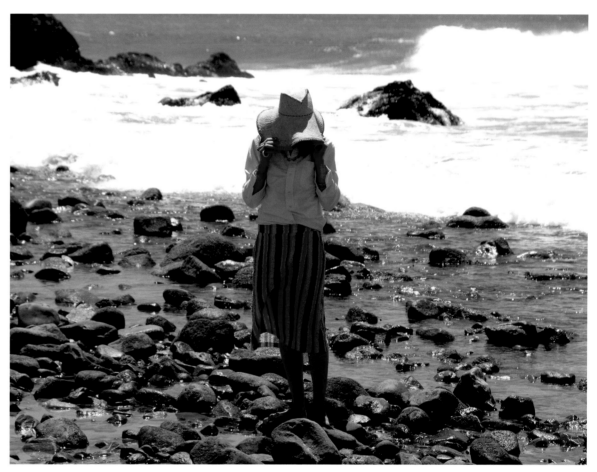

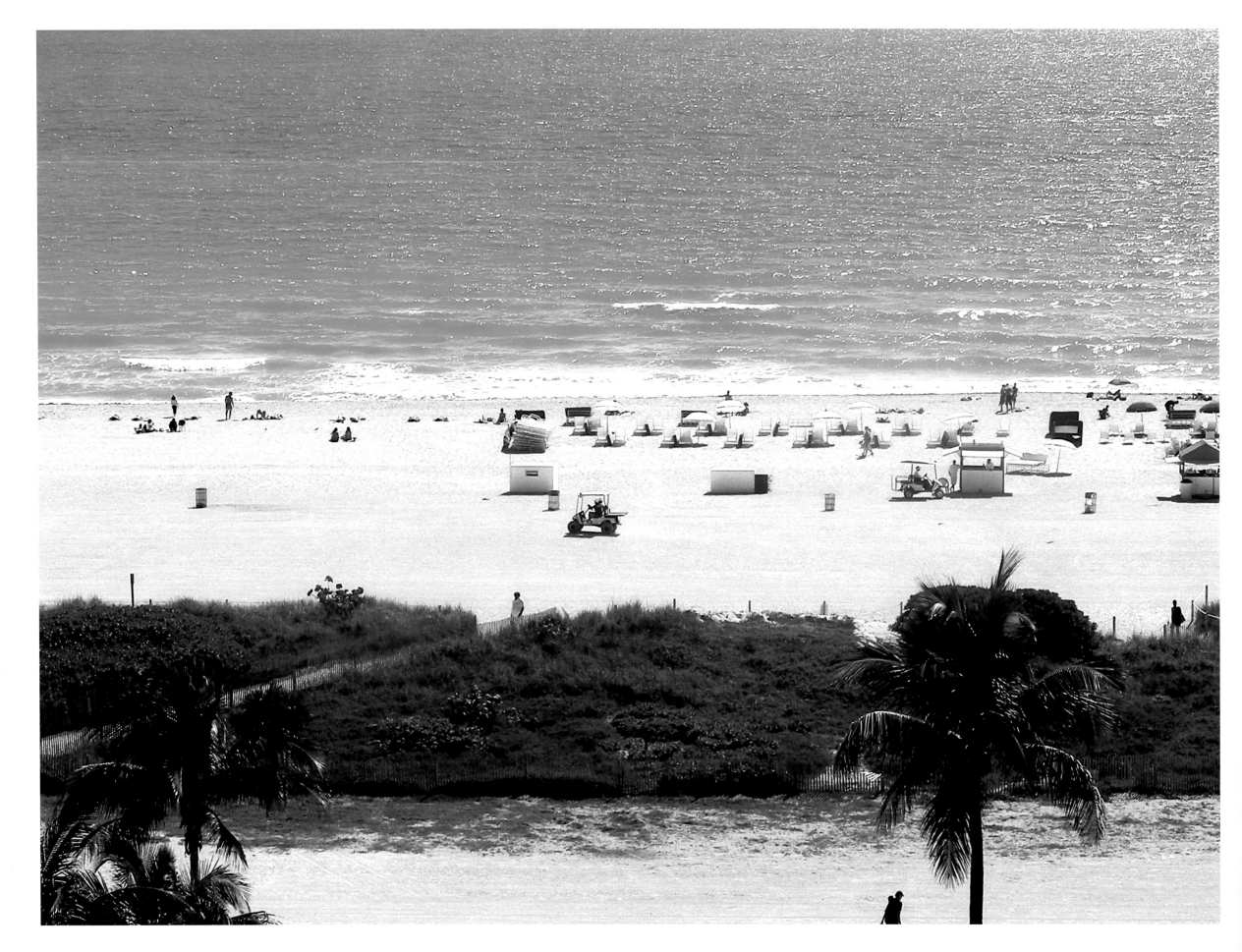

South Beach, Miami, Florida

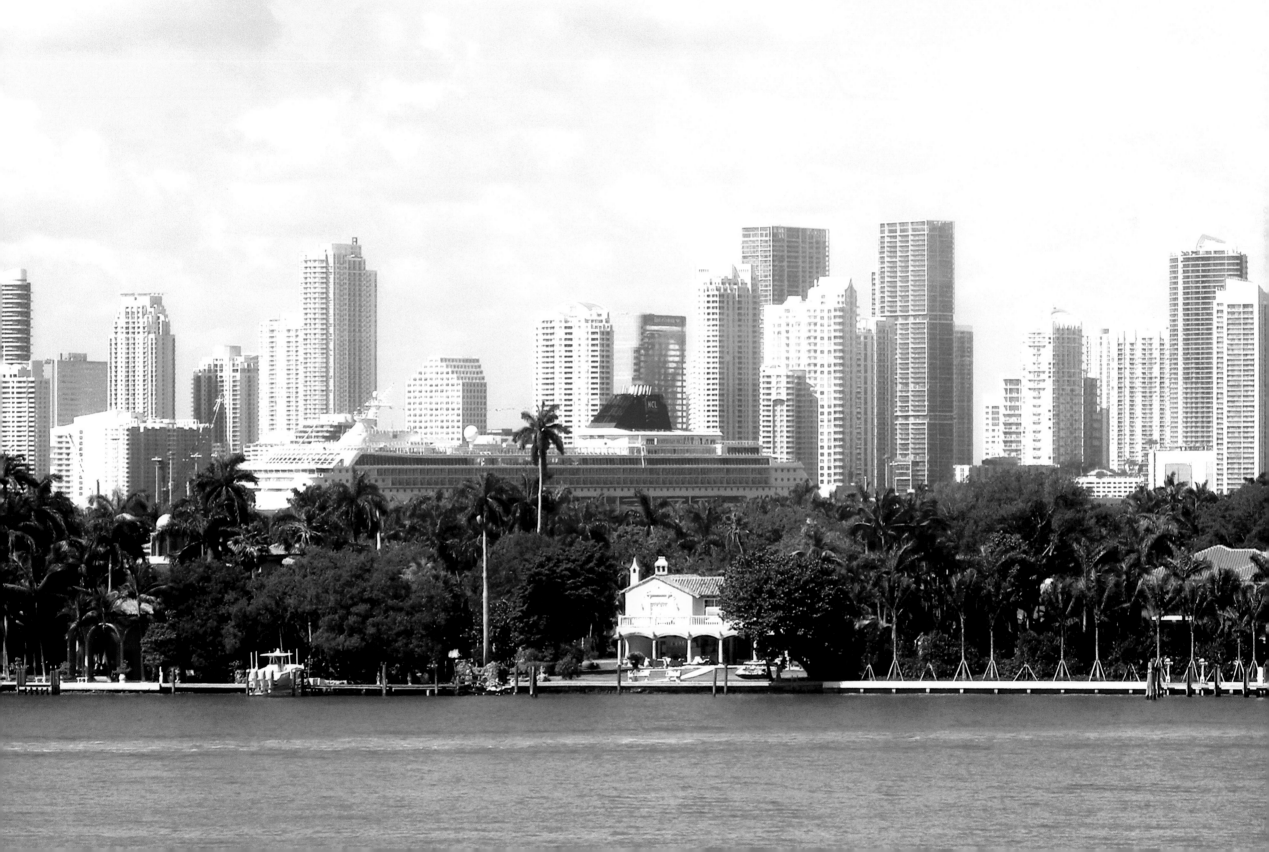

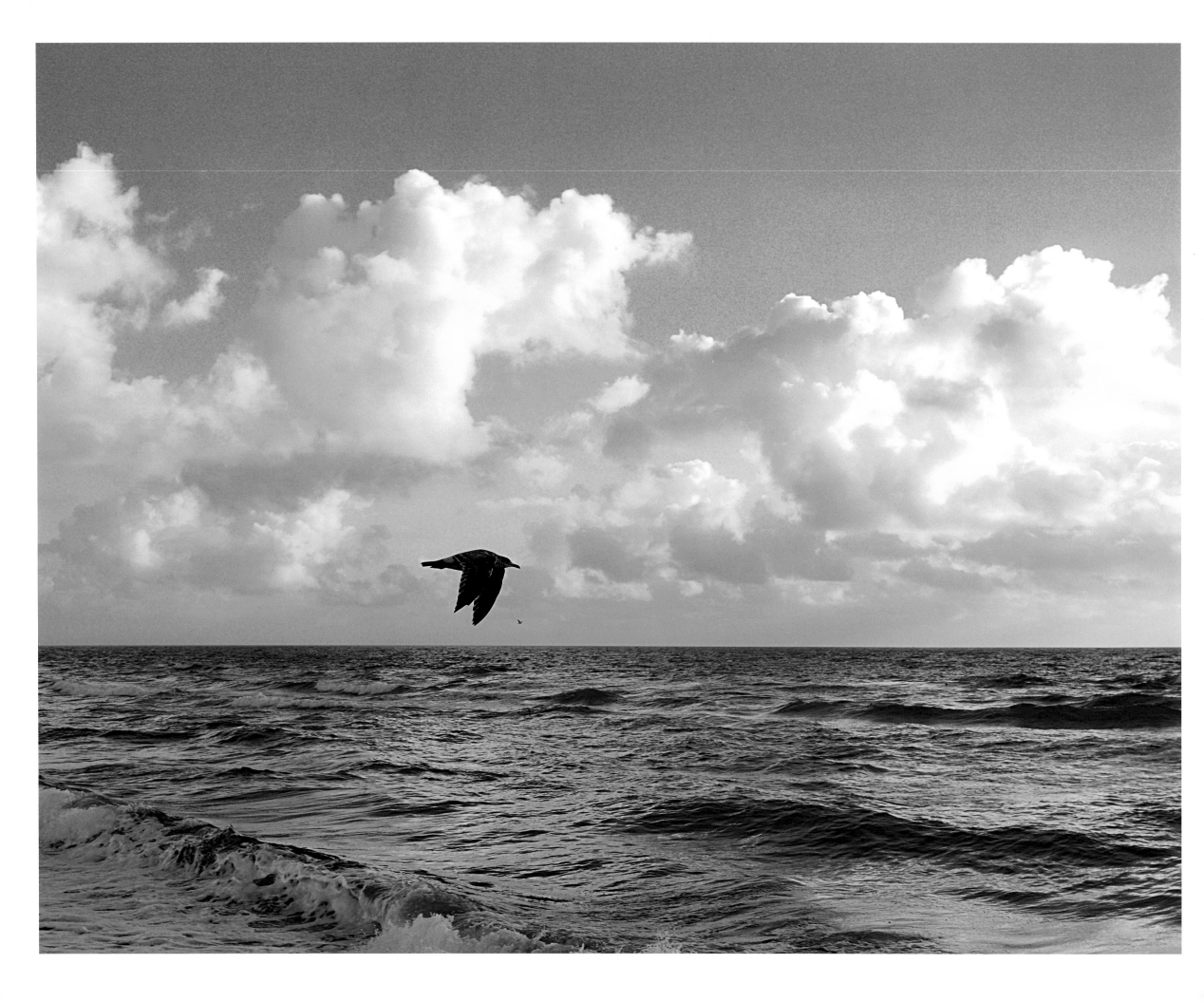

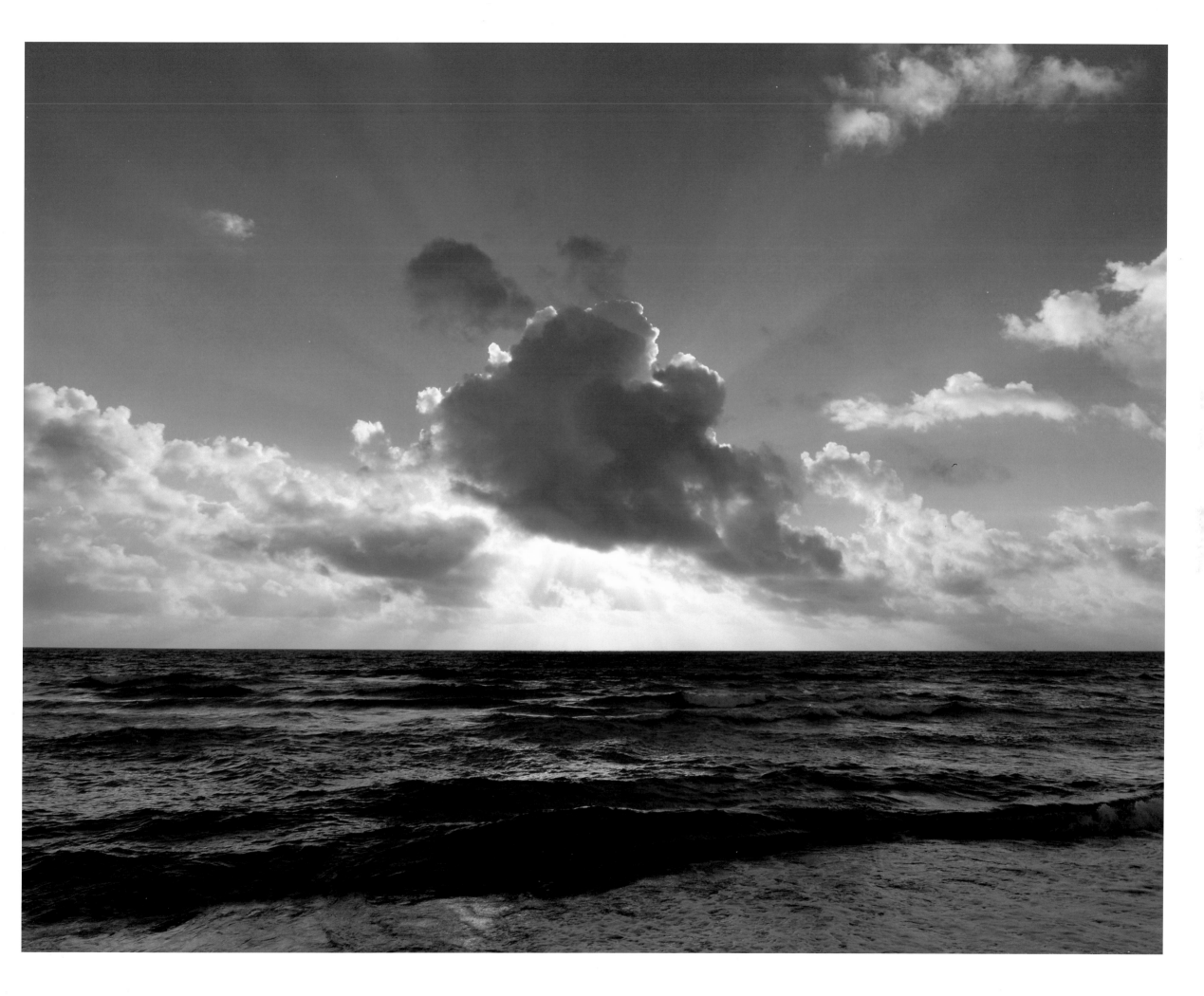

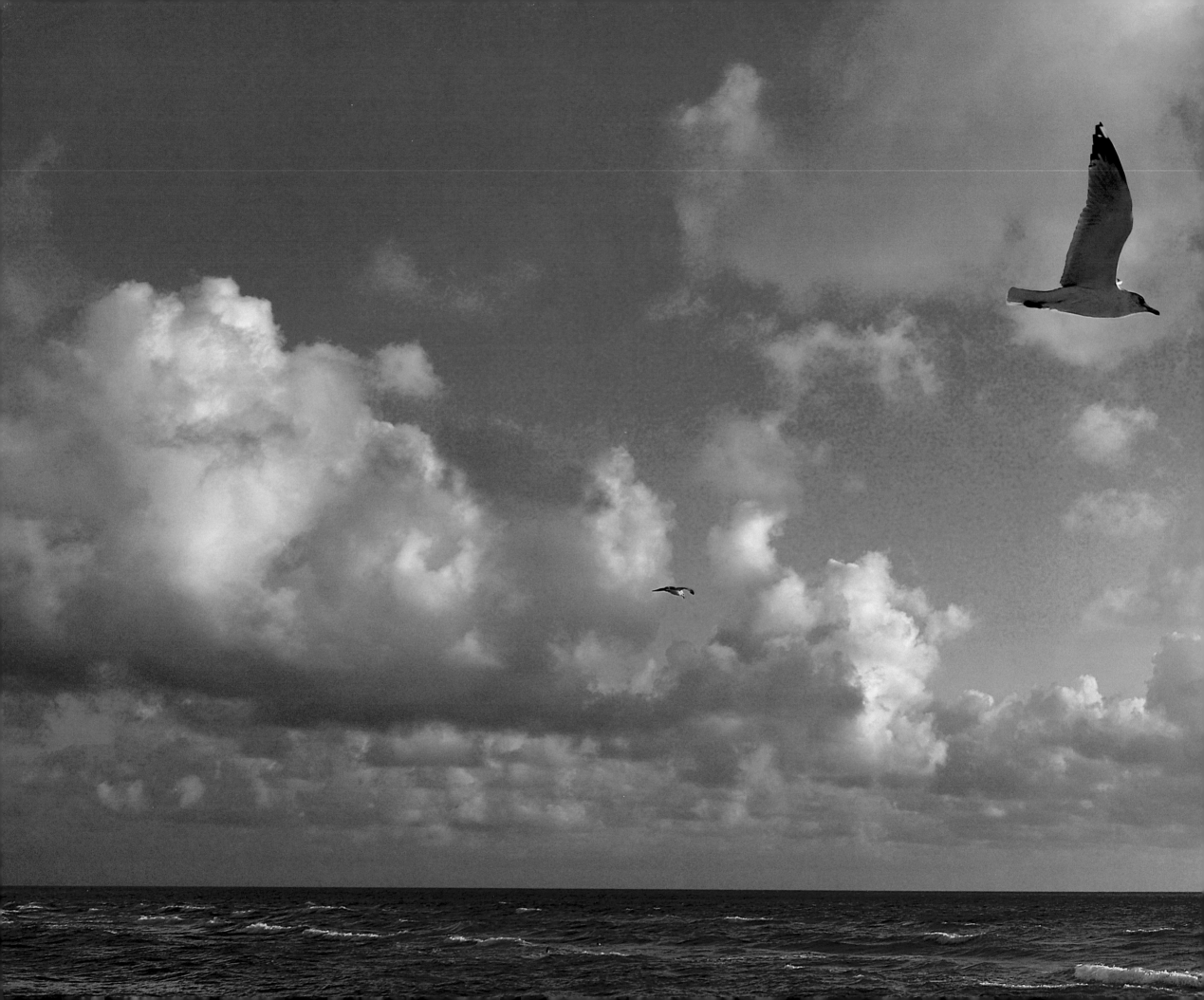

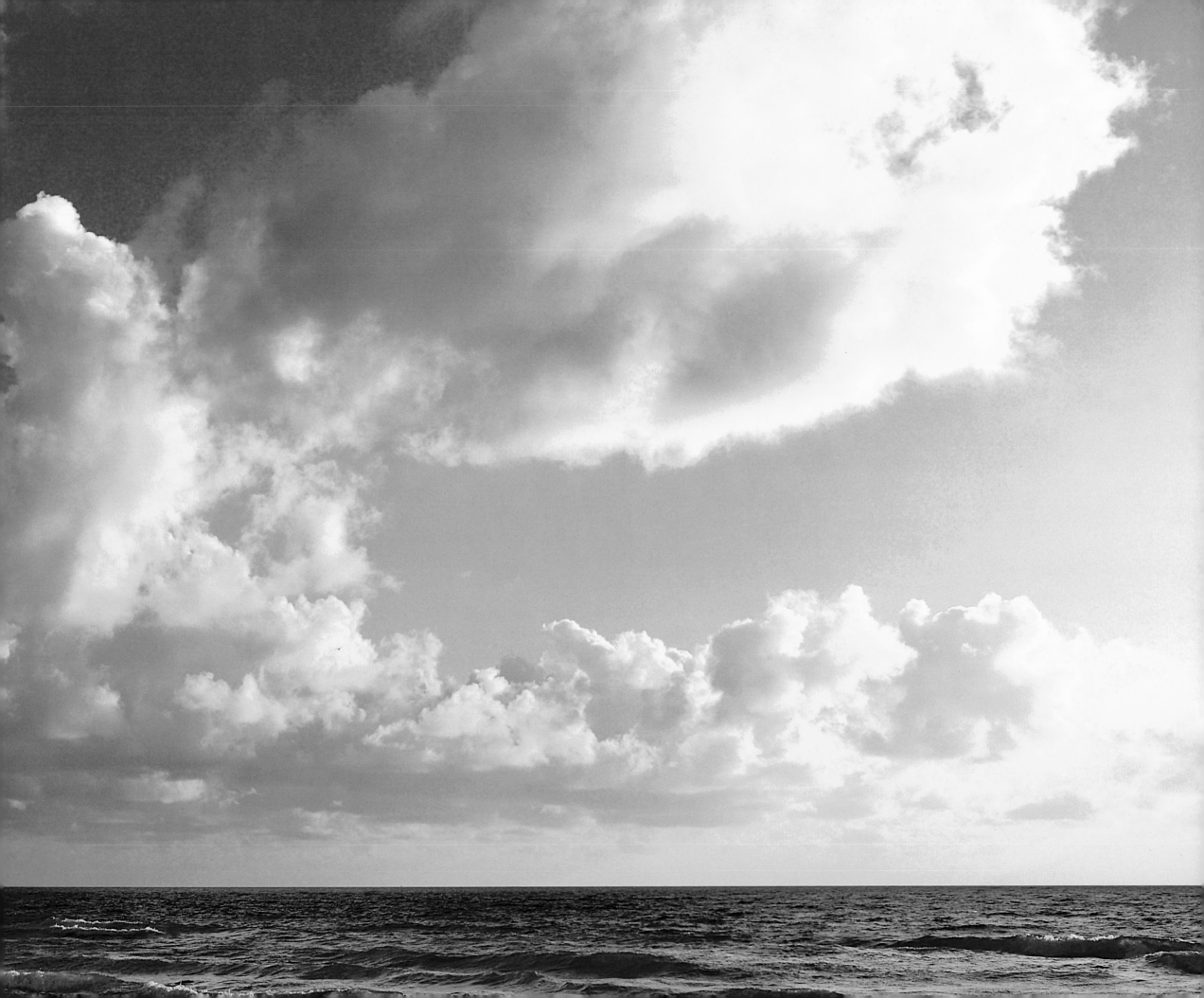

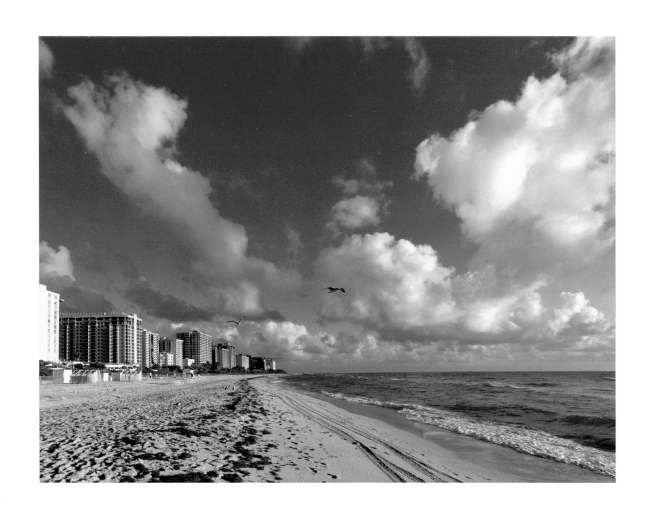
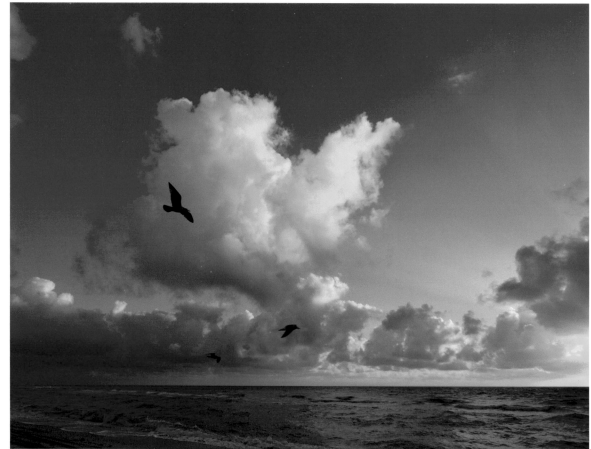

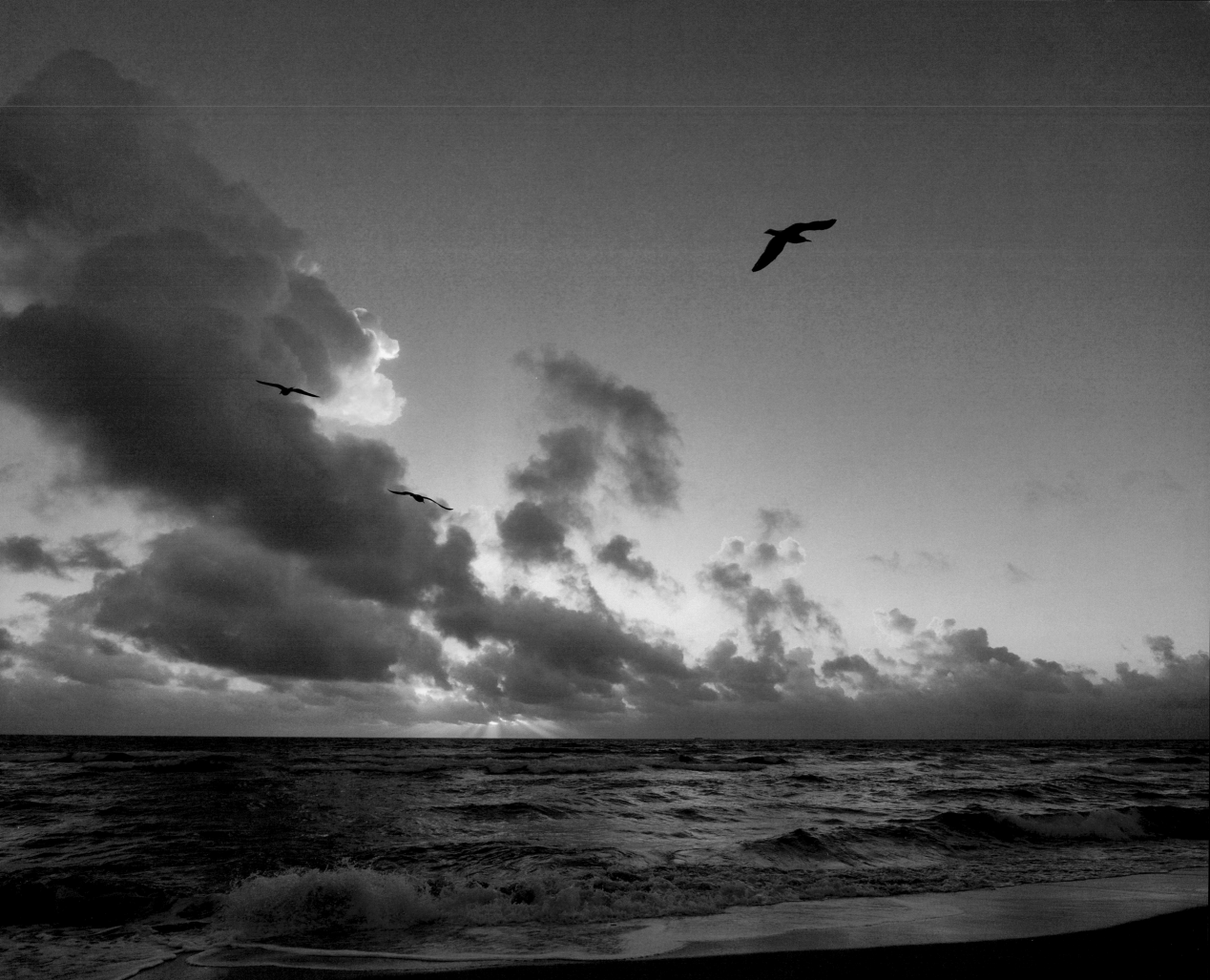

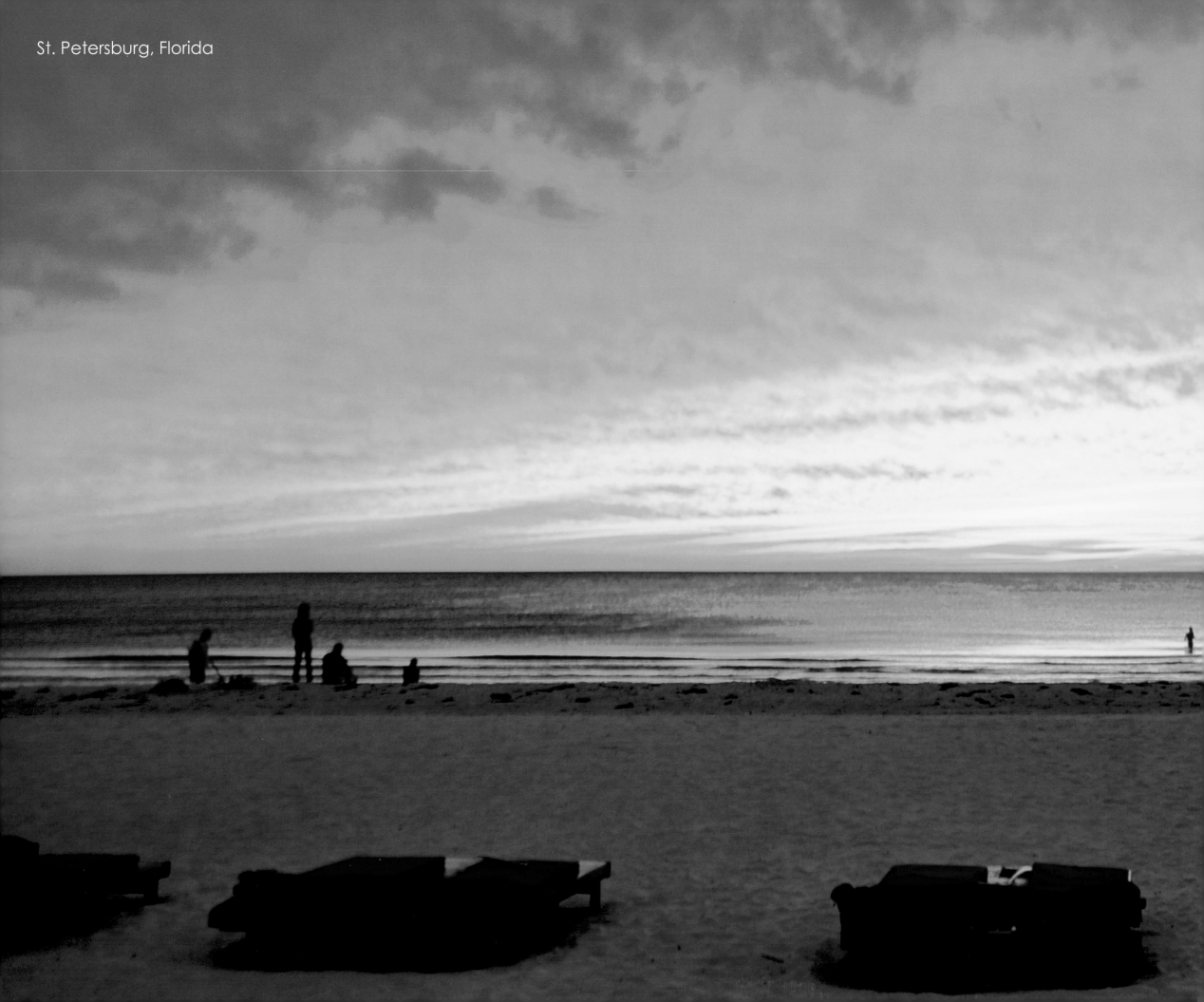
St. Petersburg, Florida

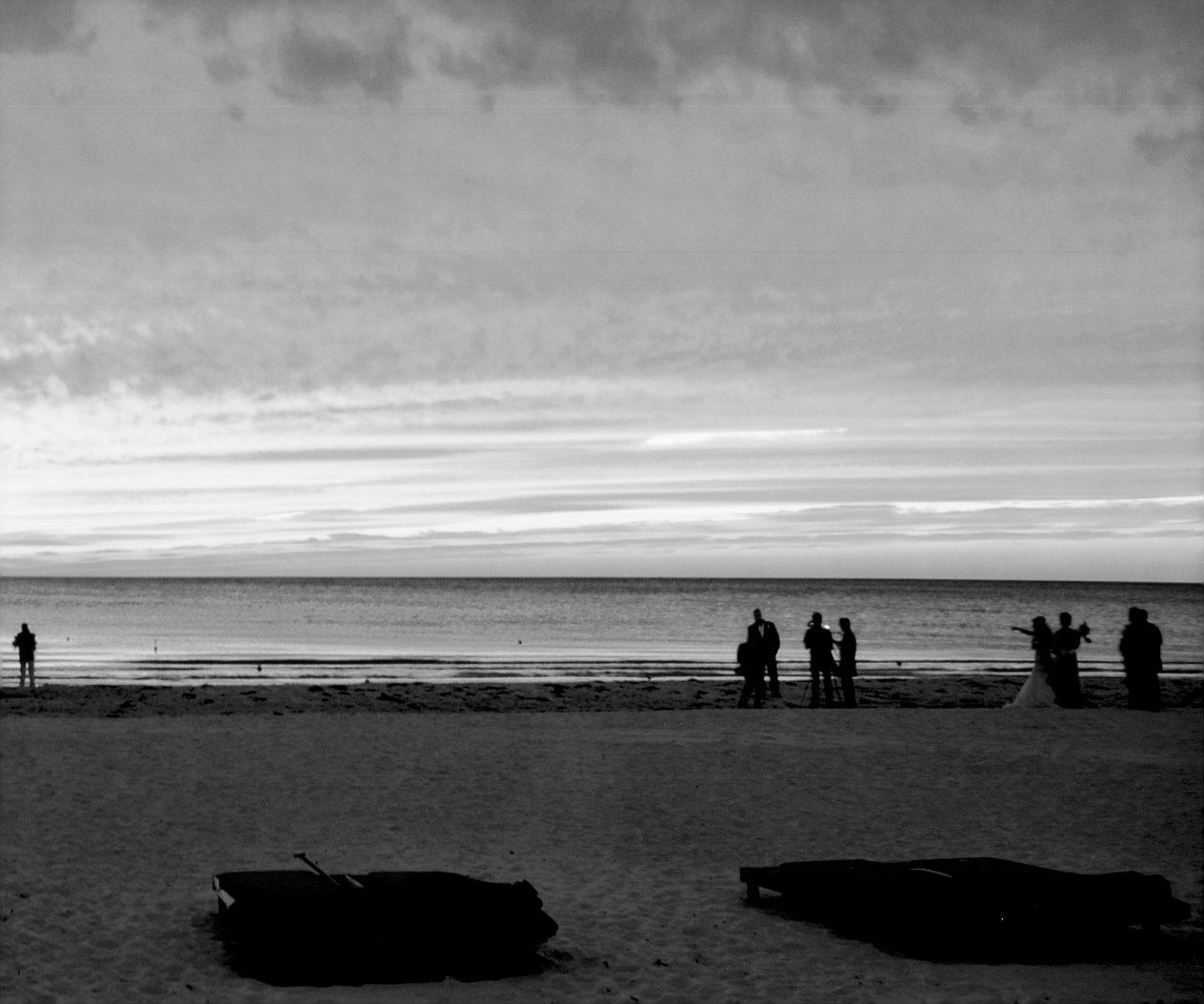

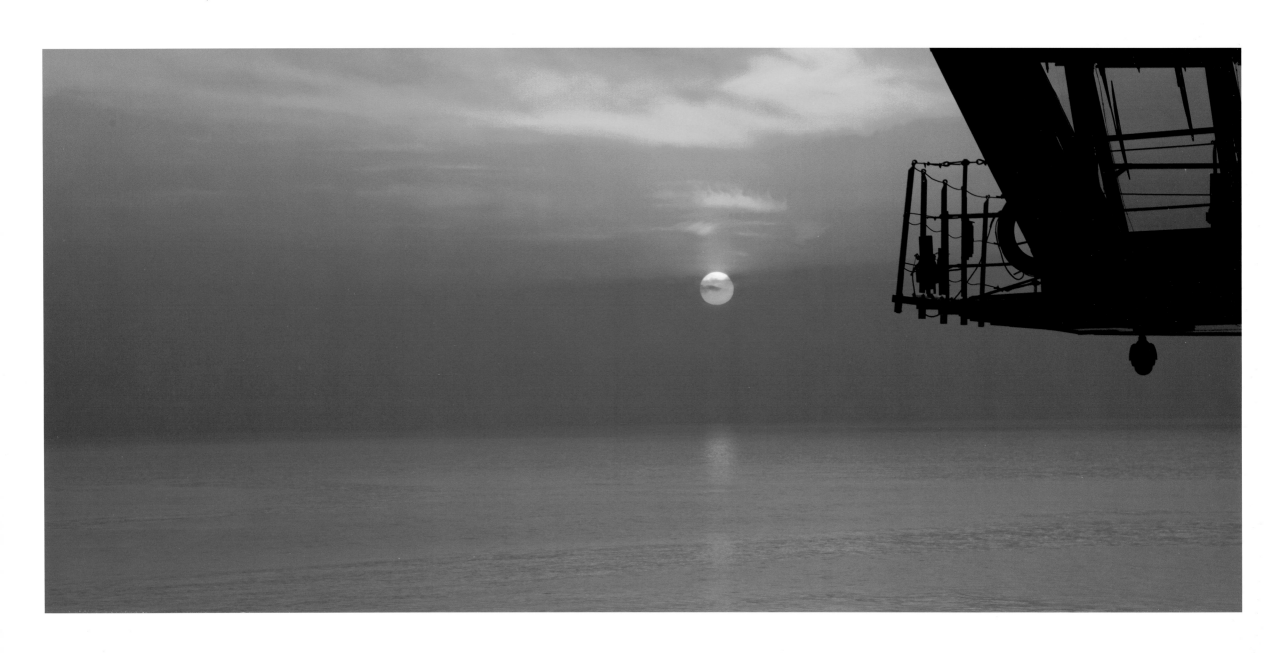

Mediterranean Sea

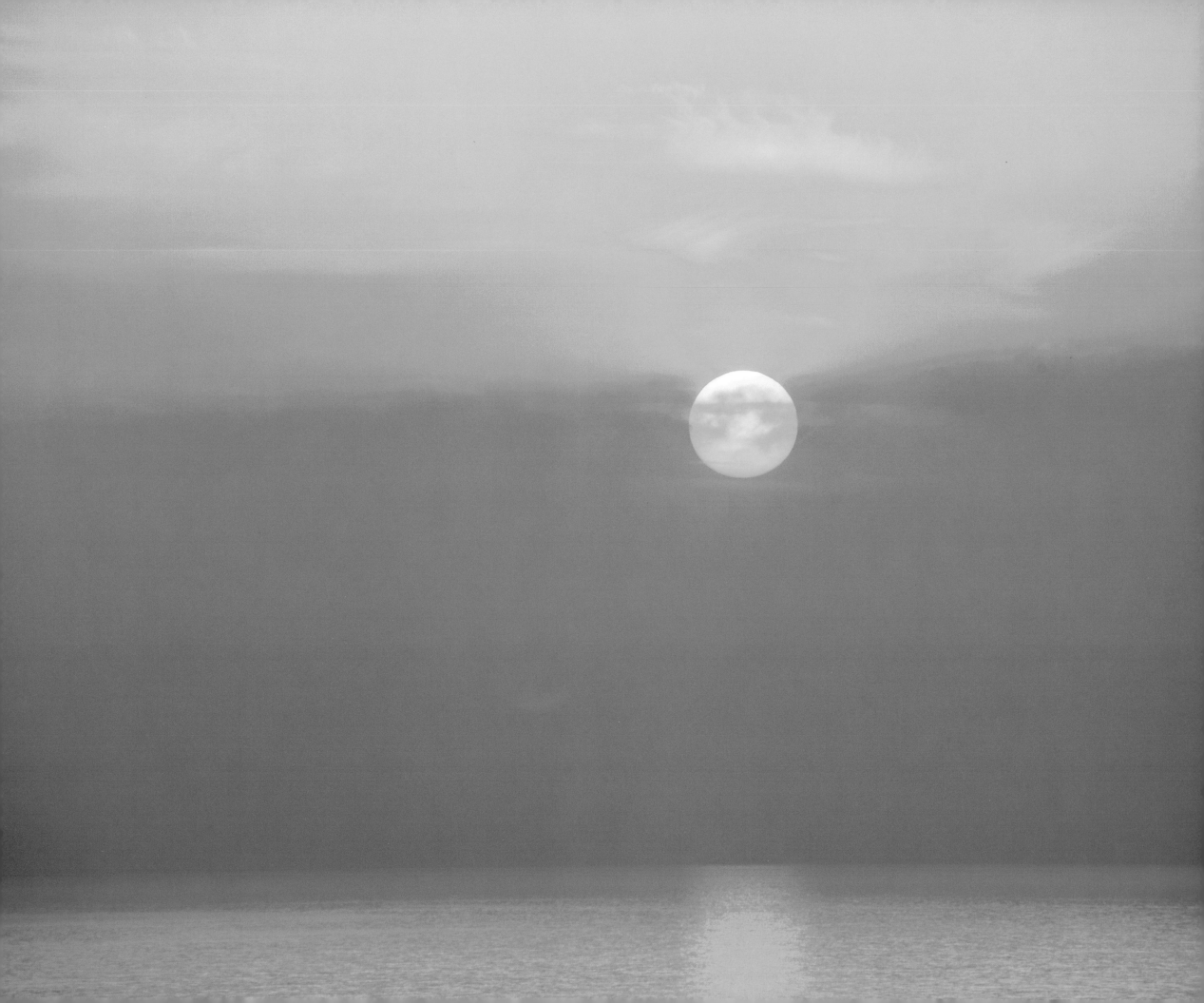

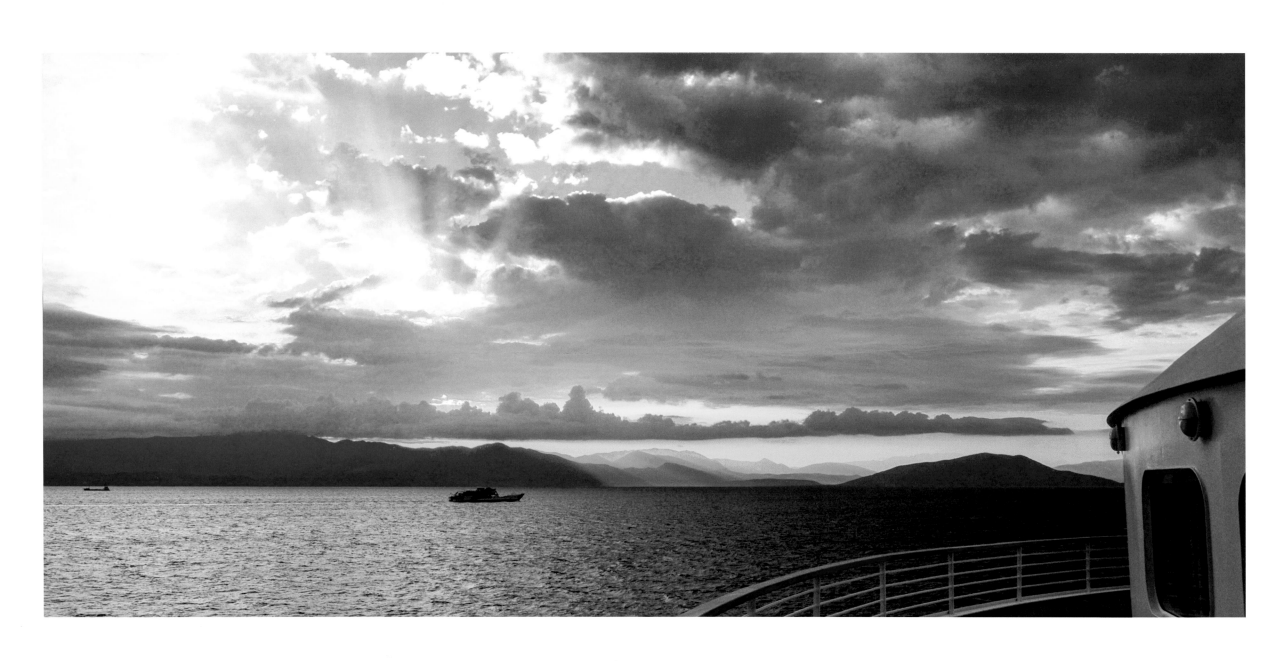

At sea along the Greek Isles

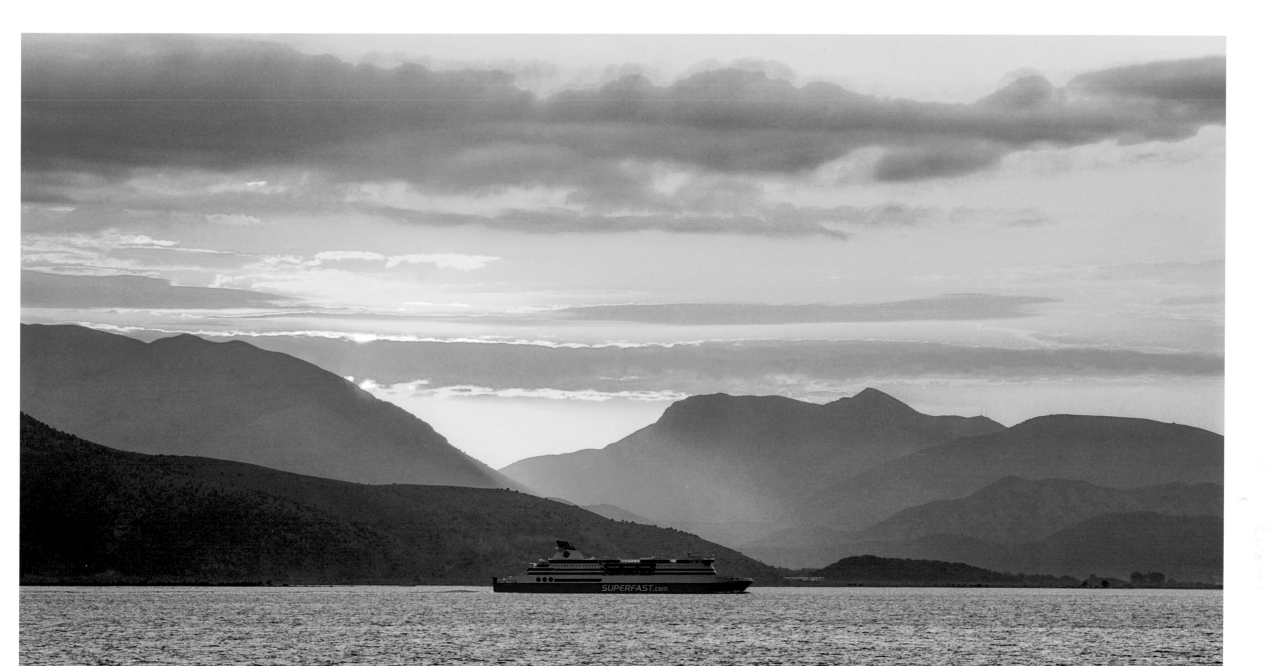

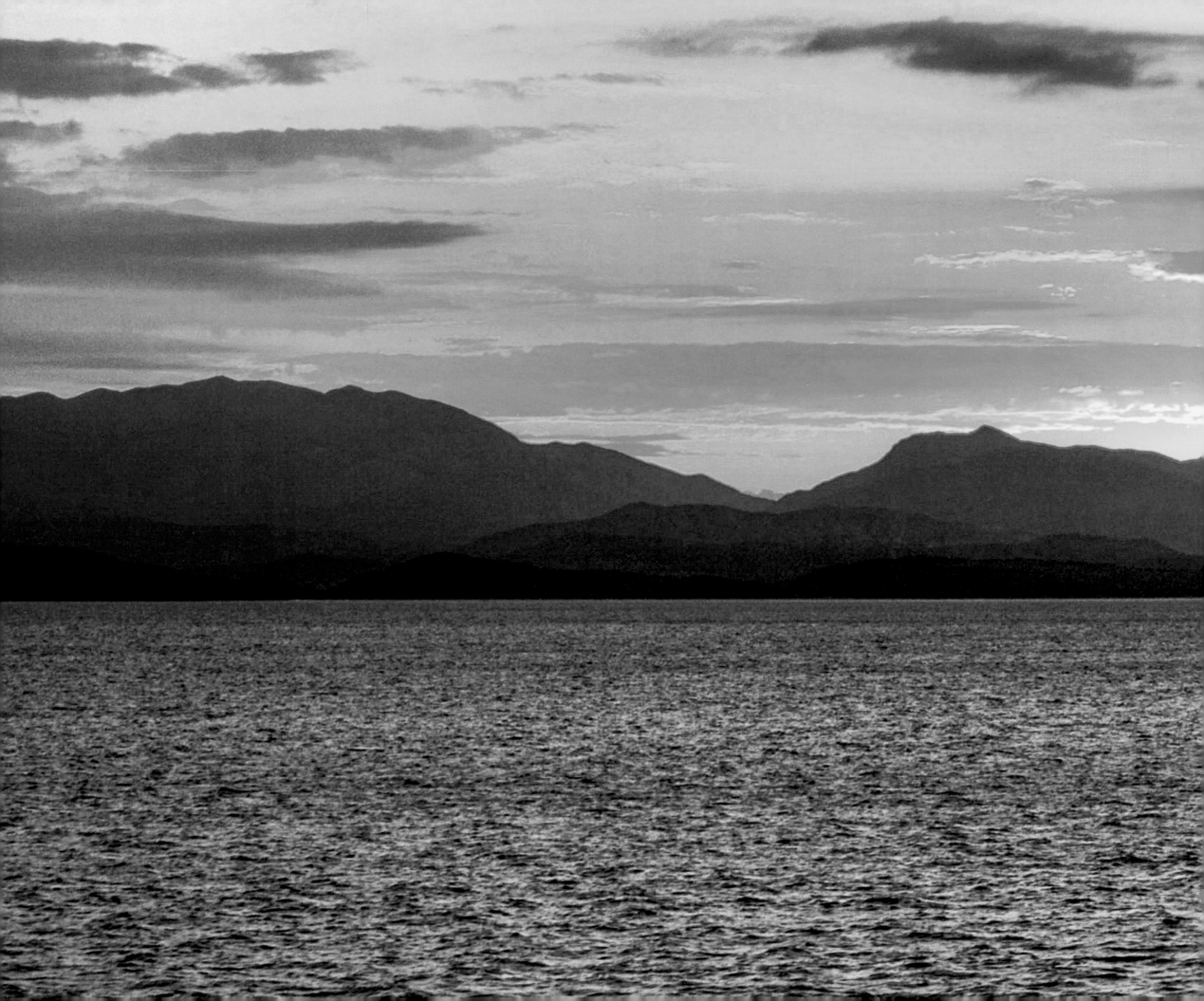

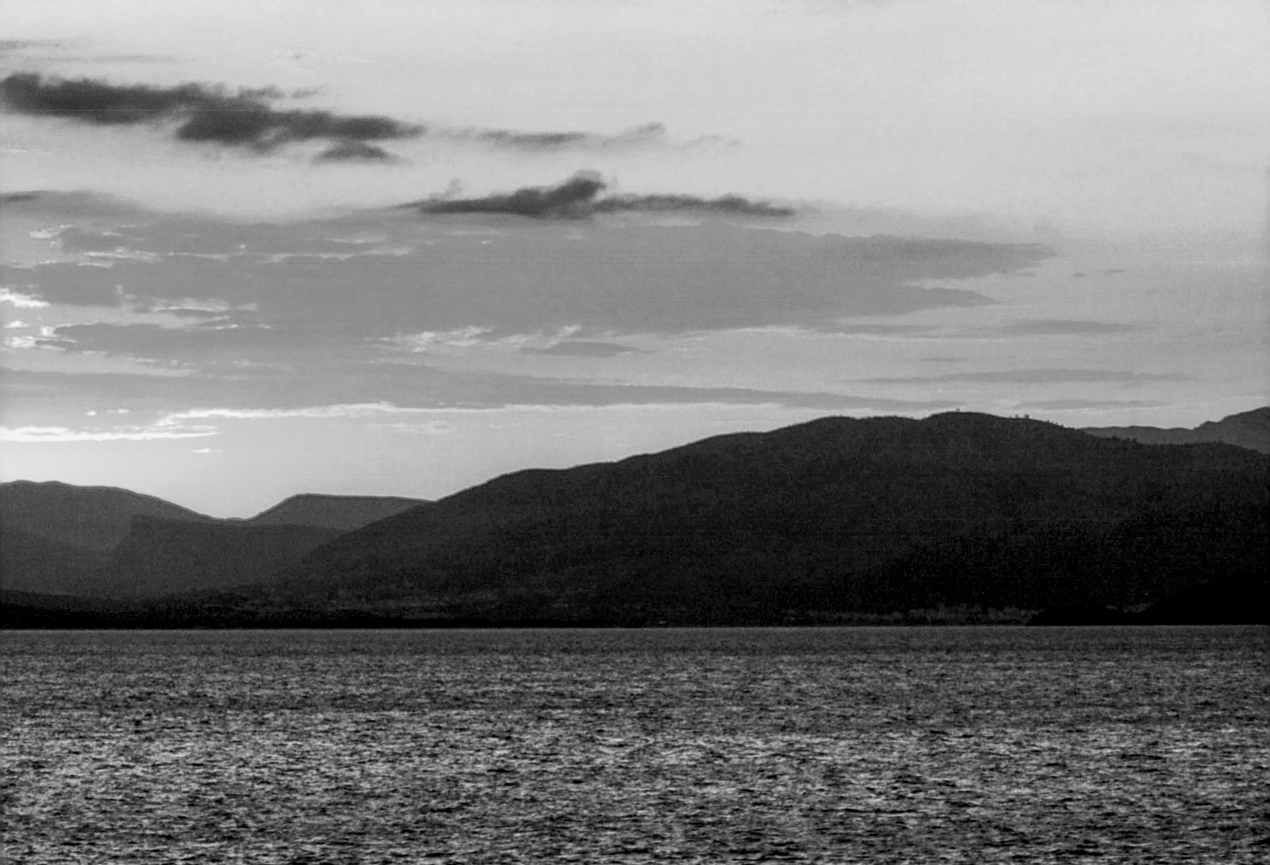

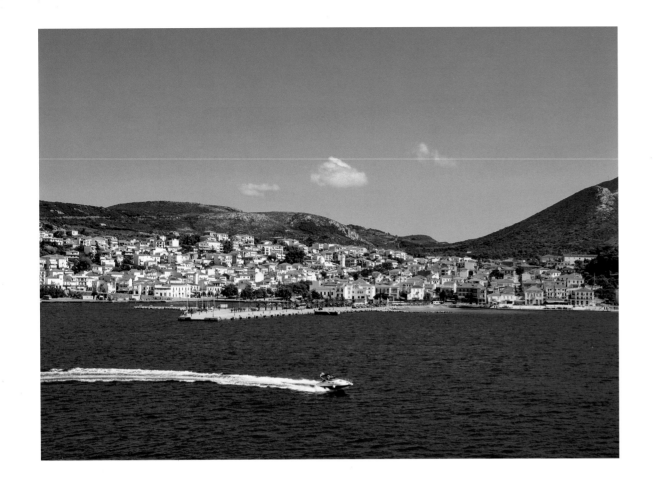
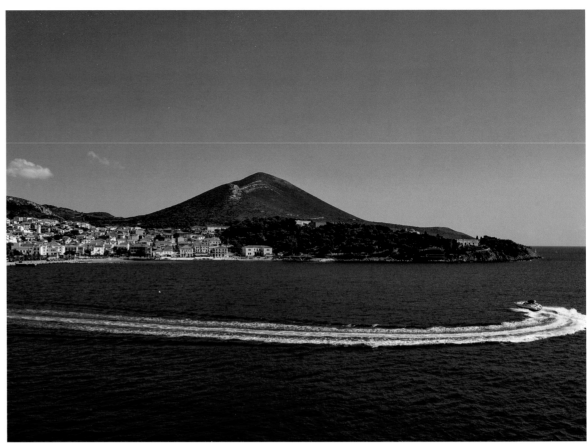
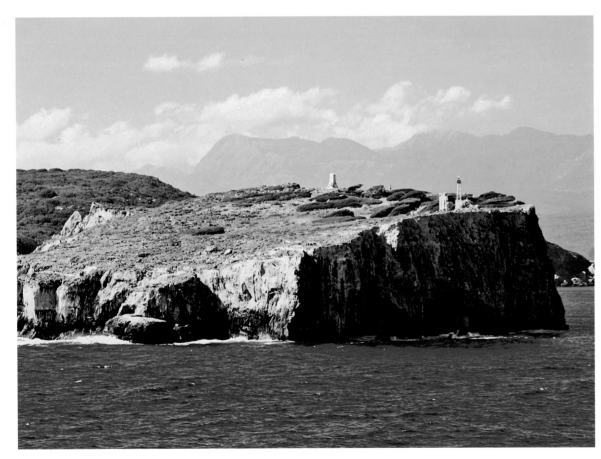
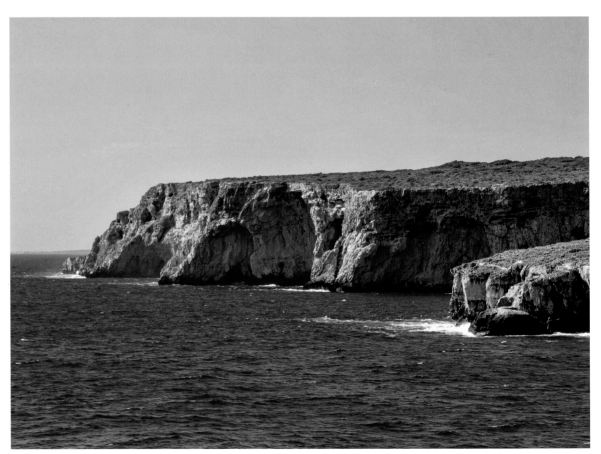

Pylos, Greece

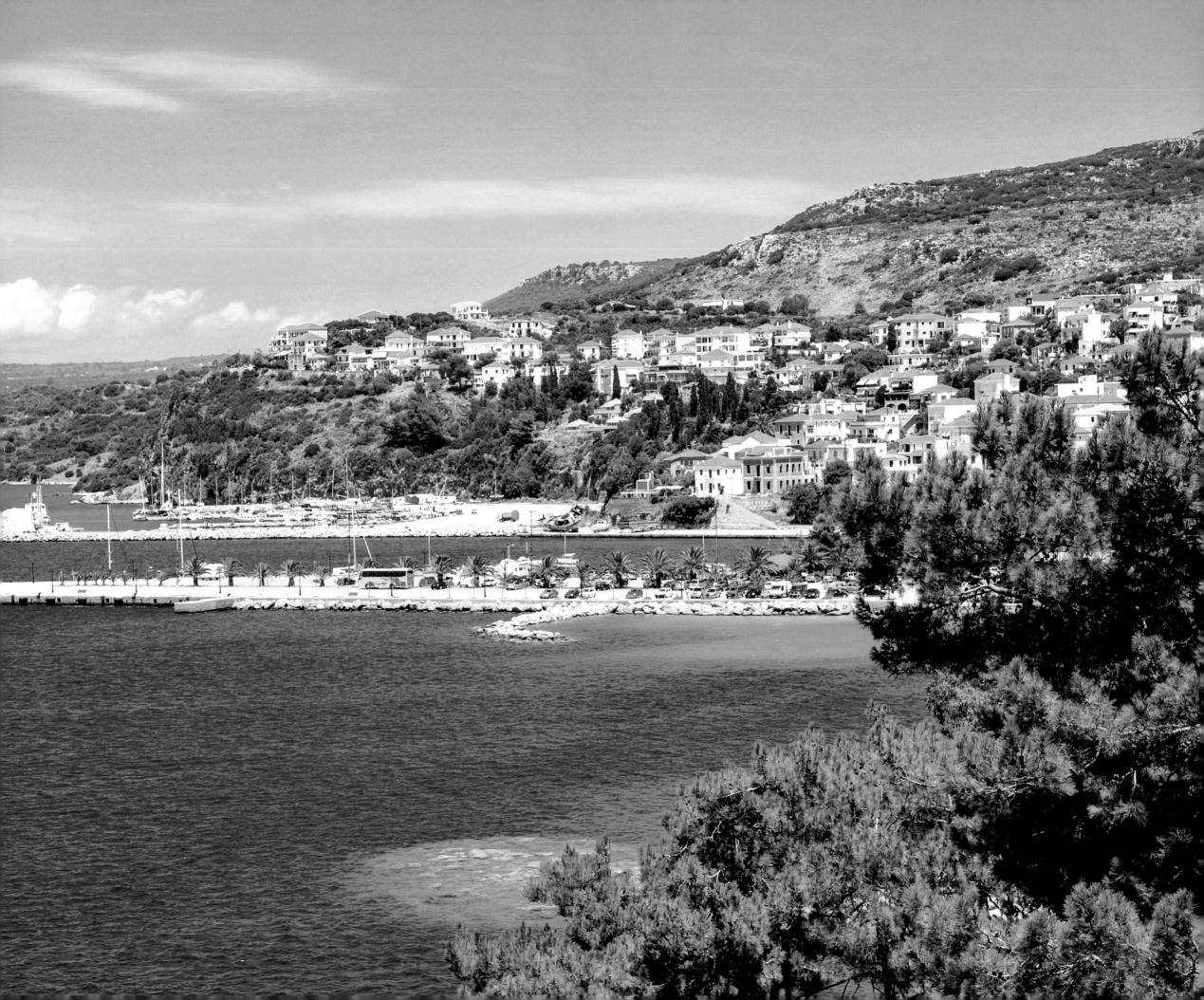

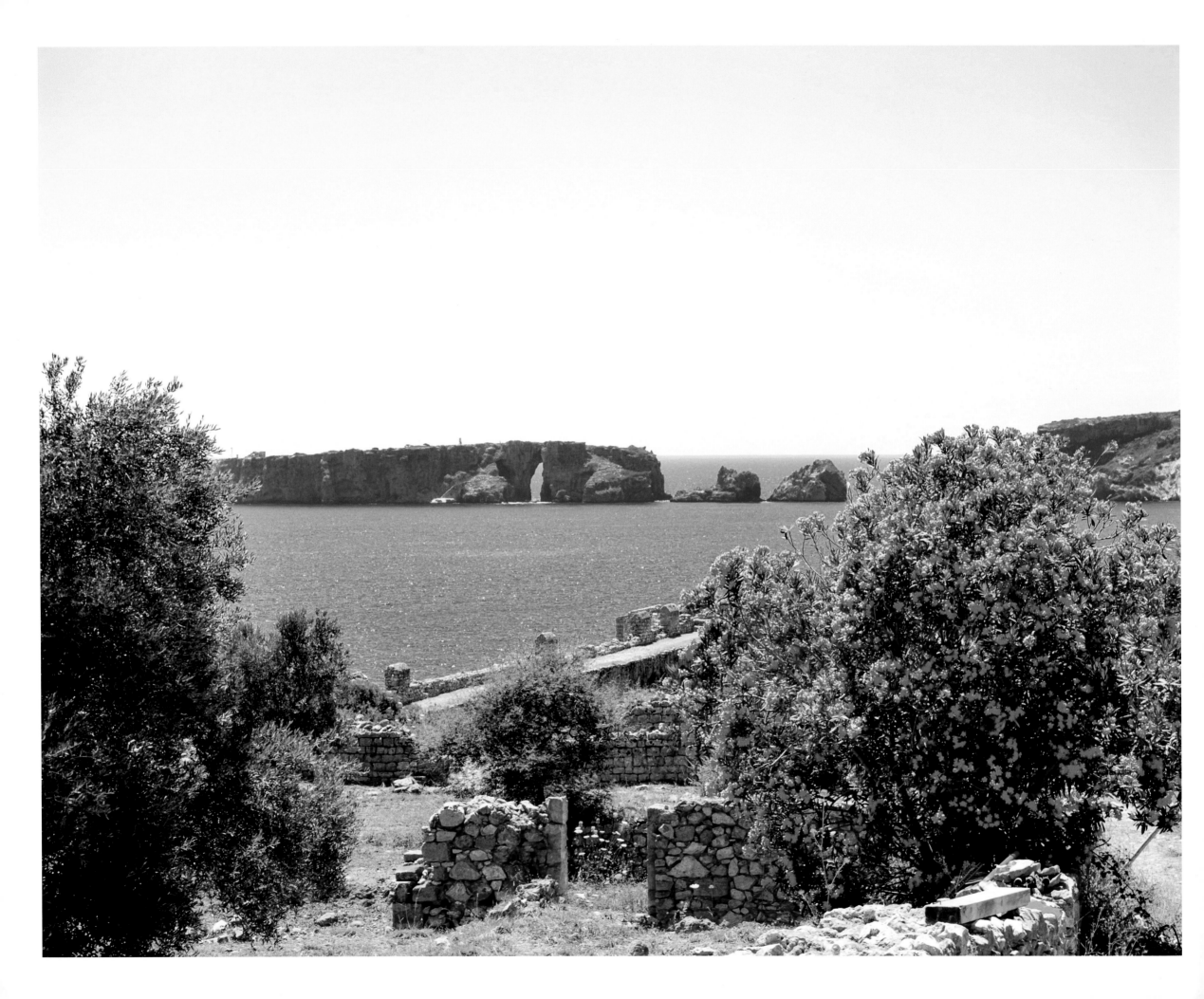

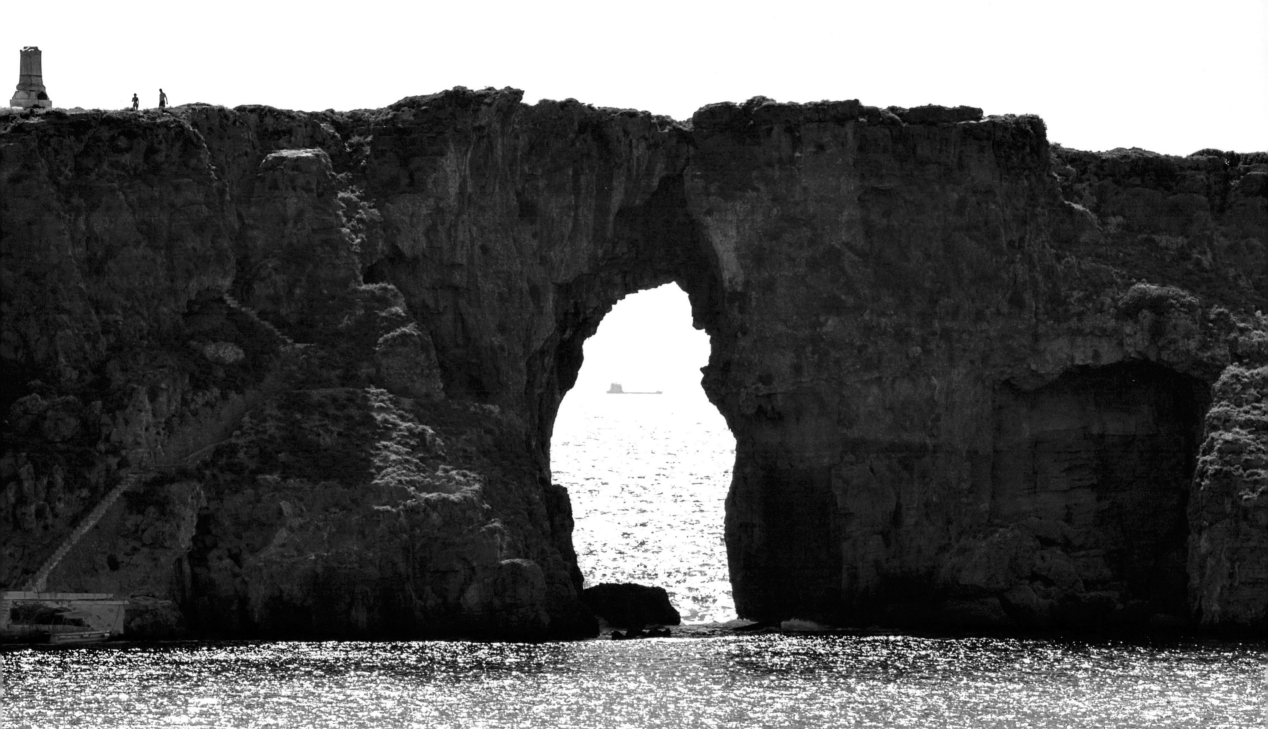

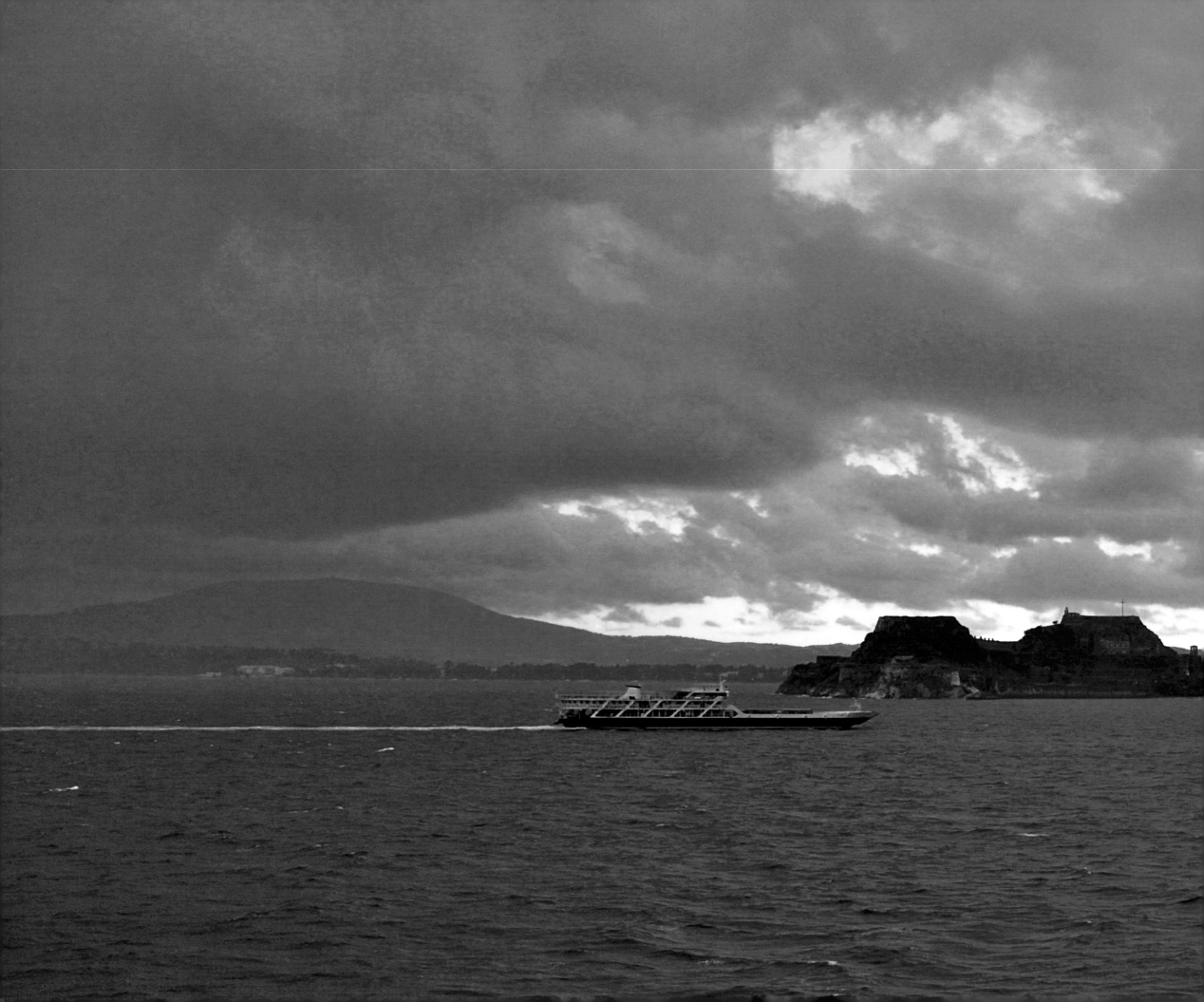

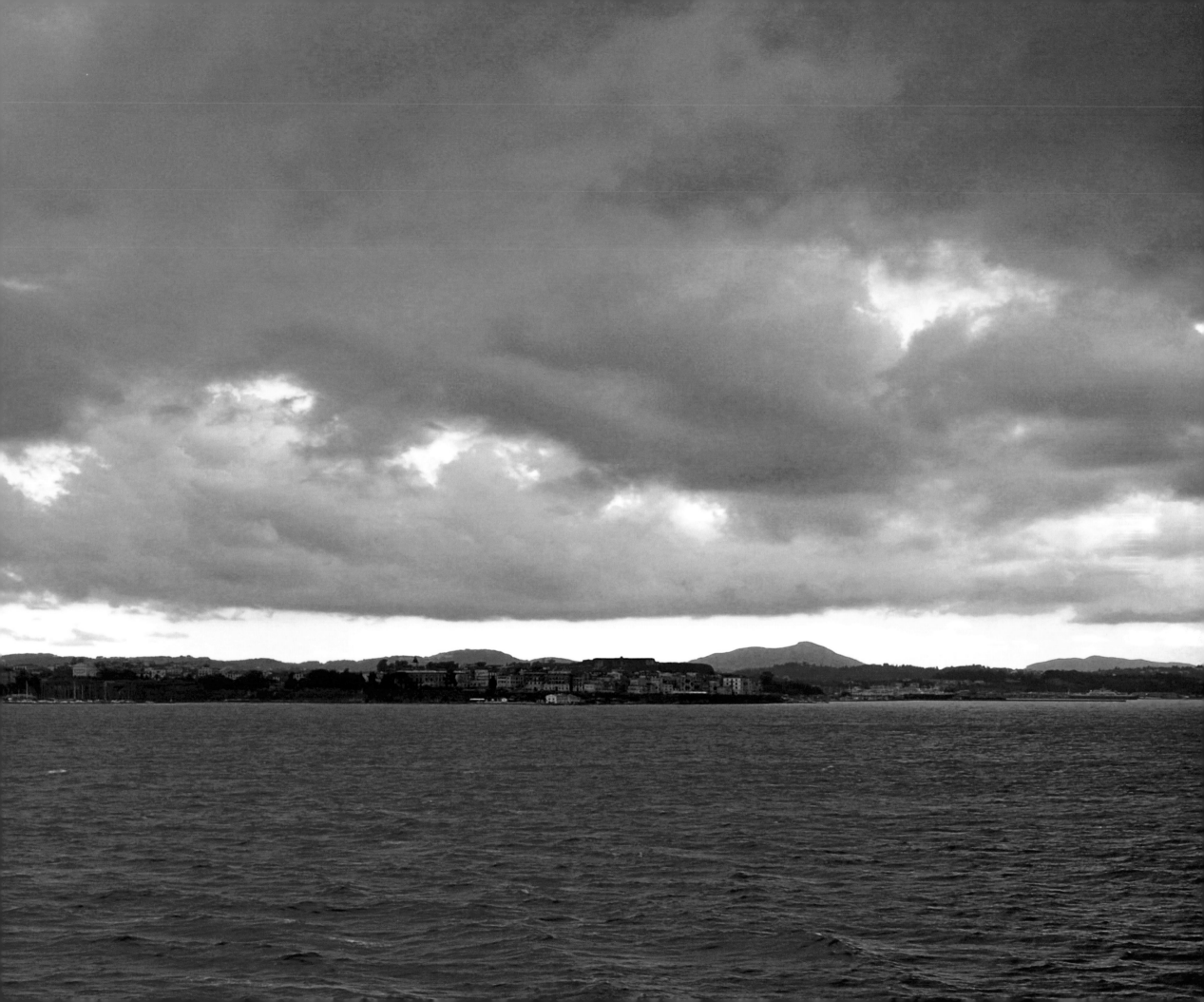

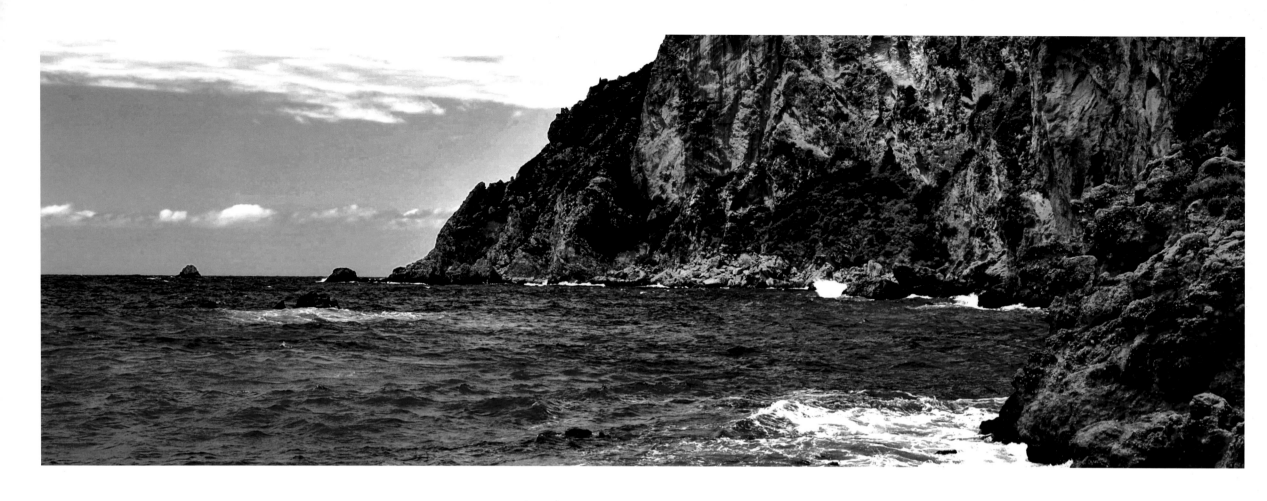

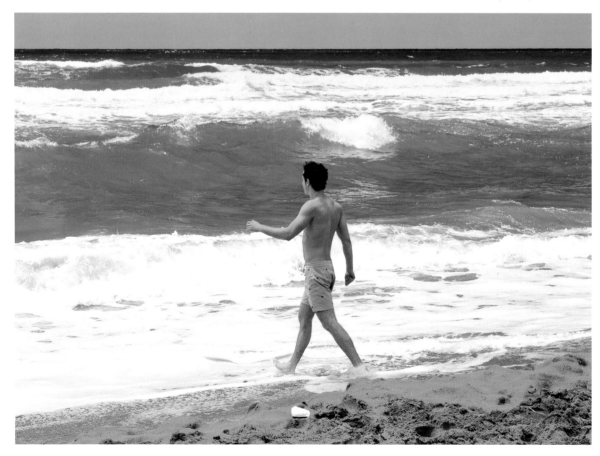

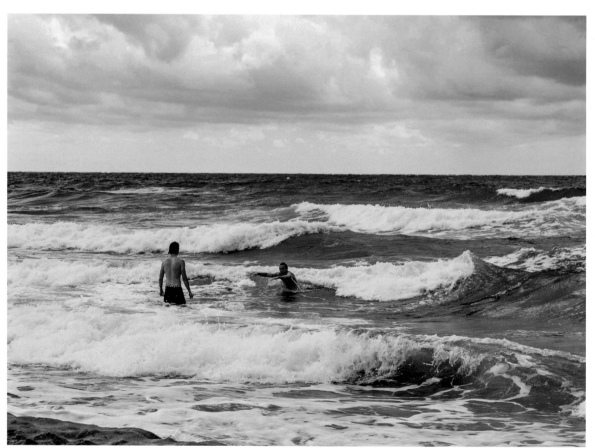

Corfu, Greece

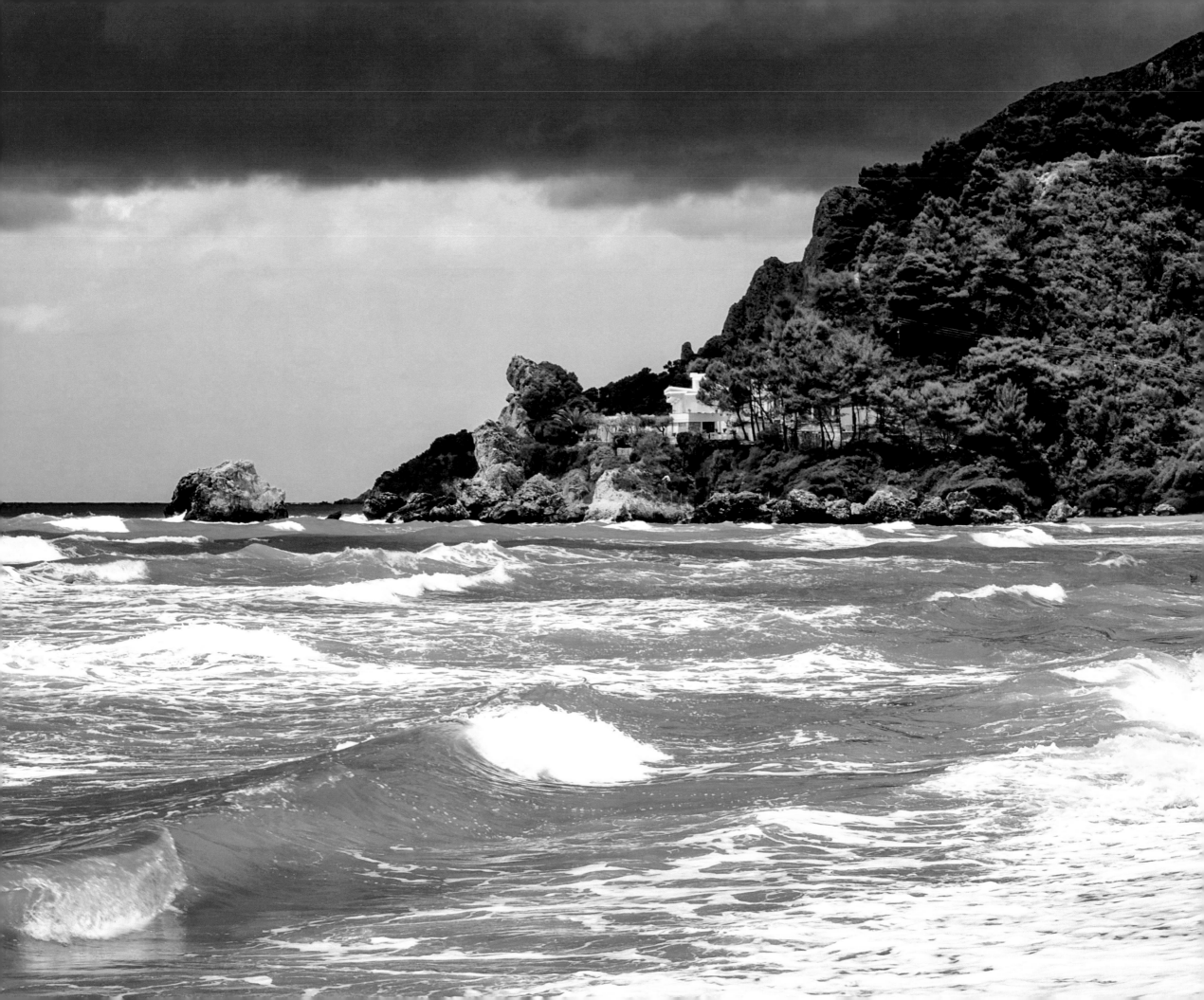

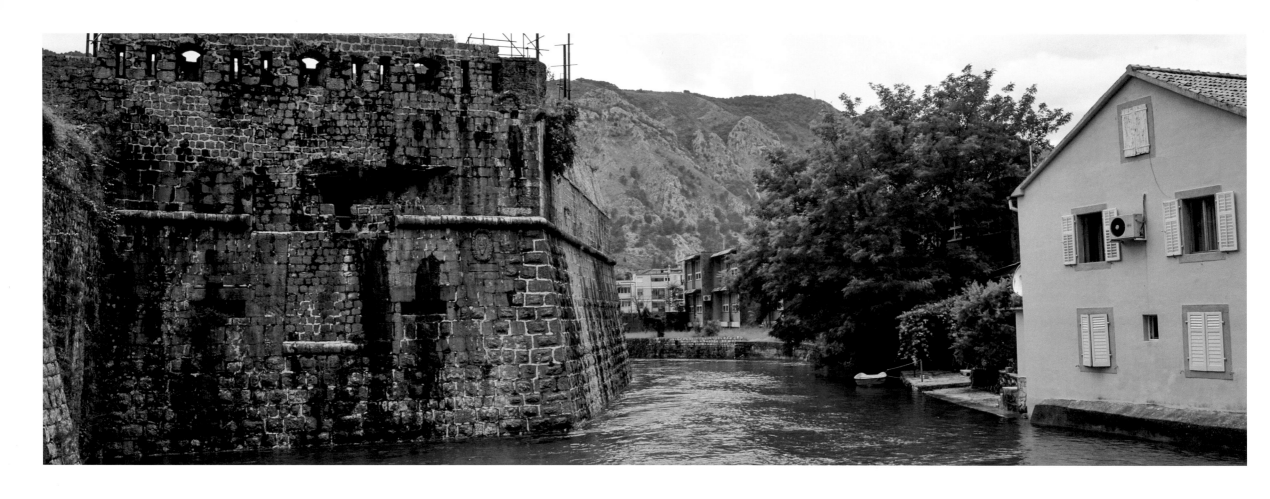

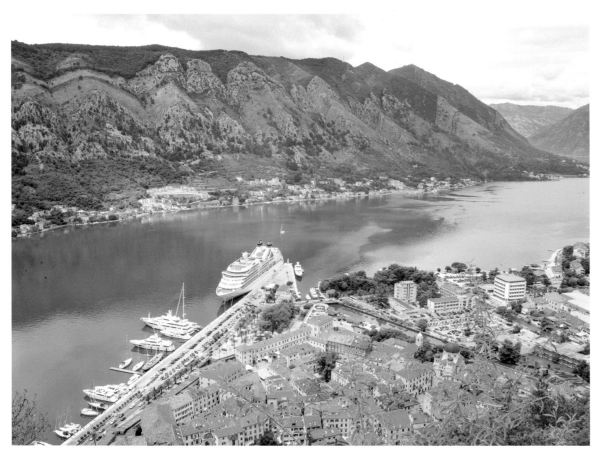

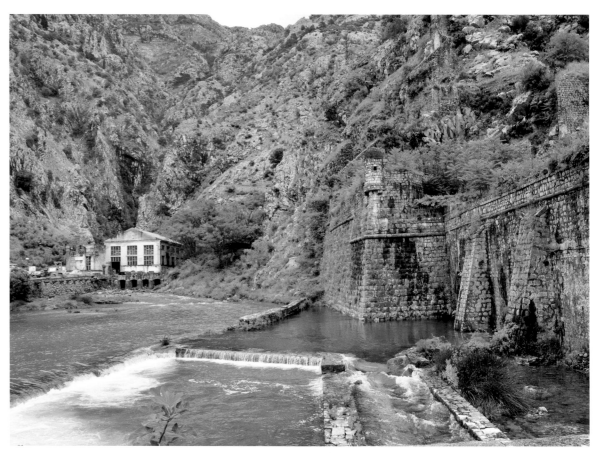

Kotor, Montenegro

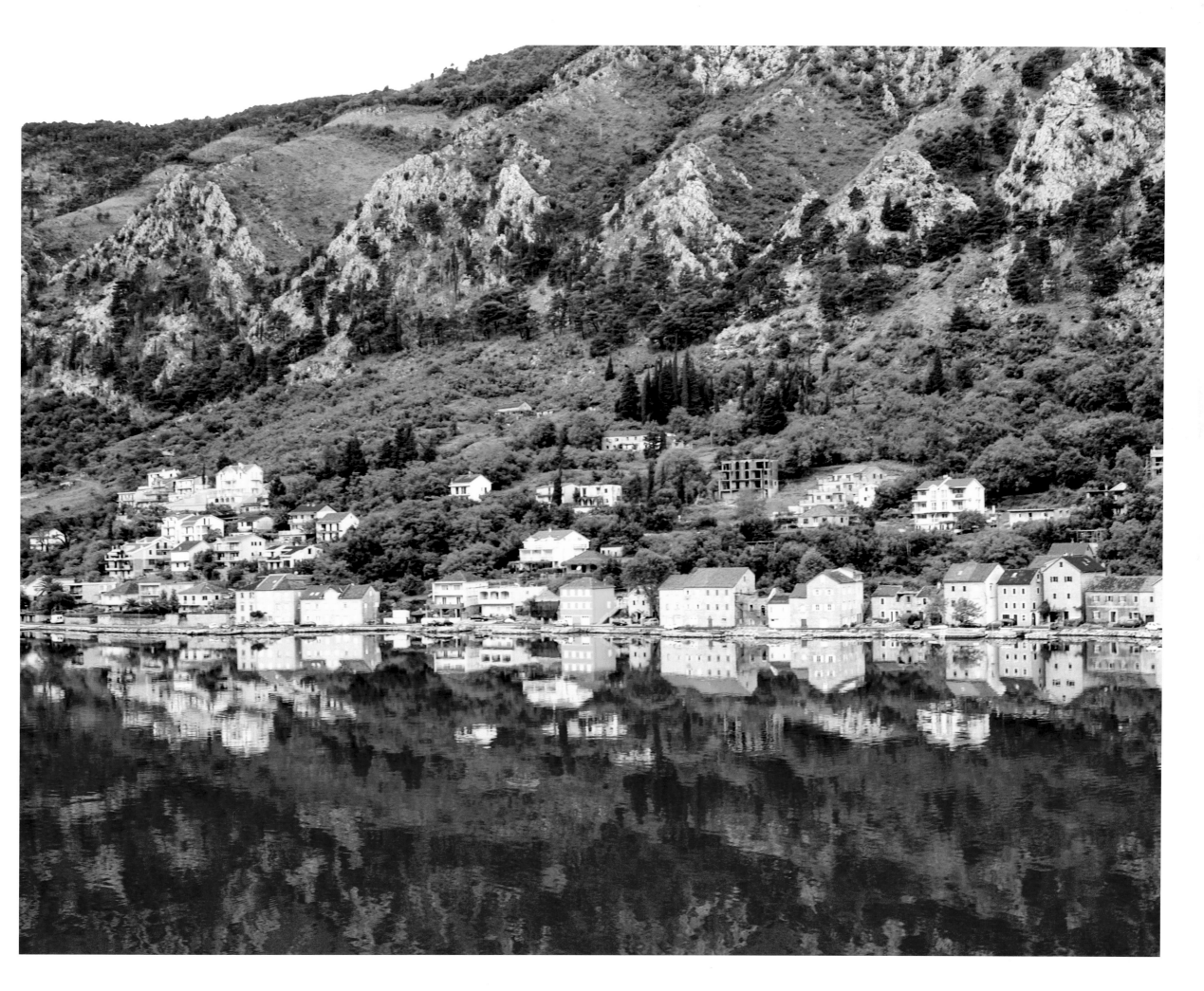

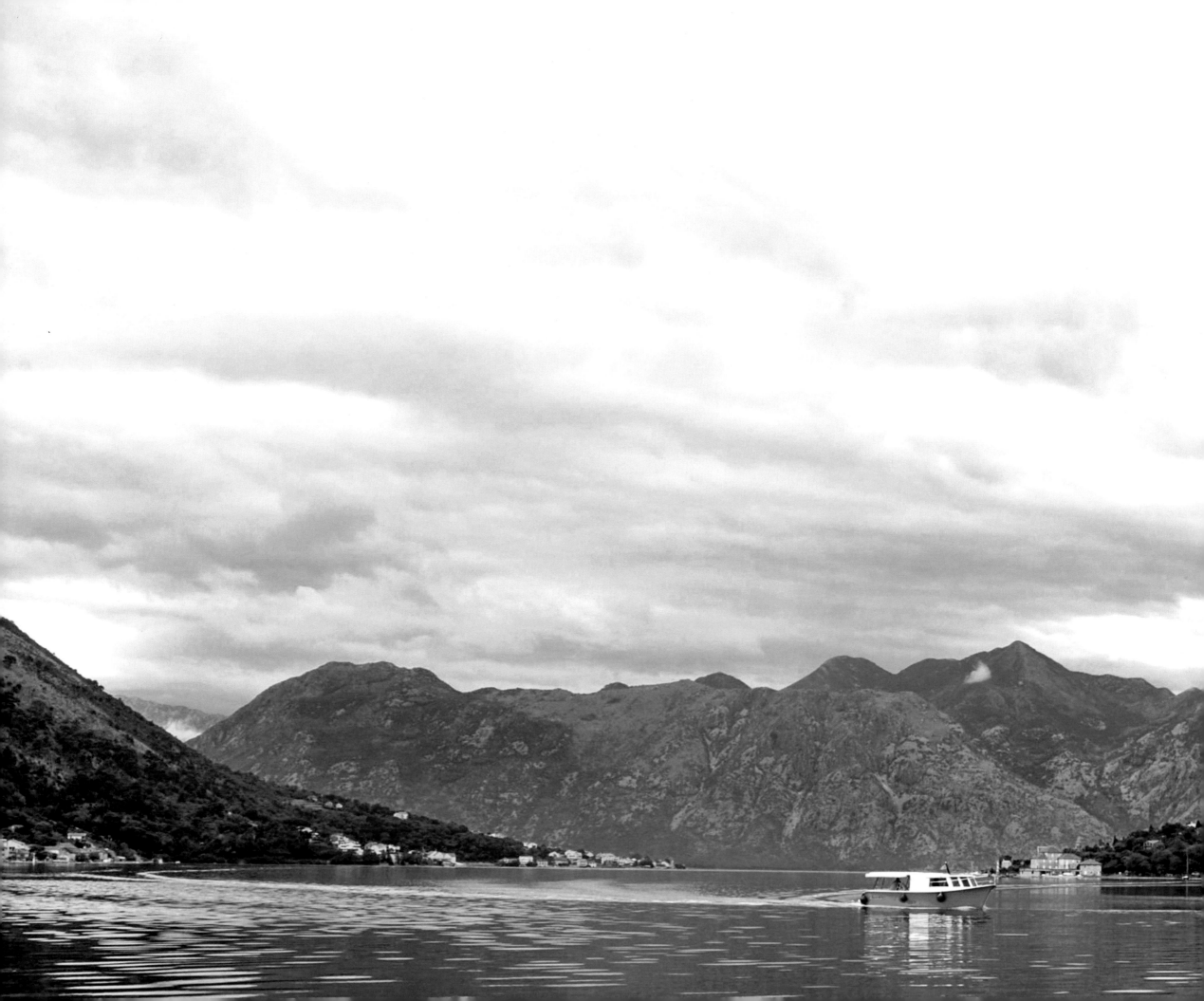

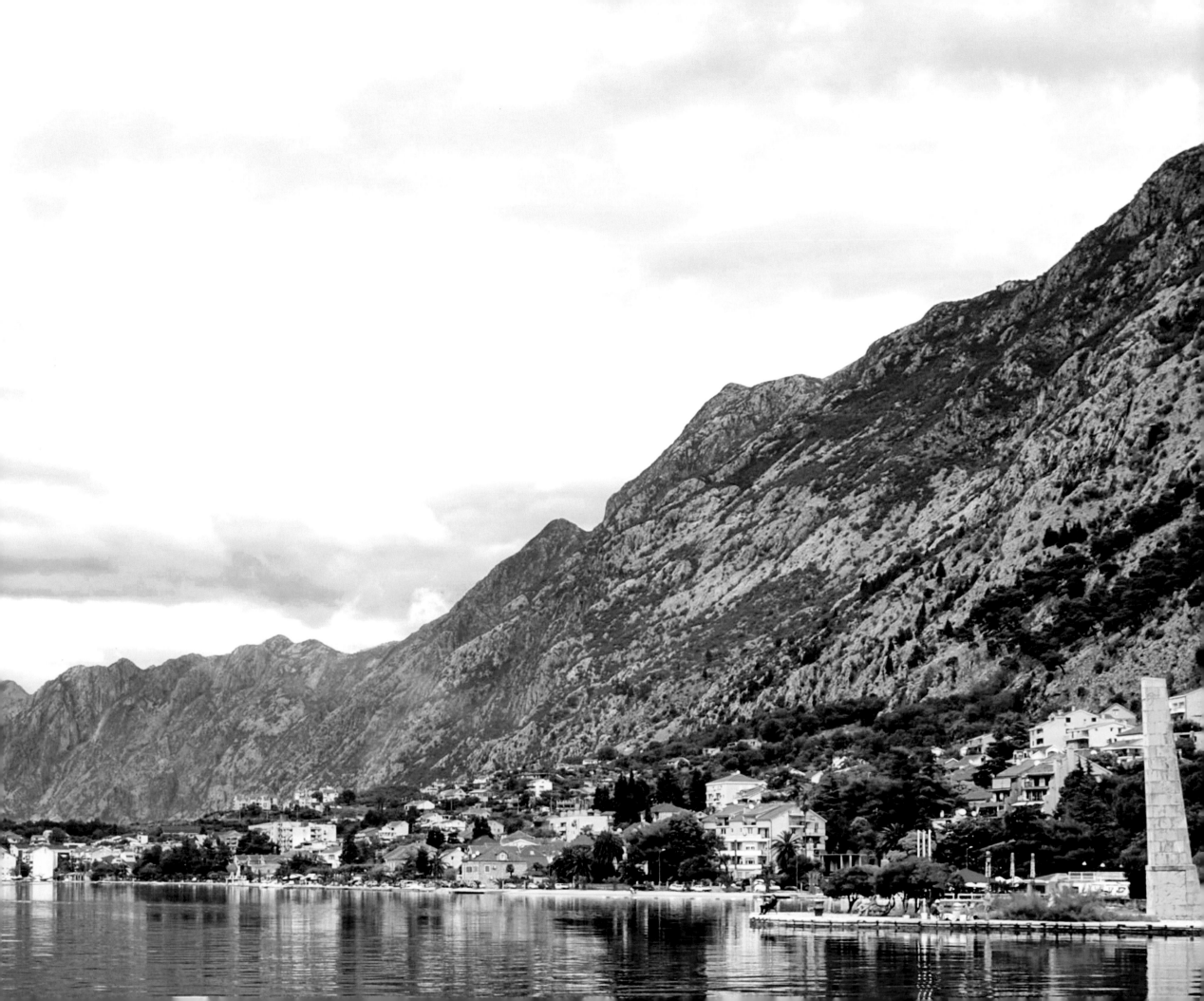

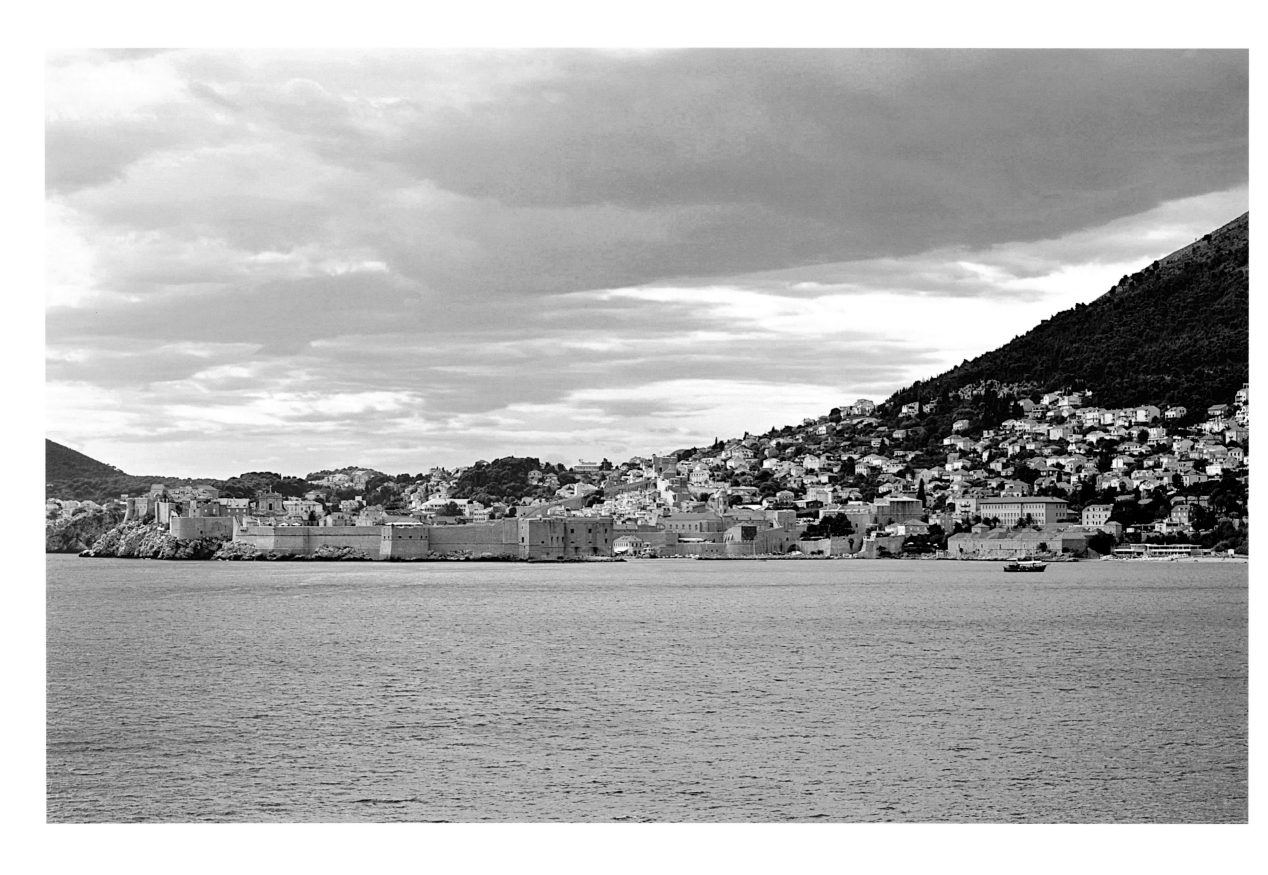

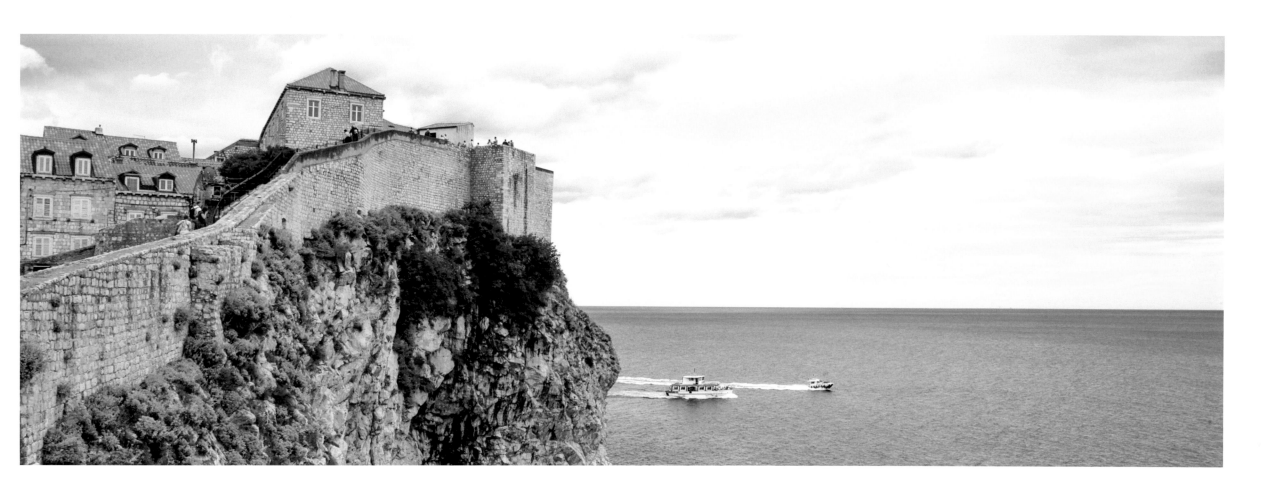

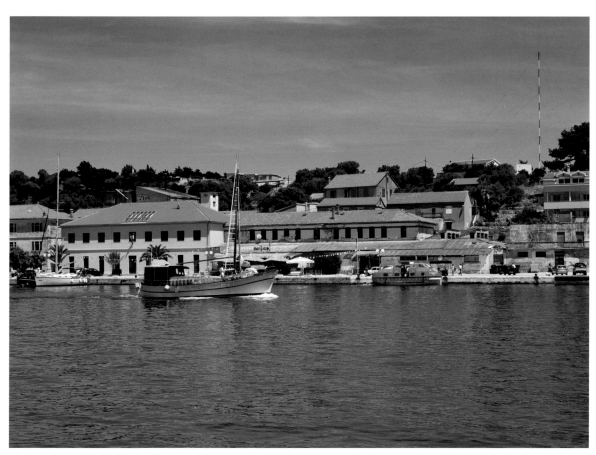

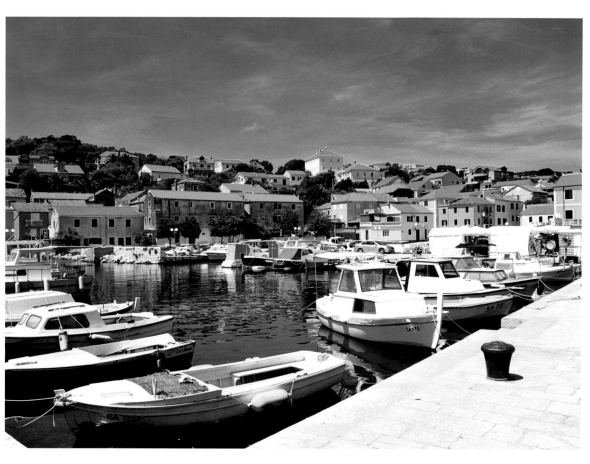

Dubrovnik & Triluke Bay, Croatia

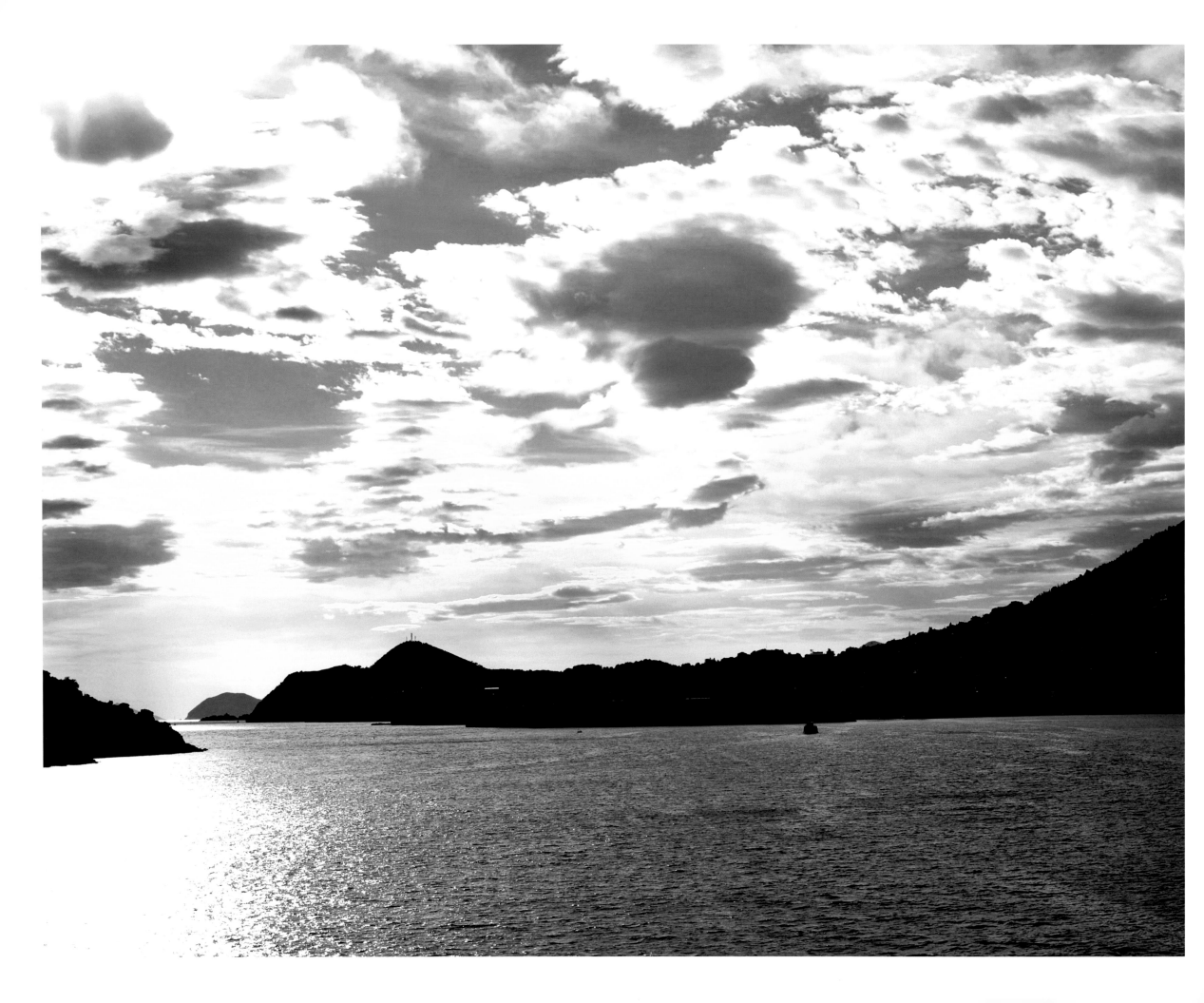

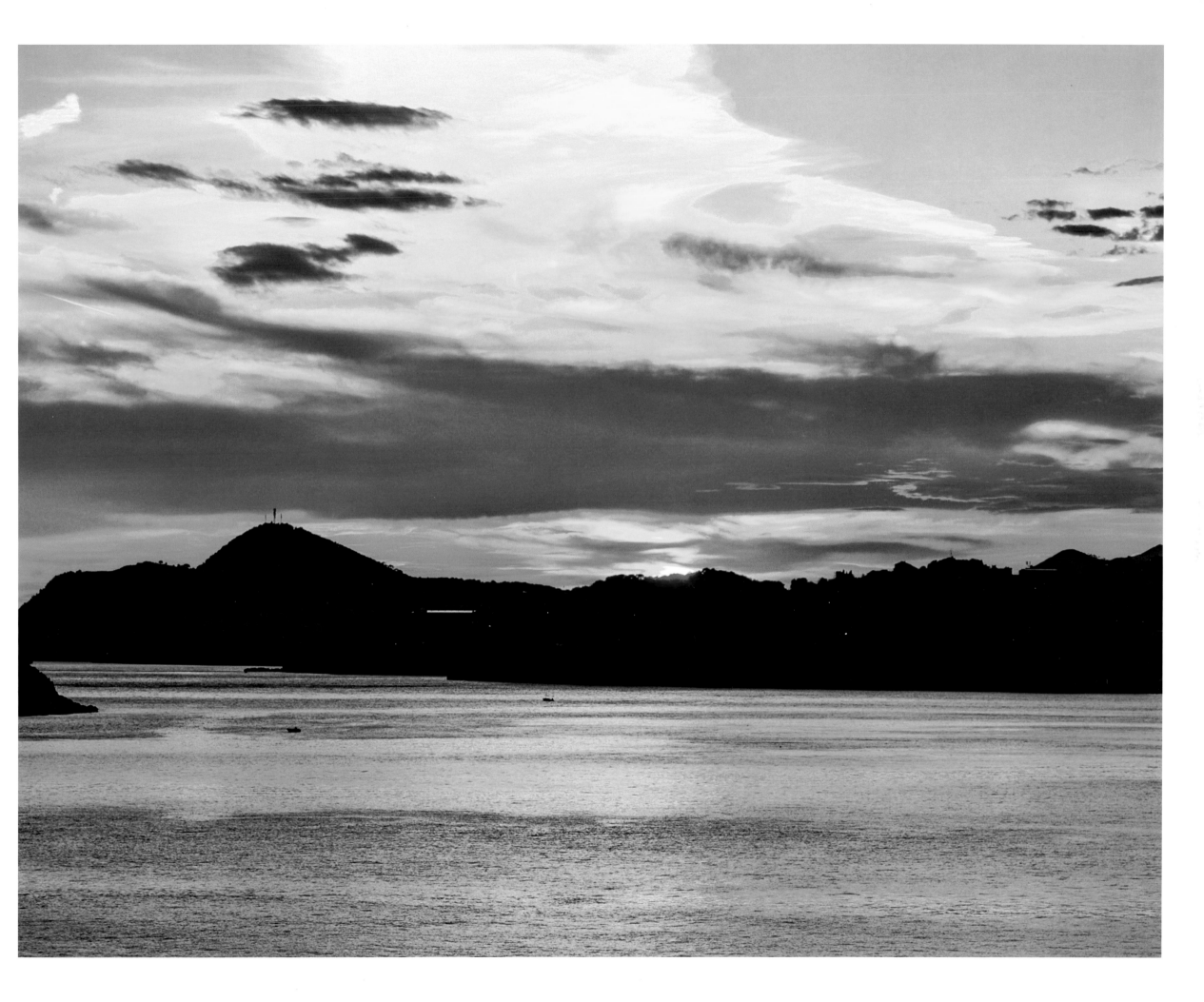

Valencia, Spain

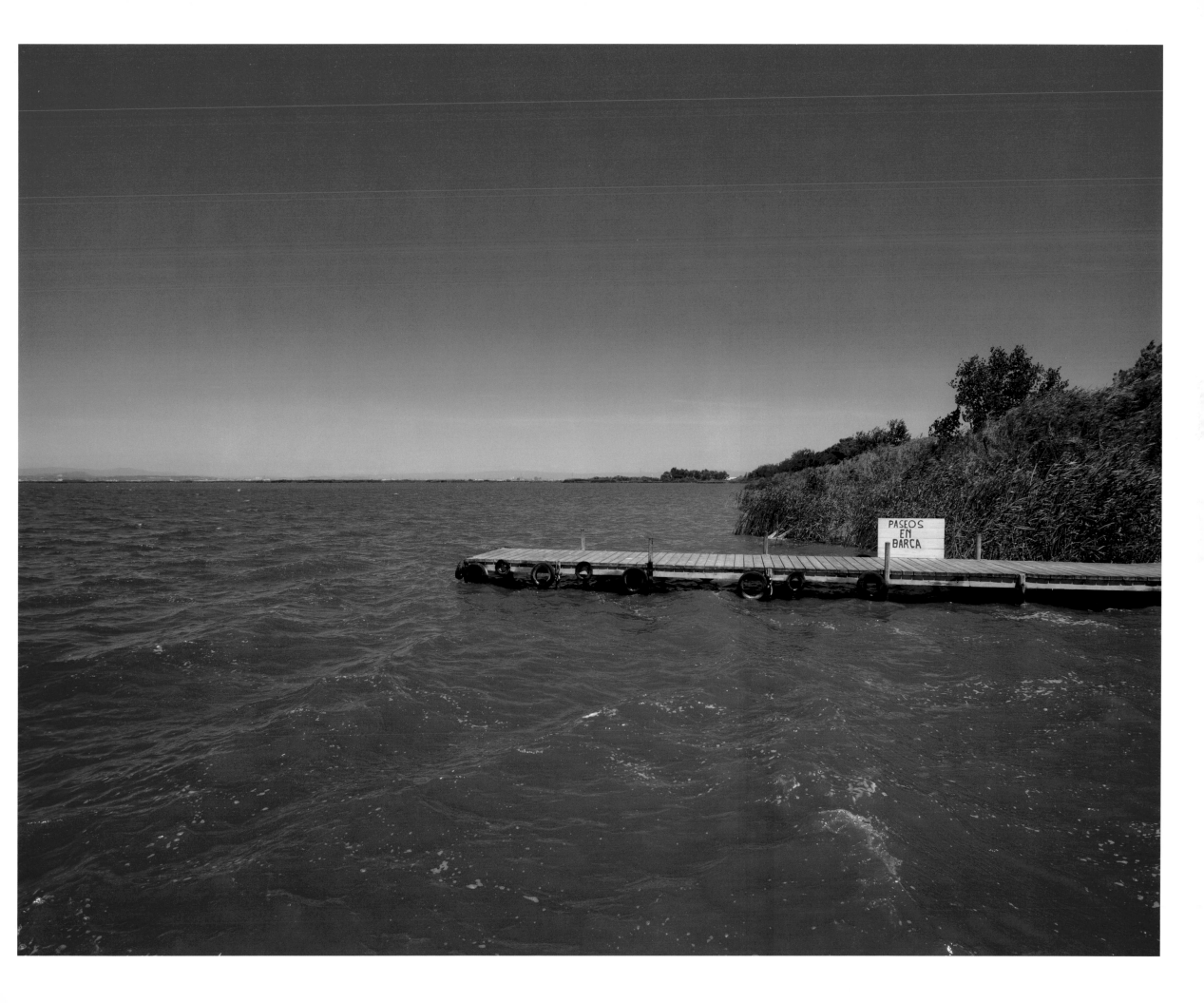

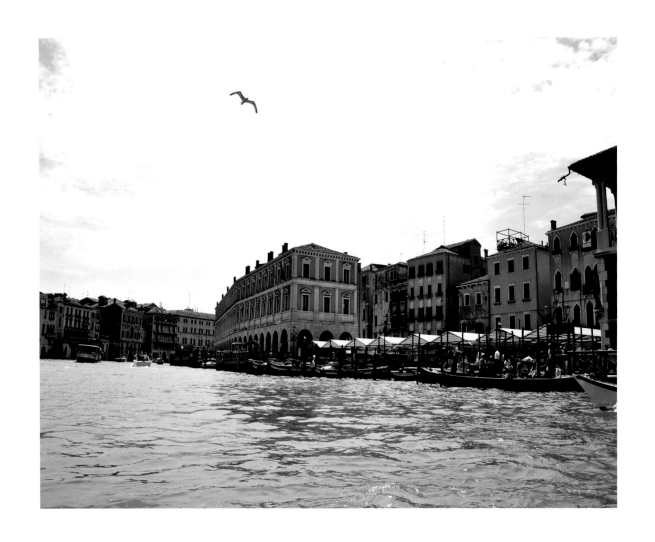
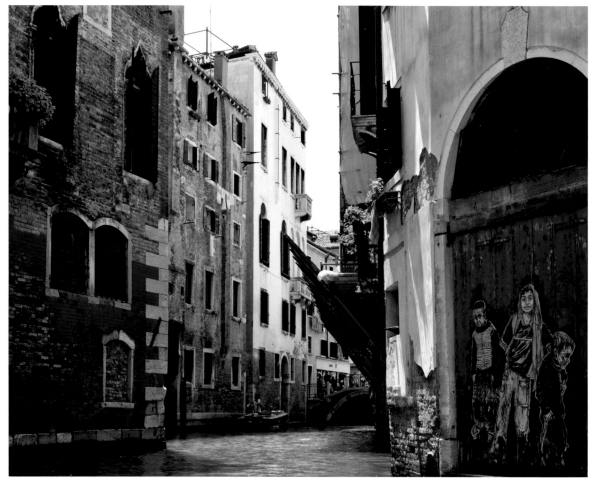

Venice, Italy

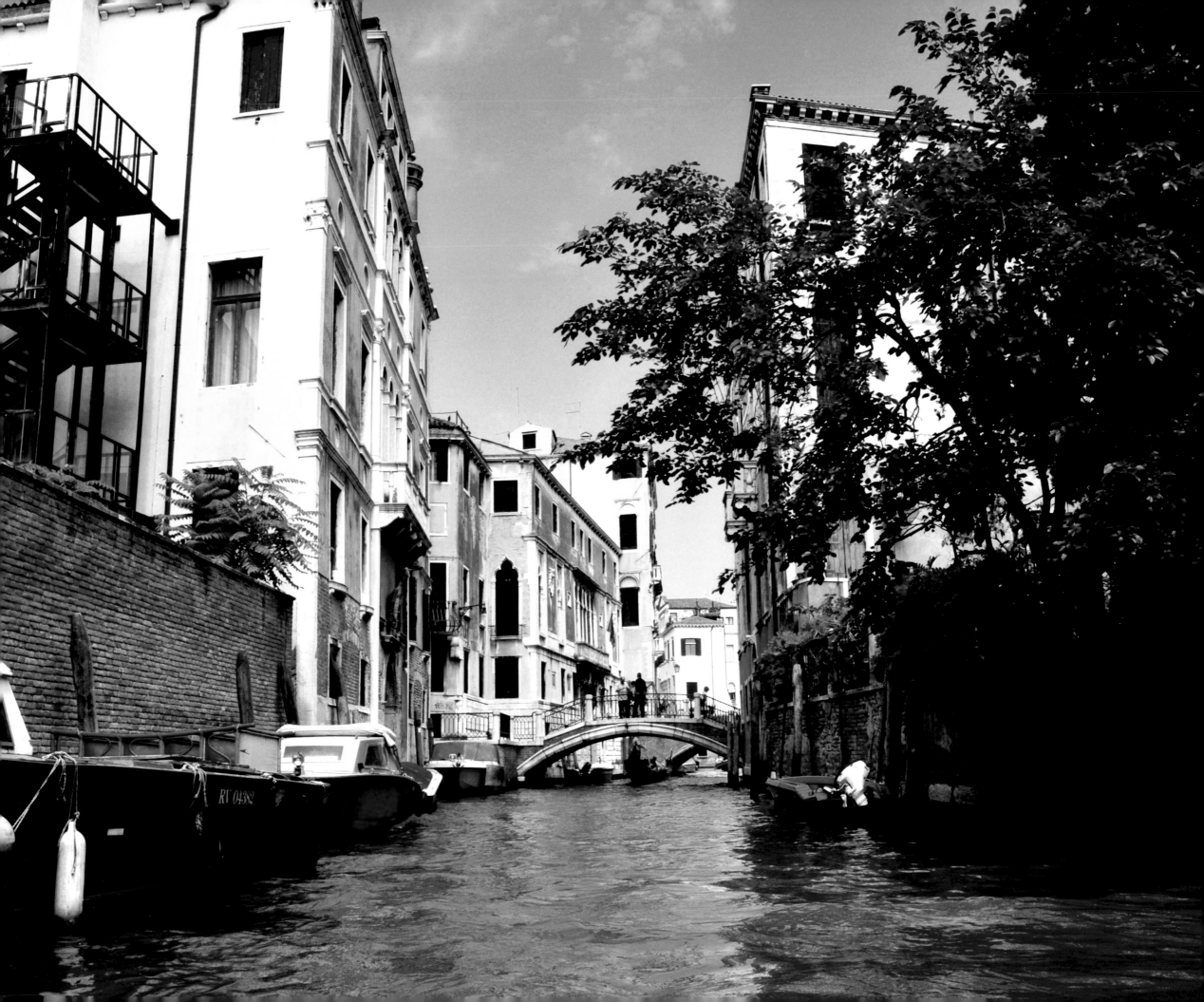

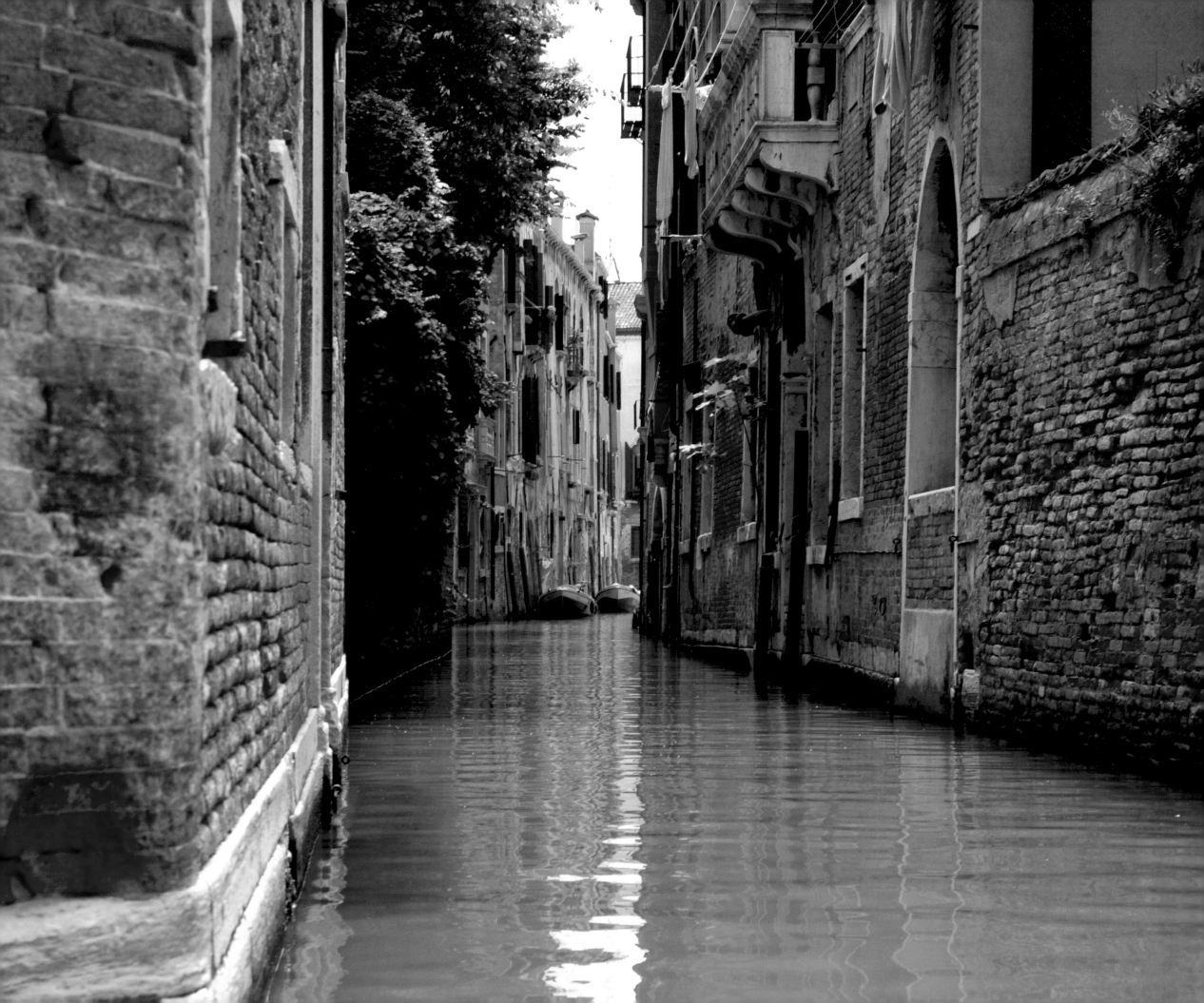

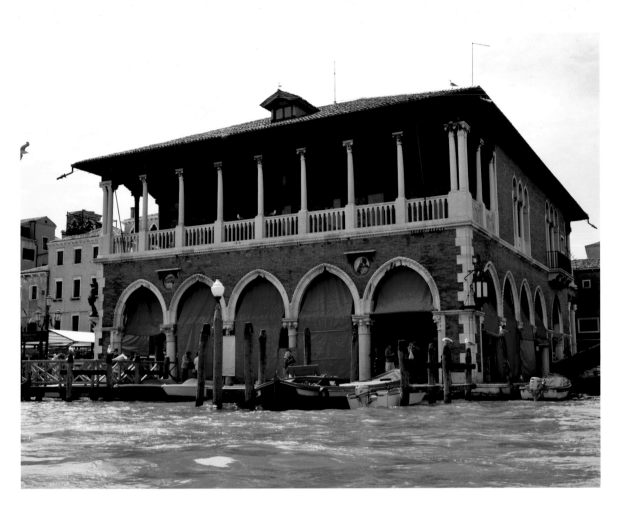

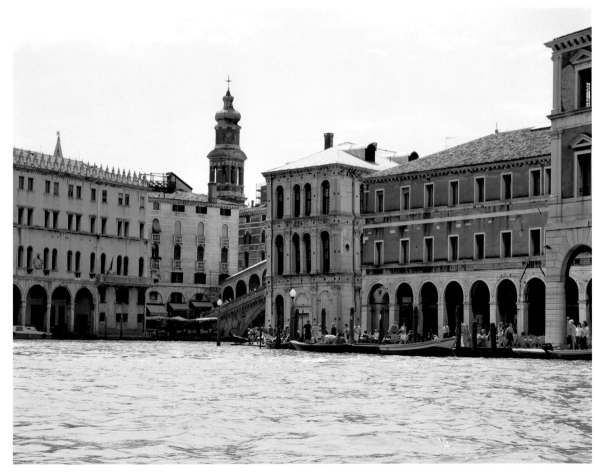

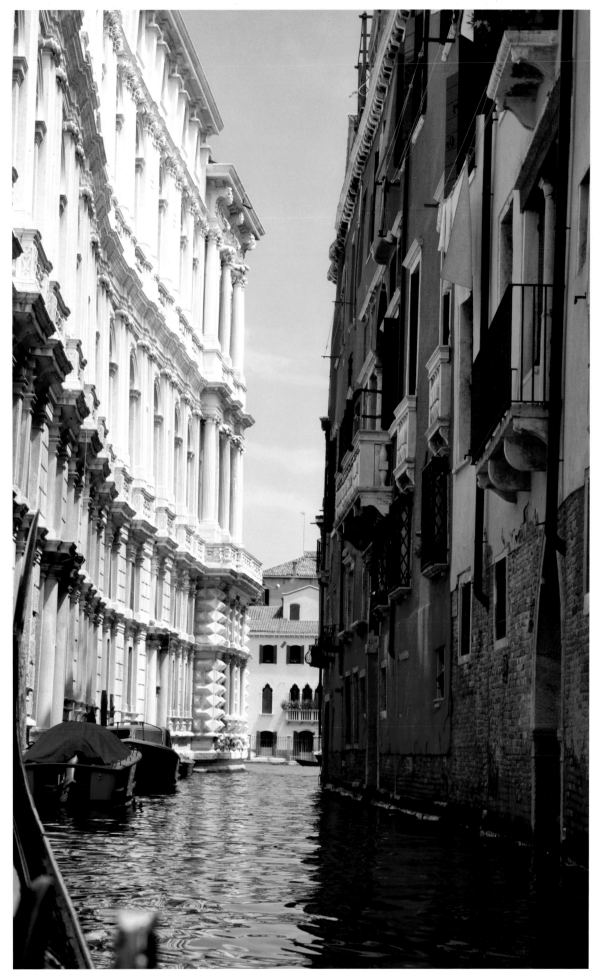

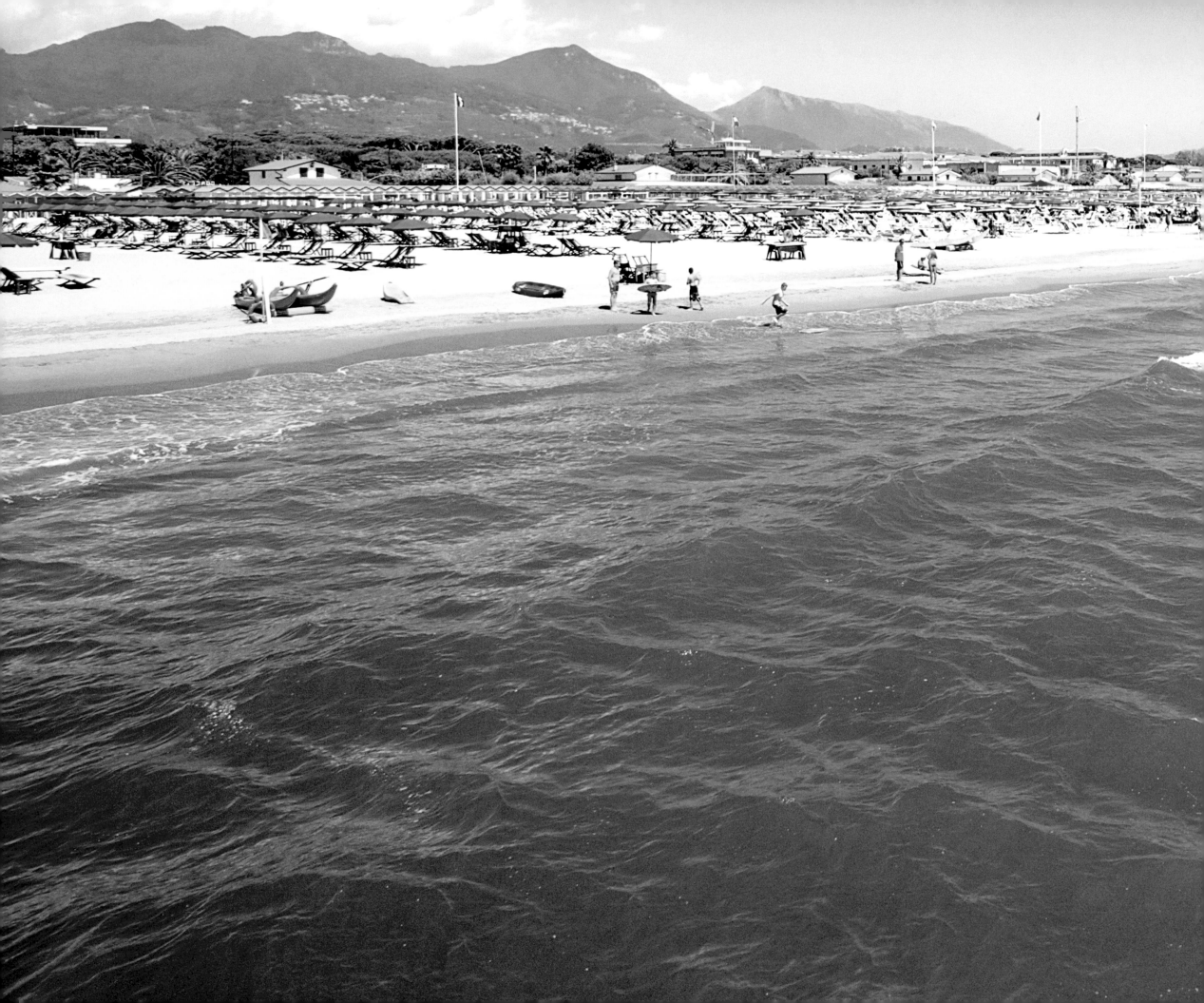

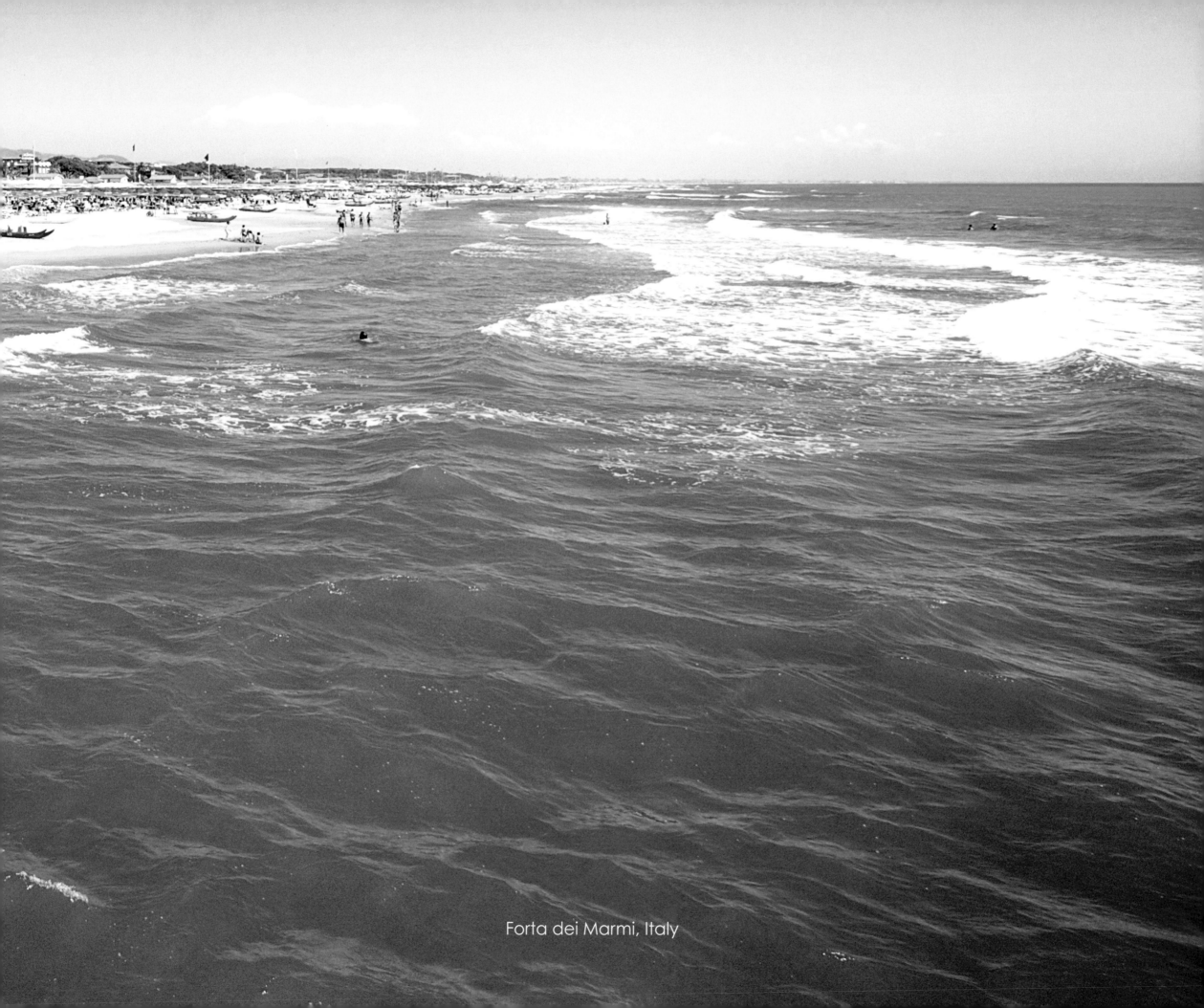

Forta dei Marmi, Italy

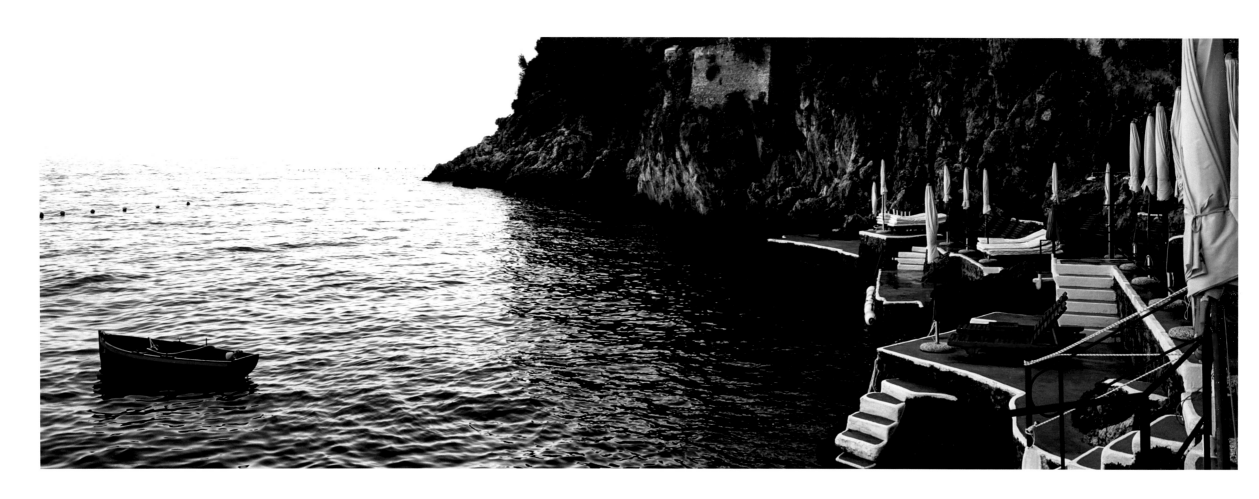

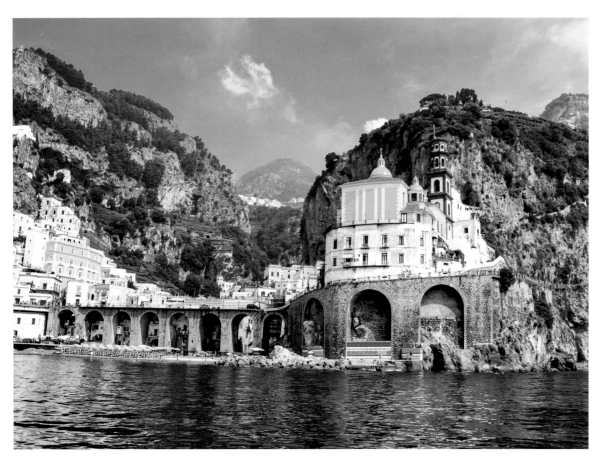

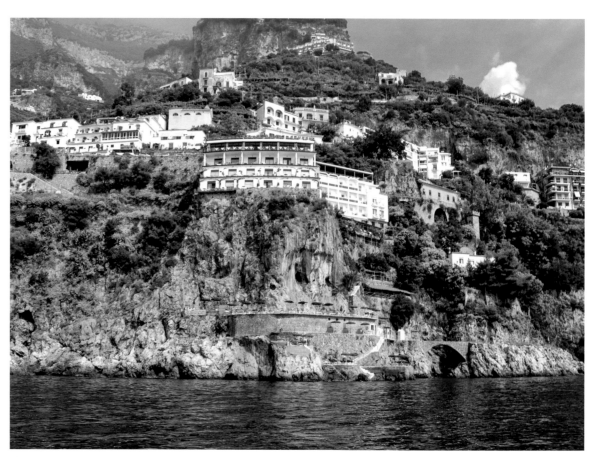

Amalfi to Positano, Italy

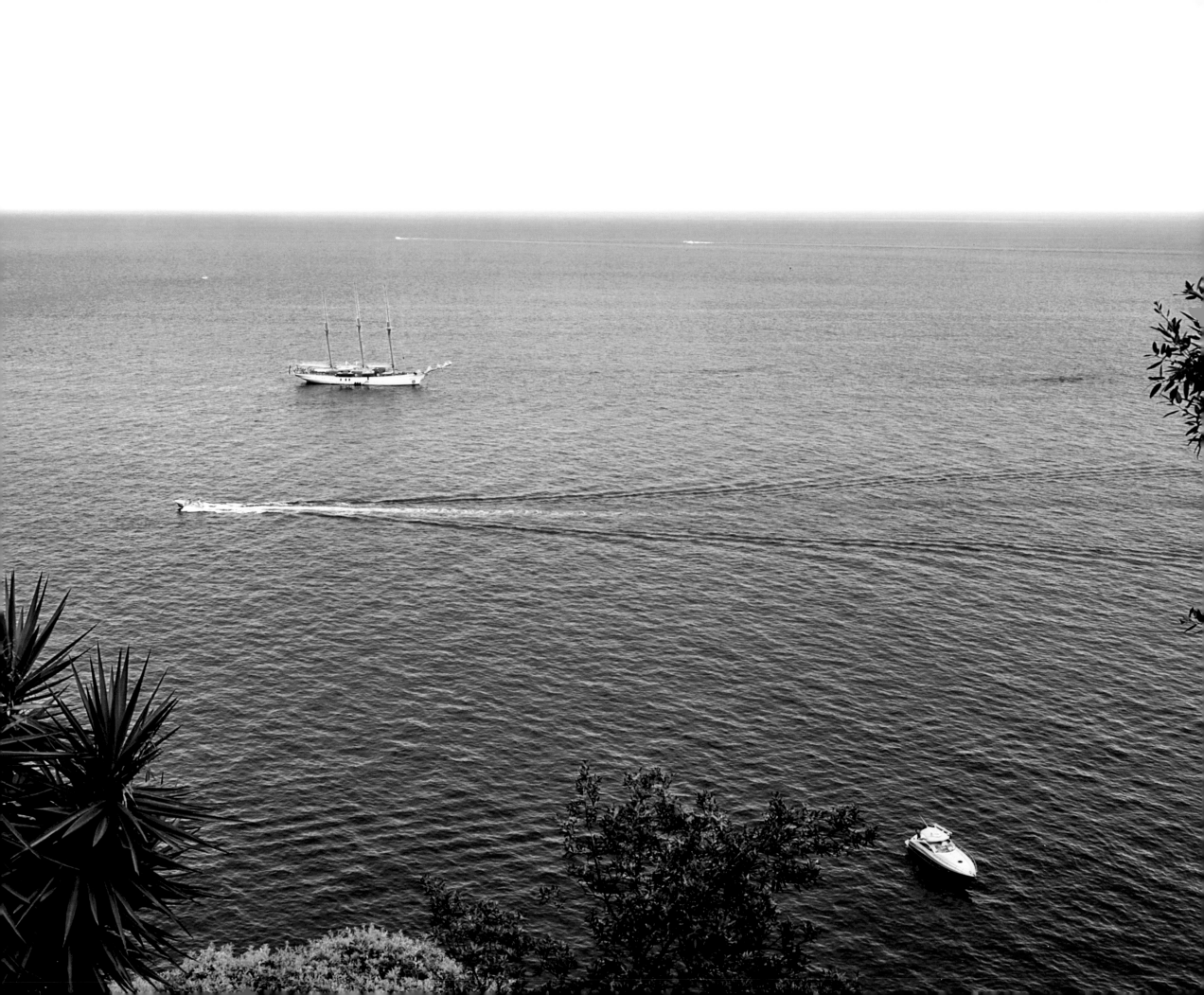

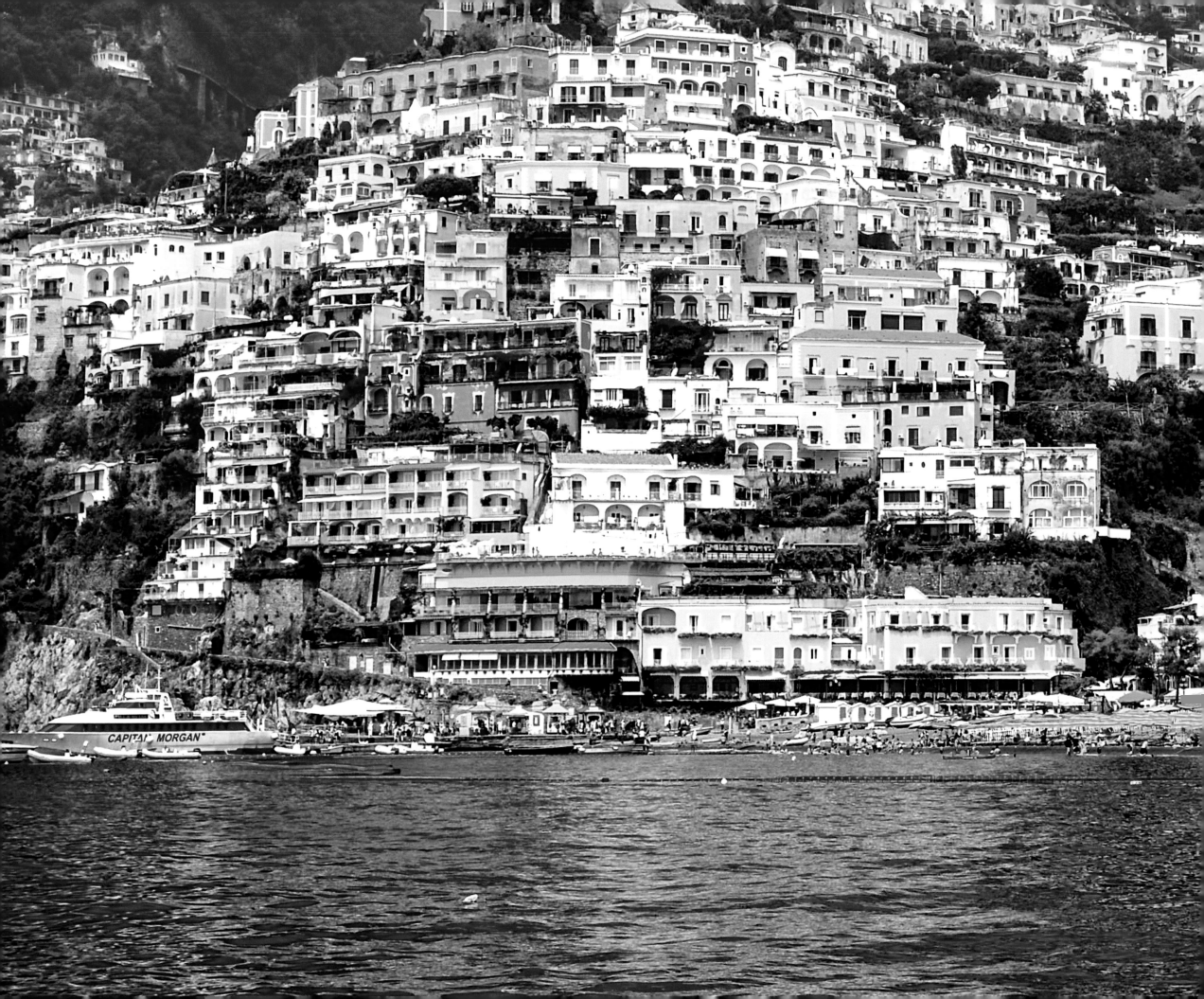

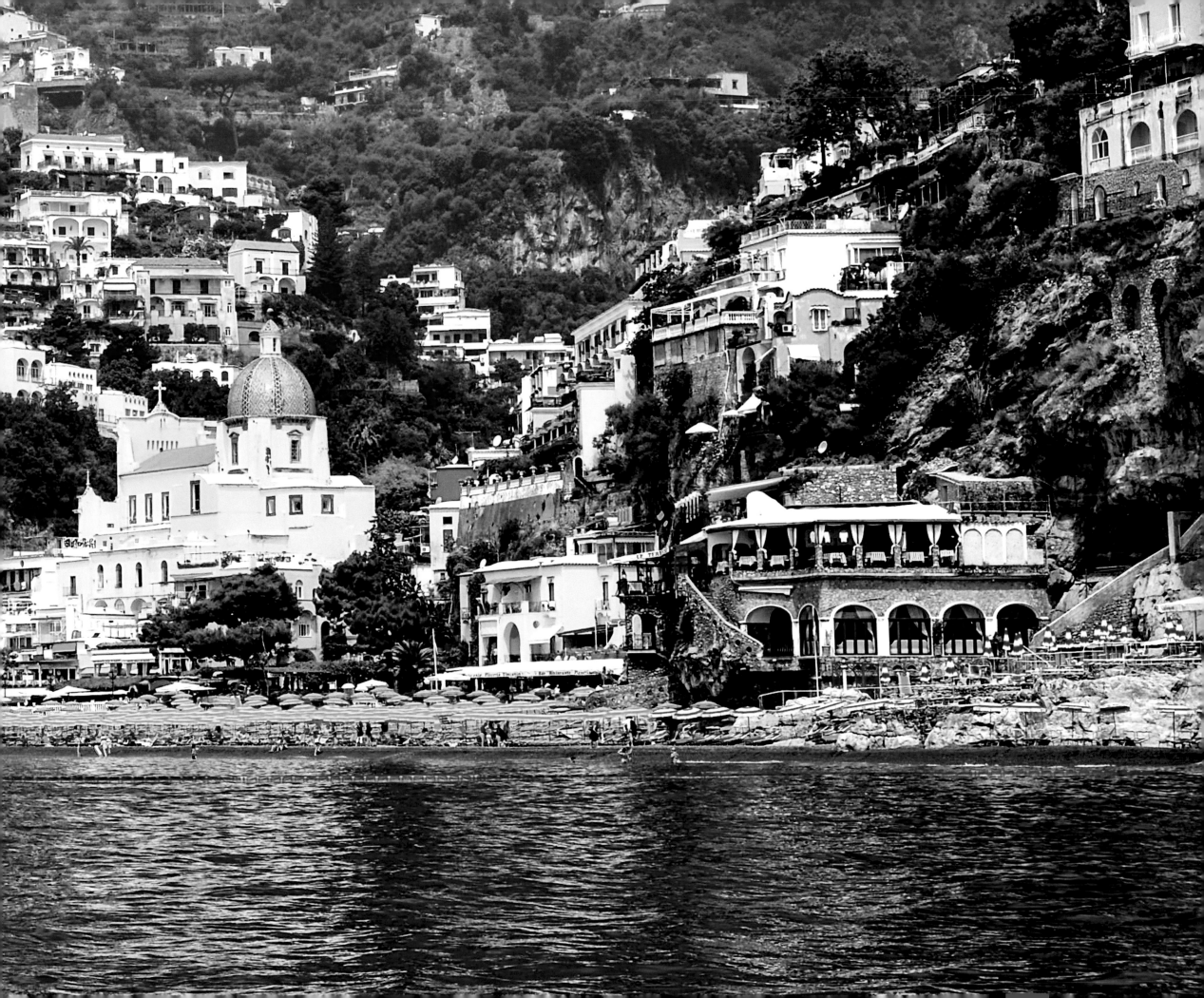

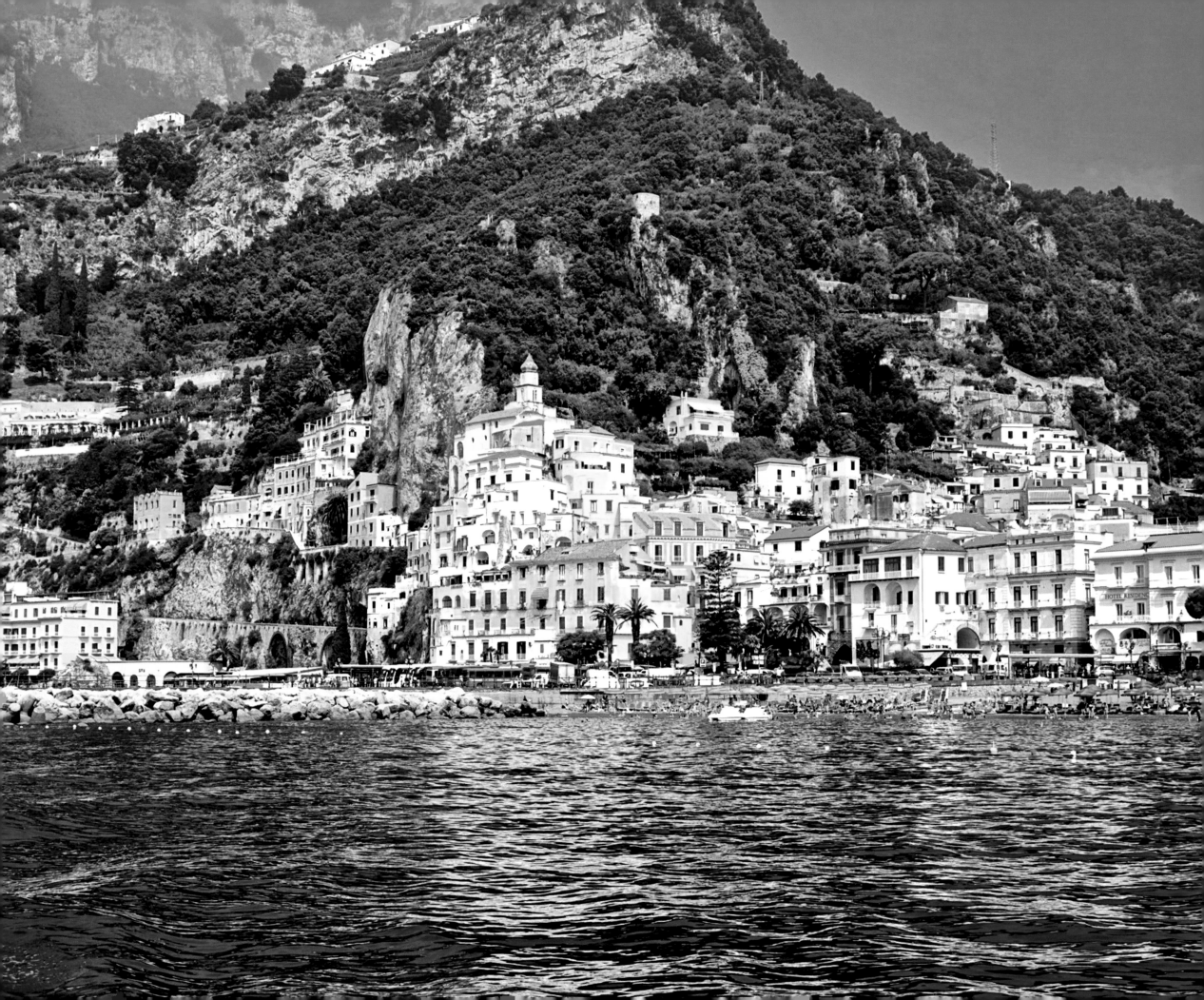

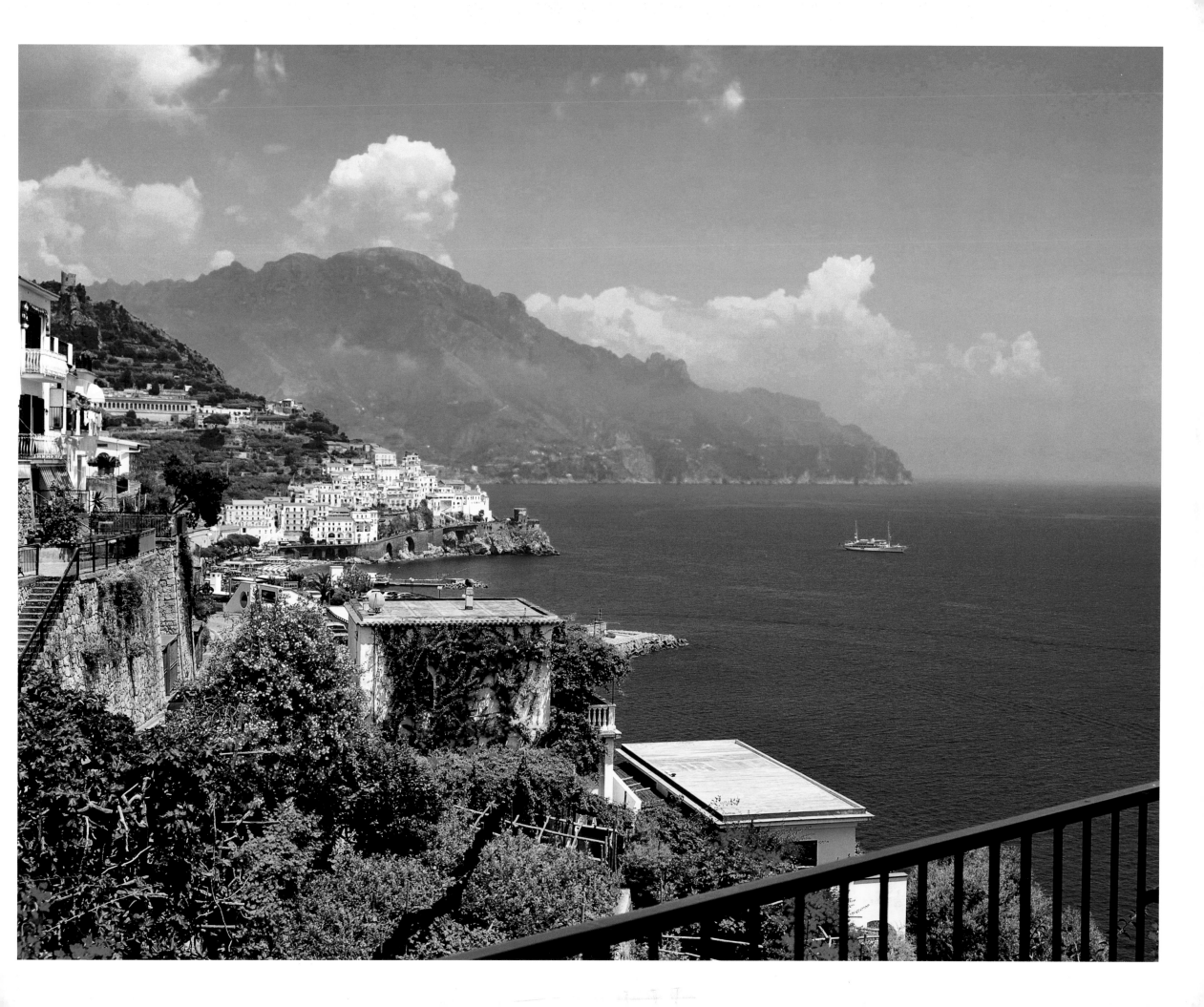

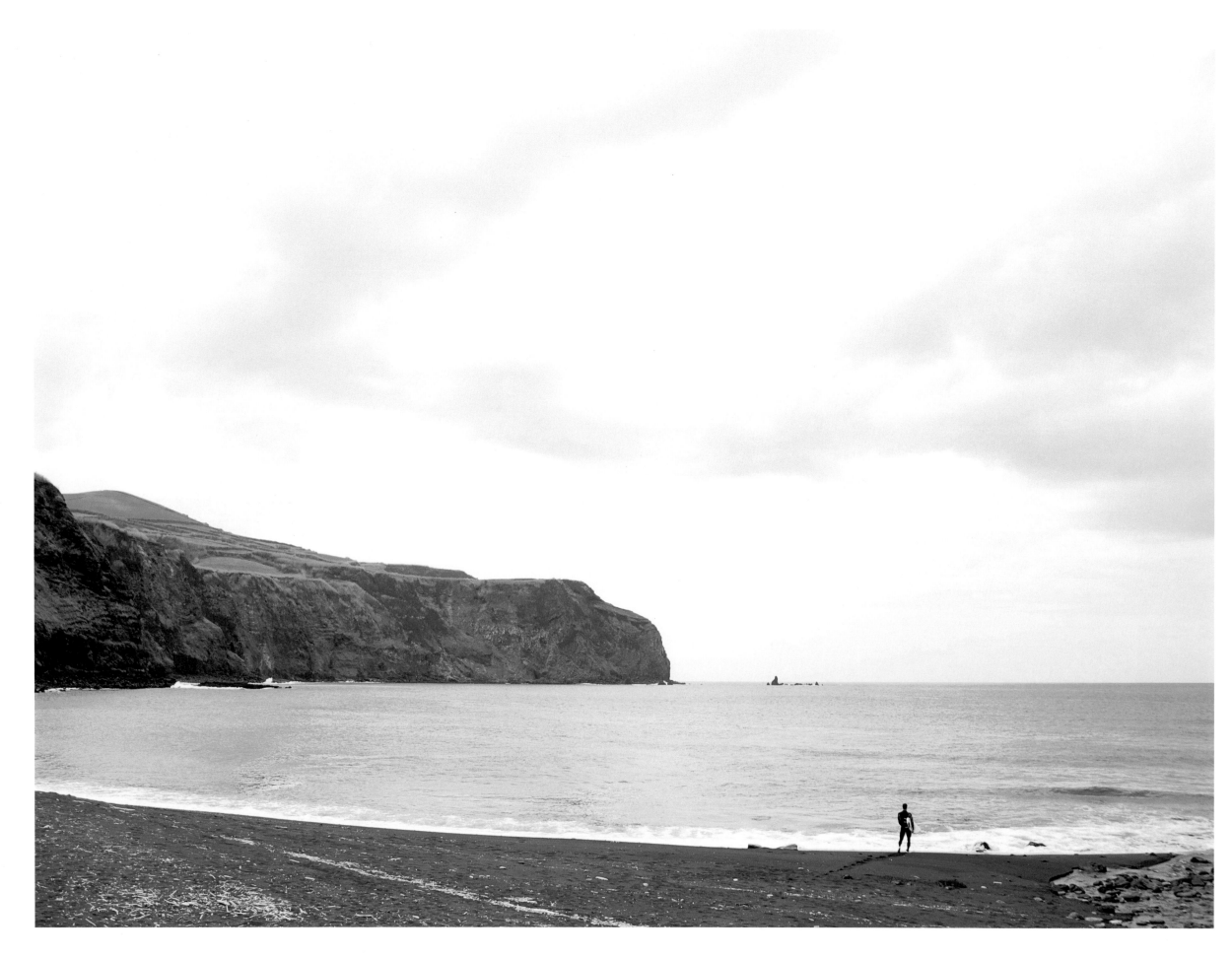

Azores, Portugal

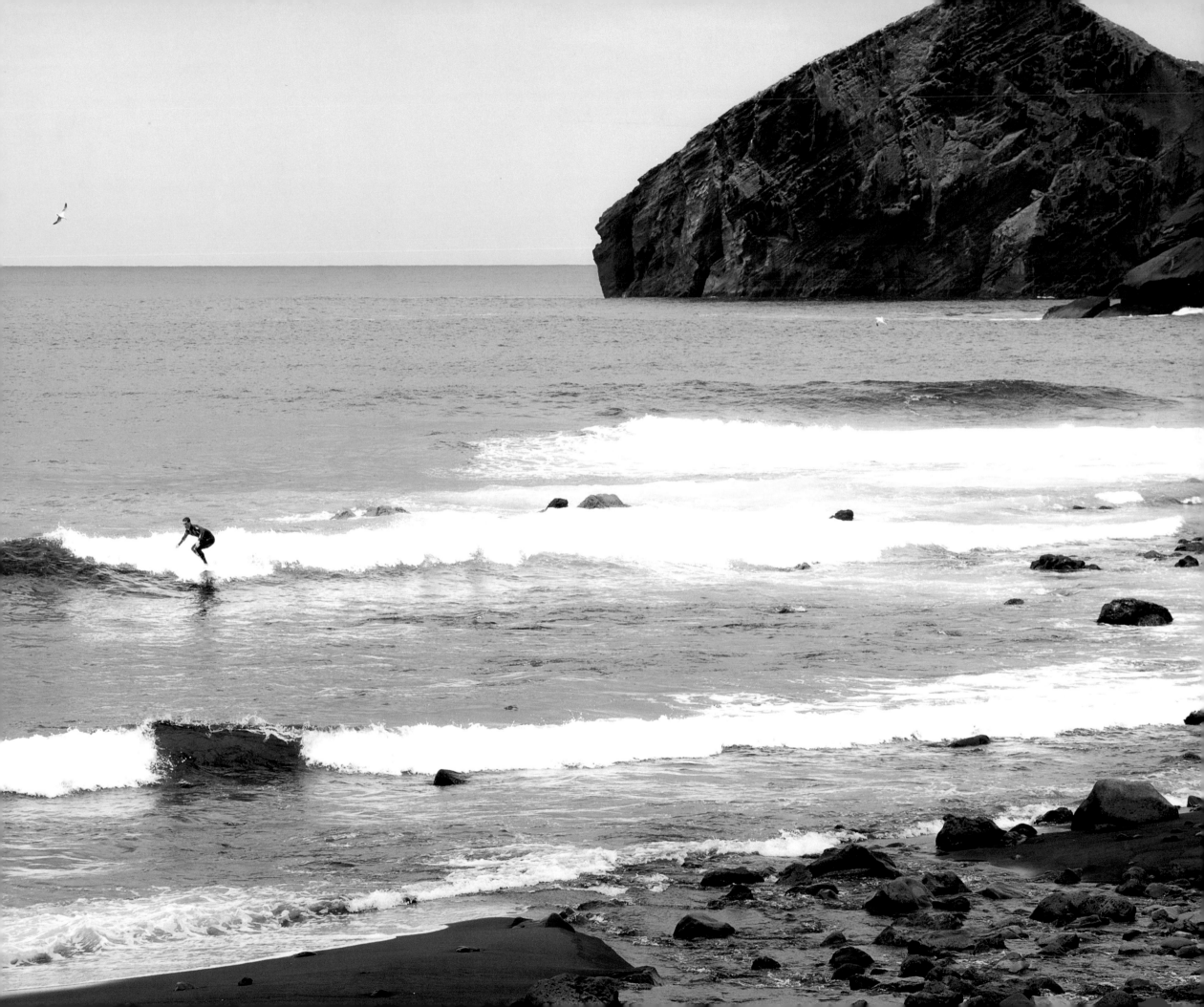

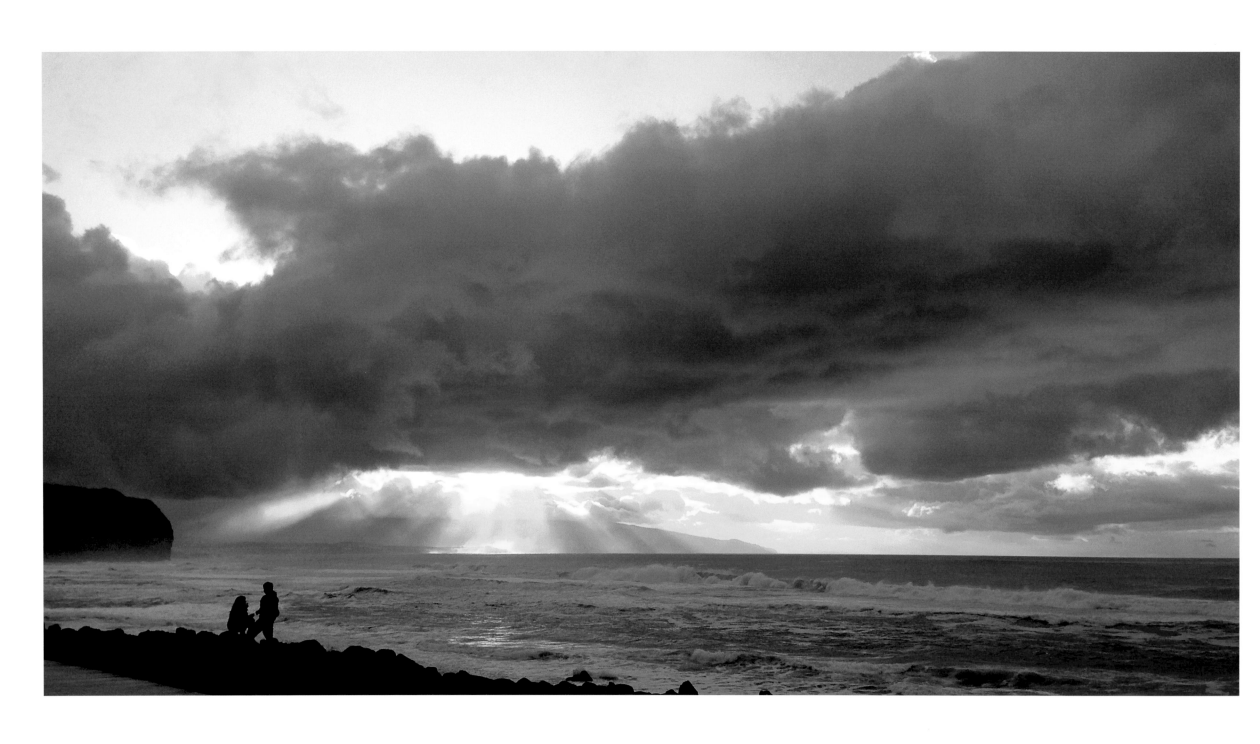

Ponta Delgado, Portugal

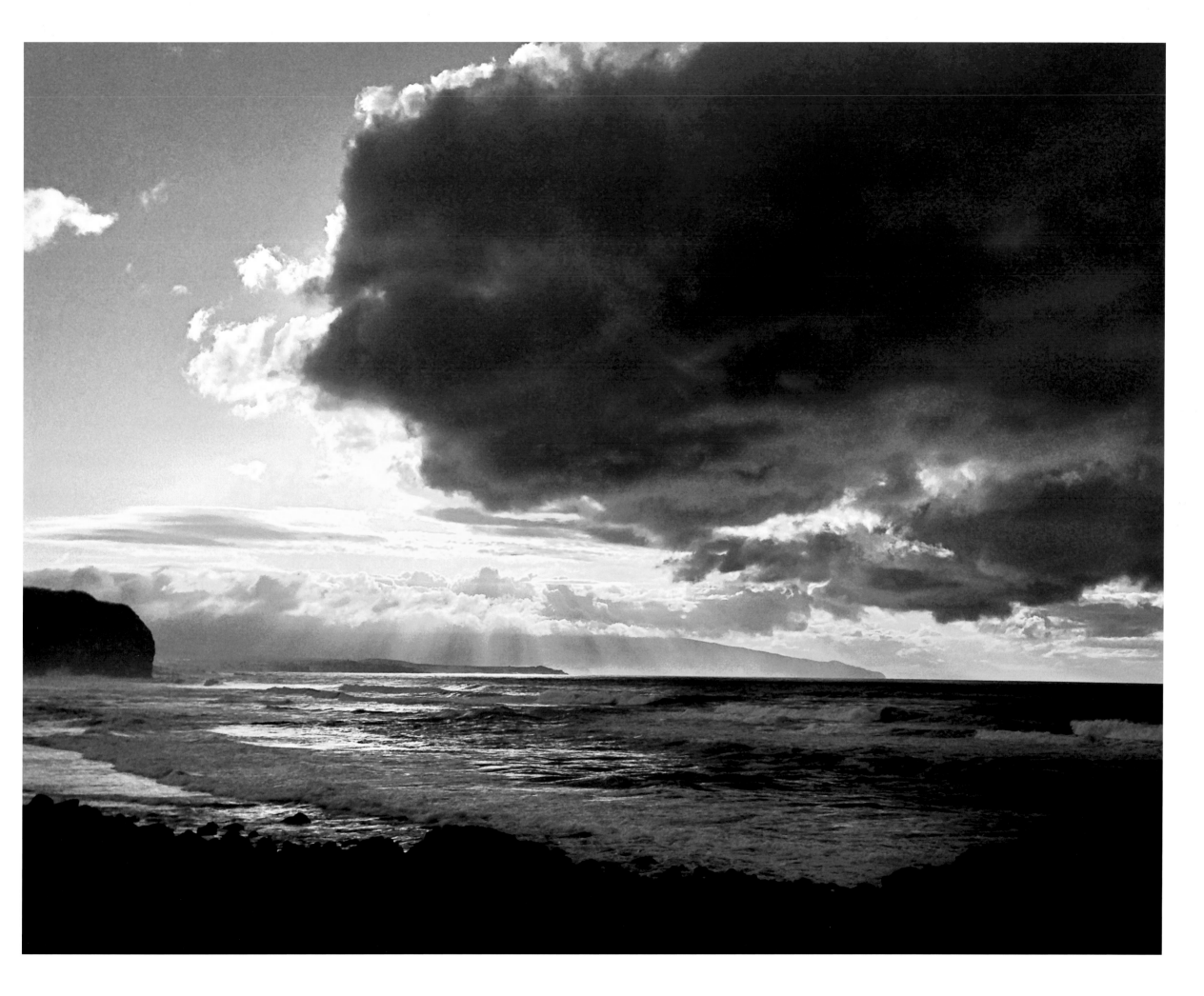

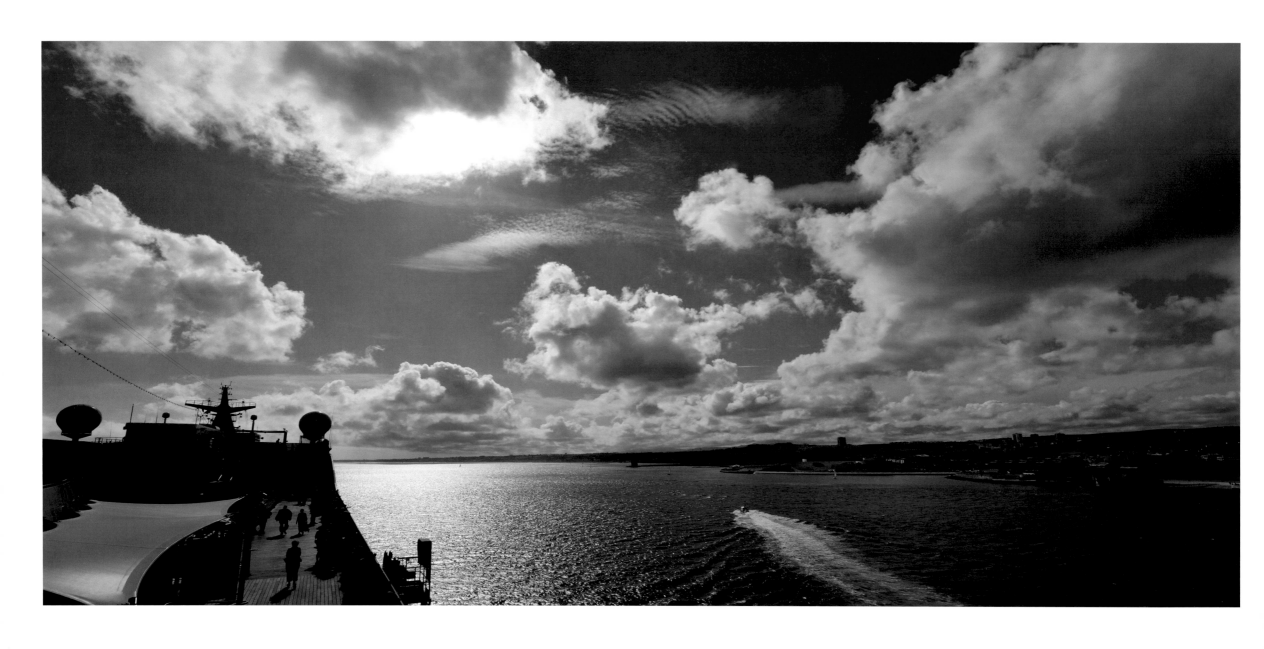

Lisbon, Portugal

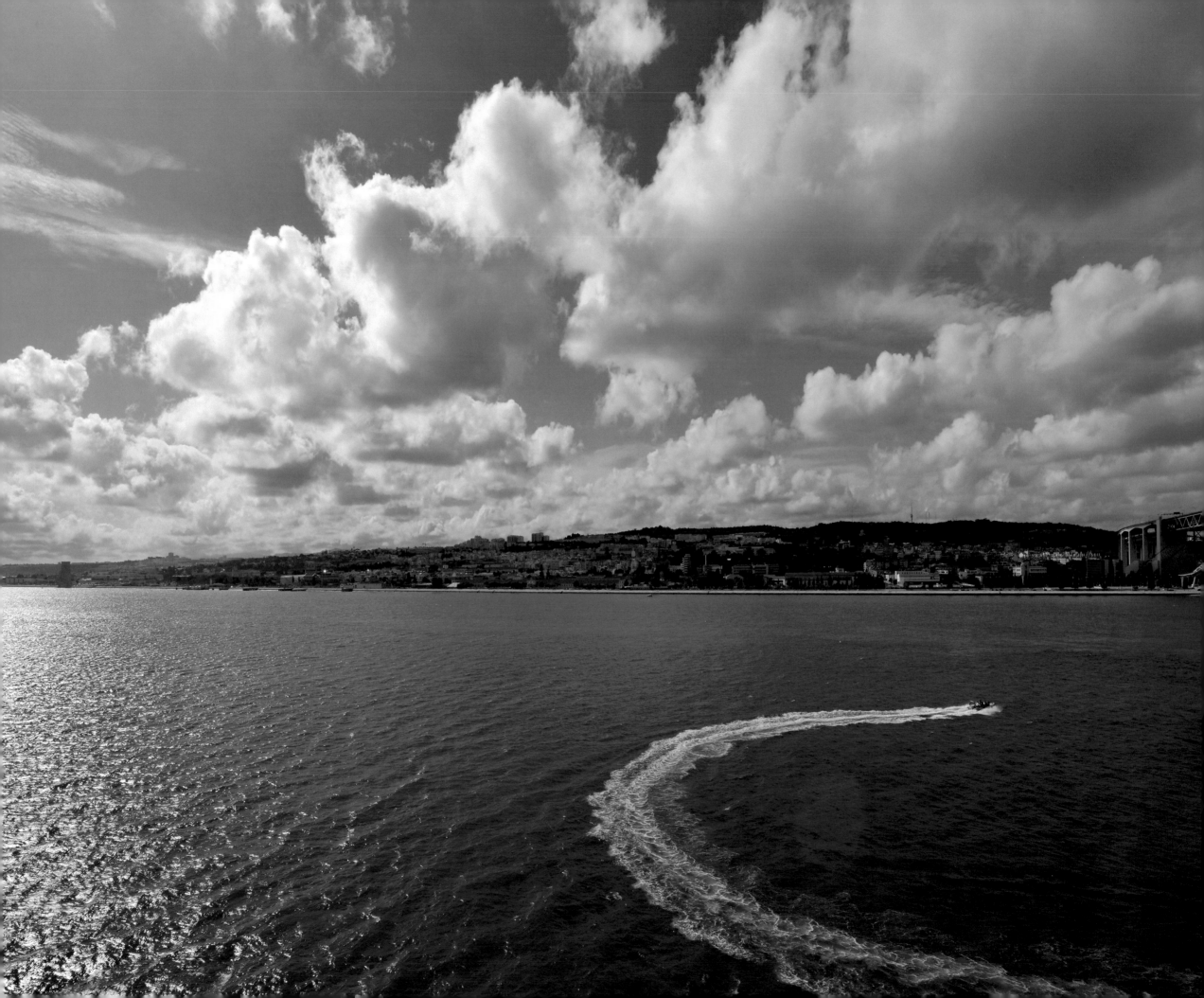

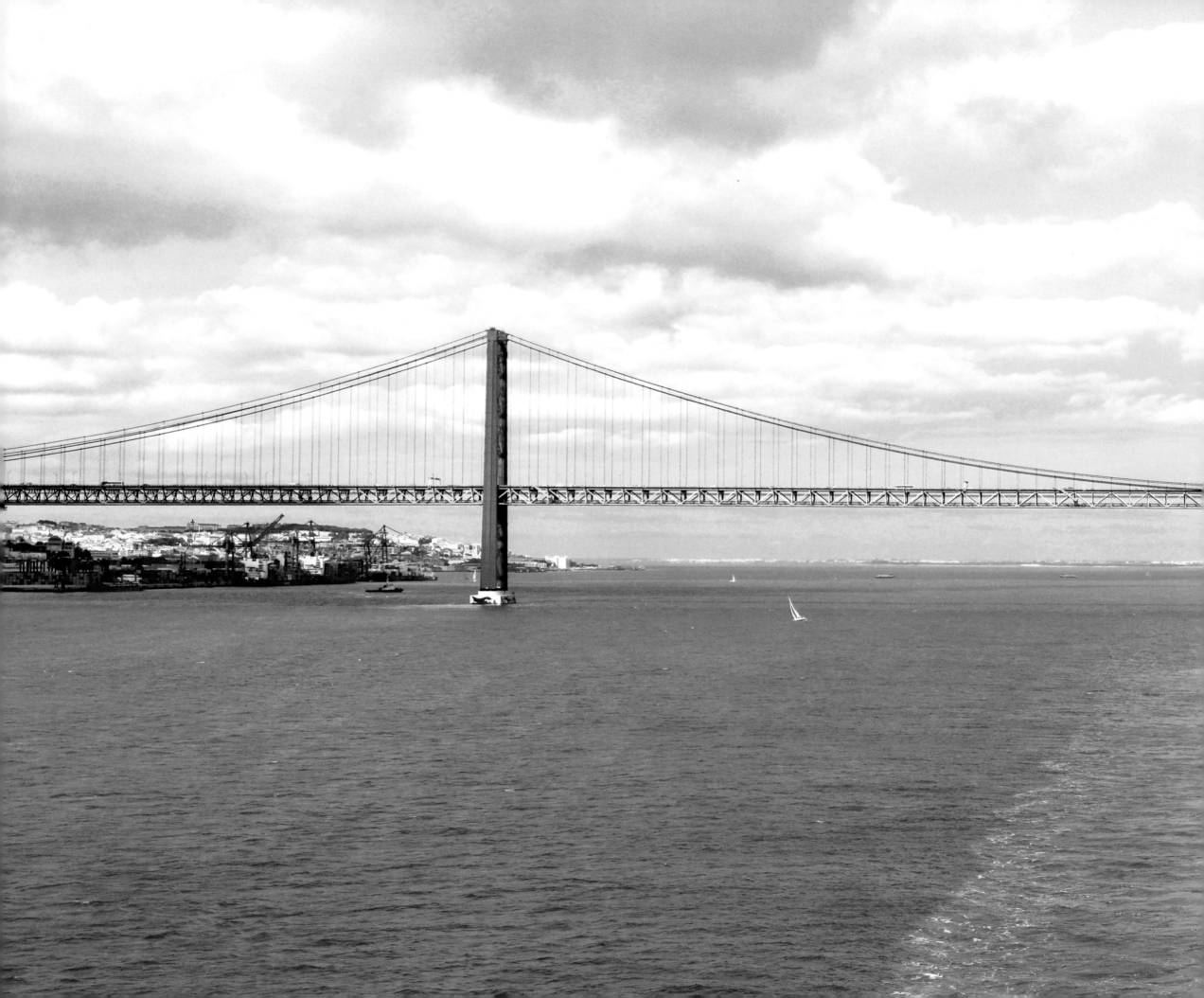

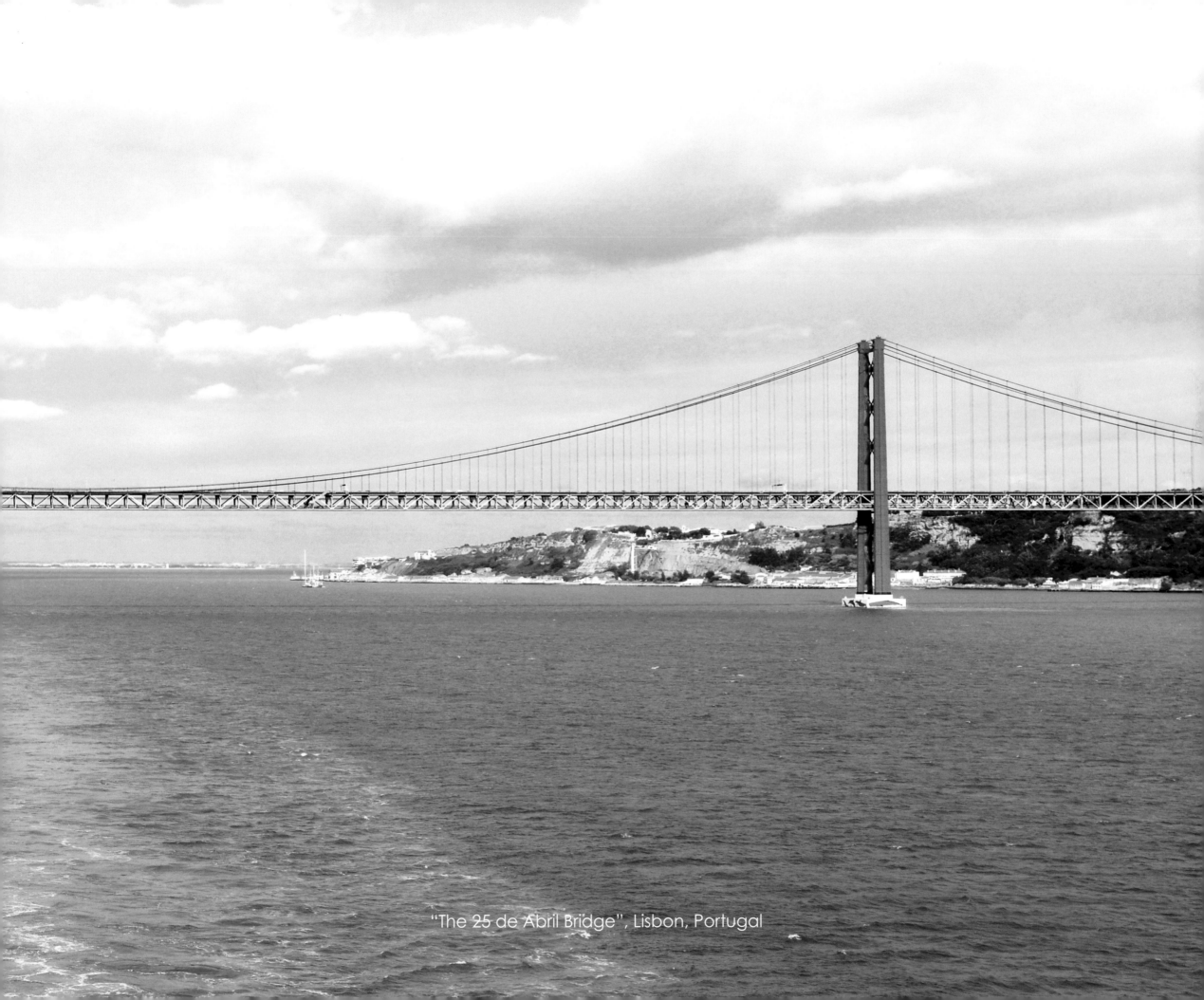

"The 25 de Abril Bridge", Lisbon, Portugal

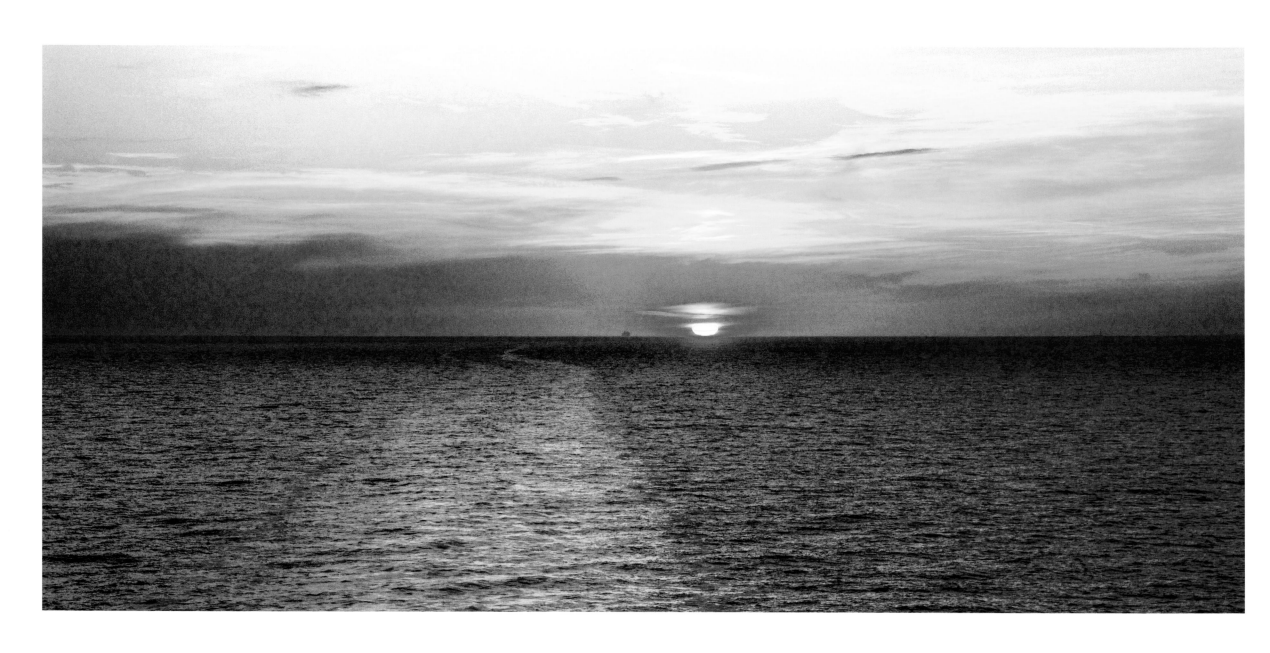

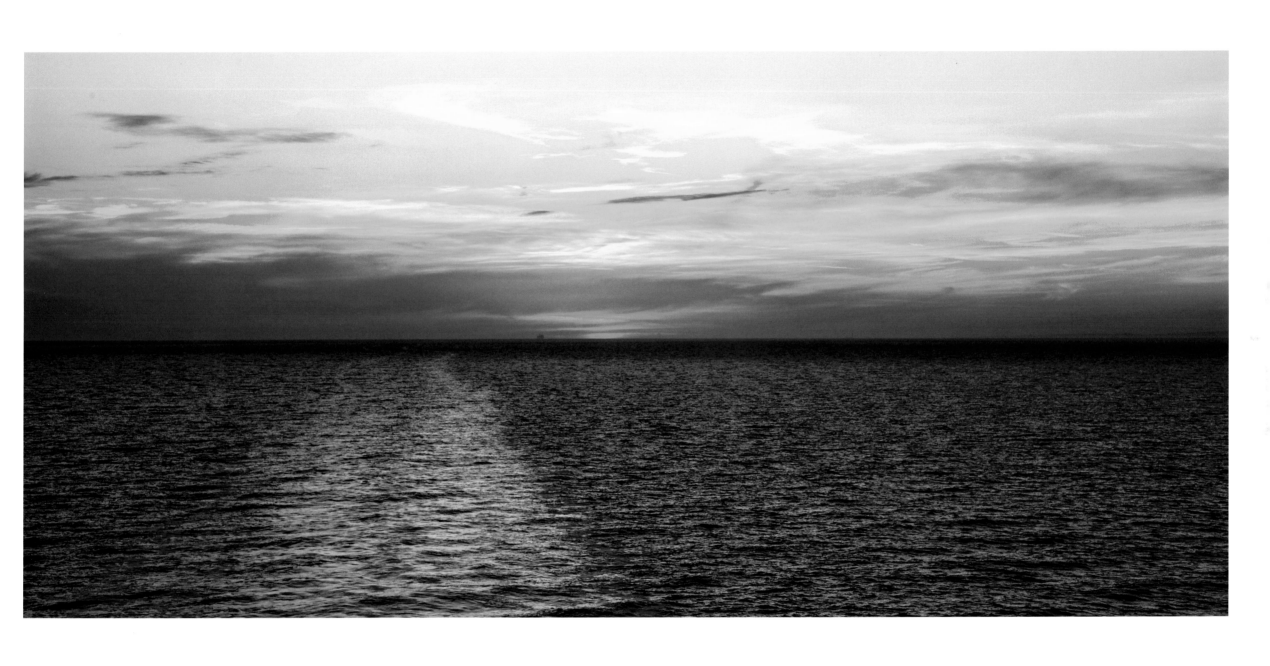

Off the Coast of Marseille, France

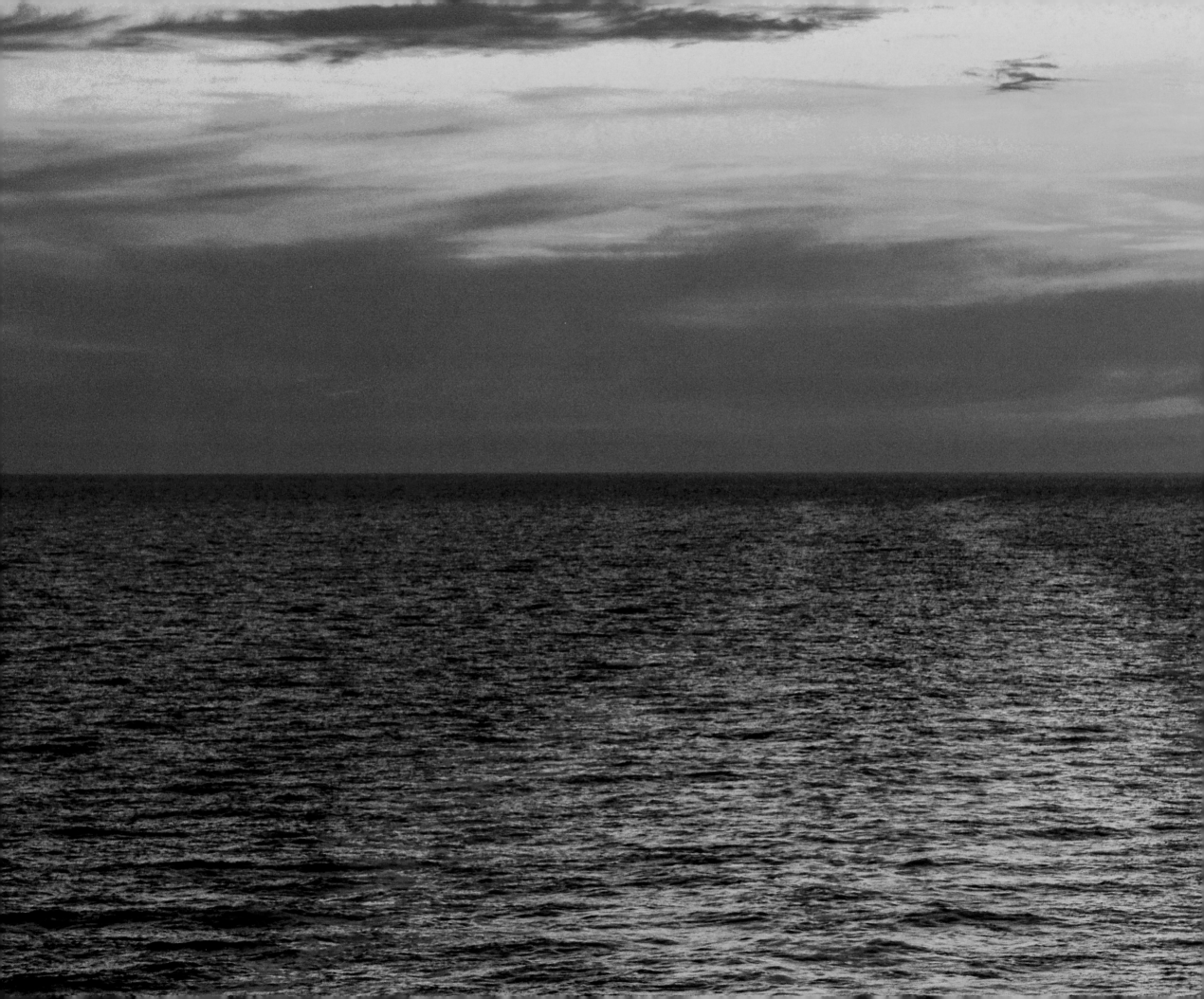

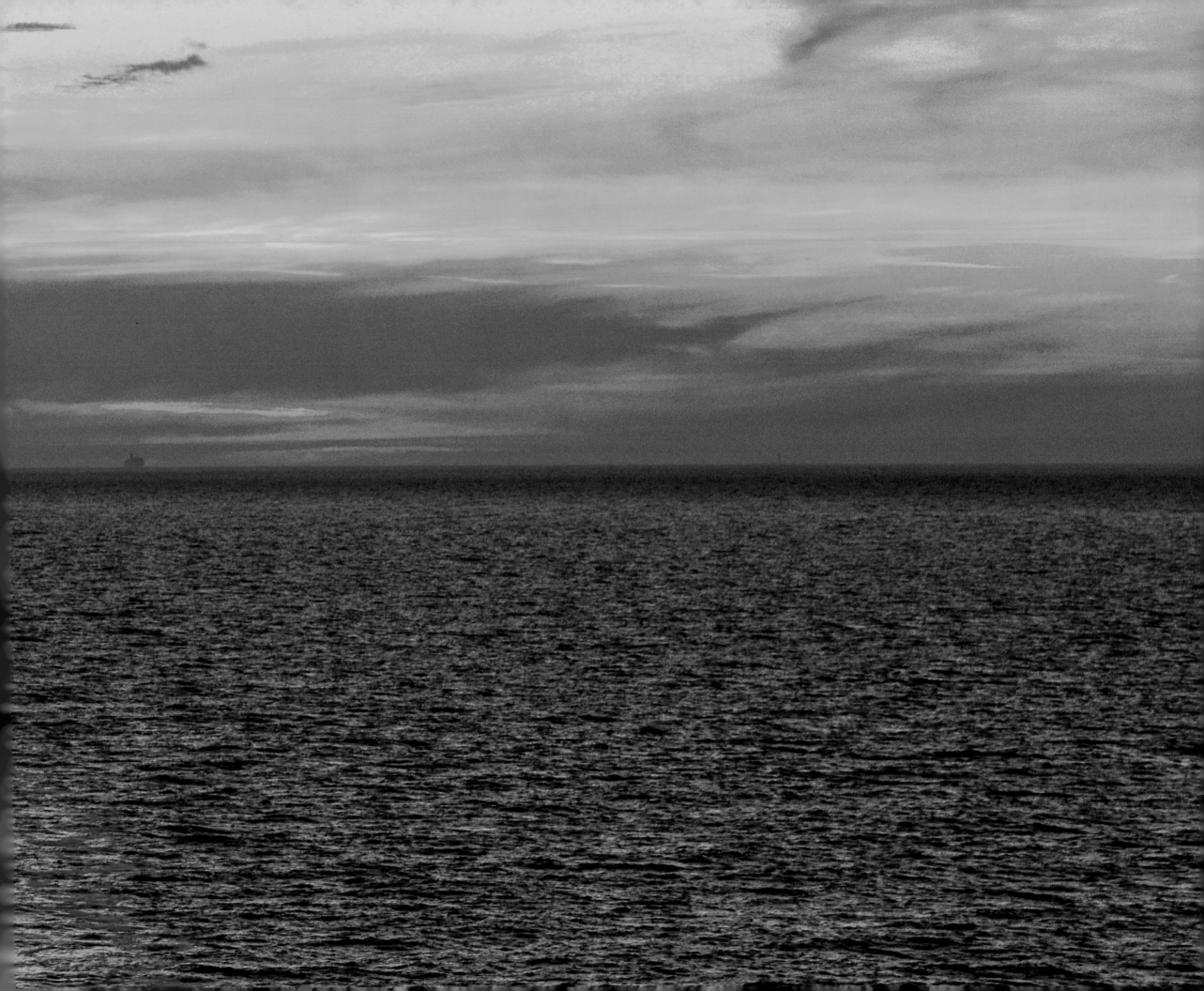

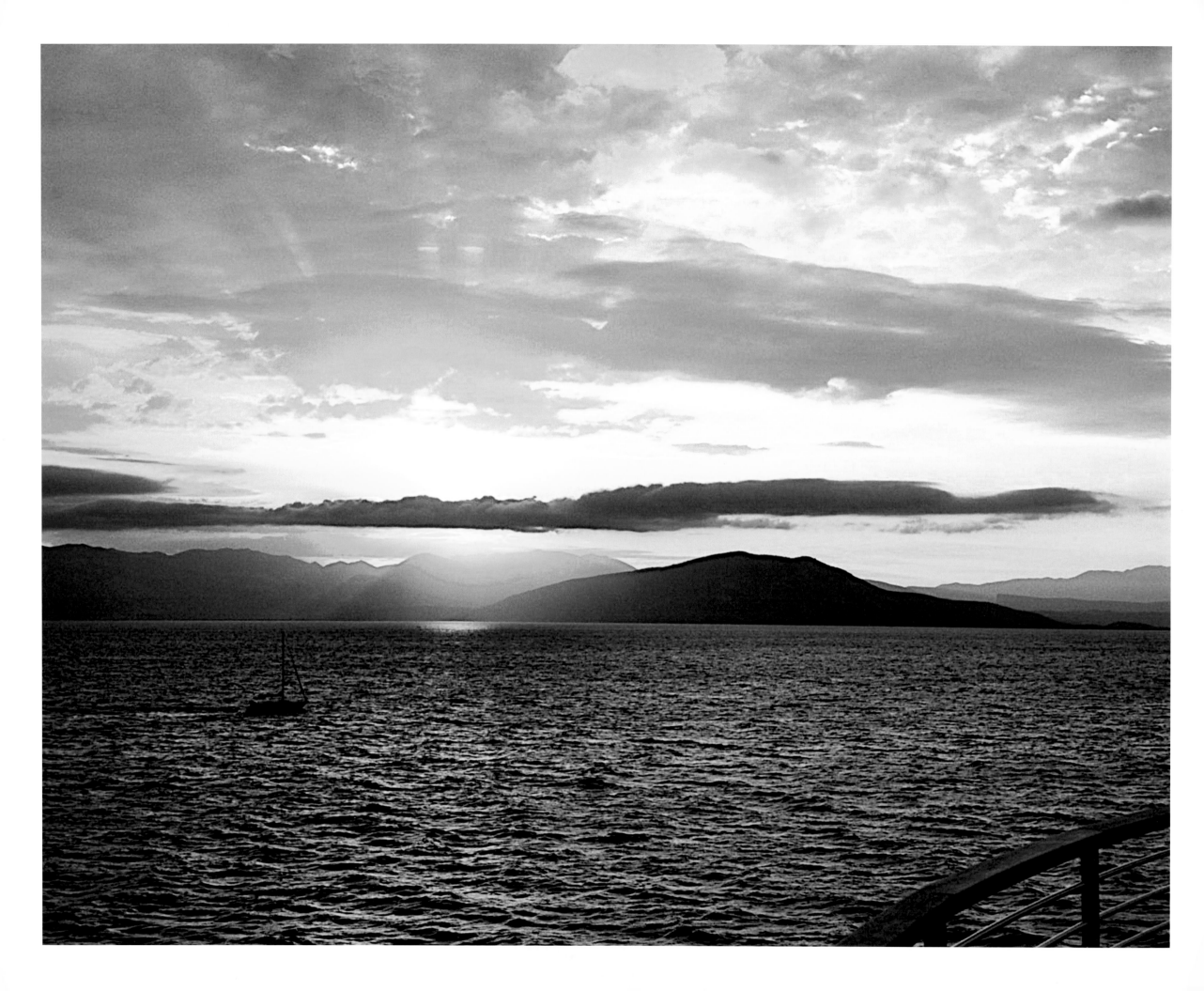

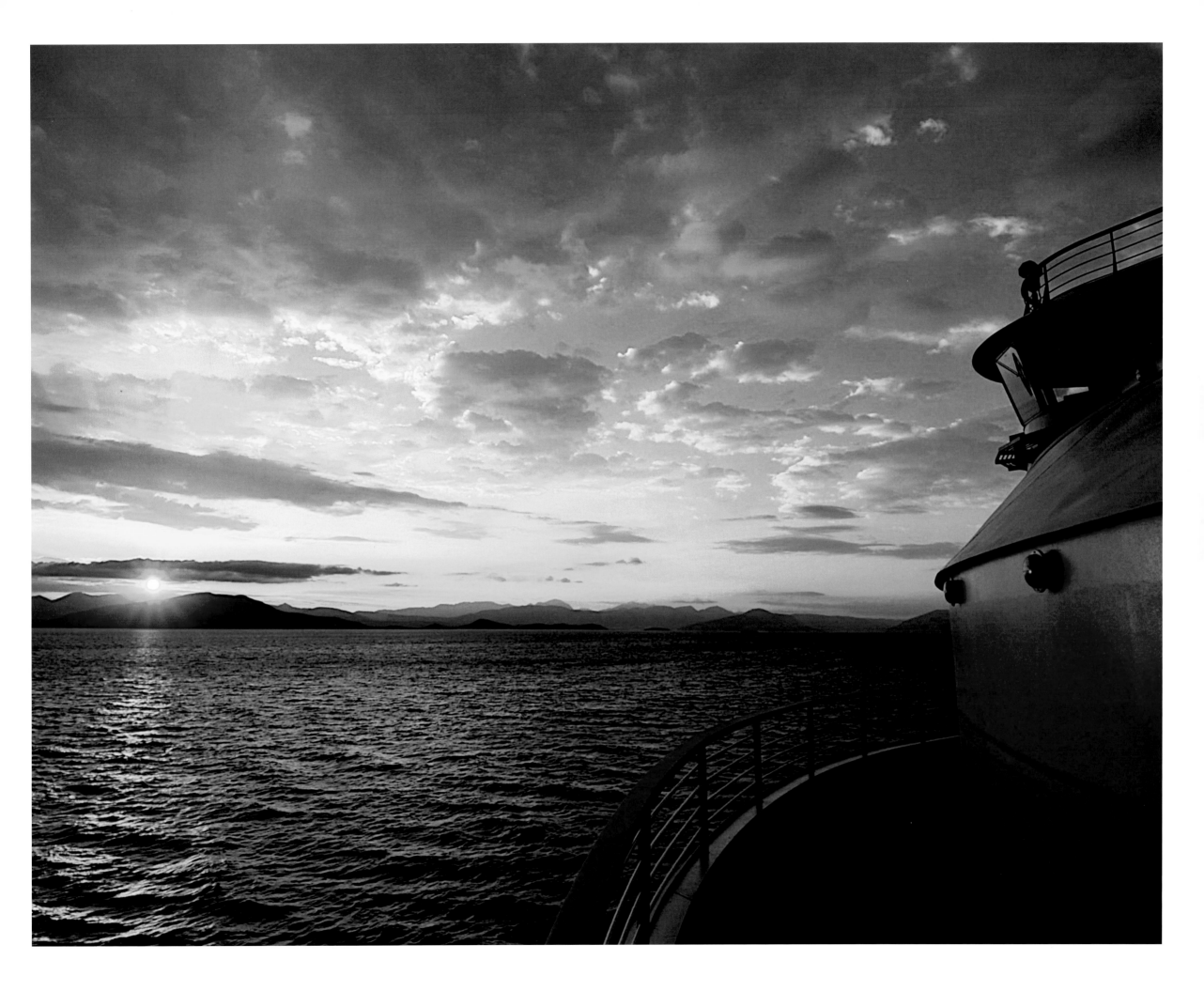

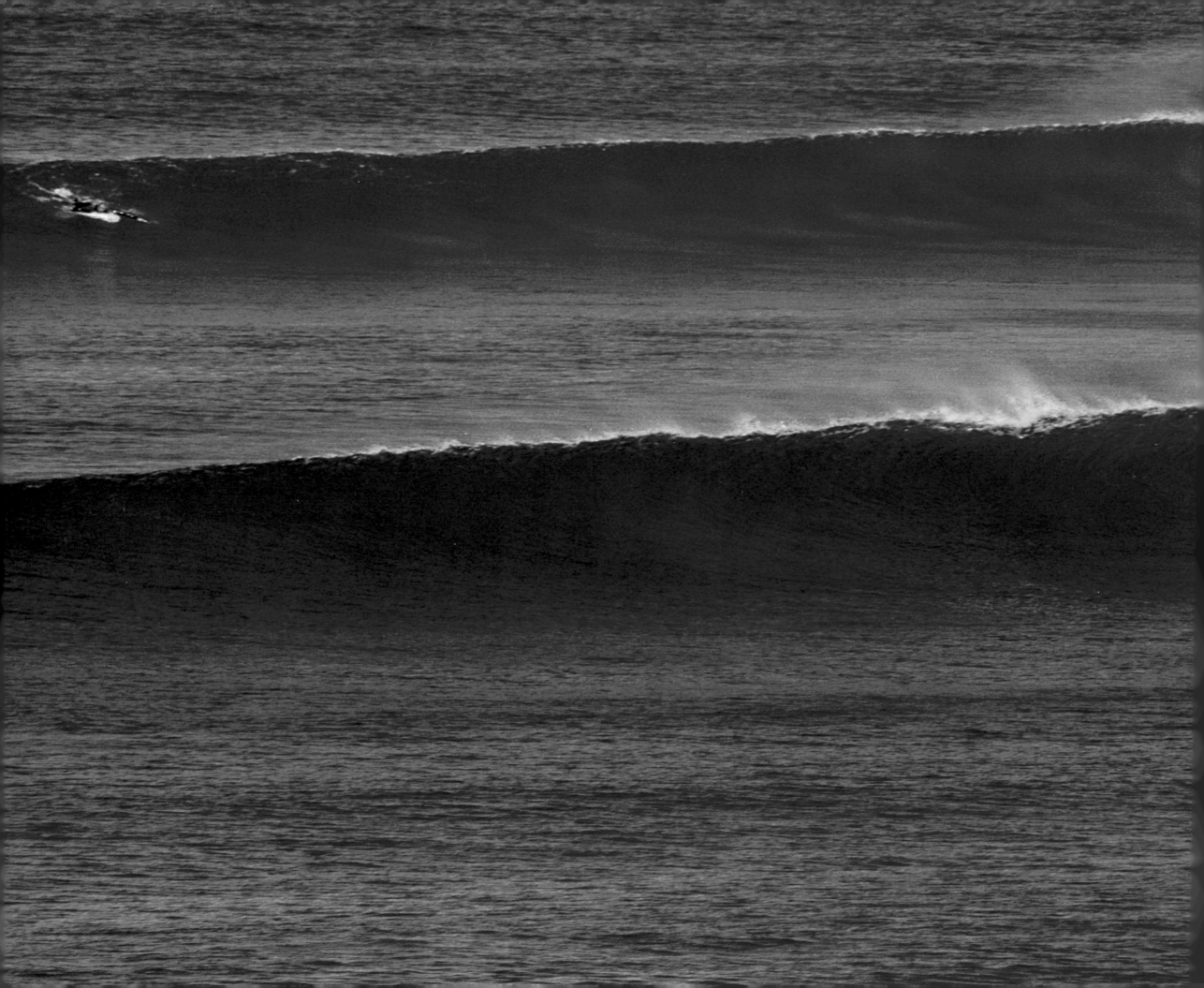

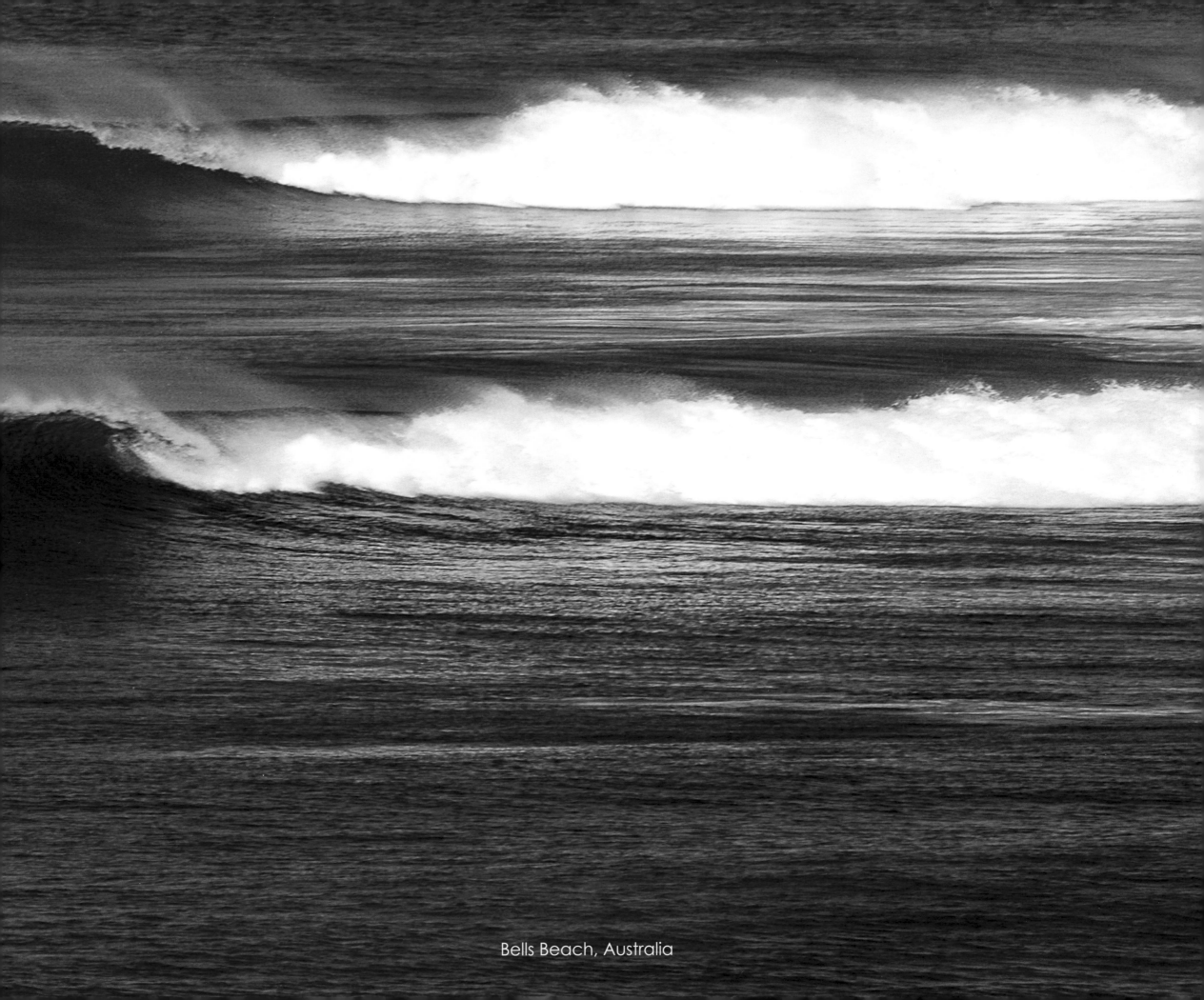

Bells Beach, Australia

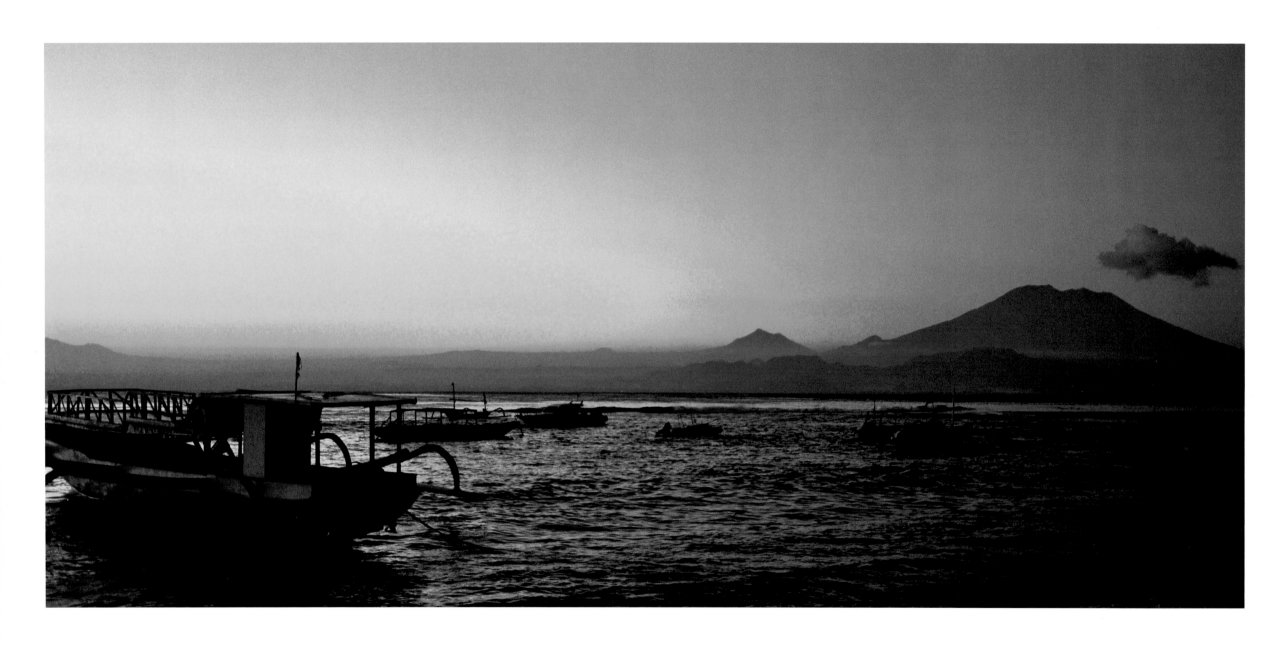

Nusa Lembongan, Indonesia

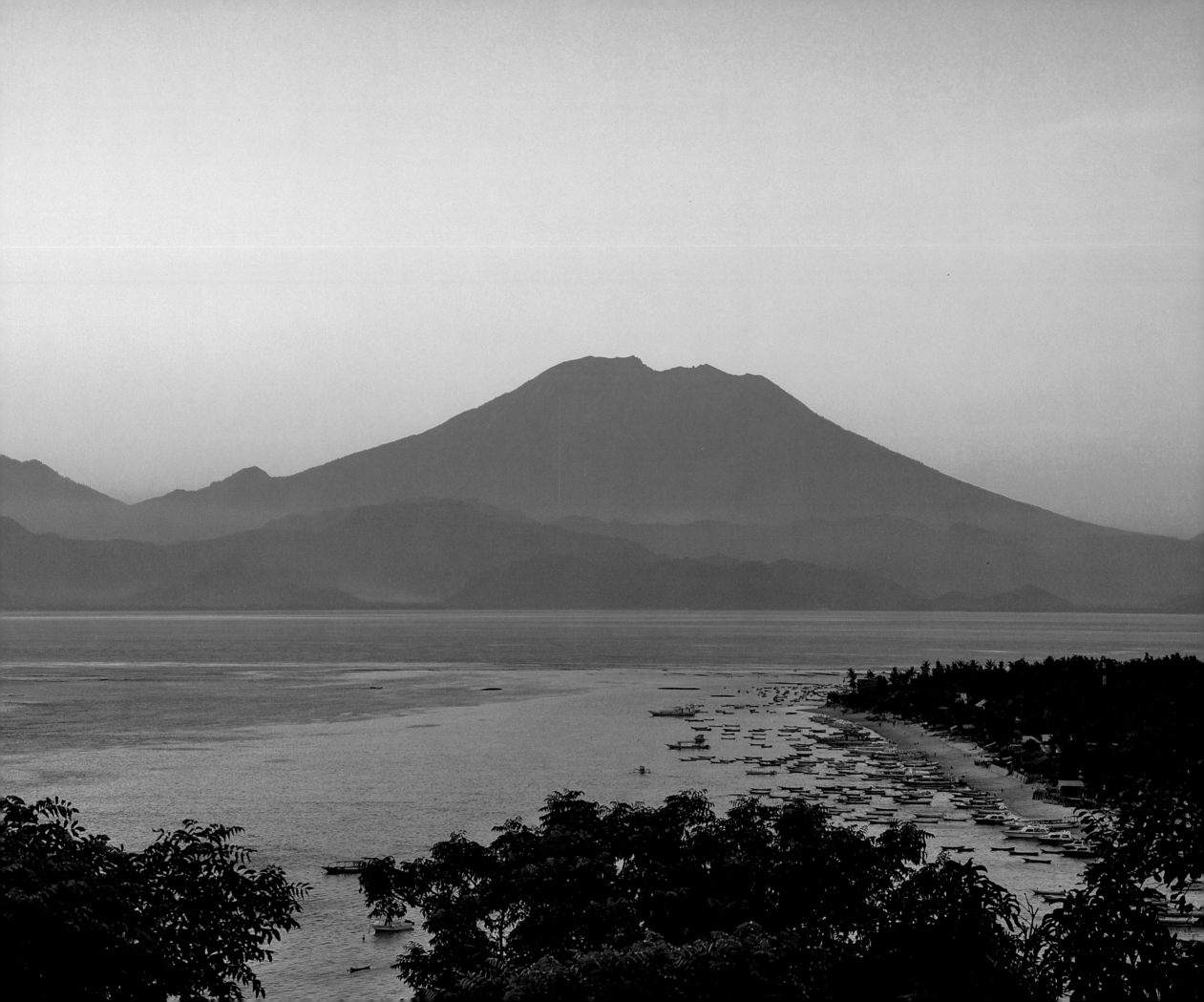

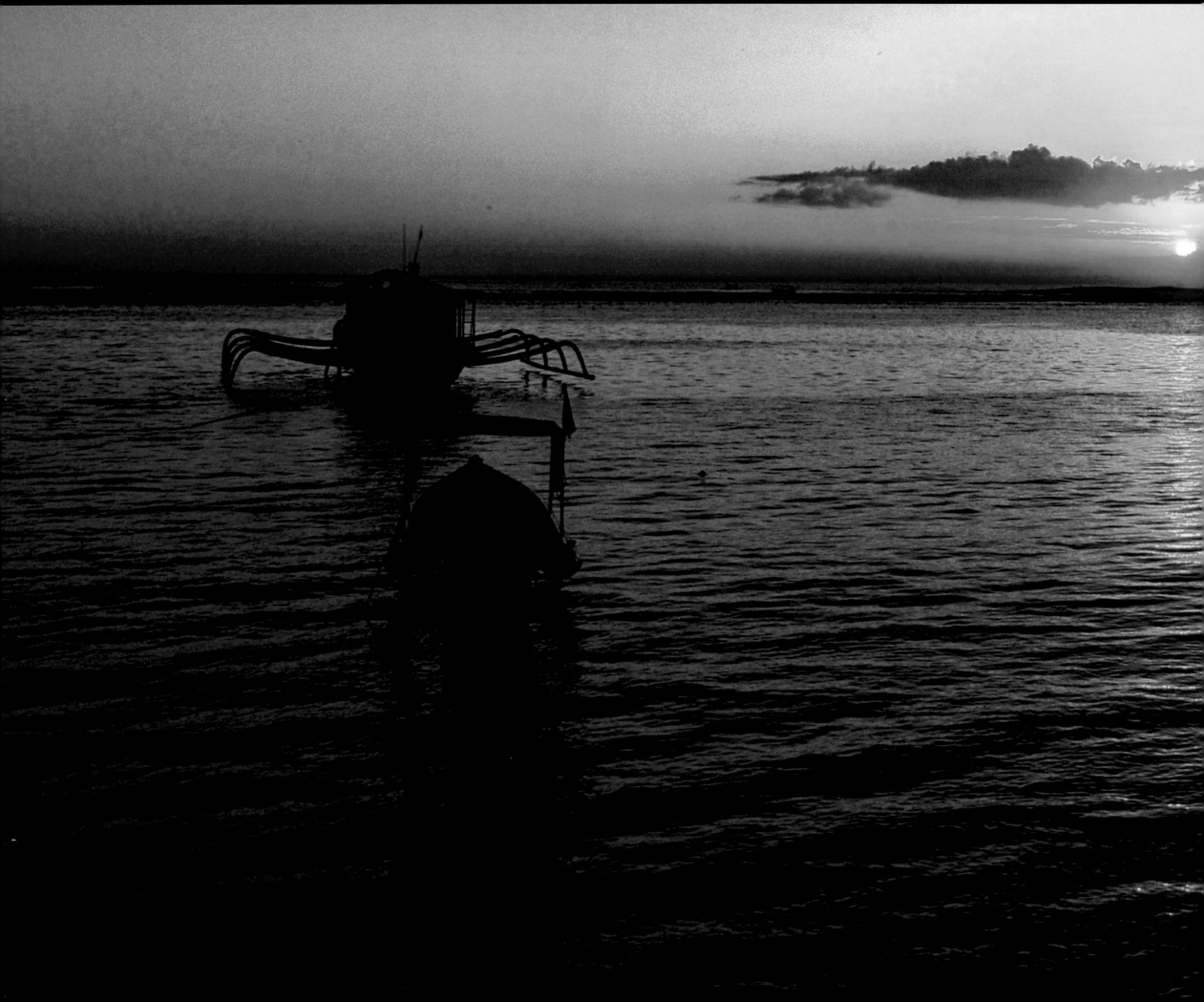

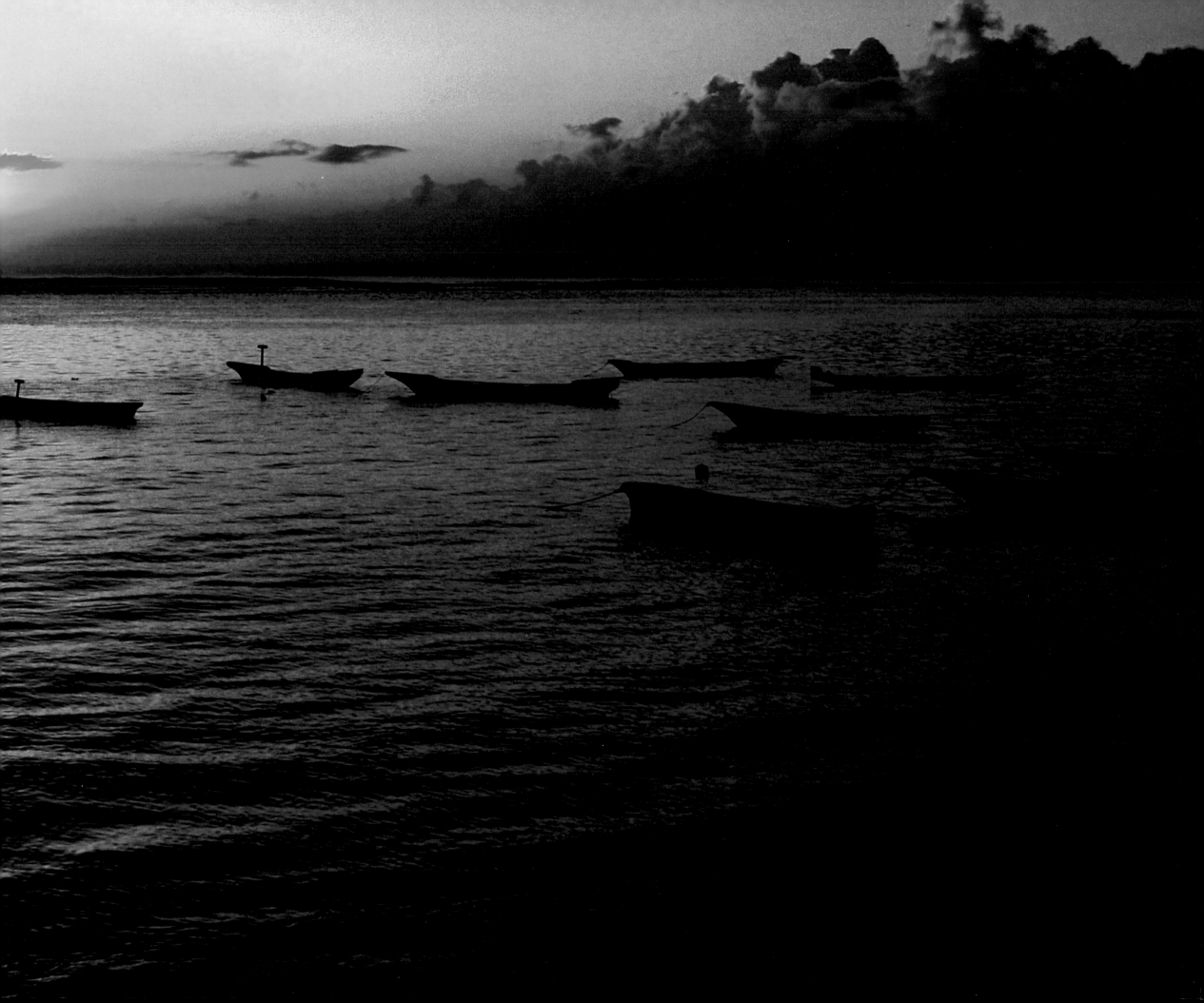

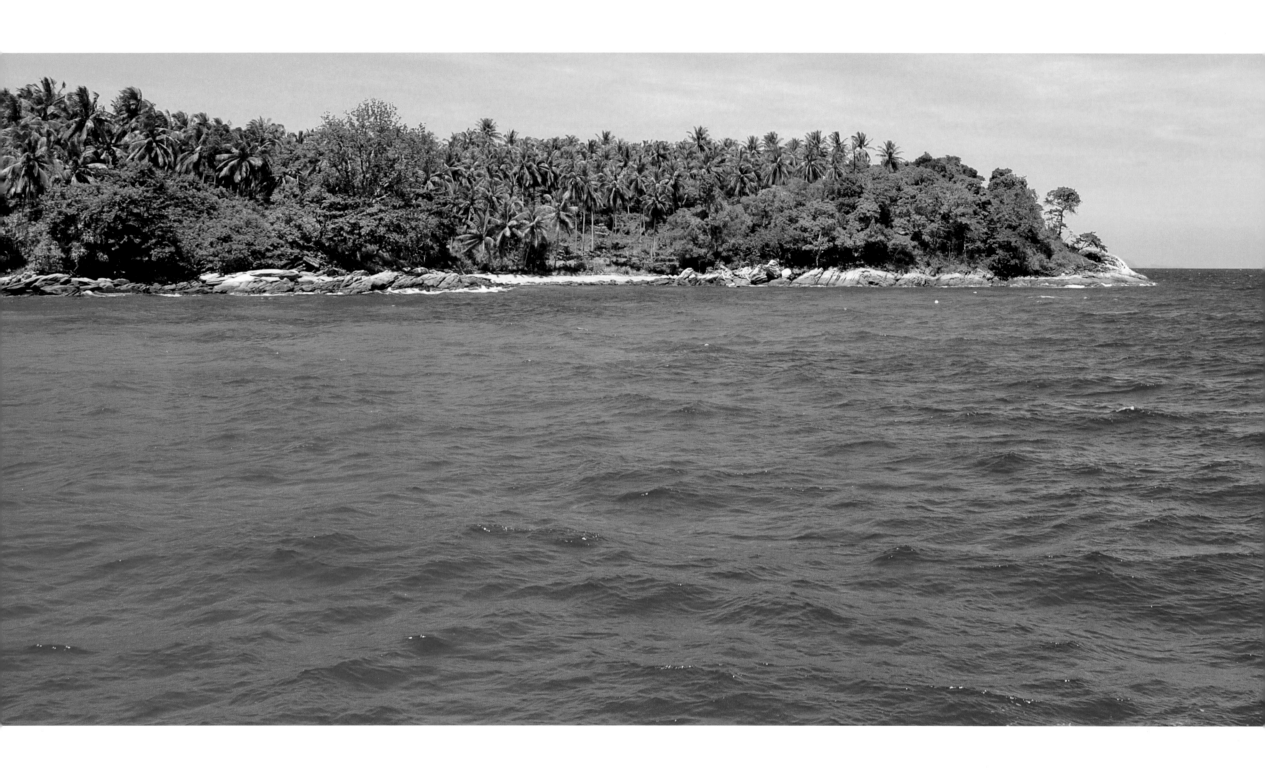

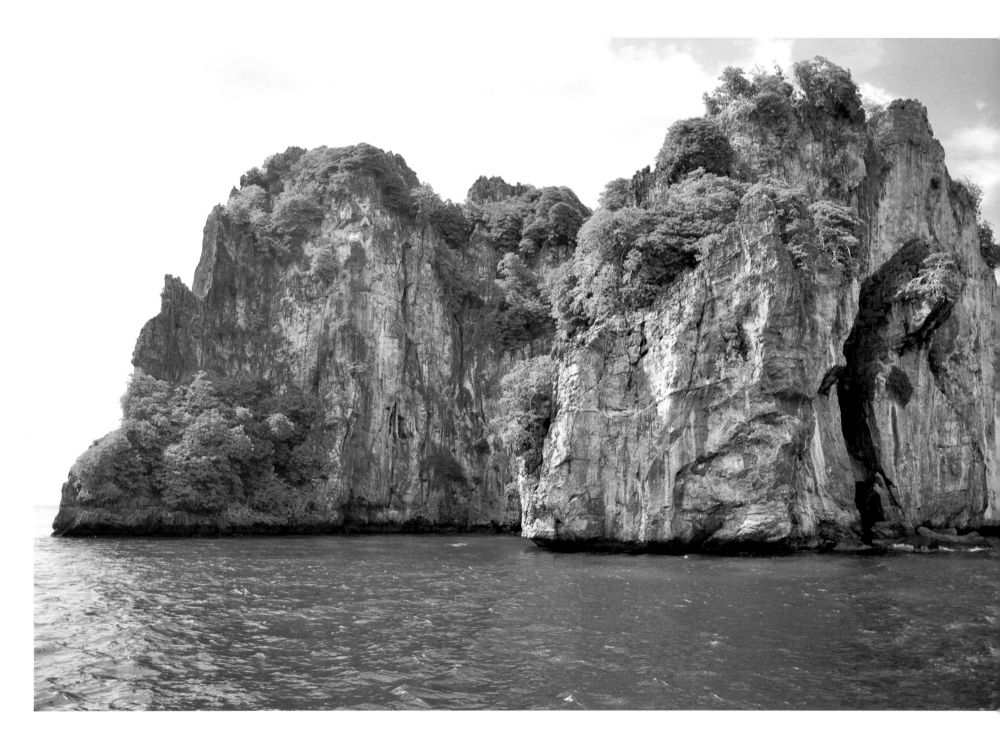

Phuket, Thailand

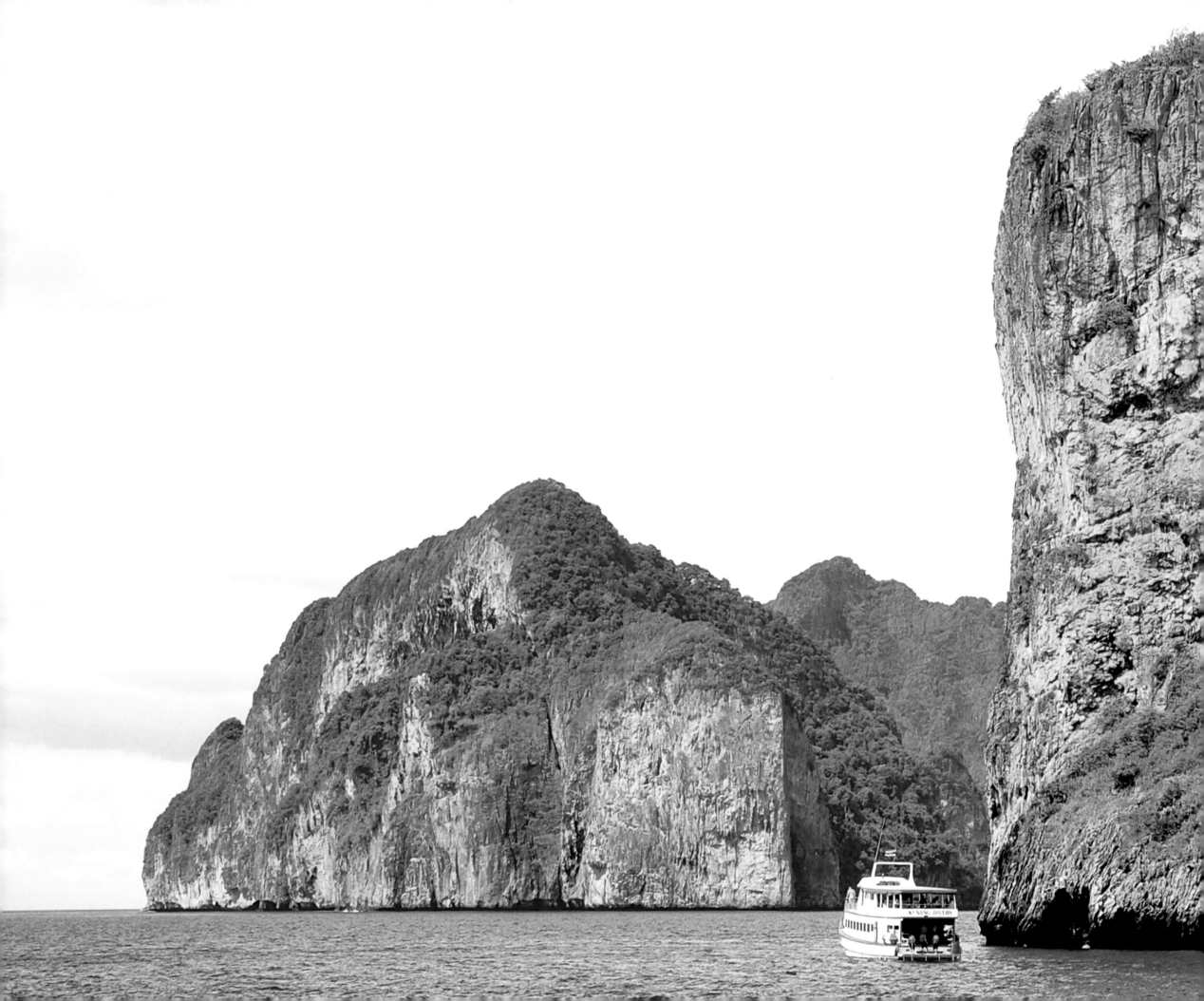

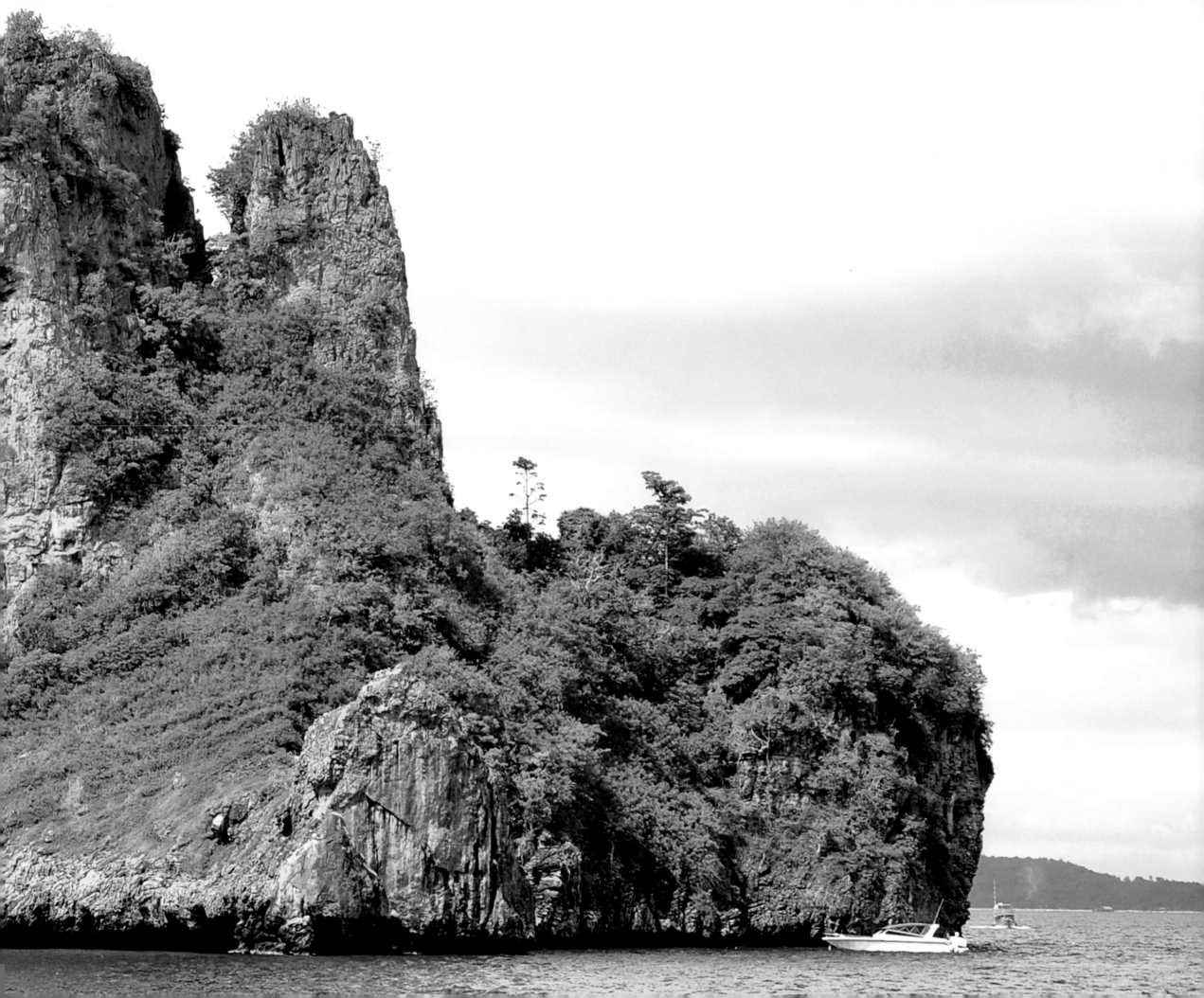

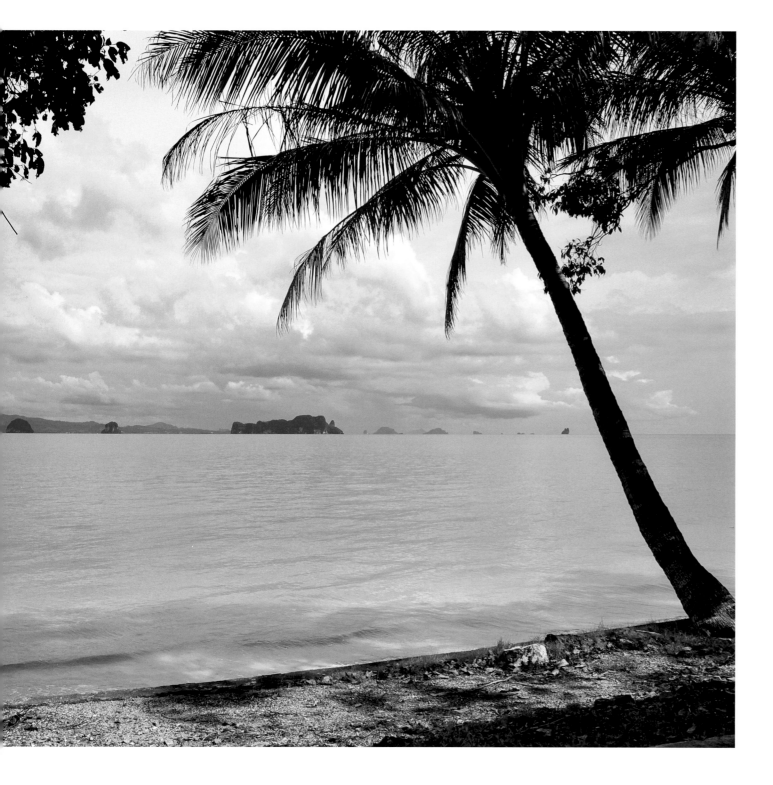
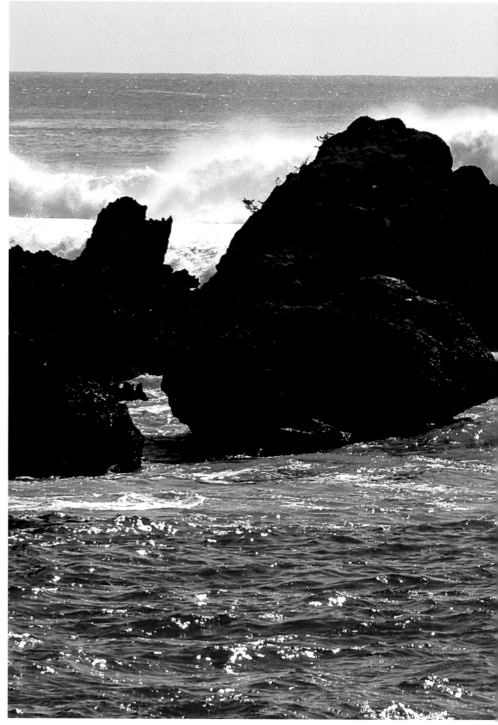

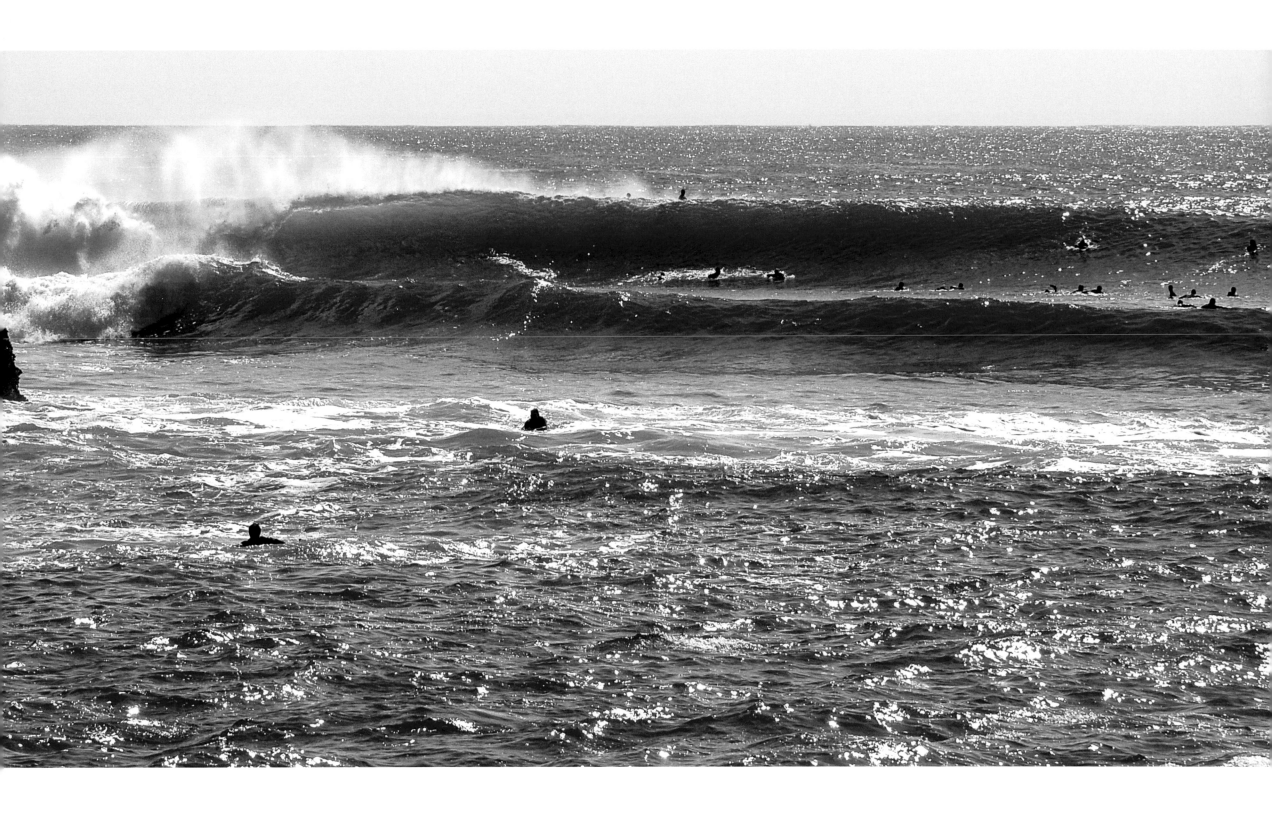

Pandang Bai, Bali

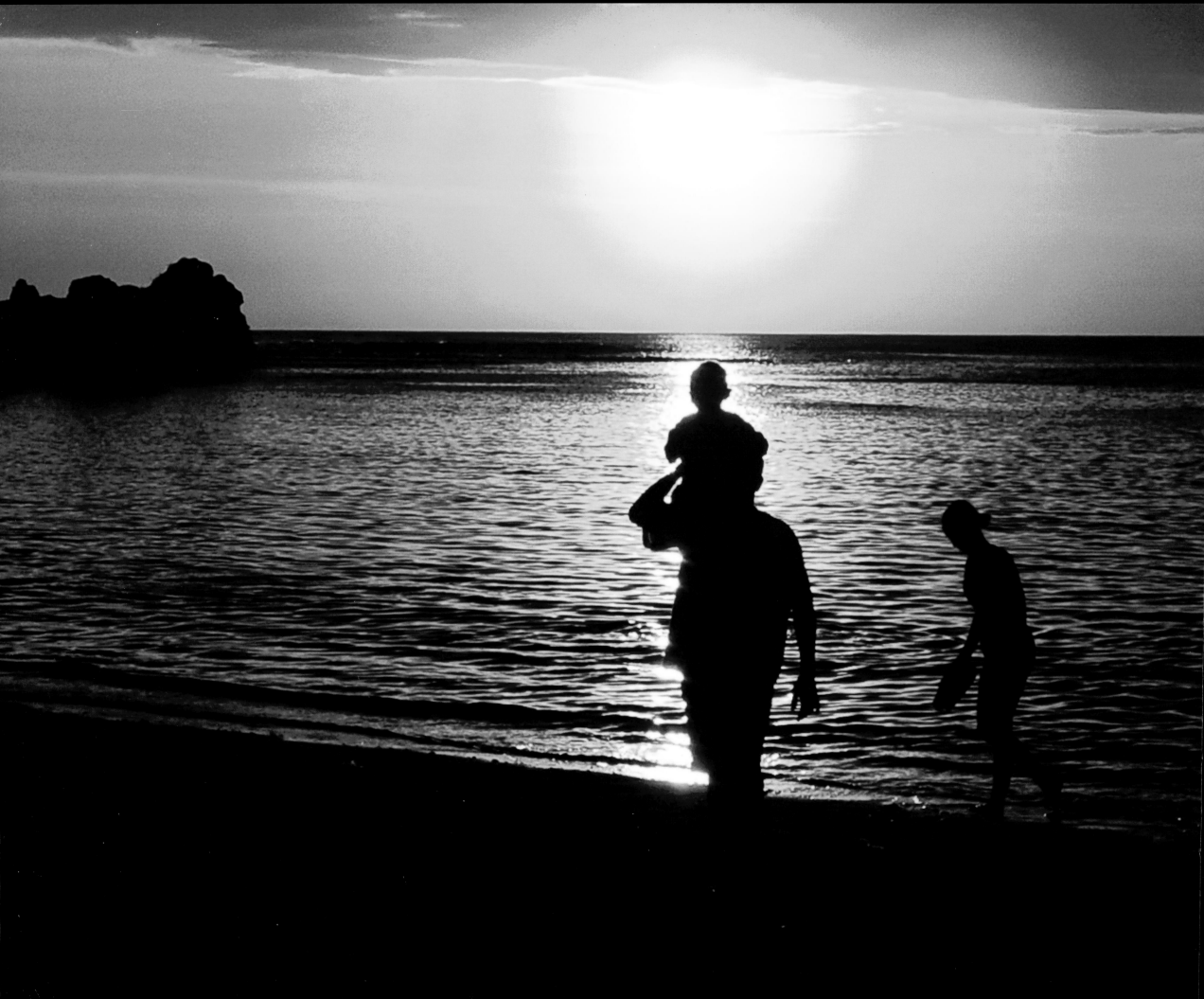

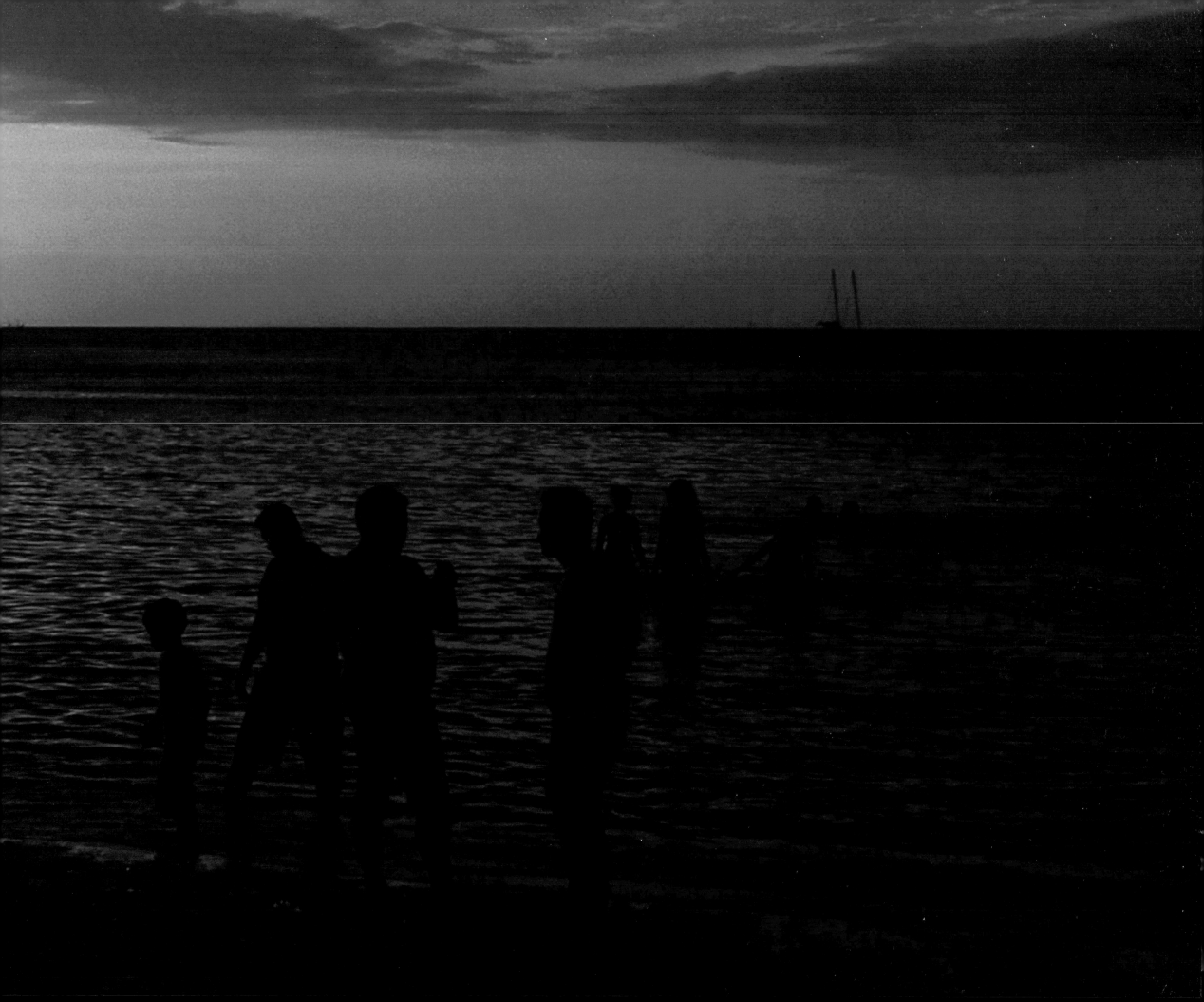

Dain Blair
photographer

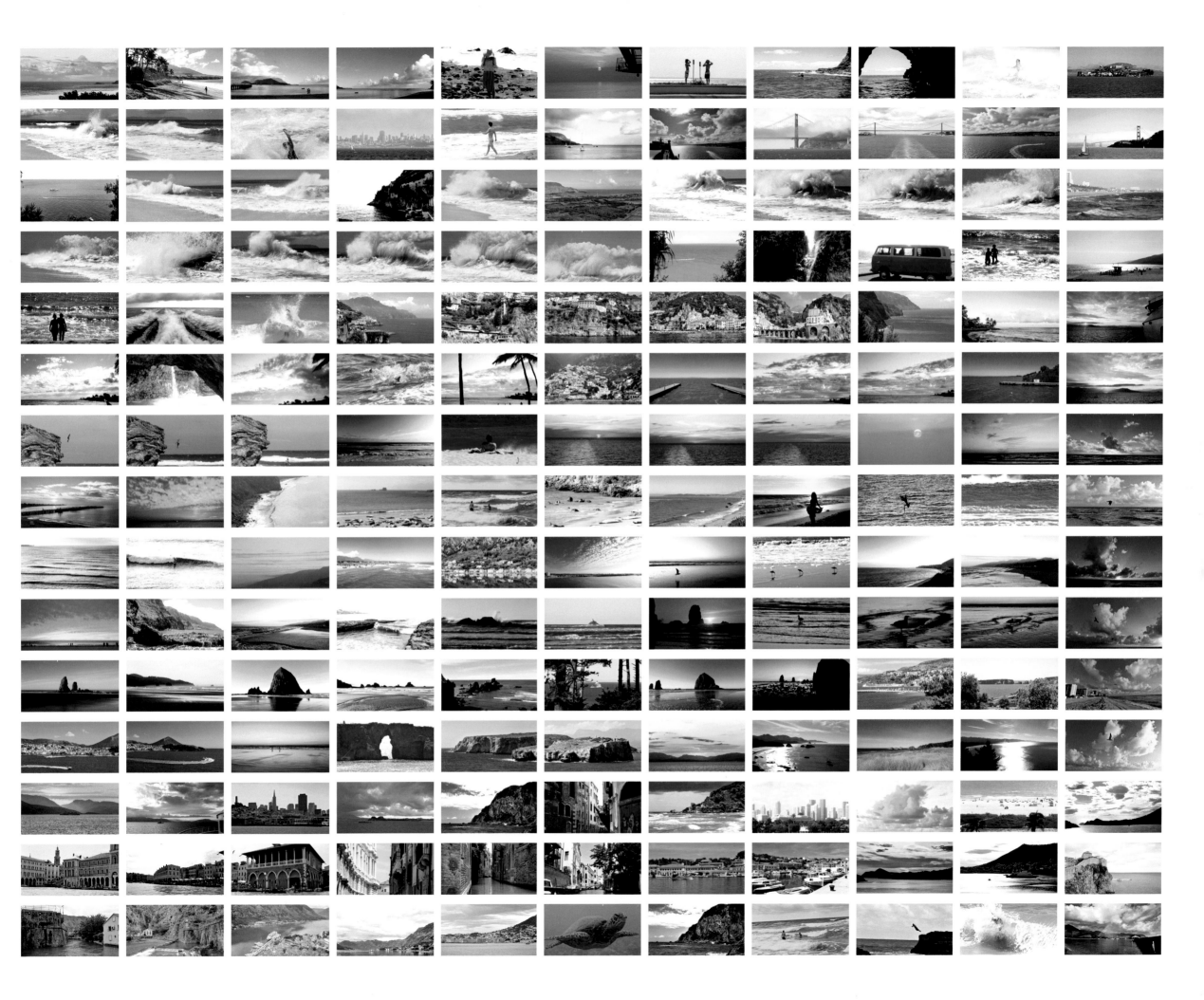

Aaron Taylor
photographer

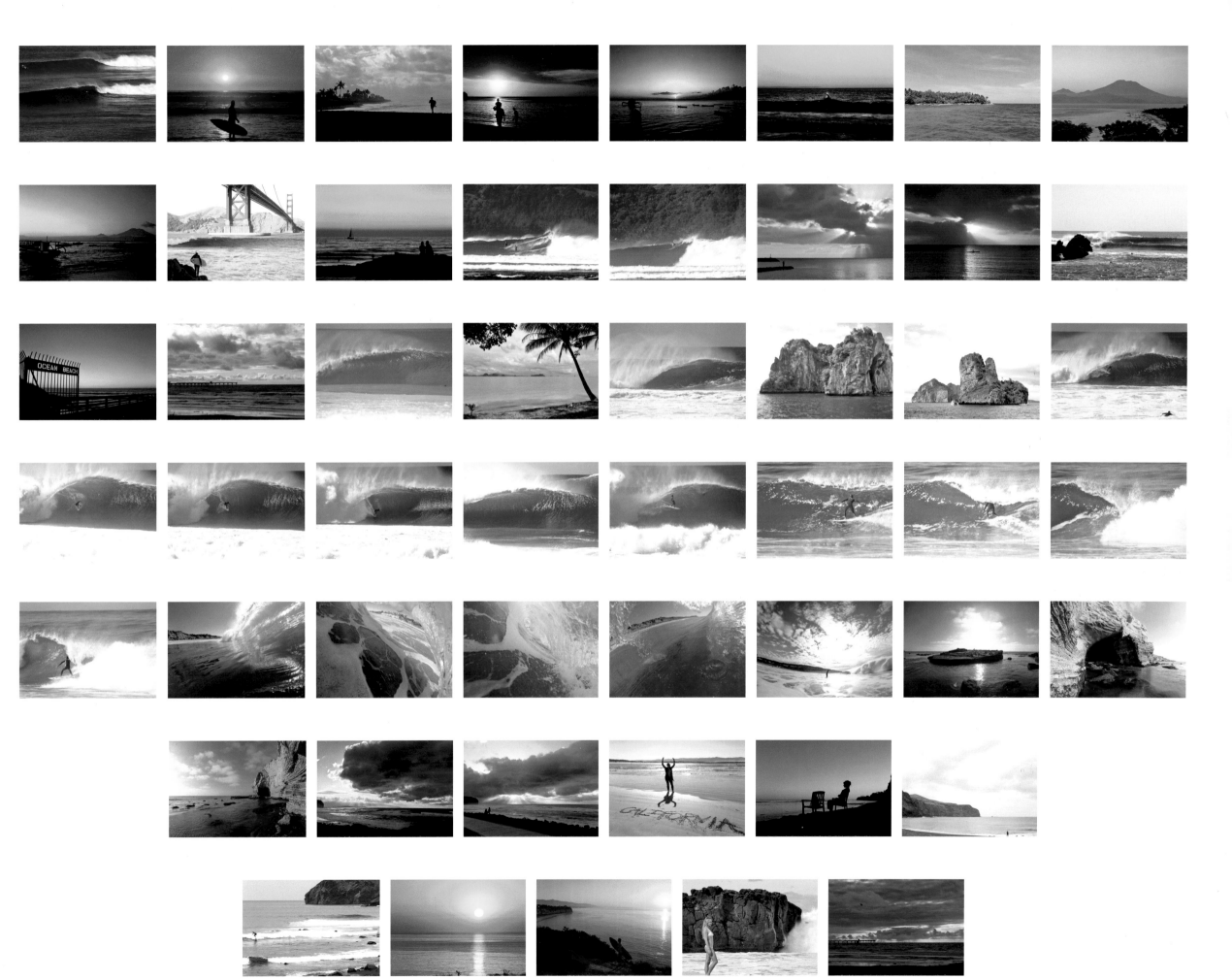

Dain Blair

Dain's experience covers everything from playing guitar and bass in touring bands to doing promotion for Capitol Records to producing artists with multiple chart records for the commercial music business. Dain started a custom music house, Groove Addicts, in 1996.

In addition to producing music for countless national TV spots, radio and TV imaging, his company scored TV shows like "Deal Or No Deal," "Extreme Makeover Home Edition," and "The Super Nanny," just to name a few. Dain has had the privilege of working with such talents as B.B. King, Jose Feliciano, Patti LaBelle, Danny Elfman, Stewart Copeland, Thomas Newman and numerous other feature film composers. Dain launched the Groove Addicts Production Music Catalog, which was sold to Warner Chappell Music in 2010. The custom company was rebranded as Grooveworx and continues to do commercials, TV, radio imaging and music trailers.

After music, Dain's passion is photography. Over the past twenty years, Dain has taken thousands of photos using first his 35mm Nikon F1 and since the digital age his Nikon DSLR cameras with multiple lenses, but most notably his 17-35 wide angle. He enjoys photographing sunrises, sunsets and oceans and whenever possible both simultaneously. Dain spent a lot of time on the water growing up in the Panama Canal Zone, between the Pacific and Atlantic oceans. Each sunrise and sunset is unique and never to be repeated, so he is always looking for something that will be more impressive than the last one. He resides in Los Angeles with his wife, Sharon and their two children, Justin and Taylor.

Aaron Taylor

Born in Redondo Beach, California, Aaron was drawn to the arts early in his life. He learned to paint by watching PBS as a small child and after moving to the outskirts of Houston, Texas he also grew fond of the outdoors. He developed a love for the natural beauty that is around us everyday, seeing more of the roses and the sunshine than buildings and human structures. After moving back to California, Aaron rediscovered the ocean through influences from his uncle and father, and his love for nature changed forever through trips to beach cities around the globe.

Aaron's family took several trips to Hawaii, which cemented his love for the vastness of the ocean. However, his transition from admirer to photographer took place during his last summer before senior year of high school when Aaron's dad took him on a surfing trip to Bali, Indonesia. Borrowing his father's Nikon camera, Aaron snapped his first ocean photo. Aaron honed his photography skills on another international surf trip with his dad in Australia, where he took more time framing shots and learning more about the technical side of the lensing systems. A photo from this trip at Bells Beach in Torquay, Australia is featured in this book.

In Aaron's second year of college he took yet another life changing journey to Hawaii. With a broken leg he was forced to sit behind the lens and study lighting and even better capture the raw beauty of the ocean. He ended up crossing paths with a massive swell from Alaska, creating waves that ranged from double the height of a man to triple overhead. From this swell, Aaron had the opportunity to shoot photos of legends such as Kelly Slater, Bruce Irons, Garret McNamara, Mark Healey, Sunny Garcia, and the young gun at the time Jamie O'Brien; a few of these images are also featured in this book.

Currently working as a media and marketing director in the surf industry Aaron has the opportunity to shoot photographs on a daily basis. He continues to travel to exotic locations as well as explore the beauty of the California coastline.

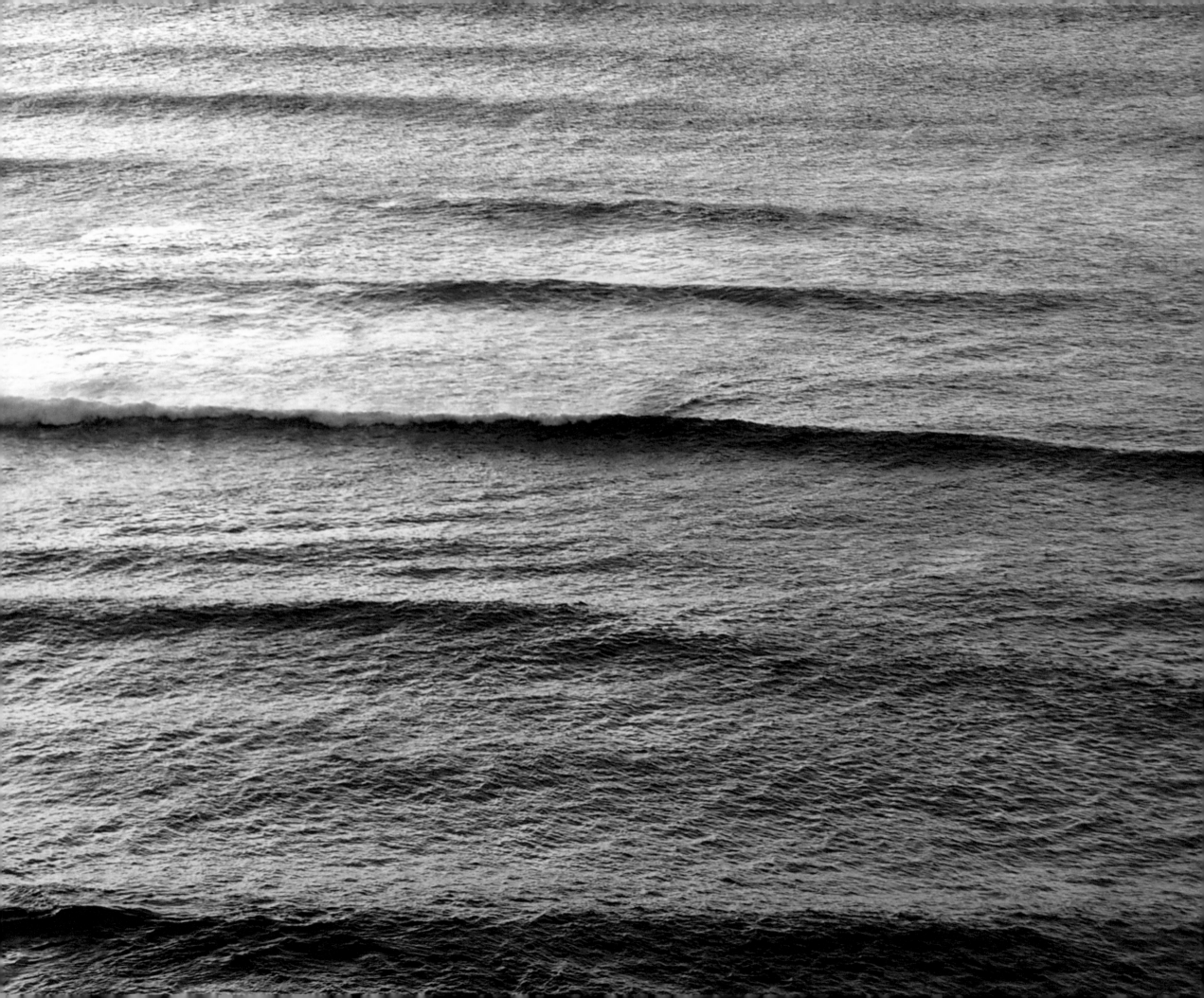

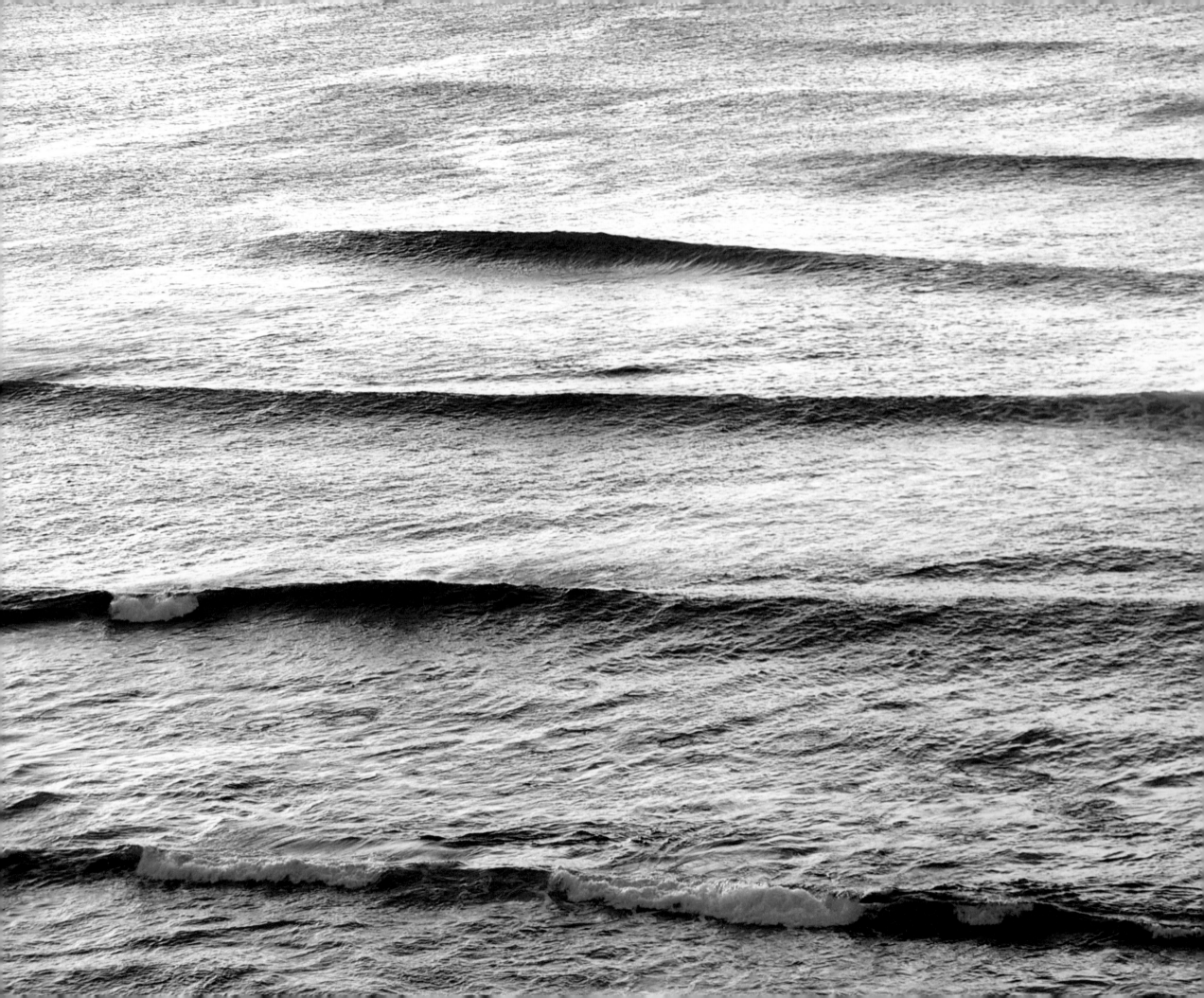